# ENGLAND'S HIDDEN REVERSE

## David Keenan

This expanded edition published 2016 by Strange Attractor Press
Hardback Special Edition limited to 1000 copies, including *Furfur*.
Unlimited Paperback Edition.

First Published by SAF 2003
Text Copyright © 2003/2016  David Keenan

Cover and Endpapers by Mark Titchner
Design and layout by Jamie Sutcliffe & Mark Pilkington

ISBN: 978-1-907222-17-7

A CIP catalogue record for this book is available from the British Library.

Strange Attractor Press
BM SAP, London, WC1N 3XX, UK
www.strangeattractor.co.uk

# A SECRET HISTORY
# OF THE
# ESOTERIC
# UNDERGROUND

## COIL • CURRENT 93
## NURSE WITH WOUND

# Contents:

## Crime Calls For Night
### Murdering England In The Dark Of The 1970s

*England's Hidden Reverse*, written in the late 1990s and early 2000s and first published in 2003, deals with a period in art and music that displays an overall obsession with what I have come to term night time imagery. My argument is that the use of this imagery functioned as an esoteric rite of transformation enacted via an ascent that followed a descent; a descent into night, into the subconscious and into the repressed – psychologically and historically – via the interrogation of the possibilities of transgression. These range from fantasies of genocide to the desecrating and reversing of history through serial murder, occult ritual and images of extreme sexual violence. I argue that the artists used these images, not as mere shock tactics, (although inescapably, as the initial experiments became explicable and were recuperated as genre, there is some of that) but rather, as a form of psychic self-surgery.

Noise and Industrial music function as the night time to pop music's day. Where pop music exists as a soundtrack to nine-to-five work and consumption, noise provides the cover of night that facilitates transgressive activities, liberating suppressed personas and jamming the wavelengths that consensual reality broadcasts on. Crime calls for night; noise is no longer music as entertainment.

*Previous page*: artwork by Produktion (see p.48/49).

In this alternate history, the formation of Throbbing Gristle in 1975 – predating UK punk – is year zero.

Throbbing Gristle's disassembling of rock music and their interrogative strategies for retooling DIY worked to liberate music from musicians. In their wake many underground cells were activated across the UK and further afield, inspired to mint a new form of intuitive music that married the primitive application of rock 'n' roll detritus and consumer electronics with a vision that looked more to 20th Century avant garde composers, Krautrock and contemporary sound art as future carriers of the original rock 'n' roll urge. Whitehouse, formed by William Bennett in 1980, took this newfound sense of permission to its extremes, effectively birthing noise music – or 'power electronics' as Bennett dubbed it – as a genre while making consistent and inexplicable use of extreme imagery, naming albums after concentration camps, like 1981's *Buchenwald*, dedicating albums to notorious serial killers, as on 1983's *Dedicated To Peter Kurten Sadist And Mass Slayer*, and using self-consciously atrocious track titles like 'Tit Pulp', 'Shitfun' and 'I'm Comin' Up Your Ass.'

So far, so very adolescent, right? But we need to be very careful when we use a term like 'adolescent' in a disparaging way. What do we mean?

Rock 'n' roll is an adolescent art form. It derives most of its energy from adolescence. If we're going to damn music for being adolescent we're going to have to write off all of the best rock 'n' roll, all of the music that we love. But as an adolescent art form the kind of grotesque, violent, hyper-sexualised imagery that Whitehouse dealt in can never be far from the surface.

Allow me to take a tangent here. I have a long-term interest in Palaeolithic art. Much of it is very beautiful, there are many coffee table books dedicated to the subject. But the majority of images found in caves, in other words the majority of the surviving Palaeolithic art, are uncollected because it doesn't fit our image of the noble artistic savage. There's a writer called R Dale Guthrie who wrote a book called *The Nature of Palaeolithic Art* in 2005. Guthrie makes a very convincing argument for the bulk of the surviving Palaeolithic art – and of course there were other forms of art that didn't survive because of taphonomic

bias – but the surviving art, Guthrie claims, was mostly made by adolescent males.

It's a startling thesis but it makes sense. Guthrie blows the popular shamanistic magico-religious interpretation out of the water. If you make a systematic study of Palaeolithic art you come to see that it is overwhelmingly obsessed by and based around images of sex and violence. Hunting and killing large mammals, oversize cocks and huge vulvas, sometimes combined in scenes of carnage. Look at the doodles of any contemporary adolescent and you will see very similar imagery. Guthrie calls them 'testosterone events'.

So we have all this adolescent art with all of this sex and violence, essentially, as its motor. And we know this and we have certain societal taboos in order to keep this energy under control. But its power is overwhelming and it continues to erupt and break out no matter what controls we set in place.

Rock 'n' roll provided a relatively safe conduit for these energies. But it caused outrage when it first broke. When Elvis appeared on the Ed Sullivan Show in 1957 the cameramen were under instructions not to film him below the waist. Sullivan went out of his way to describe Elvis as a 'real decent, fine boy.' Still, rock 'n' roll can also be seen as a safety valve, in a sense, a way of containing these inchoate powers, which is how Throbbing Gristle saw it, as a system of control. But when you attempt to dismantle that, well, think of the kind of energy that you are loosing.

Punk was the first popular music, really, to bring this ugly, out of control side of adolescent energy to the fore. Who was using Nazi imagery in popular culture before The Sex Pistols and Siouxsie Sioux? Arguably, Charles Manson and associated deprogramming cults like The Process Church Of The Final Judgment in the late '60s were perhaps the first manifestation of this night side of popular culture, which is why so many Industrialists became obsessed by Manson. But tracks like 'Holidays In The Sun' and 'Belsen Was A Gas' represent the earliest encounters with Nazi imagery in popular music.

'Holidays In The Sun', the Sex Pistols' 1977 single for Virgin, still sounds remarkable. The goose-stepping rhythms and the

chanted backing vocals match the sieg-heiling march of reason that brought the world to the brink in the first place. It's spine chilling. With 'Holidays In The Sun' we see the first steps towards a refusal of the rational and an embracing of the irrational – or the supra-rational – that would find its apex in the culture of the new noise music.

Industrial music was the first music to face this legacy head-on and to put it to use by explicitly interrogating these ideas and images and making ritual use of them. The music is often thrilling in its violence, in its erotic licentiousness, in its attraction to darkness and the taboo.

As an interesting aside, Guthrie makes the point that only adolescents, on the whole, were attracted to dangerous, dark places like caves. Indeed the story repeats itself again and again, in that many of the modern cave sites of Palaeolithic art, including the famous Lascaux cave paintings in southwestern France, were actually re-discovered by adolescents while out exploring in the fields. Guthrie goes on to expand his hypothesis to bring in the idea of an extended adolescence as well as the adolescent's attraction to testosterone events as being a key catalyst for the way human consciousness evolved, in terms of the co-operation required to hunt and kill large animals and the planning and sharing that entailed. So we can see how this energy has been an evolutionary agent but how we have also inherited the reverse side of this energy, with all of its difficulties and terrors.

Let's take a different tack. In 1998 I reviewed a publication that documented the goings on at the historic 1st World Conference On Music And Censorship. There was a lot of good stuff in there.

'Rights and freedoms usually exist to protect that which ordinarily wouldn't survive because it is against the mainstream,' wrote Charles Onyango-Obbo, editor of Uganda's *Monitor* magazine, in one of the book's most clear-eyed essays. 'If we remove the philosophical assumption that rights are primarily to protect the fringe, the objectionable, the minority view, then it all doesn't make sense... It seems to me that violence songs and hate speech can have a redemptive value, despite the very contradiction that this conjures up.' Yet four

pages later we have Isi Foighel, a Doctor Of Law in Denmark, claiming that we have an 'obligation not to misuse the right of expression.' Well, what exactly do you mean? Is NWA's anti-cop barrage 'Fuck Tha Police' a misuse? Not for a black kid growing up in LA. Does Paul McCartney's pro-Republican (and banned at the time) 'Give Ireland Back To The Irish' qualify as hate music? The Pogues' 'Streets Of Sorrow/Birmingham Six'? What about Amiri Baraka's 'Black Art'? And who decides? As soon as we start to introduce the whole concept of 'responsibility' we're on treacherous ground. What about the right to be irresponsible?

Ray Phiri, a South African musician who played on Paul Simon's *Graceland*, sounds like a deranged censorial fundamentalist in his supposed championing of liberal values in the same volume. 'I would just like to say that life is a precious gift,' he writes. 'Anything that construes life as not a precious gift is evil.' What!? Well there goes Pere Ubu's 'Life Stinks', Richard Hell, Suicide, The Velvet Underground, The Stooges, Celine, Jean Genet, Blaise Cendrars... most of the genuinely interesting and challenging art of the 20th Century, in fact. All that's left is Paul Simon, The Lightning Seeds and Sting.

Can violent imagery and hate speech really have a redemptive value? I would say yes, yes it can.

When I wrote *England's Hidden Reverse* I interviewed, lived with and got to know many of the central players in the UK's noise and Industrial underground, including the members of Throbbing Gristle, the late Peter Christopherson and John Balance of Coil, David Tibet of Current 93, Steven Stapleton of Nurse With Wound and William Bennett of Whitehouse. If you only knew these people through their art you might be a little surprised at how they were in their day-to-day lives. In my experience the people most interested in extreme culture and imagery have tended also to be the softest, gentlest, and the most intensely moral of people. Sometimes, even, the most frightened. To take morality so seriously that you have to pick it apart yourself in order to re-build it in the face of the truth of existence, in all its horror and beauty, is intensely moral. Many of these groups, especially Coil, were interested in magick and the occult. Indeed, Throbbing Gristle were the

first group to rehabilitate and re-contextualise 20th Century occultists like Aleister Crowley and Austin Osman Spare. In my understanding of magick, when it works, what it does is it reconciles you to reality, it brings you closer to it rather than removing you into some fantasy new age la-la land of ghosts and spirits.

And that for me is what the Industrial project was all about. It was an attempt to say yes to no. The American mythologist Joseph Campbell, when he would teach his courses, would talk to students about an experience he had as a young man where he came upon a caterpillar into which a parasitic wasp had laid its eggs. The live caterpillar was writhing and contorting in horrific agony as the newborn maggots ate their way out. Can you say yes to this? Campbell would ask his students. Because you have to; life feeds on life. Ultimately, Campbell argued, you have to put yourself on the side of life as opposed to the side of protective ideas about life. An attempt to say yes to life, in the face of the ultimate horror of existence; this is why I see Industrial music as a more optimistic, affirmative and more genuinely liberating phenomenon than punk rock.

But this is key: noise and Industrial music, at least the best of it, never aestheticises horror, never dresses it up. You can't write pretty pop songs about the Holocaust. Whitehouse's *Buchenwald* sounds like its subject matter; at least it doesn't betray it. Yet while the Sex Pistols are a mainstream canonised rock group, despite the overt Nazi imagery and offensively idiotic songs like 'Belsen Was A Gas', Whitehouse remain beyond the pale. Indeed most mainstream music magazines still won't touch them. They're Nazis, people say. But somehow the Sex Pistols are not. Of course, the idea that avowedly degenerate art like the music of Whitehouse might have any place in a National Socialist future is ridiculous. Indeed, the Nazis regarded atonality in music as a particular degeneracy. But more to the point, I think it might be noise music's lack of content or any kind of ready-made interpretive framework with which to make sense of it which is to blame, alongside an inability or unwillingness to give weight to points made or imagery used in 'popular' music as opposed to 'serious' music or 'high' art. It's only rock 'n' roll, right?

Whitehouse's 1981 album *Buchenwald* has no lyrics, no chords, no rhythm. It forces you back on your own reactions. Noise short-circuits any kind of easy response and Whitehouse made creative use of this. Indeed, they fostered such an intense, malevolent context for their art that all you have to do is import a word or phrase or image into the context of Whitehouse, one that outside of it might seem perfectly innocuous, and immediately it seems to pulse with night time energy. Think of Whitehouse albums like *Halogen*, *Thank Your Lucky Stars*, *Mummy And Daddy* or *Quality Time*.

*Buchenwald* is the sound of the late 20th Century blues. I'm standing over my mother's grave and I can't keep from crying. No different. No poetry after Buchenwald? Well, there's no poetry here. Let's attempt to look this thing in the face, as much as we can, without any filter of ideology or explanation or 'understanding'. This is what gives the music so much of its power, its inexplicability, its refusal to aestheticise or rationalise mass murder, this gaping hole in the narrative of rational human beings or as they were dubbed by a famous book on the subject, *Hitler's Willing Executioners*.

All the way through the Whitehouse project William Bennett was forced to contend with accusations that he was in fact 'a Nazi' and was eventually compelled by unnamed obsessives threatening venues that were booking his post-Whitehouse project, Cut Hands, to make a statement that he was not in fact a racist or a National Socialist or a sexual predator and so to sunder the equivocal artistic persona that he had maintained since 1980. What do these people want from art? An apology for reality? How interesting would an artwork be that was called *The Holocaust Was Terrible*? *Serial Killing Stinks*? How deep does that get into the darkness of the human heart? Do you intend to rationalise all evil? To wish it out of existence? *Buchenwald*, like the Holocaust itself, refuses all of our excuses, explanations and ideological safety nets. There is no poetry here.

A track like 'Ripper Territory' that opens the 1981 Whitehouse album *Dedicated To Peter Kurten Sadist And Mass Slayer* is exemplary in this respect. There's not much to it at all. It uses an off-air recording

of a television news report documenting Peter Sutcliffe's arrest for the Yorkshire Ripper murders and combines it with barked, wordless vocals and violent bursts of noise. In doing so it exposes and underlines the spectacularisation and banalisation of horror that is the daily diet of the passive mainstream consumer. The chimes of Big Ben sound dramatic power chords as the Ripper's arrest is announced, the terrible noise becomes the sound in the head of the viewer, the inchoate rage and fantastical hate that the presentation of the news fosters. Then, in a moment of extreme bathos that shows that it's all entertainment really, no matter how prurient the subject matter, the announcer moves on to how Duncan Goodhew, the British swimming athlete, has broken some god knows what record on ice. 'Ripper Territory' is also interesting for the way that it connects Whitehouse to contemporary avant classical music, which alongside Yoko Ono was really the group's main influence, by a brief, smeared sample, a little juddering wormhole, lifted from 'Purposeful Lady Slow Afternoon' by Robert Ashley, a track that appeared on Ashley's 1979 album *Automatic Writing*. Interestingly, Ashley described the piece as a woman's description of a sexual experience that demonstrates 'the dichotomy between the rational – whatever can be explained in words – and its opposite – which is not irrational or a-rational, but which cannot be explained in words.'

Coil's 1999 album was titled *Musick To Play In The Dark*. In *England's Hidden Reverse* Balance explained the provenance of the title. 'When I was young I was really quite scared of the dark,' he revealed. 'I think my parents taught me to be and I remember the deciding thing was, I turned around and said: I'm going to go to the woods at night and walk into the darkness and embrace it and if I die, I die. I remember doing that and... nothing happened. I suddenly thought: I now know fear of the dark is wrong. In fact, it's comforting. So at that point in my life I embraced – literally – the darkness. I mean, not in a sense of evil. I'm on a lifelong mission to get rid of this equation, dark is evil and light is good. It's all to do with discovering the point that we don't need lights. Light – illumination – comes from within the darkness, not from electrical lighting. I think Christian based society's got that very wrong. They think that as soon as Britain's lit up, it'll be a safer place to live –

if you can see it you can capture it, control it – and they're absolutely wrong. It's the other way around. If we plunged into the darkness everyone would be safe.'

Many of the players in the Industrial underground adopted this ritual, experiential approach to self-initiation; into the dark, into the night time. Diana Rogerson, Steven Stapleton of Nurse With Wound's partner at the time, talks of how she became a locus for damaged young men who came to her in search of the kind of ritual situations denied them by modern society that would allow them to work through the complexes and structures that kept them locked up. In Rogerson's notorious short film, *Twisting The Black Threads Of My Mental Marionettes*, she functions as an initiatrix, with her and Matthew Bower of Pure and later of Skullflower, Total and Sunroof, exposing a young man – Jonathan Peppe – to humiliation and genital torture in the pursuit of spiritual and psychological catharsis. Or maybe just masochistic joy.

There's a great moment in DA Pennebaker's 1967 Bob Dylan documentary *Don't Look Back*. Dylan takes *Time* magazine contributor Horace Judson to task for what he sees as the mainstream media's vapid denial of reality and their refusal to print 'the truth', 'a plain picture', like 'a tramp vomiting, man, into the sewer'. That is exactly what Whitehouse do.

It's interesting to contrast other musical and artistic responses to genocide and mass murder, to the horrors of the 20th Century. Take the notoriously self-flagellating left-liberal Canadian instrumental rock group Godspeed You! Black Emperor. On their 2012 album *Allelujah! Don't Bend! Ascend!* there is an 18 minute track named 'Mladič', a title that would seem to reference Ratko Mladič, the Bosnian Serb military commander accused of genocide and crimes against humanity. The music is epic, cinematic, with dramatic swells of guitar and rocking rhythms alongside a vague Balkan-esque folk melody just so you know where you are. This is the James Bond-ification of horror, the Hollywood-isation of terror, the aestheticising of suffering. Why are people not more appalled at this? When I interviewed Godspeed for *The Wire* back in 1998 they described the venues they played at, with no sense of irony, as being like death camps. The disparity in the reception of pieces like *Buchenwald* by

Whitehouse and 'Mladiç' by Godspeed You! Black Emperor underlines the hypnotic power that context – or lack of it – exerts over content. If Godspeed's commitment is to transcending entertainment to the point of a clarion call or a mourning for the victims of 'the machine', which would seem to be their deal, then shouldn't the form reflect it as much as the rhetoric? Shouldn't it be as ugly, violent, dangerous and difficult as the subject matter?

Industrial music and noise ultimately, at its best, is redemptive. It represents an unflinching descent into the dark of our evolutionary past, the dark of our blind sexual urges, the dark of our hidden terrors and fears and the petty and terrible violence of our day-to-day existence and it attempts to come to some kind of terms with them while never denying or censoring them. Going back to the article on censorship I mentioned earlier, we need an art form that does not honour life, an art form that says yes to no, an art form that in its refusal of liberal pieties and platitudes, of what is 'right' and what is 'wrong', allows passage through this heart of darkness via an orgia of sex and violence; an orgia, which in its original meaning, meant a ceremony of initiation rites. And just as in myth, when the goddess of beauty, love, war and sex, Ishtar, is returned from the underworld, perhaps we, ourselves, as humans, can rescue that spark of beauty and hope and fearlessness from our own dark places.

# A Visit To Catland, Also Called Pussydom

*To be an alien, to be in exile, is the mark of Christian suffering*
– Søren Kierkegaard

*For I will consider my cat Jeoffry. For he is the servant of the
Living God duly and daily serving him* – Christopher Smart

*The Goal is in each Kits Eye* – Louis Wain

The first cats David Tibet brought to his new home in North East
London in 1993 were two ginger tabbies, Mao and Rao. At night he
would sit by the window in his study on the first floor and watch them
skirt the fences and backyards as he gazed out over the marshes and
the reservoir, towards the City of London and beyond. The cats were
'spirits, children, angels' and under the spell of the man who painted
cats, the artist Louis Wain who ended his life in an English asylum,
Tibet began his first tentative chalk drawings. Luminous explosions
of zigzagging psychotic colour, they were attempts to capture their
lunar magic. Following the release of Current 93's apocalyptic *Thunder
Perfect Mind* LP the previous year, Tibet and his then girlfriend Janice
Ahmed aka Miss Kat or, according to the planets, Starfish, made a trip
to Malaysia, where he was born and, coincidentally, she still had family.

It was the first time Tibet had been back since he was 14, when
his family returned to England. Together they travelled out to Ipoh
in the north, a tin-mining town where his father used to work, and

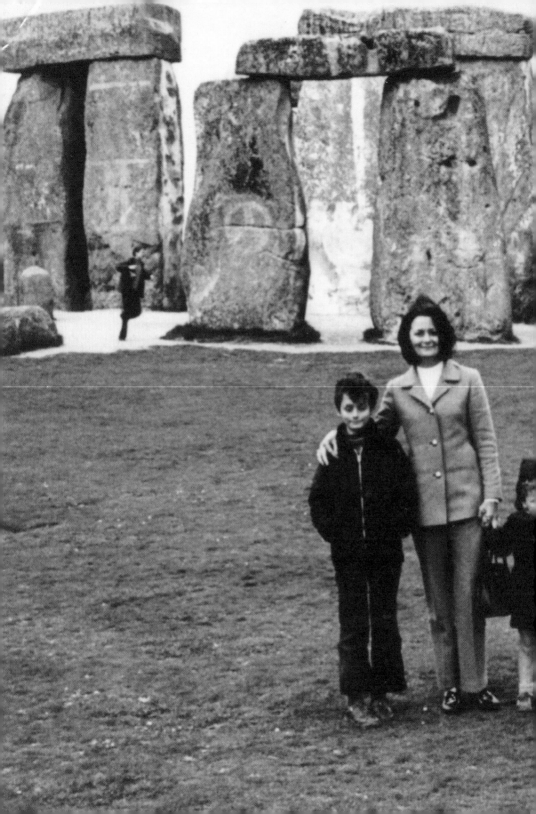

Cyril Bunting

on to Batu Gajah ('Stone Elephant') to see the converted stable where he was born David Michael Bunting on 5 March 1960. 'It couldn't have been any other way,' Tibet often joked. 'I loved Malaysia,' he recalled when I first spoke with him in August of 1997. 'I loved it. My childhood in Malaysia was practically perfect and I really miss it a lot. I dream about it a lot, it echoes in my soul always. It reverberates and as you get older you lie in bed and you think, the rain sounds like it's the monsoon coming.'

Tibet's fascination with religion began early. As a child he regularly went off exploring the Buddhist, Taoist and Hindu temples that dotted the region; and in 1992, he and Kat spent most of their return visit bussing out to various temples. In Kuala Lumpur, he was particularly taken with the straw effigy of one of the Wu-Ch-ang Kuei, 'the tall demon', with its macabre, extended red tongue. He wanted to take it home but that would've meant carrying it around with them for the rest of the trip. Instead they settled for fistfuls of Nepali skull malas picked up in a street-market. In the meantime Tibet took Kat by taxi to a ruined mansion, called Kellie's Folly, to show her where he had first seen ghosts as a child.

In Kuala Lumpur, where Tibet's younger brother Christian was born in 1968, they stayed at Kat's father's flat out in the suburbs, and visited her grandparents' house, a huge Chinese mansion that fell into ruin after the family fortune was lost to an uncle's speculation. 'My aunt had to move house because of the amount of money her husband lost,' Kat later explained. 'She gave her Persian cats to Granddad to look after. There being no servants and Grandma with a bad leg and Granddad with other things on his mind, the cats were put up on the

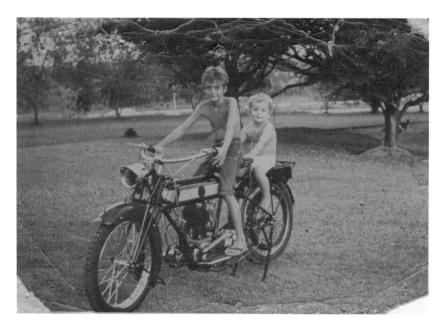

David and his brother Christian on their father's 1917 Triumph, Ipoh, Malaysia.

roof terrace, where they were basically left with whatever scraps they could remember to bring. One of the cats was evidently pregnant and gave birth, because we found all these miniature skeletons up there when we were invited to go and see them. No adult cats in sight. I expect they ran away long before. The skeletons lay on the concrete, ants crawling over the tiny bones, mute and bleached. I tried to reassure David that they were stillborn but we never got past the image that they were starved to death, attacked by insects, eaten alive, whatever.' When they went down for lunch, there were ants in the chicken-claw soup.

In town the smell of sliced banana fried with chilli oil and spicy peanuts hung heavy in the air, reminding Tibet of the trips he and his father Cyril took to see the latest Bollywood movie at the local cinema, where they ate plantain chips wrapped in paper cones. Subtitles used to frame the screen, with English running along the bottom, and columns of Malay and Chinese to the left and the right. Sited next door to a temple, you could hear a bell tolling throughout the movie. Tibet and his father were never so close again. 'I never really knew him,' he sighs. 'I didn't have a daily relationship with him. Just as I was becoming conscious of things like that,

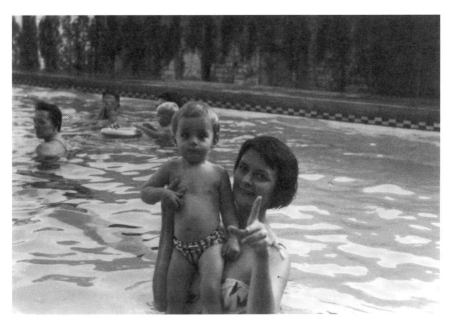

David and his mother Olivia, Ipoh Swimming Club.

I was off to the land of buggery and sodomy: the British prep school.' Yet in 2000, on the Current 93 album *Sleep Has His House* dedicated to his father, Tibet sang about how there was something of his father in him – his ability to keep his own council, perhaps, combined with a tendency to turn frustration or unhappiness in on himself. If Tibet got his savagely sarcastic sense of humour and essentially social nature from his mother, Olivia Cynthia Johnson, his father's legacy ensured that he never gave too much of himself away to anyone. Listing the details of his father's life, *Sleep*'s title track takes the form of a liturgical prayer to the memory of the man Tibet never really got to know: 'All of your fields, all of your bodies, all of your joys, all of your countries...'

'Tibet's mum and dad were very normal and down to earth,' Kat maintains. 'His dad was lovely. I regarded them both as substitute parents in the absence of my own. Tibet would have had a very warm, supportive upbringing. They are so sanguine about everything. His mum goes to his gigs and she went through the whole occultism thing which all happened before I knew him. She probably just thought he was a bit funny and his dad probably didn't think about it at all. He's also close to his brother Christian but they're both very different. He's a very normal guy. He's got

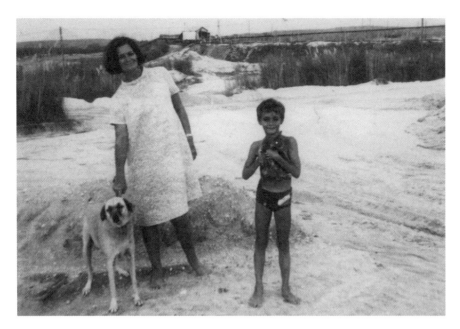

Olivia and David Bunting with dog Lassie and an unnamed cat, on the outskirts of Tanjong Tualang Open-Cast Mine in Perak State, Malaysia.

kids now, works as a schoolteacher and is very straight in his tastes. He never got interested in any of the things that fascinated Tibet. He also looks very different. Christian looks like his mum whereas Tibet looks more like his dad.'

Cyril Bunting certainly suffered a great deal in his life. Growing up in a very poor family headed by an alcoholic stepfather, he was so desperate to escape that he lied about his age to enlist in the British war effort against Nazi Germany. He also served in Asia, where the atrocities he witnessed left him with a lifelong hatred of the Japanese. Many of his friends were killed on the Burma Railway and he himself took a shot in the buttocks, which he always used to say made it look like they'd got him while he was running away. He would joke that he was simply 're-grouping'. His experiences continued to trouble him long after the war was over. Tibet recalls his mother telling him that, shortly before his death on 4 February 2000, his father was in tears watching a documentary about the Germans' last big push at the Battle Of The Bulge, where many of his friends fell. When Tibet was hospitalised with peritonitis not long after his father died, he couldn't escape hearing a dying patient repeating 'what brave men they

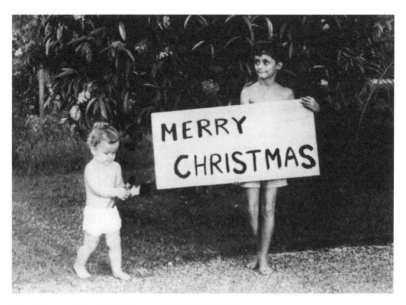

Christian and David, Christmas 1967, Batu Gajah.

were' over and over, through bouts of tears. Between his own illness and the morphine killing the pain, the delirious Tibet was convinced that his father had entered the old man's body and was attempting to reach him one last time.

Although Tibet was essentially a solitary child, he had plenty of friends. As colonials, the Buntings tended to mix with other colonial families, and there was no shortage of English kids to hang around with, although his father's work meant they had to move so often that they were rarely in one place long enough for him to establish any deep friendships. As it happened, Tibet preferred playing with the local Indian boys. Regardless of the company he kept, he was often the centre of attention, thanks to his generous father who was always building him great toys, such as the motor-powered Go-Kart in which he used to roar around the temples.

One legacy of his Malaysian childhood is a rich lode of macabre incidents and memories, which Tibet has periodically mined for Current 93 songs. On 'The Frolic', from *All The Pretty Little Horses* (1996), Tibet revisits a children's party attended by his eight year old self, when he intones: '...the child's legs lay smashed. 'Please pray for him'/she says to me too late alas ohsotoolate.' 'It was just a standard party, a barbecue,' Tibet clarifies. 'We

8

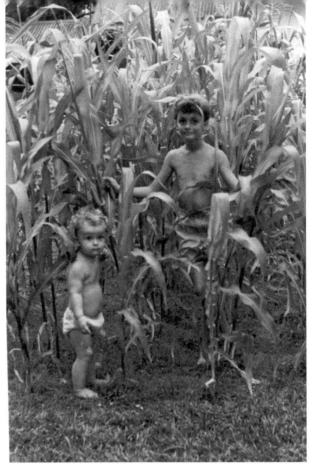

Christian and David lost in the jungle, Kellie's Folly, Batu Gajah, Malaysia.

were all having a good time when one of the kids ran out into the road and straight into the path of a steamroller, which flattened his legs completely. He died in hospital. I remember the ambulance coming, and I remember turning to a woman there and saying, we're all having a really lovely time, aren't we? I was trying to convince myself it was okay but she said, no, we're not actually, we're not anymore. I remember even at that time thinking that the world is how I want to see it, and that perhaps just through force of believing or saying something, you can change the reality around you.' That could almost be Tibet's artistic credo. The same song references another horrific incident: '(mother recalls child in pool: 'What is that that lies?/ Deadchilddead.')'

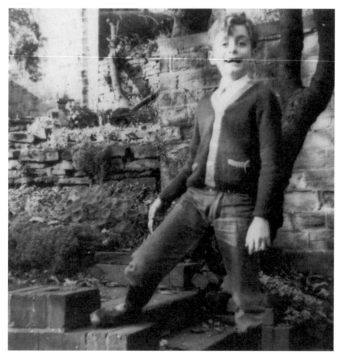

*Top:* Batu Caves, outside Kuala Lumpur, Malaysia, 1972.
*Bottom:* David back in England.
*Right:* David and Christian at Stonehenge.

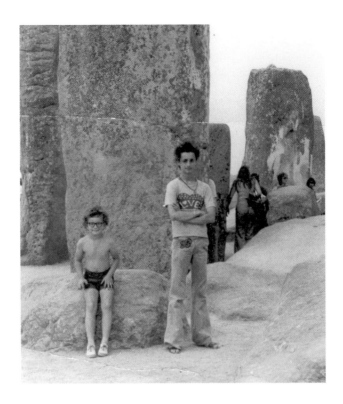

'We went to a public swimming pool once and we thought we saw a towel at the bottom of the pool,' Tibet elucidates. 'Later on they dragged a child up, it was actually a kid who'd been lying there dead.

'When I was young my parents would often go out to social events,' he continues. 'There was quite a tight-knit social community. I remember my parents going out and being in my bedroom, when a fire started in my cupboard and smoke started pouring out. My memory of course was that I was nearly burnt to death. But for years afterwards I had all the melted toys from the cupboard. I remember one in particular, one of those old steam engines, really slow with the big cogwheels. It had a little Rolls Royce car next to it and they were all melted together, horribly distorted and totally black.' Tibet had a bad relationship with that particular room, the atmosphere of which still vividly clings to his memory: the smell of mothballs, ineffectual air-conditioning, the heat. 'To go into it you had to kind of close the door a bit to put the light on,' he recalls.

'I remember once I went in and the door shut behind me with the breeze and as I went to switch the light on – I was very nervous of the dark

– two masks appeared on the wall.' He attempted to recreate these faces in chalk on the cover of Current 93's *Live At Bar Maldoror*. 'It was a sun and a moon face. They looked at me and I froze like in a nightmare, and they said to me, you will stay here forever until we let you go. You can't move. There was all fire burning round them. I couldn't turn the light on, I was absolutely terrified. I don't know what they were. Eventually my mum came in and the masks went, but I was always scared that they would come back. I had a hyperactive imagination as a child and read loads of comics and fantasy. Maybe it was a comic I visualised, other times I think they were representatives of the demonic forces of this world saying to me that demons are everywhere: We are everywhere and all of you are under our power until we let you carry on.

'However, I still believe that when I was a child was the last time I was ever happy, I'm constantly looking back to that and trying to recover what made me happy, but at the same time I'm aware that we do romanticise the past and maybe that's fine. Maybe having romanticised it, it becomes true. We have created it in our own image, we've made it what we want it to be, but I think that if we actually did recover it totally, then like all things in life, we'd be disappointed by it. Still, we can't do it, we can never recover it – what is it in humans that make us desire to recover something that is unrecoverable?'

Whatever it was that Tibet was hoping to rediscover in Malaysia seemed lost forever in September 1992. Although they intended to stay a month, Tibet pressed Kat to return home after three weeks, and he rejoiced as soon as he caught sight of the green fields and red roofs around Heathrow. 'England was never a topic we discussed in its own right,' Kat says. 'Except whenever we flew in from some foreign town in a foreign land. Consider that David didn't come to England until about the age of ten, where he spent unhappy years in a boarding school in the green fields stretching across Yorkshire, followed by university in Newcastle and coming down to London to live in squats. Perhaps he never found England at all.' Indeed, Tibet's idea of England, first developed as a child in Malaysia and later, filtered through the visions of a panoply of marginal artists like Louis Wain, Charles Sims, Shirley Collins and William Lawes, and finally articulated in records like *Earth Covers Earth* and *Of Ruine*

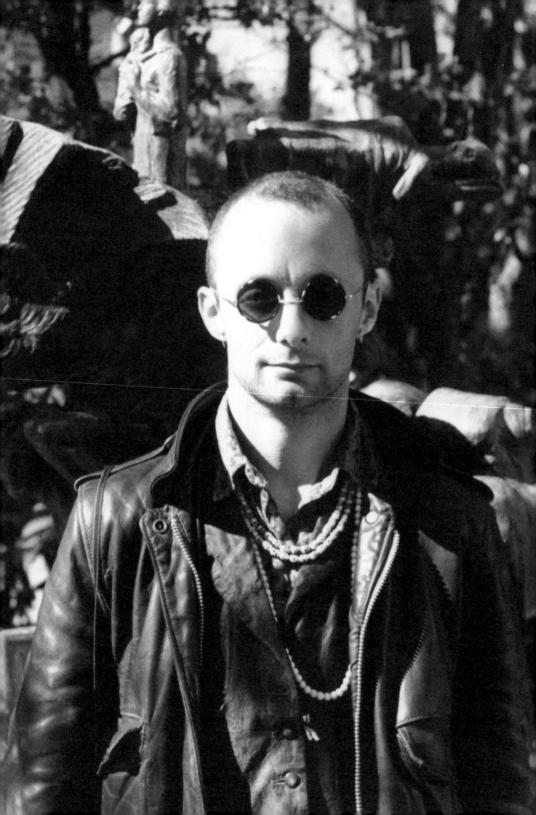

*Or Some Blazing Starre*, has less to do with England itself, and more to do with a Blakean construct, part new Jerusalem and part unattainable paradise of childhood.

A year or more on from Kat and Tibet's Malaysian trip, their first ginger tabby Mao disappeared. Kat dreamt of its body lying dead in the snow. Their fly-posted pleas for information were finally answered by someone who had found and buried a cat fitting its description. Some months later, Tibet's favourite, Rao, also disappeared. After their loss, Kat started working Saturdays in a cat rescue charity shop in Walthamstow, and they started taking in as many cats as they could cope with from shelters and their local vet. They also managed to track down Louis Wain's grave, overgrown and long forgotten in the Catholic section of Kensal Green Cemetery. Tibet immediately submitted a proposal, rejected, to take over its upkeep.

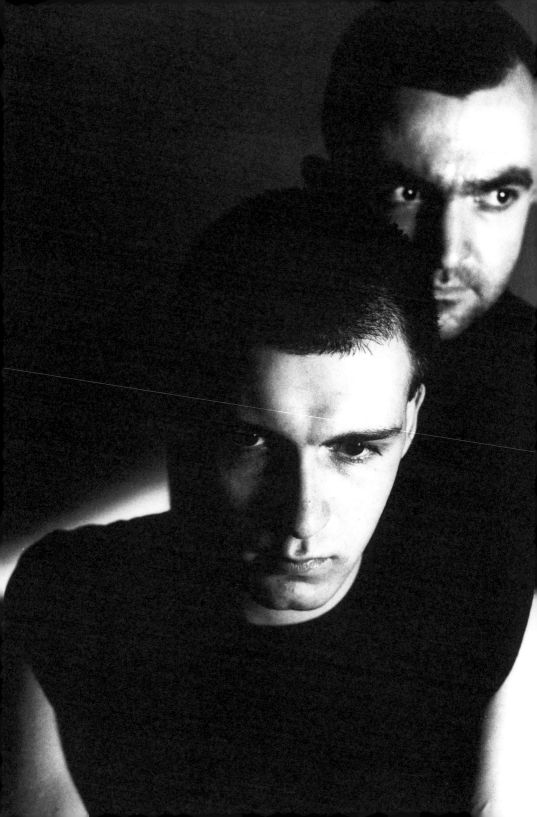

## Further Back And Faster

*Ghosts are not lawful* – William Blake
*Ghosts are sidereal* – Austin Osman Spare

Threshold House, Chiswick, South West London, spring 1995. Coil's Peter Christopherson aka Sleazy is staring out the window. The late evening sun animates the playing fields below, casting a lugubrious orange glow over his face. As the reel to reel slowly starts to spool, he breaks into a grin. ELpH had resumed contact.

Earlier that week Christopherson had picked up a *Mission Impossible*-style tape recorder from a junk shop in the City. He had barely got it through the door when he discovered the original reels hadn't been erased. Amidst the crumbling tape's wow and flutter, a woman with a frail cockney accent was singing to herself, lost in reverie across the decades. Electricity had raised another angel. 'For all we know we may never meet again,' the voice sings. 'For all we know on this dusty road again/We won't say goodnight until the very last minute/I'll hold out my hand and my heart will be in it/For all we know this affair may be a dream/So kiss me my darling/ Tomorrow was meant for some/Tomorrow may never come/For all we know.' What Sleazy was hearing was more than a tentative first experiment with a tape recorder – the deteriorating magnetic tape was releasing a mysterious female voice from another age, which sliced the timelines inside which Sleazy and partner John Balance's studio work had become hopelessly entangled, and once again the music began to flow. Backwards.

*Backwards* is one of the early working titles for the follow-up to 1991's *Love's Secret Domain*, the album where, under the influence of electricity and MDMA, Coil's alchemical cocktail of futurist noise and altered states for once chimed in time with the music of the moment. They had begun working on *Backwards* immediately after finishing *LSD*, with Balance and Sleazy paying for all-night studio sessions and coming back each morning feeling exhausted and psychotic. At first they had intended to revisit the visceral zones of earlier records like *Horse Rotorvator* – hence *Backwards* – focusing on live takes, loops and rawer vocals; but the deeper they went, the denser and more convoluted it became, sounding more like a 'psychotic amphetamine dance music', in the words of future Coil member Drew McDowall. Sometimes compounded together from six or seven separate song fragments, the music inevitably gridlocked and the sessions stalled.

Sleazy describes *Backwards* as sounding like '*Love's Secret Domain* with crank overtones' but the few tracks that have surfaced so far put the lie to his description – rather, they sound startlingly prescient, pointing to the kind of blasted alien landscapes of the two *Musick To Play In The Dark* volumes Coil recorded in the late '90s. Perhaps the *Backwards* sessions were simply premature. Creatively crippled under the weight of expectation attending new Coil music, Balance and Sleazy instead diversified, spawning various new alter egos as a strategic attempt to make music free of pressure. In 1994, they were working on one such sideline when ELpH made its presence known. During a first pass at Coil side project Black Light District, Sleazy, Balance and McDowall became aware of something subliminally directing their decisions. They named that presence 'ELpH' and set themselves up as 'receivers' of its broadcasts from beyond. The outcome was the *Coil Vs ELpH EP*, featuring some of their eeriest, most reflective electronica. When they found it impossible to move *Backwards* forwards, ELpH encouraged them to reverse direction.

With their friends/collaborators Current 93 and Nurse With Wound, Coil constitute a shadowy English underground scene whose work accents peculiarities of Englishness through the links and affinities they've forged

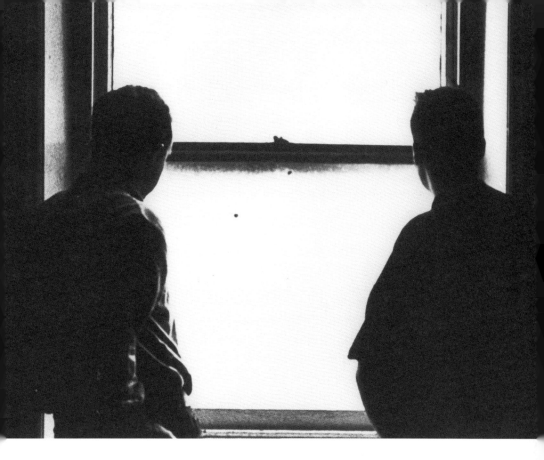

with earlier generations of the island's marginals and outsiders, such as playwright Joe Orton, writers like death decadent Eric, Count Stenbock and ecstatic mystic novelist Arthur Machen, and occult figures like Austin Osman Spare and Aleister Crowley. In many cases, a combination of social inadequacy and the received critical wisdom that deemed their work too damned perverse, decadent or mad resulted in them being ignored in their own lifetimes and condemned to obscurity thereafter. Like Current 93 and Nurse With Wound, Coil have helped disinter the art and lives of such lost figures, factoring them into their portrayal of England's hidden reverse. Bathed in their light, Englishness is not always a pretty sight: O Rose, thou art truly sick.

From further afield, Coil's often nightmarish electronic dreamscapes draw on dada and surrealist methods of recovering buried truths. Their longstanding working friendship with the late William S Burroughs, for instance, was based on a shared interest in derailing control logics with

word and sound cut-ups, sexual magick and other useful irrational tools. For all that, Coil have maintained a symbiotic, yet uneasy relationship with the mainstream of popular culture, even as their beliefs and practice repel them farthest from it. Their impact goes deeper than is usually acknowledged. Their early pioneering work with samplers and electronics has been soaked up and assimilated via the fringes of dance culture and Electronica; and through Marc Almond, a close friend and sometime Coil vocalist and guitarist, they have retained a loose connection to the pop of the last 20 years. Yet they'd be the last to deny that Coil's story has unfolded outside public view.

That the Coil story is still a secret history after two decades of existence is as much determined by their prehistory as the difficulties presented by their subject matter, if not their music. On this alternative timeline, 1976 stands as year zero, but not everyone was out sniffing glue. The formation of Throbbing Gristle a year earlier was the crystallising moment for a constellation of previously disenfranchised teens.

Throbbing Gristle were the first group to fully deliver on punk's failed promise to explore extreme culture as a way of sabotaging systems of control – beginning with rock music itself. Where punk ranted against rock while playing a debased version of the same, TG might have assumed rock's classic quartet format, but they were very consciously anti-rock 'n' roll. Active between 1975-1981, they maximised their largely rudimentary musicianship by drawing howling machine noise from their instruments and amps over monotonous production line rhythms in magick rituals designed to disturb the body's equilibrium by accumulating and releasing its sexual energies. For their trouble, they were branded everything from art school poseurs to depraved perverts. Far from breaking their bones, such names rarely hurt them. On the contrary, when the late Tory MP Sir Nicholas Fairbairn denounced them as 'wreckers of civilisation', he couldn't have provided them with a better manifesto.

TG were formed in 1975 from the ashes of Coum Transmissions, the performance art troupe as media guerrilla cell put together by Genesis P-Orridge with his then partner Cosey Fanni Tutti. When Peter Christopherson, then a young graphic designer, visited their Couming

*Right:* Sleazy self-portrait.
*Left:* Throbbing Gristle flyer by Sleazy.
*Overleaf:* Sleazy's press shots for BOY.

Of Age exhibition at South London's Oval House Theatre in 1974, he asked if he could take some pictures. The ensuing conversations led to him joining the troupe for the following year's Couming Of Youth performance in Amsterdam. The idea of Throbbing Gristle finally crystallised with the introduction of Chris Carter, whose passion for building his own synthesizers and keyboards was hitherto expressed through his solo electronics project, Waveforms. Under that alias, he had been helping out his performance artist friend John Lacey, himself a moonlighting member of Coum whose artist father Bruce Lacey was the caretaker of the Martello Street space where Cosey and P-Orridge rehearsed. After witnessing Carter in action at a Lacey event, P-Orridge and Cosey invited him to one of their jam sessions, most of which were mixed and manipulated offstage by Christopherson, whom the others had dubbed 'Sleazy' in recognition of his healthy interest in all things perverse. The name stuck.

Sleazy was born on 27 February 1955. His father Derman had taught engineering at Cambridge before eventually becoming a knight of the realm and settling into his role of Master of Magdelene College. After graduating in 1973 from Ackworth School, a Quaker co-educational

23

boarding school where he was in the same class as Phillip Blakey and Debbie Layton, two future members of Jim Jones's Guyana suicidal church, Sleazy travelled to the State University Of New York in Buffalo to study computers, creative fiction and new media. After braving one semester, he returned to the UK where he joined Hipgnosis, a design group responsible for some of the most innovative album covers of the '70s. Alongside Hipgnosis's Storm Thorgerson and Aubrey Powell, he also formed Green Back Films Ltd to produce music videos, through which he went on to direct promos for everyone from Asia, Barry Gibb and Björn Again through Nine Inch Nails and Rage Against The Machine to Diamanda Galas.

As a designer he was also involved in the initial plans for The London Dungeon, a dank theme park featuring gruesome re-enactments of various barbaric events from the city's past. However he was soon dropped from the project on the grounds that his work was just too realistic, based as it was on techniques that he had picked up during his time as a member of the Casualties Union where he simulated injuries for the training of members of the emergency services. Indeed, up until he joined Coum Transmissions in 1974 Sleazy had been unable to find a suitable outlet for his uncompromising vision, with the result that much of his early work remains little known. The police seized the window display that he and John Harwood put together for soon to be Sex Pistols manager Malcolm McLaren and Vivien Westwood's BOY shop in The King's Road after it had been up only two days. Purporting to be the charred remains of a boy's body, it now resides in Scotland Yard's notorious Black Museum. His early publicity shots of the Sex Pistols, featuring Glen Matlock topless in a public toilet and Steve Jones handcuffed and in pyjamas were far too ambiguous and suggestively queer for McLaren, who vetoed them.

At the time Christopherson connected with COUM, P-Orridge and Cosey were growing increasingly disillusioned with high art's voyeuristic performer-spectator set-up, to the extent they readily embraced Sleazy's argument that they'd do better redirecting their energies away from the gallery and towards alienated kids and rock fans. Rather than abandon performance art entirely, however, they

carried over what they had learned about audience confrontation and media manipulation into popular music. In the process, they obliterated rock's usual single transmitter/1,000 passive receivers principle, transforming the concert place into an interrogation room where the audience's complicity in rock idolatry was broken down and ridiculed. With all exits for rock's Dionysian energies blocked, TG's audiences would inevitably turn on each other, the group or the hall for release.

Throbbing Gristle, so called after the Hull slang for an erection, started out the way they meant to go on by launching themselves as the live attraction at the Coum exhibition Prostitution, at London's ICA between 19-26 October 1976, where they simultaneously kissed goodbye to their earlier performance art incarnation. Featuring signed and framed shots from Cosey's days as a glamour model in porn mags, the exhibition and TG performance together played with notions of subject and object, while projecting the concept of prostitution onto the artist-spectator relationship and by extension the social contract economically binding citizens to the state.

Live, Throbbing Gristle's early shows in particular constituted some of the purest manifestations of their non-musicianly ground-levelling aesthetic, with any standard notion of rock form all but abandoned in favour of a psychotic, improvised mess of squealing homemade electronics (including a prototype sampler made up from a rank of walkman recorders), overloaded guitars and sawing violins. Emerging from this harrowing sonic gloop, P-Orridge's deliberately weedy vocal mocked traditional rock machismo as he spewed lyrics that cut together domestic non sequiturs, newspaper headlines, accounts of serial murder, scabrous abuse and other such effluvial outpourings.

'Listening to the live stuff now I still really like it for its honesty and raw strength,' Cosey says. 'It has an energy you only seem to get when things are developing form. And we were all doing just that on many levels, not just music. The sound was cathartic and used as an assault weapon.' 'We knew enough about experimental music forms to know that we did not need to know anything,' Sleazy expands. 'We were conduits – the music came through us.'

Unlike most of their punk peers, for whom the idea of cultural commentary invariably stalled at the level of rock cliché, the more deadpan Throbbing Gristle deployed their music as a weapon attacking the apparatus of the music industry, which they treated as the propaganda wing of the then growing entertainment industry empires incorporating news channels, film, video and music media, and businesses developing and manufacturing computer hard- and software. TG set up their own label, Industrial Records, for the distribution of their klanging factory noises as a cold parody of the entertainment industry's process of industrialising music. Yet even as they incorporated the art gallery practice of making special limited edition hand-assembled LPs, pre-packaged videos and live cassettes, they also endeavoured to make available most all of their live shows (many of them in one swoop on *24 Hours Of TG* – a limited edition 24 cassette set packed in an attaché case, originally released in 1979, reissued as a CD set in 2002). In addition, they sent out regular pop profile communiqués, including special postcards, patches and badges, which detailed the activities of the various members. Nothing was beneath them. While all of the other rent-a-rebels were sniggering up their sleeves, Throbbing Gristle let loose a kind of pop-cultural contagion, a strategy that P-Orridge describes as 'an aggressive use of whimsy'.

'I think the resonance that can happen when a band, a writer or an artist seem to speak the thoughts and feelings of a section of people is a blessing,' P-Orridge says, weighing up TG's legacy. 'Choosing to risk humiliation or be simply wrong in one's feelings about the world and being alive in it is a perceptual gift. To break the cycle of isolation and disconnection that causes so much pain, especially in adolescents, is a wonderful but lifelong responsibility. Throbbing Gristle reduced post-blues rock 'n' roll down to the essentials and sanitised it largely of Americana. We found a new style that was rebellious enough in terms of image and theories that it appealed to a previously unnoticed group of people. We were deliberate without a pre-conceived notion of the result. Our own clarity of intention is what powered us. We were exploring new sonics in public. Certainly we knew the function of a symbolic band and the unifying nature of it on its people.'

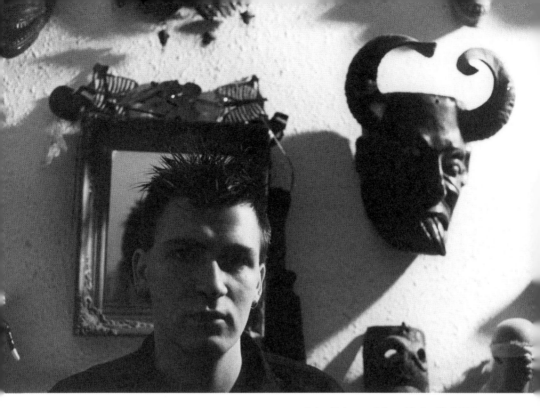

John Balance. (photo Keiko Yoshida)

For John Balance the existence of Throbbing Gristle validated his questioning of all forms of authority during his formative years and fed a growing fascination with deviant modes of expression. Empowered by his growing involvement with the so-called Industrial Underground, he would go on to conduct his own experiments with tape loops and cathartic electronic noise, using music as the context to exorcise his personal demons and explore his own sexuality.

Balance was born Geoff Burton in Mansfield, Nottinghamshire on 16 February 1962 but his childhood was all over the map. His parents separated when he was two and he spent most of his early years being shuffled between both sets of grandparents and his mum, who was living with her sister. His real dad, Larry Burton, was absent for most of his life although in recent years they've resumed some kind of contact. 'He worries even more than I do,' Balance laughs. 'He has nervous breakdowns and stuff. He was always doing things like having fights with managers and punching them out and leaving, he couldn't hold a

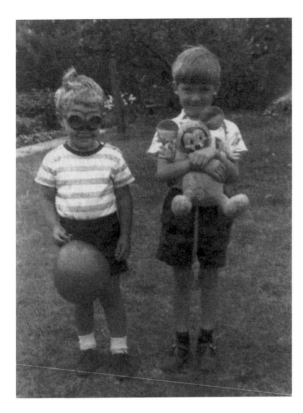

job down.' Balance's mother Toni has been a housewife most of her life
although for a while she had learnt to set jewellery in Grimsby.

While Tibet was born in a stable, Balance was born in a barn
surrounded by animals. 'I think I might be developing some kind of
Christ complex,' he deadpans. 'My dad was a farmhand into livestock and
animal husbandry. He studied at agricultural college. I was born in the
grounds of a hospital for shell-shocked soldiers. I suppose it was actually
a mental asylum. My parents lived in the barn. It was a great building and
it's still there – another ambition is I want to get the weathercock off the
top. It's exactly above where I was born. If I want to get a bit of balance in
my life I need the weathercock.' While living with his mum at her sister's,
he was made to sleep in a dog basket on the floor. 'I related to the dog,'
he claims. 'I'd sleep in the basket and eat dog biscuits and stuff. My mum
was courting a bit later on when I was five and if she brought somebody
home and I didn't like them I'd run in and bite their ankles.'

His mum eventually remarried and Balance took on his stepfather's

surname, Rushton, when he was six years old. 'I didn't decide to take on my stepdad's name myself,' he claims. 'That's why I became John Balance. I've got an identity confusion really.' His stepdad had worked himself up through the RAF rank by rank, ending his career as squadron leader. Rushton senior was very much a product of his own parents' background, having been brought up in the Raj in India, where repression was the norm; he still claims he hasn't got a musical bone in his body and can't understand what Balance is doing. However, Balance's mum was always playing music, and outlaw ballads and weepy teenage hits by the likes of Johnny Cash, Merle Haggard, Elvis Presley and The Supremes soundtracked his early days, dancing on the table to 'Baby Love'.

Really, I fell straight into the mould of lonely child and because I fell into it so early it was just assumed that's what I was and I was left to my own devices,' Balance remembers. 'I was one of these kids who would make a tent on the front lawn and hide in it all day hoping other kids wouldn't come along. I'd obviously convinced myself that if other kids didn't come along then I wouldn't have to deal with it. But then when I was eleven I got accepted to a state-funded boarding school cause I'd been to nine schools by then, dragged around everywhere.' With spells spent in Germany, Italy and Scotland, Balance had a typically unsettled and strictly regimented military upbringing. 'It was really quite hard for them and me,' he continues. 'My memory won't let me remember the sorts of toys I wanted. I used to play with Lego and plasticine, making little gods and idols and sacrificing them. From the age of seven I began making all these illustrated books full of pictures of girls falling to their deaths into big pits with spikes with all their hair trailing behind them. My stories were always a bit like Lovecraft although I can't remember if we had any of his books. They would inevitably revolve around subterranean caves where I'd be walking alone and a man would hand me a flabby pancake and I'd fall down another hole and find myself in another cavern with men with webbed fingers.

I was reading through them recently and I read this story called 'The Aryan' – I must have got that from some Blavatsky-styled potboiler meltdown – it's all about this weird entity visiting people.'

Balance's interest in the macabre blossomed during his schooldays. He was a boarder at a state-funded comprehensive school, Lord William's in Thame, Oxfordshire, at the time one of the biggest in the country with 2,500 pupils. It had previously been a grammar school and it retained a weird 'public school' undercurrent in its bullying traditions of basin runs and forcing victims to stand on hot pipes. But its class sizes were huge and open to all classes of children, attracting many sons of diplomats and military families. More significantly, it was also one of the first schools in the country to have an autistic unit attached to it. By day pupils mingled with the autistic children, while at night about 70 boarders slept over in long, grey barracks with old Louis Wain prints above the beds, long worn to shreds by the flick of wet towels.

Balance first attempted to make contact with the other side at age twelve when he wrote a letter to Alex Sanders, Britain's self-styled 'King of the Witches', asking to join his coven. Although he now describes him as a *News Of The World* occultist, back then the elemental qualities of his philosophy spoke to him, especially the fact that Sanders's coven was 'in touch with nature' and worshipped the moon. To the young Balance it was certainly more appealing than polishing your shoes and getting spat at on the way to church. It also spoke to his growing sense of isolation from the people around him. From an early age, he started referring to everyone else simply as 'species' and still claims he prefers trees, solitude and his own company to other human beings. 'Of course this turns against me now,' he admits. 'I haven't ever really learnt social skills. I'm very bad at communicating, even with my friends. I could blame it on my star sign but it was the way I was brought up. I was never reached out to so I can go for ages and suddenly think – shit, I haven't phoned Tibet or Steve Stapleton. They're quite sociable so I often feel like a bad friend.'

When Sanders eventually replied he politely requested that Balance wait until he was sixteen before getting back in touch. His letter was later confiscated after a school investigation into Balance and his friend Henry Tomlinson's late night attempts at astral projection. Henry was the son of British character actor David Tomlinson, who had starred in

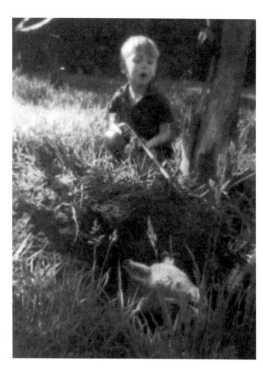

*Right:* Balance
aged three.

*Mary Poppins.* With the help of a teacher from another school, they both began an extensive course in attempted astral projection. 'We would genuinely do it,' Balance claims. 'We had all these weird notes where we took down evidence that we'd been receiving transmissions from spacecraft that were hovering in the atmosphere over Africa. Henry used to wake up in the morning and ask me if I'd enjoyed the astral conference we had had. It was really bizarre. I started getting these transmissions in the form of hieroglyphics although I actually think I was just subconsciously copying the designs from *The Planet Of The Apes* headdress. They found out we were astral projecting and took it so seriously that they questioned us as to what it involved, asking us if it involved going inside other people's minds because 'we really don't think you should be doing that!' How do you explain to someone something that they really don't believe in but are worried about you doing? They sent this great letter to my parents which went something like, I'm afraid Geoffrey is once again becoming unhealthily obsessed with the occult. Mr David Tomlinson has asked us to step in. Has Geoffrey kept back any letters from the teacher that he and Henry are involved with? Mr

Tomlinson is worried that abuse might be involved. It wasn't at all. It was a good, genuine friendship but he still got the sack and one day David Tomlinson came to school in his limousine and as I stepped off the bus his chauffeur called me over and said, Mr Tomlinson would like a word. Who's he, I'm thinking, maybe a teacher? But he dragged me into the back of the car and sat me there and asked if his son was having an affair with this teacher. I was completely shocked! He demanded any letters that I had as proof because he was really trying to nail the guy. I panicked and kicked the door in and began screaming. It was the guy from *Mary Poppins*, which made it even scarier!' *Bedknobs And Broomsticks* would never look the same again.

Balance discovered occultist Aleister Crowley via another interested teacher, David Irwin, who also helped nurture his lunatic aspect. 'I was taught at an early age to not follow any creed and to make up your own rituals,' he explains. 'I'd have the whole of the dorm doing full moon rituals out the window, shouting at them to concentrate and to project themselves to the moon. The teacher would come in and switch the light on and be like – what the hell is all this? They tried to kick me out several times and when I asked what for, they'd say, subversive behaviour. Whatever it is you're doing, don't do it again!'

Balance's early interest in subversive shamanism was intensified by exposure to dada and surrealist artists like Kurt Schwitters and Max Ernst. But his behaviour was becoming progressively unbalanced, peaking in an attempt on another schoolboy's life. 'I tried to throttle him with my arm,' he remembers. 'I would have killed him had someone not come in. I was feeling rejection by my parents. Looking back on it now I had obviously completely flipped. I set up an altar in my locker with a horse's head chess piece and covered it all in talcum powder in which I drew symbols, in order to encourage the UFOs to come and get me.' Balance became convinced that he was in fact schizophrenic. More likely it was an overly sensitive child's reaction to stress and abandonment. He had one session with a psychiatrist, who asked him why he slept under the covers each night and offered him some cake with pink icing: psychiatry in the '70s. 'I used to administer Rorschach tests on myself,' Balance says. 'I also taught myself yoga. The teachers used to get me up

in the middle of the night – this is what they get the sack for – all pissed on sherry and get me down on to the coffee table and get me to do the double-lotus position or do a stand and then walk. They'd treat me like a plaything. My nickname at school was 'Weird', but I liked that. I was always very honest about my sexuality and beliefs. For instance I always said I was a pagan, which inevitably ended in confrontation. We used to go to Low Catholic Church and I refused to say the words or sing the hymns except for ones like 'The Holly & The Ivy' or 'Oh Come, Oh Come Emmanuel'.'

Balance was also aware that he was gay from about the age of nine. 'I got really pissed off because on one of the school camps that I was on, I used to go to see horror films at the cinema with this twenty year old RAF guy and something could have happened between us but in the end it didn't and I was pissed off over the school holidays about it. I used to stay in school during the holidays, I wouldn't even go home.' Although Balance continued to have girlfriends, he was slowly sleeping his way around most of his fellow pupils. He soon knew everyone who had had sex with everyone else. Using this potentially

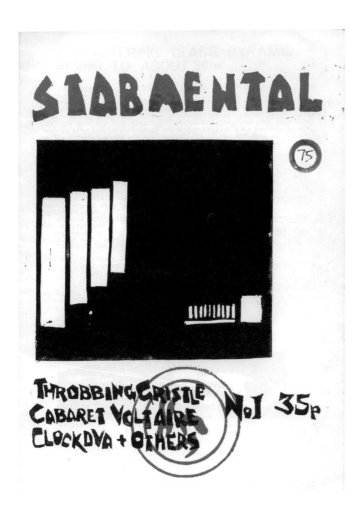

incriminating information, he developed a complex baroque system for manipulating people. 'I was a total sissy so my parents might have guessed,' he confesses. 'Instead of playing football I'd be pirouetting around the pole at the end! My dad would come up to me and slap me on the thighs and he'd say it was for being 'a bloody sissy', he was watching me out of the window. You can always tell little sissies because they stop and smell flowers on the way home while everyone else is kicking each other's heads in. I had to develop a tough streak as well though. The first time anyone even attempted to bully me I'd smack them very hard or stab them in the hand with a compass,

# STABMENTAL

(369) **THIRTY PENCE.**

# STABMENTAL

35p

'THIRD ISSUE'.

**CABARET VOLTAIRE & JAPANESE THE RESIDENTS & OTHERS.**

# STABMENTAL

WINTER

**PASSAGE·THROBBING GRISTLE MARK PERRY·EYELESS IN GAZA·40p**

# STABMENTAL

45p                    7

SUMMER

**THE VIRGIN PRUNES
T.G.    CABARET VOLTAIRE
CULTURE DE       S.P.K.
THE BIRTHDAY PARTY
TESCO BOMBERS.   HEUTE**

so people would leave me well alone thinking I was a nutter. Do something extreme and word goes around quickly.'

After he left school, Balance took a year out and concentrated on publishing his own fanzine, *Stabmental*, which he'd begun while still a schoolboy. His head had been turned via late night listening to John Peel's radio show where he first picked up on stuff like Throbbing Gristle and The Residents' *Duckstab*. Although early issues mimicked punk zines' Pritt-Stick collage look, with detourned headlines and mutilated photo journalism, later editions looked elegantly austere. By then he was living with Tom Craig, the grandson of artist and designer Edward Carrick, née Craig, and so had access to old printing presses. Carrick used to be a friend of Austin Osman Spare, exhibiting with him in the 1920s, and it was through Tom Craig that Balance first came into contact with the work of his future mentor. Inside *Stabmental* were interviews and prescient features on UK underground groups like Throbbing Gristle, Cabaret Voltaire and The Lemon Kittens, alongside American savants like Half Japanese, commentaries on Residents' shows and the first UK piece on the activities of Negativland.

'Every teatime I would get a big pile of mail from groups like Cabaret Voltaire before they even released a record,' Balance beams. Stabmental had originally been the name of the first group that Balance formed at school with Craig. They 'played' two highly conceptual concerts at the time, both non-appearances, entitled 'Non-Appearance One' and 'Non-Appearance With A Little Girl'. 'We prepared tapes for half hour performances using found sound sources and pop group samples on a reel to reel tape recorder,' Balance explains. 'Everything was set to be real and then we deliberately didn't turn up. We also caused a bit of a scandal when we entered a large black and white photograph of a dog turd as our contribution towards a competition that involved drawing a caricature of a member of staff.' Stabmental went on to contribute a track called 'Thin Veil Of Blood' to a DIY cassette compilation titled *Deleted Funtime: Various Tunes By Various Loons* released by Deleted Records in 1980. A full Stabmental cassette album called *Hidden Fears* was also advertised but never materialised. 'It was kind of Non sounding,' Balance

remembers. 'I had a reel to reel and a record player to manipulate alongside a cassette recorder that used to scream out in broken feedback. Excellent sonic weaponry.'

While at school Balance also contributed to releases by Cultural Amnesia and performed as Murderwerkers (both of whom contributed tracks to a compilation cassette put together by Nigel Ayers of the psychedelic noise group Nocturnal Emissions in 1979 on Sterile Records) and A House. Balance formed the latter with Euan Kraik, who took over as *Stabmental*'s co-editor from Tom Craig, who had branched off into dealing in fine art. A House recorded a performance in the school hall and cut a four track demo that Cherry Red briefly showed an interest in releasing. Balance still has the recordings. Conceptually following up his no-show unit Stabmental, he also imagined The Anti-group, as an outfit that had a concrete existence even though they never played any shows. He wrote to a fanzine announcing the concept and fantasised about a dream line-up that included Genesis P-Orridge and Adi Newton of Clock DVA. In the event Newton lifted the name for his side project and thereby ruined the concept forever. 'Back then I was most interested in sound as a physical thing,' Balance reveals. 'I was always playing around with reel to reels and piano innards, slowing down the soundtrack to *A Fistful Of Dollars* to see the effects. Always experimenting. I used the soundtrack to *That'll Be The Day* a lot. I loved that record back then, as well as David Essex's 'Rock On'. Coil might still do a cover of that. Seriously.'

David Tibet had a similarly unsettling education. His childhood idyll in Malaysia came to an abrupt end when at the age of ten he was shipped back to England in 1970 to enrol at Red House Preparatory School For Boys in Yorkshire. There simply weren't the schools in Malaysia, reasoned his parents, who felt that boarding in England would give him some stability away from the family's constant flitting around the peninsula. Tibet had no real experience of England beyond visiting his grandmother. An English education would be good for him.

Red House played an important part in the history of the English Civil War. In 1644 the nearby Battle Of Marston Moor marked a

significant turning point in the war, when Oliver Cromwell's army crushed the Royalists. The father of the famous Royalist Sir Henry Slingsby built Red House in 1607. Every year, on the anniversary of Sir Henry's beheading on 8 June 1658, his ghost was rumoured to walk along the promenade. At night the organ would play when no one was sitting at it. On arriving at Red House, Tibet's parents left him with the boy who was assigned to look after him, but all the way through his first tour of the school he couldn't concentrate for the hope that his mum and dad would be waiting for him in the driveway when he got back. The next morning he was woken at 7:40 am for a cold shower before school started.

'It was really torture,' he shudders. 'I went into myself a lot then and became more peculiar, partly because I was very unhappy and partly to put a wall around me and keep people away. My nickname used to be 'The Mummy' because I would lie in bed at night grimacing with a skeletal face. It was a good way to keep people away from me but I was very unhappy. The fact that my parents were in Malaysia made me unhappy. Other kids got to go and visit their parents at the weekend. Still, it really opened me up and made me fiercely independent.'

Tibet's Red House experiences uncannily paralleled John Balance's schooldays. He also sought solace for his isolation in the works of Aleister Crowley, which he first encountered through a Sphere paperback copy of his 1922 novel, *Diary Of A Drug Fiend*, while visiting his parents in Malaysia, instantly captivated by the the edition's cover description of Crowley as 'the wickedest man in the world'. At Red House, he was singled out by the divinity master, who fed Tibet's early occult habits by buying him books from The Sorcerer's Apprentice bookshop in Leeds, although he would frequently quiz Tibet as to what he saw in Crowley. The teacher was actually a devout Christian who claimed he felt the power of the cross burning into him when he entered the chapel – he said it always revivified him – yet he had no qualms in shelling out for the Castle Books edition of *Magick In Theory And Practice* or the paperback of *Moonchild*. He wasn't Red House's only misfit teacher: the alcoholic geography teacher loved Tibet by day

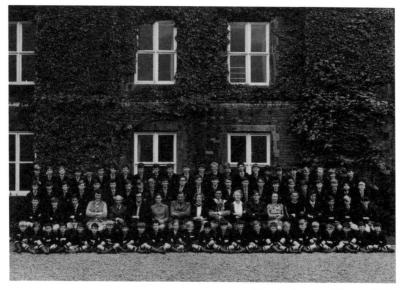

Tibet's class, Red House, 1973.

because he was a good pupil, even as he went out of his way to persecute him by night.

'I remember waking up one morning when I was head of the dormitory,' Tibet recalls. 'I heard children's voices around me, saying, please wake up Bunting! I looked around and all the kids, 13 to 16 of them, were standing around the bed, clearly terrified and pointing at the corner of the wall. There was an upright piano there and in the corner between the piano and the wall were two white shapes, man-high, that were undulating. They would separate into the vague outline of human faces with dull rubbed eyes and then merge back into one another and become one. It was absolutely terrifying so I got all the kids out and took them up to the headmaster and he said: Bunting, what's the meaning of this? It was after lights out, between 10 and 12. I said there are ghosts downstairs. Of course we all went down and there was nothing there and I got into trouble for it but the whole dormitory saw it. There was supposed to be a tunnel under the church that led out beneath the river to the other side because in the civil war it was a bolthole for the Royalists. Apparently in the 1930s a child had gone down there with his dog. The tunnel collapsed killing him and now he haunted the thing.'

In the dormitory there hung a reproduction of Johannes Vermeer's 'The Little Street', which shows a faceless woman sitting sewing in the twilight and the painting became a focal point for the kids' macabre imaginations, as the rumour went around that the old woman sometimes materialised under your bed and would come and sew up your eyes while you slept. 'From an early age I was aware that a whole other order of being existed and the ones that you are likely to see are hostile,' Tibet claims. 'I never saw angels but I believe I saw demons.'

After graduating from Red House in 1973 Tibet went onto Pocklington public school in Yorkshire. As his parents returned to England the following year, he was eventually able to attend as a day pupil. The ascendancy of glam rock was also helping him make it through the night. In Malaysia T. Rex had kickstarted his teenage libido when he bought a pirate 7" of 'Get It On'. Thereafter he joined the dots from David Bowie to Iggy & The Stooges and soaked himself in the white heat of *Raw Power* all through the summer of 73. 'I was interested in that sort of glammy proto-punk stuff,' he confesses. 'I bought *The Slider, Billion Dollar Babies, Tanx* and *Aladdin Sane* when they came out. Then I bought The Stooges' *Fun House* and first album for 49p in Virgin in Leeds. I bought The New York Dolls' first LP at a WH Smiths stall in York railway station. They'd sell cutout stuff. I didn't actually like it that much but they had make-up on on the front so it was a steal.' He had also fallen in love with the weird fiction of HP Lovecraft and, in particular, Clark Ashton Smith.

Tibet's experiences of the English public school system might have left many scars, but there's still something of the mythic English schoolboy about him. It's most noticeable in his infectious capacity for excitement and enthusiasm, for what Charles Baudelaire described as 'profound and joyous curiosity'. In 1978 he moved to Newcastle University to study Politics and History. 'I was interested in extreme politics, extreme left and right wing,' he relates. 'Totalitarianism, fundamentalism – academic extremes.' Originally he had been set to pursue Politics, Philosophy and Economics at Oxford but instead he followed his then girlfriend Kate Edwards up north to Durham. 'I wasn't so bothered about what I studied,' he recalls. 'I guess it was just

three more years where I could put off starting to think about what I was going to do. Kate was my girl then. In the sixth form Pocklington began taking in girls and my best friend at the time fell in love with this extraordinarily beautiful girl that came to school. Although I never felt that any girl would want to go out with me, I wasn't shy with girls. I said I'd ask her out for him. They started seeing each other but as a result she and I became very close and we eventually became boyfriend and girlfriend. She was the first woman I ever slept with.'

Tibet eventually settled into 51 Caroline St in Benwell, Newcastle, where he spent his second and third student years with a group of friends from halls. Today it's a litter-strewn wasteland sandwiched between some of the most rundown streets in the city. Now he had his own room, he could at long last mould his own environment, painting it black and menstrual red. And in a purchase that seems strangely out of character, he bought himself a Triumph 500 Tiger with his student grant.

By 1980 punk was running out of snot and Tibet's tastes were also diversifying, taking in everything from Leonard Cohen, Gregorian Chant and Rush to Throbbing Gristle, Whitehouse and Nurse With Wound. He was also collecting everything on the United Dairies, Come Org and Industrial Records labels. 'The first three Nurse albums were totally unavailable at that point so I wrote to United Dairies and got a copy of their fourth album *Insect & Individual Silenced* with a nice letter from John Fothergill,' Tibet remembers. 'Virgin in Newcastle used to sell records by Whitehouse, so I got their *Total Sex* – the early edition with the white card sleeve, the De Sade quotes and the drawing from a porn mag illustrating a Cosey Fanni Tutti photo shoot of a woman in chains. That's when I became more interested in Whitehouse and Nurse With Wound than Throbbing Gristle and I started writing to Whitehouse's William Bennett. From the records it seemed that Whitehouse were busier doing more material and Nurse seemed somehow more esoteric and not so active. I didn't even know if Nurse were still going, whereas Whitehouse were constantly putting out new stuff. William was very friendly, open and generous straight off. His letters were always highly entertaining.'

David Tibet (left) in August Strindberg's *Miss Julie* at Pocklington school. On the right is Kim Fenton, singer in the school punk band The Void, managed by Tibet.

Tibet's Newcastle girlfriends all impacted on his work to some degree. 'Anita Plank meant a lot to me even though it was only a brief fling,' he recalls. 'I spent a long time regretting that it was over. I was a very shy young man, lacking in confidence and fairly clumsy and gawky in relationships. Although I liked Anita a lot I didn't handle it very well and put her off. Understandably. I was a prat. Not unpleasant, just ungainly and stupid. She was very beautiful and had an Anita Pallenberg look – the most feline face I've ever seen and very sexually charged. Far too much for me to handle, in fact. We ended up going out with each other again in London for a longer time.' In Newcastle his longest relationship was with Fiona Burr, who later designed covers for Current 93, Nurse With Wound and Death In June as well as Whitehouse's notorious Rapemaster t-shirt. She also contributed to several Current and Nurse records.

His other significant relationship was with Suzanne Riddoch, 'the girl with the pentagram in her hand', pictured in the booklet from Current 93's *Thunder Perfect Mind* CD. Trouble was, Tibet was

also seeing Fiona Burr and the whole affair became messy. Suzanne undoubtedly had a big influence on him, for whom he later wrote 'Lament For Suzanne'. 'I started having a series of intense dreams when I was writing the *Thunder Perfect Mind* album,' Tibet explains. 'One was about Hitler as Kalki and the imminence of Anti-Christ and the other was a series of dreams about Suzanne where she appeared in semi-divine form to me as her way of castigating me for the way I'd treated her. I was unfaithful to her and Fiona at the same time. It really hit me very badly later and I felt great guilt, which I still feel. Suzanne married and went to live in Germany. Where she is now I don't know. Fiona also married, had children and moved to the Scottish Islands after becoming a born-again Christian. She was a quite extraordinary artist and still is. I treated people badly and it's a great regret. If you treat people badly then evidently you're treating yourself badly. People today forget the power of guilt because they're too walled off from it but you will be treated finally as you treated other people and a lot of the mental and emotional problems I had later were partly due to the way I treated people, especially Suzanne and Anita.'

He left university with a BA 2:1; but after three years in Newcastle he was bored and decided to move to London. He had some vague ideas about studying Tibetan but getting a grant looked difficult, especially as he had always been hopeless at filling out forms. On arrival he applied for a job at Foyles bookshop on Charing Cross Road and took a day's trial at Notting Hill Gate's Music & Video Exchange. He flunked them both. Fortunately he was able to rely on a support system that consisted of contacts he had made in the occult underworld. By the time he had left Newcastle his interest in Crowley and magick had peaked, culminating in his application for membership to the 'Typhonian' OTO.

The OTO, or Ordo Templi Orientis, was seeded at the dawn of the 20th Century, when it was founded by an Austrian freemason Karl Kellner, who attempted to combine all of the key living esoteric traditions within a single organisation. Kellner's primary use for the OTO was as a vehicle to propagate the techniques of sexual magic, itself an occult extension of Eastern tantric techniques. Sex magic is about harnessing the ecstatic energies generated by climactic sexual activity

and the resulting dissolution of the 'artificial' construct of personality. The initiate focusses on the object of the working or the state that he wants to bring about during the sexual act, often going on to anoint a particular talisman either with semen, if the ritual involved masturbation, or the mingling of secretions if it were sex. Aleister Crowley got involved in the original OTO when Kellner's successor, Theodor Reuss, accused him of giving away their secrets within the labyrinthine passages of free verse that made up his *Book Of Lies*. Crowley had seemingly intuited the workings of the secret society and Reuss was so won over by the quality of his insight that he invited him to form the society's British wing. When Reuss relinquished the post of OHO in 1922 due to ill health, Crowley became the new Outer Head of the Order.

'Basically Crowley reformed the OTO to make it a vehicle for Thelema, a spiritual dispensation he received that was capable of empowering and ennobling the individual, however humble his origins,' explains Hymenaeus Beta, the current acting Outer Head of the Order and a friend of both Balance and Tibet. 'It was and is a human rights advocacy group, but one that extends to all spheres. Crowley's system is keyed to the release of genius in whatever form it takes, determined by the individual's true nature. That speaks to the goals of the organisation, actually. Crowley's method of Thelema presaged the extreme individuality and image morphing that we now tend to associate with rock 'n' roll but first saw in art movements. I have been a member of the actual OTO since 1978, which is round about the same time Tibet was involved with an English group run by Kenneth Grant that called itself OTO but was not. They called themselves 'Typhonians'. We had expelled Grant many years before, in 1955, and the membership of his group has always been tiny.'

Grant also had a literary angle, which couldn't have failed to appeal to the young Tibet, with a personal mythos that linked Crowley's magical techniques with supernatural avatars like HP Lovecraft and Arthur Machen. 'Crowley was a genius, very much ahead of his time, something he paid for dearly again and again,' Hymenaeus Beta asserts. 'Tibet is the sort of person Crowley would have befriended and respected. Crowley had no time for disciples – at least, he expected them to get over that

phase and individuate, and he pushed more than one out of the nest. Tibet knows his works well and in my view probably benefited from that peculiar education. Crowley once said that much of his published material reflects his own peculiar genius and style of work, and that anyone really doing their True Will – as he put it – will produce material that is just as strikingly theirs.'

Tibet had started corresponding with John Balance after picking up an issue of *Stabmental*, although Balance maintains that he initiated the correspondence. Tibet's girlfriend Fiona Burr had painted a series of Manson t-shirts and Balance had written asking how to get hold of one. Tibet also mentioned in an early letter that he was trying to put together his own group, an extreme electronic outfit that would combine the eviscerating noise of Whitehouse and Throbbing Gristle with occult esoterica. 'His vision was perfect,' Balance states. 'The exact blueprint for Current 93. He simply came down to London and it happened.'

Balance had made contact with Throbbing Gristle early on, in 1978. He deluged them with fan mail, striking up a friendship with P-Orridge, who would often call him up in the evening when he was doing his homework. 'We'd talk about anything,' Balance confesses. 'I got the impression that I was his schoolboy confidante and he was always out to pervert me in some way. I was invited to all the TG concerts but of course I couldn't get out.' He didn't actually make it to a TG show until he and Tom Craig attended the recording of the *Heathen Earth* album that took place before an invited audience on 16 February 1980 at the group's Martello Street Studios. It was here that he met Sleazy for the first time, although they barely spoke, and Balance got to see his first ever gay porn via the images that accompanied the performance. 'I just thought, fucking hell,' he says. 'I couldn't quite believe it. I was nervous because I already had this thing about Sleazy. I remember seeing the cover of *20 Jazz Funk Greats* and something weird clicked with that image. I just new I was going to spend my life with him. But I was obsessed with all of them, I suppose Genesis in particular because he pushed himself more than

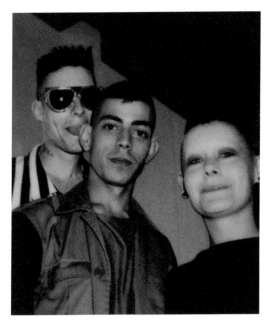 

*Left to Right:* Ross Cannon, Paul Hurst & Christine Glover of Produktion.
*Right:* Produktion's Kensington Market salon. *Opposite:* Paul Hurst & Christine Glover.

the others, but I've got loads of letters from all of them at the time, except for Sleazy. He never wrote.'

After announcing the termination of the TG mission in 1981, P-Orridge and Sleazy began plotting their next move. Alex Fergusson, who had played in the punk group Alternative TV, had recently moved into a squat in Beck Road in Hackney, next door to P-Orridge. Although P-Orridge had sworn that he would never be in a group again, Fergusson succeeded in prodding him back into writing songs. 'He kept haranguing me,' P-Orridge sighs. 'One day, just to shut him up, I gave him a scribbled poem that was stuck to the water heater with a magnet. It became 'Just Drifting', the first Psychic TV song.' PTV was originally conceived as a 'para-military occult group' designed to 'rejuvenate the arena of magick'.

In the meantime Balance had moved to Brighton to study philosophy at Sussex University but nine months later he mysteriously dropped out. While there he made up the Brighton wing of Brian Williams's dark ambient group Lustmord. Otherwise nothing much was happening for

him and after a few months on social security he moved to London to live with Sleazy. 'I turned up on his doorstep with an Echo & The Bunnymen floppy fringe which he promptly chopped off,' smiles Balance.

The first new acquaintances David Tibet made in London were two Australians and a Tasmanian: Paul Hurst, Christine Glover and Ross Cannon. The three were big Whitehouse fans who ran a hairdressing outfit/performance art unit called Produktion in Kensington High Street Market. You could buy Come Org records there while having your hair remodelled to a soundtrack of Throbbing Gristle, Chrome, Whitehouse or their own Produktion tapes, assembled from loops of skipping records or the sound of a stuck stylus. 'It's true that they'd play Whitehouse while you had your hair cut,' confirms William Bennett. 'And very good at it they were too, although quite uncompromising. You had it cut their way or not at all.' Mary Dowd, who worked alongside the Produktion crew, describes Hurst and Glover as 'the Clark Gable and the Carole Lombard of the Industrial movement'. 'Ross Cannon was a strapping, six foot plus, charismatic *mensch* who was always making a striking fashion statement, stomping around in knee length leather boots and floor length couture-styled leather coats,' she adds. 'I made some films under Ross's tutelage that were shown at various venues to mixed reviews. Our experimental work was certainly innovative for that time. For one short I was soaked in yellow dye and covered in multi coloured maggots. Getting rid of all those maggots took a

lot of creativity. For another I was buried in the back yard complete with a headstone. Very few people can lay claim to having already had their funeral!'

Hurst had first made contact with Tibet through a fanzine where Tibet had mentioned that he was trying to put together a magazine on the films of Kenneth Anger. 'Ross was gay but was married for passport reasons to a model called Scarlet Harlot who was a friend of Boy George's and appeared in Culture Club's 'Church Of The Poison Mind' video,' Tibet explains. 'Scarlet was a tiny, always essentially feminine work of art,' Dowd remembers. 'She stopped traffic on Kensington High Street with her infamous hair cuts, flowing outfits and meticulously individual make up. She was virulently heterosexual but always surrounded by gay males and Ross pursued his homosexuality voraciously pre-AIDS. Scarlet married Ross in 1982 to celebrate their unique passion for each other and to aid him in his immigration efforts so that he could remain in the UK. While Ross and Scarlet didn't have a conventional relationship it wouldn't be right to describe their union as anything less than passionate and committed.'

'Scarlet impressed me because she claimed she always had £100 in her bank account in case she was ever homeless,' Tibet marvels. 'I couldn't believe anyone could have as much money as that. They were really good to me. It's funny to be nostalgic about that time now but something was really in the air. It was post-punk. Punk was dying but no matter how exciting it was it was still basically rock 'n' roll. Produktion were championing a whole new and really odd scene. I moved in with Ross and Scarlet, who were staying in a really unnerving squat in Hammersmith. Initially I had been living with an architect friend I knew from Newcastle whose parents were quite wealthy. They had a beautiful big flat in Belsize Park but I was only sleeping on the floor. I had to find somewhere on my own but I've always been really terrible at finding accommodation. Eventually I moved into this squat which had been occupied by a woman who'd set fire to herself in order to kill herself.'

She had actually set fire to herself in the doorway between two rooms. The former tenant had become a born-again Christian and believed

her immolation in the doorway symbolised passing from one world into the next but she generated so much heat that she went through the floor into the flat below. The place had no hot water and the toilet wouldn't flush, but at this point squats were Tibet's favoured form of accommodation because all of his possessions were in a plastic bag and he felt good to know that he could move from one place to another at a moment's notice. Part of his bed was over the hole in the floor and in the kitchen he discovered a series of disturbing letters, some of which were from her husband in jail, some of which were from a lesbian lover. They also found double dildos and prescription drugs for depression, and the sliding doors onto the veranda had cracked and buckled under the heat. Before she'd killed herself, the previous occupant had walked down the hall and written along it 'Ded Woman, Ded, Ded, Ded' in red lipstick. 'That really stuck with me,' Tibet admits. 'That's why later in Current I would have 'Maldoror is Ded, Ded, Ded...' I've used it all the way through.

'At the time there was definitely the feeling that it was interesting to live in a weird place,' he continues. 'I didn't have any money and so had very little choice. Ross was a big fan of crucifixes and once he stole several small stone ones from the graveyard and smashed them up and turned them upside down in the room where I was sleeping, which was fundamentally the lounge. He came back and tried to get into the room and he said there was an invisible force keeping him out of the room and he heard the woman say, You only come back into this room if you promise to put the crosses up the right way and take them back to the graveyard. He did that and they went. I believe him, I believe everyone.' Nevertheless Tibet was beginning to feel weirded out. It was undoubtedly a tough time – he had no money, he was signing on and he was frequently depressed. Even so he undertook to study Tibetan at home. All that changed when he bumped into P-Orridge in 1982.

Tibet had already spoken to P-Orridge on the phone several times and had met him once before, at a TG performance in Manchester. While he was wandering down Portobello Road, P-Orridge recognised him

and called him over, inviting him to call round for a cup of tea. 'I said I would but I didn't,' Tibet confesses. 'I felt it was just too fan-like to do it. I bumped into him again and he reminded me that I'd said I'd come over and he gave me his number again. I still didn't go but then I bumped into Paula at Camden Lock and she said, You said you'd come over, so I thought: okay, three times, I should go over. I went to see him in Hackney and we got on well but I guess I was a bit nervous. I can't really remember what our first meeting was like but I'd hazard a guess that we talked about Manson and Crowley.' Ever since *Rolling Stone* made him a cover star after the Tate-LaBianca murders in 1969, Manson, with his links to the Beach Boys and the Monkees, has been cast by some as the ultimate transgressive rock 'n' roll star. Tibet's own interest in Manson was first roused by the strain of apocalyptic Christian thought that dominated his 'philosophy'.

'I don't know why Tibet would think that Crowley and Manson were the subjects of our first conversation,' P-Orridge retorts. 'He seemed obsessed with Aleister Crowley and I think wrongly assumed I was well read and researched in the museum of magic. I'm not. The idea of Manson as a metaphor for society was a fleeting and minor interest in 1969 and the early 70s. It quickly became a tired and ethically bankrupt topic. Once people see the taboo as an accessory, or build their ego by attaching themselves to the amoral, then the same formula for disgracing the species that those in control exhibit becomes a quality, though distorted as hip, of the neo-radical. The desire for endless self-esteem through vicariousness is a sad behaviour to watch. Tibet was endlessly writing magickal journals to join the Typhonian OTO. He's a great and dedicated scholar and wit, but it was his trip not mine.'

P-Orridge remembers the circumstances of their first meeting somewhat differently. 'During 1982 a young man with very bulging eyes under strong spectacles, incredibly skinny, unremarkable hair and with a look and demeanour I would characterise as studenty approached me at 50 Beck Road,' he recalls. 'He was living down the street at the time and knew who I was and introduced himself as David Bunting. Beck Road was pretty much an open house at that time. Members of 23 Skidoo were living in legalised squats I had arranged in numbers 48

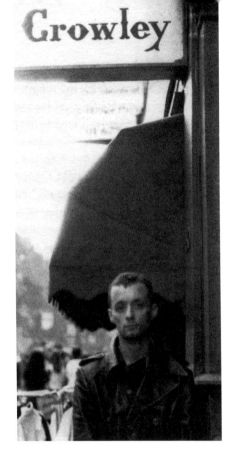

Tibet near IPS Studios,
Shepherd's Bush, London, 1983.

and 52. I dubbed him Tibet to delineate him from other Davids and due
to the fact he was actually going to classes to learn to speak and read
Tibetan. At the time that I met him I had just finished the first drafts of
*Thee Grey Book* with Sleazy's input.' *Thee Grey Book* was intended as an
instructional manual for 'psychick youth', a compendium of techniques
for usurping control logics and recovering the mastery of self. Through
their intimate knowledge of occult and religious schemata, Balance and
Tibet's influence on the final form of the book was key. 'It was Balance,
alongside Hilmar Örn Hilmarsson, who together thoroughly infused
Austin Osman Spare into the Psychic TV melting pot, and helped to
send the subject out 'into the wild',' says Balance's friend Gavin Semple,
a publisher and Spare authority. 'While Genesis tended to get the credit
for all the stratagems associated with both TG and Psychic TV – through
being very voluble – the sigil method, taken from Spare's methodology,

which formed the ritual axis of the associated network and the ethos connected with it, was more or less down to Balance and Hilmarsson.' 'We all chipped in a lot of stuff to that actually,' Balance confirms. 'Tibet and I would formulate stuff which we'd report back to Genesis. Everything had to be reported back to him, nothing was allowed outside the net. It was really draconian.'

'Tibet is incredibly intelligent and certainly at that time he was both a great sounding board for ideas and stimulating in his Thelemic extremism,' P-Orridge continues. 'It was important for me to meet people that confirmed my own experiences and reactions to the world and be reminded that the path opening up was inevitable yet 'EXTRA-ordinary', as I prefer to think of it. Tibet seemed to 'get it'. I didn't have to explain any occultural references and he was brainstorming simultaneously, which is always fun when you hit what Brion Gysin described as a creative or magickal hot spot. He was enthusiastic and ready to help in practical ways. Very witty and dry. Ready for anything and certainly then, very methodical, consistent and efficient. Tibet also had a photographic memory and had actually sat down and read his library and referents, a rarity in that day and age, never mind now. It was like having a library, or computer programme instantly on hand. His recall was a tremendous resource.'

By 1982 Tibet had completed his nine months probationary record for the OTO. Candidates for the OTO have to choose a specific magical ritual with a particular aim and follow it for nine months, all the while keeping a journal that charts their progress. Tibet was working on Netzach, which was a sephirah or sphere on the Qabalistic Tree of Life pertaining to Venus, and the rituals he used were designed to invoke the planet's attributes. 'It obviously worked,' Tibet shrugs. 'As you can see by my huge sex appeal now.' Tibet submitted his typewritten magical record to the OTO and received his certificate of membership. 'Despite its shady, occult image the OTO was more like a course of self-study,' Tibet maintains. 'There were no orgies and no group meetings. It was very private and more to do with self-discipline.' However his flirtation with the organisation didn't last long and within two years he had rejected its demagogic hierarchy.

54

Since arriving in London, Tibet had begun working as a music journalist for *Sounds* and *Flexi-Pop* and he'd persuaded Kris Needs, *Flexi-Pop*'s then editor, to run a cover story on Aleister Crowley as their final issue, specially numbered 666. He penned the main text and sent a copy to Kenneth Grant. Grant was incensed and wrote back insisting that all dealings connected with Crowley had to be submitted to him first for approval. Tibet had had enough. 'I wrote back and told him that I'd just left school, I don't have to submit anything for approval,' snorts Tibet. 'It wasn't even that I was breaking the party line. It was just an article on Crowley. I thought I was being treated like a child so that's the main reason I left. I feel nothing for my time in the Typhonian OTO now and Crowley only interests me in a minor way. I have no time for the absurd over-complexity that is found in many elaborations of Crowley's basic ideas. I think they're often quite *jejeune*. However, as the distance between me and my membership of Crowleyean groups lengthens, I still find myself admiring some facets of this extraordinary man, despite the well-attested unpleasant and manipulative aspects to his character and work that co-habited with charming, charismatic and brilliant aspects. Thelema is often presented as needlessly complex; complexity is normally foisted onto doctrines to hide vacuity.'

In the wake of the formation of Psychic TV in 1981 there came a sister organisation, the deliberately shadowy Temple Ov Psychick Youth. Their 'First Transmission': *A Personal Message From Thee Temple ov Psychick Youth* announced their intent: 'We have reached a crisis point. We are aware that whole areas of our experience of life are missing. We are faced with a storm of thee fiercest strength known. We are faced with the debasement of man to a creature without feelings, without knowledge and pride of self. We are faced with dissolution far more complete than death. We have been conditioned, encouraged and blackmailed into self-restriction, into a narrower and narrower perception of ourselves, our importance and potential. All this constitutes a Psychick attack of thee highest magnitude. Acceptance is defeat. Resistance is dangerous and unpredictable but for those

who realise the totality of defeat, resistance must be thee only option conceivable. RIGHT NOW you have these alternatives: to remain forever part of a sleeping world...To gradually abandon thee hopes and dreams of childhood...To be permanently addicted to the drug of the commonplace...Or, to fight alongside us in Thee Temple Ov Psychick Youth! Thee Temple Ov Psychick Youth has been convened in order to act as a catalyst and focus for the Individual development of all those who wish to reach inwards and strike out. Maybe you are one of these, already feeling different, dissatisfied, separate from thee mass around you, instinctive and alert? You are already one of us. The fact that you have this message is a start in itself. Don't think we are going to tell you what to do, what to be. The world is full of institutions that would be delighted if you thought and did exactly what they told you. Thee Temple Ov Psychick Youth is not and NEVER WILL BE one of them. We offer no dogmas, and no promises of comfort or easy answers. You are going to have to find out your Self, we offer only the method of survival as a True Being, we give you back to yourself, we support your Individuality in which the Spirit and Will united burn with passion & pride. Our function is to direct and support. Work that is needlessly repeated is simply wasteful. Accordingly we will be making public books, manuscripts & other recordings of our progress, in various formats, video and audio. These do not contain meaningless dogma but are examples of our interests & beliefs in action. They are made not as entertainment, but as experience, not the mundane experience of day to day routine but of the Spirit & Will triumphant.'

Early TOPY manifestoes often parodied organised religion, reading like the covert epistles of utopian religious societies. Yet there was much more to them than mere pastiche. TOPY at their purest was a daring utopian project geared towards the total subversion of contemporary morality through disciplines designed to focus the will onto one's true desires, thus enabling the individual to live an authentic life. It's easy to see how TOPY appealed to the young Tibet who already had the feeling that he'd lost something ineffable in his passage from his childhood in Malaysia to England and adulthood. Tibet joined PTV at the time of their debut album, *Force The Hand Of Chance*, and

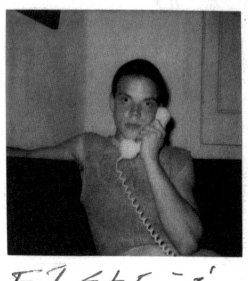

Fritz Haäman of 23 Skidoo.

along with Balance he was part of the first and best line-up of this tempestuous group. PTV began life exploring the mechanics of cult religions only to end up mimicking one, but before their degeneration they popularised Tibetan monk haircuts, recorded a musical setting for 23 Tibetan thighbone trumpets and released two filmic and harshly beautiful records – *Force The Hand Of Chance* (WEA 1982) and *Dreams Less Sweet* (CBS 1983) – which not only evoked the sexual landscape of Burroughs's *The Wild Boys*, but also anticipated the rich textures of Coil's early albums.

'The first time I met Tibet in person he came around to visit Sleazy and I in Sleazy's flat in Chiswick and he was really fucking pretentious,' Balance maintains. 'Well, maybe that's the wrong word, he seemed really arrogant, he and Genesis just marched in wearing their fatigues and Tibet clacked up the stairs like he always does in his fucking great boots and this huge leather coat that he always wore in those days and he pissed on me! We were doing one of our things, one of our rituals, so he pissed on me the first time he met me. He and Genesis were really quite tight.'

Although Balance and Tibet later became very close, at this point Tibet was spending most of his time with Fritz Haäman from ethno-trance outfit 23 Skidoo. 'He was a phenomenal drummer,' Tibet recalls. 'I think that ecstatic rhythmic feel was of more interest to him than the Tibetan stuff or Crowley.' 'Fritz was great,' Balance confirms. 'There was a little gang of us at that point and we all used to march around London as if we owned it. We always went down to Skin Two, the original rubber club, when David Claridge owned it, the guy that created Roland Rat.' 23 Skidoo eventually asked Tibet to join and he played with them at the first WOMAD ethnic music festival in 1982. He also showed up on their 1983 recording *The Culling Is Coming* playing a Tibetan thighbone trumpet. Tibet was obsessed by the shamanic and musical potential of the thighbone trumpet in those early years. He and P-Orridge used to spend their weekends at a market behind London's Bond Street Station that specialised in Tibetan and Nepali artefacts, scouring the stalls for perbas and nadojais before heading off to a little bric-a-brac place near Centre Point that had a good stock of African shamanic instruments.

Tibet was still involved in Psychic TV when he cut the first Current 93 record, *LAShTAL*. The origin of the group name is complex. It's a phrase that possibly originated with Aleister Crowley but even Hymenaeus Beta can't find it anywhere in Crowley's published works. 'He did espouse a theory, which some theologians call dispensationalism, that held that the preterhuman forces directing planetary evolution initiate new 'currents' at regular intervals,' Beta explains. 'This results in a fresh influx of spiritual energies that manifest, gradually, in all spheres of life and all cultures. Crowley taught that major new influxes occurred with each new 'Aeon', a period in evolutionary time that he usually defined as being around 2,000 years. He also taught that there were what he termed 'sub-currents' set into motion every 600 years or so and he cited [16th Century occultist and royal astrologer] John Dee and Edward Kelley as an example of such a subcurrent. The main dispensation advanced by Crowley was that relating to the Aeon of Horus, which he taught was initiated in 1904 with his reception of *The Book Of The Law*, the basic religious text of those who subscribe to Crowley's religious

Balance's new PTV haircut, 1982.

system of Thelema.' Two key words in *The Book Of The Law* are will and love, both of which add to 93 using Greek gematria, a system where each letter in the alphabet is assigned a specific numerical value, thus enabling the establishment of relationships between words of equal value. Indeed followers of Crowley's word – Thelemites – have taken to abbreviating the two salutations from *The Book of the Law* that Crowley opened and closed letters with – Do what thou wilt shall be the whole of the Law, and Love is the law, love under will – as 93, and 93 93/93 respectively. Hence the 93 Current, a phrase that gained popularity through its constant use by Kenneth Grant and his school. Tibet flipped it on its head and got Current 93 which, loosely translated, would mean 'influx of will/love'.

The first Current 93 session took place because a friend of a friend from Newcastle, Nick Rogers, had a job at the Roundhouse Studio, Camden – essentially Bronze Records' in-house studio, where Uriah Heep recorded 1982's *Abominog* and Motörhead cut a string of albums. Rogers called Tibet to see if he fancied making use of some dead time. Tibet called in Balance and Haäman and together they pooled a couple of basic ideas. Haäman brought a loop to the table and Tibet suggested they treat the session as an invocation of Malkunofath, another of the qlippoth on the Qabalistic tree of life. The group based their performance around a certain musical note that was Malkunofath's attribute.

The word LAShTAL was one of Crowley's codewords. With both La and aL assigned the qabalistic number 31, *LAShTAL* added up to 93, although Tibet now admits that it was 'one of those things Crowley had a million meanings for'. Today Tibet dismisses *LAShTAL* as 'witless shamanic posturing'. It's true that across the glare of the decades it doesn't stand up too well. 'I've always really hated drums and maybe it's because it's the most drum-heavy of Current tracks that I can't listen to it,' he groans. 'If you listen to *LAShTAL* and then you listen to the first Current album, *Nature Unveiled*, there's absolutely no connection. *LAShTAL* was me, Balance and Fritz in the studio with about a day's warning and we just went in with this stupid Crowleyan idea for no reason whatsoever other than it was the sort of thing you do when you're a stupid adolescent. But I think the good thing about doing that stuff when you're that age is you're not self-conscious, and at the time I thought it was really fantastic and sounded different. But now it does seem pointless and so when people send me things which I think are hopeless, shamanic, neo-Crowleyan rubbish it's always salutary to remind myself that my first release was exactly that.' 'From what I remember it was mostly improvised,' Balance adds. 'Fritz was a great drummer but apart from that we were all open spaces as far as musical training or conditioning was concerned. I remember David freaking out because he didn't have a title for one of the tracks and one was needed, so I called up the guy that was putting it out and told him to call it 'Salt', part of *LAShTAL*. Of course that was totally wrong and that was argument city for about a week. How dare I chip in! David can be as draconian as any of us. But it was good, we would be going into these big studios and it was all new shiny objects and it was like – oh, what does this one do? You didn't realise what you could or more importantly what you couldn't do so you just did what you wanted completely.'

*LAShTAL* was released in 1983 on the new Belgian label Laylah Records, who must have thought they'd signed Industrial music's first supergroup, what with their 23 Skidoo and PTV connections.

Just after the recording of *LAShTAL*, Tibet began extricating himself from the PTV circle. 'I thought TOPY was a really good way to

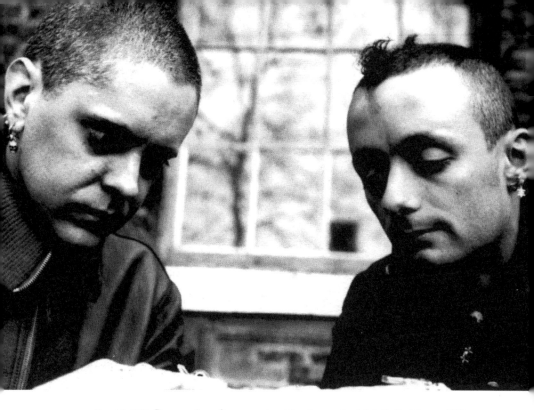

Psychic TV, *Dreams Less Sweet* session, Farnborough, 1983: P-Orridge and Tibet.

(photo © Genesis P-Orridge)

disseminate interesting information on interesting areas that people may not have thought about beyond the usual clichés associated with them,' he explains. 'Still, I was very unnerved when it seemed to be becoming a cult. I wasn't happy with any of the directions the project was moving in. I left quite early on and I fell out badly with Balance because I felt he should have left at the same time as me. We'd both discussed it and he was undoubtedly unhappy with it too but obviously Sleazy had loyalty to Genesis, they'd been friends for a long time, and so Balance had to stay as well. I wouldn't speak to Balance for a couple of years afterwards. At one point I felt that Genesis and I were quite close friends but that relationship disintegrated to the point where I felt it was no longer the case and I was unhappy. I think his character changed. Why I don't know.'

'It's funny, charisma goes a long way and when you're young and excited and things are happening and when you're obviously causing a

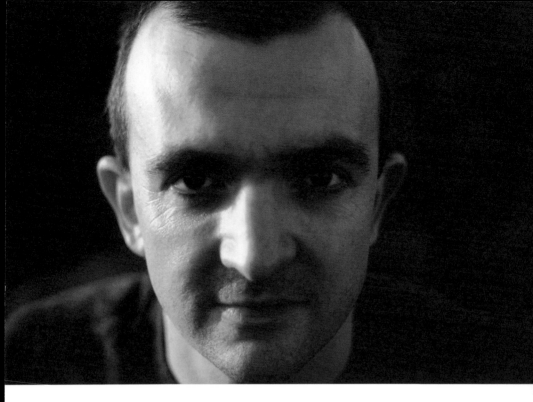

Sleazy, PTV *Dreams Less Sweet* session, 1983.

sensation in some way you stick with it,' Balance counters. 'David saw through it first and was quite scathing about me staying, but of course I was with Sleazy first and foremost so I couldn't just leave. There was a big falling out with David and me. We cut contact for about a year or so. The whole thing ended very badly and Genesis accused David of stealing a load of Doors records. It was just really petty. There are things you use as a wedge to get relationships to end. Ludicrous. They were complementary promos we got from the label, Warner Brothers, and Gen reckoned that David had walked down the road with them to his flat. He probably just borrowed them – I mean, we were living in each other's front rooms. David obviously felt uncomfortable but he came out to Farnborough, where we were recording *Dreams Less Sweet* with Ken Thomas producing, and that's the last time we saw him, just skipping. There's this great film of him skipping, he couldn't skip and we watched this great film of him skipping in leather trousers and with his big boots on. Sleazy, as usual, was the last to move from a difficult

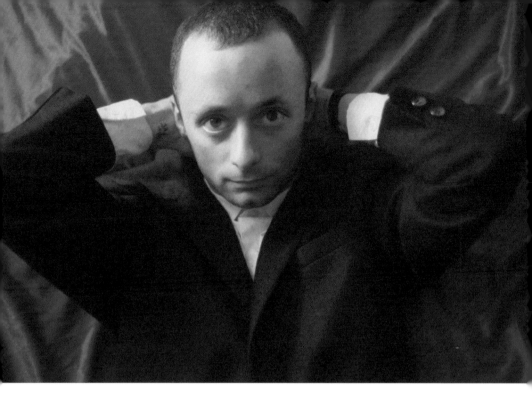

Tibet. (photo Ruth Bayer)

situation. He never takes the lead but I was desperate to leave. He has a very strange emotional masochistic streak in him, he likes people to depend on him and at that time Genesis and Psychic TV certainly did, just as Throbbing Gristle had before.'

Although critics accused PTV and TOPY of becoming the autocratic religious cults they set out to parody, P-Orridge is under no illusions as to the contradictions that brought on their eventual termination. 'I was one of the first of those critics,' he maintains. 'TOPY didn't become that in my humble opinion until after we terminated it in 1991. Precisely because it had to end in order to prevent that happening. I have no knowledge of TOPY setting out to parody anything. It was a serious metaphysical, shamanic and magickal investigation. It was unique in particular in its demystification of classical Western Magickal groups/orders. It was even more remarkable for setting up a non-hierarchical system to explore sex-magick and sigils on a co-ordinated international level.

Nobody else has synchronised literally thousands of orgasms to a single purpose, just to see what happens!'

'We were very aware of what had happened with Throbbing Gristle in terms of the way that fans, or the people buying the records, had seemed to want a kind of leader to follow,' Sleazy told Biba Kopf in an interview in 1997. 'It was at a time when there were various cult leaders coming to the fore, bringing about their own suicide and the suicide of their followers. I am obviously thinking of Jim Jones. Both Genesis and I were very interested in that sort of cult of personality and we were really trying to demystify it, trying to turn it on its head. So it was quite frustrating and depressing to us that, especially in the US, people seemed to follow blindly, you know, do as they were told, and we felt it was quite important to get people to be more self-reliant and more creative and more independent of those ideas. That was certainly one of the things I was trying to promote with PTV and TOPY, which grew out of it. Unfortunately, as Balance and I saw it, those ideals were kind of sidetracked or hijacked, and it became for us, anyway, a cult of personality focusing on a leader. It was a kind of horrible sort of manifestation of the exact opposite of what we intended to do in the first place. (It became) in other words, a cult with a leader, whose followers did whatever he said, and promoted him in that way, and that was one of the reasons that we left.'

Freed from his energy-draining work with PTV, Tibet became increasingly interested in translating his own idiosyncratic ideas into sound. His interest in religion had been re-ignited and he spent hours in the reading room of the British Library, scouring old chapbooks for information. He happened upon RK Emmerson's newly published *Antichrist In The Middle Ages*, where he was particularly taken by Emmerson's inclusion of the speculative writings of Adso of Montier-en-Der. In the Tenth Century Adso developed the theory that Christ's speech from Matthew 11:21 'Woe to thee, Chorazaim! Woe to thee, Bethsaida!' anticipated the coming of Antichrist, who would spend his life in Chorazaim and Bethsaida. He would perish on the Mount of

Olives, 'in the place opposite to where the Lord ascended to heaven'. MR James, England's greatest ghost story writer and a future Tibet obsession, writes of this idea in his short story 'Count Magnus', in which Magnus makes 'The Black Pilgrimage' to Chorazaim. 'The Industrial Underground as it was then had an interest in marginal figures and marginal creeds,' Tibet relates. 'Antichrist was certainly marginal in that sense although it had an incredibly obscure, literary and academic air but I was thinking about Antichrist all the time. I didn't think he was going to be a pin-up along the lines of Crowley but by that time I'd left the OTO and my interest was much more along the lines of apocryphal and apocalyptic literature. I just thought that I could make a record about Antichrist and try and capture what I feel about that and express my beliefs and my obsessions and my doubts and, uh, get Youth from Killing Joke in. God knows how that happened.'

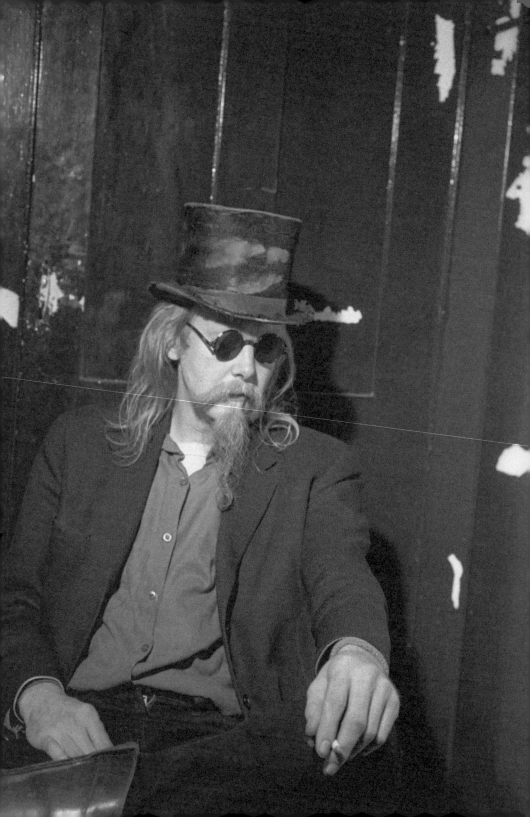

# Chance Meeting

*A rock'n roll session is a session where we can do what*
*we want to do... – Jac Berrocal*

Inspiration often arrives in the unlikeliest of guises. It was Tyrannosaurus Rex's 'Elemental Child' that finally pushed Steven Stapleton over the edge. He'd been spinning the song in his tiny bedroom in North London through the post-punk summer of 1978, after his desperate quest for freakout rock kicks had brought him to the depths of Marc Bolan's sloppy soloing. His pals were right – even he could do better. If it wasn't T. Rex, it was 'Sister Ray', Amon Düül's *Psychedelic Underground*, Guru Guru's *Känguru*, Stapleton's record collection in the mid-70s was bulked with some of the most wayward music of the international underground. Bathed in the liberating light of their excess he was ready to make his own stab at nailing the muse. He recruited two record collecting buddies to help out. One was John Fothergill, a bookish hippy with a decadent line in moustaches and an uncle who used to be a friend of Aleister Crowley; the other was his brother's friend Heman Pathak, who Stapleton had met over a Focus LP. Though none of them had actually made music before, they cut Nurse With Wound's 1979 debut, *Chance Meeting On A Dissecting Table Of A Sewing Machine And An Umbrella*, in the space of a few hours.

Since then, Nurse With Wound has become the nom de disque for any Stapleton project plus anyone who happens to collaborate with him. Over 24 years of ceaseless activity he has refined his compositional

methods, bolstering his non-musicianly fervour with an array of esoteric and alchemical studio techniques. In the process, Nurse With Wound's work has grown increasingly abstract, displacing 'ordinary' sounds – radio play snippets, detourned lounge music, the klang of metal on metal – into extraordinary situations. 'Nurse music is surrealist music,' Stapleton asserts. 'Today surrealism has been swamped by advertising and has lost all of its purity. That's why it's down to me to carry the banner for what's genuinely odd, giving a completely different angle to the way instruments and composition are looked at.' His notion of 'surrealism in sound' involves channelling the murky subconscious into music that provokes unpredictable reactions and tests particular mental states.

Like the surrealists, Stapleton is obsessed with macabre Victoriana. He is also fascinated by the body horror fetishism of mannequin artist Hans Bellmer and Viennese Actionist Rudolf Schwarzkogler. Their influences are most evident in the collages and paintings adorning Nurse releases. But Stapleton's aura-popping use of humour has never allowed Nurse With Wound to congeal around the kind of clichéd shock tactics that held sway in the early '80s. Even so, Nurse With Wound have often been lazily tagged as 'Industrial'. Stapleton himself traces his points of departure to European free improvisation; the futurism of Luigi Russolo (to whom the first Nurse album was dedicated); Pierre Schaeffer's musique concrète; and the Krautrock of Faust and Guru Guru. In fact, Stapleton roadied for several Krautrock groups when he and Pathak lived in Germany.

Stapleton didn't own an instrument before he made the first album and he doesn't have one now. Consequently, the Nurse sound was born out of the different creative strategies devised by a committed non-musician. Nurse With Wound toured once, disastrously, in 1984, and since then Stapleton has been entirely studio based. Yet he is the nexus in a web of epoch-defying underground artists linked by an intensity of vision, a shared curiosity in hidden histories and extreme esoterica, and a determination to create their own artistic universe. The lively dialogue sustained through his close ties with Current 93 and Coil informs all their music, as well as that of an inner circle of artists as

diverse as Whitehouse, Christoph Heemann, gypsy violinist Aranos, The Legendary Pink Dots and Jim Thirlwell aka Foetus.

The trajectory of Stapleton's discography tracks the arc of his life. The violent claustrophobia of early Nurse sides, cut when he was cooped up in his cramped cupboard bedroom in his parents' house in East Finchley, stand in stark contrast to the more expansive blooms that followed his move to a goat farm in the wilds of Western Ireland in 1989. In his initial mission statement Stapleton might have proclaimed that he wanted to make 'cold, clinical music', but his work has never been less than intensely personal.

He was born to his housewife mother Margaret and decorator
father Peter on 3 February 1957 and taken home to 35 Brackenbury
Road. The couple had three other children, two boys, Michael and
Kevin, and a girl, Lisa. Michael was the reigning pogo-stick champion
of North London. Stapleton started drawing at an early age, making
models and constructions and putting on exhibitions at school. His art
teacher at Alder Secondary regarded him as a prodigy and encouraged
his many school galleries. Although his earliest paintings were all fairly
straightforward attempts at portraiture, a fascination with fish – he
had a huge aquarium installed in his bedroom, sandwiched between
record shelves – slowly permeated his work, which became increasingly
amphibious. 'But I think what really changed my approach was when
I got into cacti,' he ventures. 'I started drawing them and they're so

intricate, the shape of the bodies and the spines, the symmetry of them. I used to spend weeks on one cacti drawing.' Then as now, he gave most of his pictures away as soon as they were completed. His grandmother kept a stash of them under her bed, but they were thrown out when she died. He still remembers them, some measuring four feet by four feet, all mapped out in pencil and others crammed with hundreds of meticulously drawn contorted cacti. 'It was the flower power time and there was a lot of that imagery around, flowers and swirls,' he adds. 'It was only a small step from the abstract shapes of cacti to psychedelia so I suppose I started doing peculiar things then.'

Stapleton's parents evinced little interest in their son's talent except to occasionally boast to the neighbours that he could draw. 'They've never heard any music I've ever done,' Stapleton confirms. 'They've never even asked to hear it, absolutely no interest, the same with my entire family. I was always known as the black sheep, the weirdo, although I had respect from my parents because I could keep the rest of the kids under control.' But he wasn't quite the elder role model they had hoped for. As soon as he hit his teens he built his own bedroom out of what was an old toilet, a shoebox measuring approximately nine feet by six. 'It was constantly painted,' he remembers. 'I had the most amazing designs on the walls. I wrote a story around the walls from top to bottom, the walls were black and the story was in block letters in red. Then over the top of that I did a thinner roman type with another story in blue. I had a red light and a blue light and if you turned the red light on you could read the red story and if you turned the blue one on you could read the blue story.' Every night he used to lie on his bed in a red/blue glow, blowing his ears open with repeat headphone spins of the Velvet Underground's *White Light/White Heat*, particularly side two's improvisatory 'Sister Ray' jam. 'From an early age I liked the songs that went into a freakout in the middle,' he says. 'But 'Sister Ray' was something else. I couldn't believe that anyone could do a track that was 17 minutes long and just a total freakout from beginning to end. That was a big moment discovering that.'

Another discovery that sent out far-reaching ripples was the primal thud of Krautrock's most Cro-Magnon outfit, the original Amon Düül.

Stapleton scored an import of their *Psychedelic Underground* in Virgin's first store, just off Oxford Street in central London. 'That was when things really got obsessive,' he smiles. 'The first time I played it was on a tiny little player in the middle of our front room. I was speechless. I'd never heard anything like that. I started getting the other Amon Düül stuff and I remember buying *Känguru* by Guru Guru, a brand new import, in 72. That knocked me out and from then on I was completely obsessed. All that German stuff is still my favourite music. It's got a feel like no other music. They really cared. The Americans and the English were so into their lyrics but the Germans weren't really. It was just sound. They went a lot further than any English or American bands at the time. I mean, something like Guru Guru's *Hinten*, you can't imagine any English or American bands doing anything like that. It was so uniquely German.'

Stapleton first met Heman Pathak, one of the original Nurse trio, through his younger brother Michael. One day Heman, a teenager of Indian descent, came round clutching an album by Focus and – for reasons he still finds totally inexplicable – Stapleton asked if he could give it a spin. Although Pathak wasn't as big a fan of experimental music as Stapleton, they both shared a drooling obsession with The Groundhogs. 'We both loved them,' he admits. 'Albums like *Split* are genuinely strange and the whole feeling of *Thank Christ For The Bomb* is unique. It's not an English album, it could've been recorded anywhere. There were a few songy bands that I liked but they were very few indeed. It was really Tony McPhee's guitar playing that I loved. He was the nearest to someone like Guru Guru's Ax Genrich or Can's Michael Karoli. So Heman and I went to every Groundhogs gig that came up and there were a lot. They were playing college gigs every weekend. Heman and I used to go to the Marquee four nights a week. I think we probably saw just about every band from that era.'

Stapleton's meeting with John Fothergill was much more bizarre, though each of them remembers it slightly differently. 'John was in the Record & Tape Exchange in Golborne Road searching for records with his mum,' Stapleton claims. 'Heman and I had started going around all the secondhand record shops and buying anything that was peculiar,

Steven Stapleton in Europe, 1973.

anything with long tracks or that looked druggy or unusual. Here was this strange looking guy who seemed to be doing the same thing and he had all these records under his arm that looked really interesting. I said to Heman, who is this guy? He's got all the best ones! I can still remember his mother shouting over to him, 'Look, John, here's an unusual one!' It was bizarre. So I went up to him and asked if I could check out the records that he'd picked up and that was it, we got talking. A couple of days later I called him up and he came round to the house and we were amazed. We had exactly the same taste in music. And he had a moustache.' Stapleton was blown away by the extent of Fothergill's interests and knowledge, which spanned experimental music, art and literature. Stapleton had had a pretty sheltered education and upbringing and had never heard of dada or the surrealists before Fothergill turned him on to them. 'He taught me so much,' admits Stapleton. 'I was learning stuff from him all the time. He put me on to the avant garde on every level, from architecture and drama through music, art and poetry. John was interested in anything that was off-kilter

Heman Pathak on the road in
Europe, 1974.

but he was very particular about what he liked and why he liked it. For
instance, he loved a certain type of squealing guitar sound and he said
he'd always keep a record even if it was rubbish if there were even three
seconds of squeal.'

'My mother assures me that she wasn't present when I first met Steve,'
Fothergill counters. 'The way I remember it is that we were both trying
to buy the same exceedingly obscure album, now forgotten. We used to
trawl the secondhand record shops of London for anything weird. What
enabled us to listen to far more, and to experiment much more widely, was
the astonishing pricing policy of Record & Tape Exchange, particularly
at the Golborne Road branch, where unsold records were marked down
at monthly intervals until they were priced at 10p. The weird records
were almost all 10p. Virgin had a whole section of Krautrock but we
mostly picked up stuff secondhand. After that first meeting we went back
to Steve's house to listen to records.' Stapleton's room was a revelation.
'Never had I seen a room so small but with so many records,' Fothergill
recalls. 'There was room enough for a bed without legs, a record player
and nothing else. Visitors sat on the bed. The back wall was lined with

record albums, almost from floor to ceiling. We spent several hours totally absorbed in music. From then on, we met every single Saturday morning without fail, spending the whole day searching secondhand shops, first in London, then in towns like Brighton, and later in France and Holland.'

Fothergill's interest in underground culture dated back to 1970 when he was still attending Latymer Upper in West London. An unusually liberal school, several pupils in the year above him had contributed to the notorious 'Schoolkids' issue of the underground magazine *Oz*. 'While I was at school I started listening to the Velvet Underground's *White Light/White Heat* album, Nico's *Marble Index* and Frank Zappa and The Mothers, particularly *Lumpy Gravy* and *Uncle Meat*, as well as Soft Machine and early Pink Floyd,' he says. 'It's certainly where I acquired my taste for a very acid style of guitar, much favoured by the acid rock groups of the late '60s and the French groups of the 70s. Still, the greatest single event to influence me was the arrival of Virgin – both the record label and the shops. Virgin released Henry Cow, which was a true revelation, like no music I had ever heard before, and Virgin shops started to import Krautrock. Faust's early records were extraordinary, particularly the first. But until I met Steve I never really picked up on the full range of the German scene in the early 70s beyond Can and Amon Düül II. Other Virgin/Caroline/Watt releases led me to the free jazz scene, particularly the work of Evan Parker and Paul Lytton.'

Tibet, who's still in occasional touch with Fothergill, describes him as 'very eccentric, very odd and completely obsessed with hieroglyphics and writing the ultimate book on James Joyce's *Ulysses*. Stapleton and Fothergill were both great because nearly everyone else on the scene was post-punk looking, whereas Steve and John both looked like hippies or 'underground heads'. Stapleton was a lot more chatty than Fothergill who was slightly withdrawn because of his nature but he was a fantastic guy.'

Fothergill was born in Johannesburg, South Africa, but moved to Richmond, Surrey at the age of six. His grandfather was an archaeologist, artist, writer and confidante of Oscar Wilde as well as Aleister Crowley. Fothergill still owns several editions of Wilde's work personally dedicated

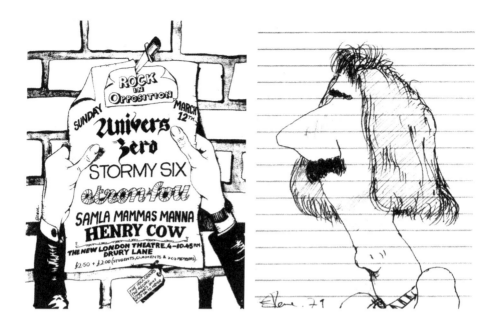

to his grandfather. His eccentric design ideas earned the praise of Wilde, who described him as 'the architect of the moon'. After a period spent in the States, working for the Boston Museum Of Fine Arts, Fothergill senior returned to England and opened The Spreadeagle pub in Thame, which pioneered quality grub with such bizarre delicacies as gjetost, a brown Scandinavian cheese, Fothergill's patented Black Soup, made from brown beans laced with brown sherry, and Mavrodaphne Trifle, a sickly combination of sweet Greek wine and lots of cream known locally as Hermaphrodite Trifle. While John Balance was at school in Thame, The Spreadeagle became the place to go and debauch. Fully aware of Fothergill's history, he and his friends would make regular raids on the cellar in the hope of uncovering some rare Crowley manuscript.

Fothergill senior also published many books in his lifetime, including volumes on gardening and nature in Greek art as well as a cookery book and three volumes of autobiography, the first of which is still his best loved, the tedious yet endearing *An Innkeeper's Diary*. In 2000 it was re-issued by The Folio Society. John Fothergill senior died in 1957. His grandson undoubtedly inherited much of his eccentricity. The younger Fothergill carries himself with the same unworldly air of dandyism and boasts similarly esoteric obsessions including collecting

books on Venice, an affliction that's taken him £80,000 into debt. 'Venice is quite impossible to explain,' he admits. 'Never has so much misleading rubbish been written about a city. The atmosphere of the decaying buildings and canals has a silent watery air impossible to convey in words, and there are no tourists at all within a five minute walk from the Piazza and the Rialto. The average tourist spends less than a day there. Finally, I dragged my father there for a day. He said he liked the city, but it was half a day too long. Yet I could spend a lifetime there and still hardly fathom the place. To take a line from a certain well-known song by Lou Reed about another form of addiction – it's my wife, it's my life.'

At 16 Stapleton left school and briefly attended Hornsey Art College, whose stifling environs he immediately hated. He dropped out and spent a year 'surrounded by my fish tanks, listening to Amon Düül and wanking. That was the year I lost interest in cacti. I had my own greenhouse and up to that point I'd spend a lot of time in there drawing the plants and just tending them but Amon Düül blew all that away.'

Stapleton had entered into some tentative correspondence with some of his favourite Krautrock bands, firing off letters to Kollectiv, Kraan, Guru Guru and Cluster. They were all so stunned that some English guy had been following their activities that several groups invited Stapleton to come over and visit them whenever he had the time. Stapleton and Heman immediately packed their bags. 'We had a fantastic time,' Stapleton smiles. 'We went back several times. I designed a cover for Cluster's *Sowiesoso*, their 1976 album, but the record company rejected it. I can't even remember what it was like now. Fothergill didn't like to leave England, he was very stuck in his ways, so he didn't come with us. He did join us for a few record shopping trips to Amsterdam and Paris but I don't think he made the Italian leg. It's really weird now because all the Krautrock CD reissues have come out and you can buy everything you want in this big lump, along with all this information about what happened and what it sounds like. But then there was no information at all and all these bands were just

swept under the carpet. All the European bands, all the Scandinavian groups, it felt like a great discovery every time you found one of their records. Most of them would end up in the secondhand shops, review copies that had been sold straight away. You'd find brilliant things on a regular basis that no one had ever heard. It was such a voyage of discovery. It was more fun than having stuff handed to you on a plate.'

In 1973 Stapleton and Heman stayed with Conny Plank in Onkurchen and through him made contact with Faust. Although they were invited to stay at Faust's communal schoolhouse in Wümme, near Hamburg, no one was at home when the duo turned up and they ended up spending a miserable night in a bus shelter. 'We also spent a lot of time with Kraan and Guru Guru,' Stapleton reveals. 'Guru Guru's drummer Mani Neumeier was crazy, really lovely. That picture of him on the back of *Känguru*, leaping through the air with his hands stuffed down his top like a clown, that was him totally. Guru Guru would be jamming all the time. There was always somebody in the house playing.' Guru Guru lived as part of a commune near Heidelberg right in the middle of a forest where the parties never ended. Heman and Stapleton moved between the Heidelberg commune and Kraan's place at Wintrup while criss-crossing the country in a series of road-trips. Stapleton had found a job as a signwriter back home and this helped fund his European pilgrimages, along with regular roadie work when Kraan and Guru Guru hit the road. Through his signwriting job he secured the cheap recording time that produced the first Nurse album.

In September 1978 he was working at the British Marketing Service's studio in Wardour Street, Central London, when he got talking to its in-house engineer, Nicky Rogers (not to be confused with Current 93's Nick Rogers). 'It was weird how it came about,' Stapleton relates. 'I remember painting the window and spotting John Cleese walking by on the other side of the street. Everyone in the studio suddenly stopped and came over to the window to watch. He was just walking down the street with a briefcase but everyone suddenly collapsed on the floor with laughter. It was so strange, seeing John Cleese almost do a silly walk, but it was after that I got talking to Nicky.

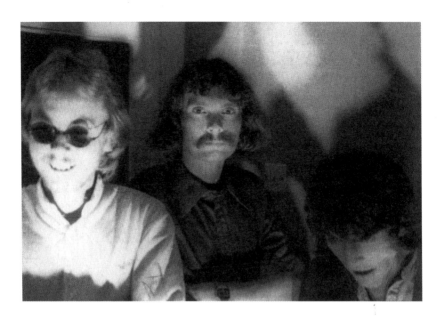

Nurse With Wound, *Chance Meeting* session, Stapleton, Fothergill, Pathak.

'He mentioned that he could sort me out with cheap studio time if I was ever interested and I said, yeah, as a matter of fact I play in a band,' he continues. 'I totally lied and he said, what about this weekend? I said, right.' Stapleton got home from work that night and immediately called Fothergill and Pathak and persuaded them to go out and buy some instruments. Fothergill bought an electric guitar with a treble booster and a ring modulator, Pathak picked up an old keyboard, and Stapleton brought along a box of toys, tools and electronic devices. 'There were no roles, none of us had even picked up an instrument before,' Stapleton laughs. 'We didn't even do a practice. John had only got his guitar about four days before the session but I remember him saying, 'God, it's amazing, it's so easy!' We just set up and after a 30 second run through we just went for it with no idea how long it was going to be or what form it would take, it just grew as we did it, mostly live, with very little overdubs.'

Fothergill's haphazardly prepared guitar embedded barbed shards in Stapleton's conveyor-belt electronics, while Heman unfurled a drone from his heavy, Teutonic-sounding synth. Part of the studio deal meant they had to let Rogers loose on guitar. His proto-metal lead work might

sound incongruous on the first track, 'Two Mock Projections' – 'It sounds like fucking Santana,' groans Stapleton today – but just such bizarre chance juxtapositions later played a major part in Stapleton's surreal armoury. 'Much of the session was improvised initially, but unlike true improvised music it was reworked extensively, through editing and the adding of effects,' Fothergill explains. 'As such Nicky Rogers's engineering skills were invaluable. He made many very helpful suggestions and it put us in a difficult position when he proposed adding the lead guitar.'

'The Six Buttons Of Sex Appeal' moves further out, with Fothergill's guitar mining the kind of forked vectors pioneered by Derek Bailey. This early on, they're still sounding out the extremes of their various record collections – the gravity-defying fug of early AMM, the Industrial klang of early Cluster, the hallucinatory euphoria of The Mothers Of Invention – yet the music is already very much their own.

Convinced that there would be no audience for *Chance Meeting*, Stapleton came up with an attention-grabbing cover featuring some heavy S&M drawings modelled on the front cover of the American porno mag *Latex And Leather Special*. 'I thought if I could put together a really outrageous cover it would get us noticed and it really did,' he boasts. 'It sold out in about three weeks. I always remember taking it to this record shop in Camden Town with John and the guy at the counter looked at it and said to leave it with him. We went back the next week and he said he thought it was total shit. I said, what do you mean it's shit? It might be a bit weird but it isn't shit. He said it isn't weird, *this* is weird and he pulls out a single by The Human League. So he didn't take it, it wasn't weird enough for him.'

'Steve put together the cover art but we all discussed and approved the final product,' Fothergill adds. 'It was undoubtedly important to get a reaction but it would be greatly misrepresenting Steve's work to suggest that the intention was simply to shock. I think it was John Cage who said about his compositions that you don't need to call them music if the word offends you. Well, the same could be said of the art on the covers as much as our music. Nevertheless, Geoff Travis of Rough Trade [London's pioneering independent record shop] was offended by

the first cover and refused to sell the record in his own shop without a brown paper bag around it. Fortunately, Rough Trade were prepared to distribute it elsewhere uncensored.

'Looking back I don't think that record would ever have come out had it not coincided with the early days of punk rock,' he continues. 'It was then that a culture first emerged around difficult and challenging independent music, with specialist shops and magazines springing up everywhere. Record distributors and stores like HMV were prepared to buy directly from small labels for the first time. Before the arrival of punk, UK distribution was entirely mainstream. If the record wasn't on a label like CBS or WEA, then there were no outlets at all. Still, it always did strike me as odd that Nurse With Wound were often pigeonholed as punk rock and I used to wonder how many punk rockers were tempted to buy it and were then delighted or appalled as a result. HMV took large numbers of the first record, which they sold for far less than Virgin and played over the speakers in the shop as well. I was told that it was very good for clearing the store when it became too crowded at lunchtimes.'

Fothergill's mother, meanwhile, coined the group's name. 'She picked it out of a list of words that I had drawn up,' Fothergill explains. 'Nurse and Wound were on the list through my passion for Francis Bacon and his painting of a screaming woman after the scene in Eisenstein's film *Battleship Potemkin*, where a nurse is wounded in the eye on the Odessa steps.' Heman Pathak suggested the label name. 'It was prompted by a very obscure Dutch record on the Moo-Cow label, which had the words 'A horse is not a cow of course' written on it,' Fothergill continues. ' Heman then came up with United Dairies. The name proved to be a real problem when setting up a bank account, because United Dairies was a large milk company. Initially, the bank refused to allow the name to be used, despite the complete lack of any connection between music and milk. In a bizarre coincidence, my mother pointed out that one of her uncles, Sir Reginald Butler, had founded the original United Dairies and the bank had a change of heart when I told them.'

Stapleton remembers it slightly differently. 'We couldn't decide on a label name for ages,' he recalls. 'Then someone asked me 'Well, what's

Nurse With Wound, *To The Quiet Men* session: Pathak.

your favourite band name?' and I said I really like the name Milk From Cheltenham [a post-punk group with links to The Homosexuals that featured Lepke Buchwater, latterly of Die Trip Computer Die]. This guy just said 'Milk From Cheltenham on the United Dairies label!' I said, amazing, that's the one!'

Also included with *Chance Meeting* was the notorious Nurse List. Essentially an A to Z selectively indexing their combined record collections, it still gets the world's most obsessive record collectors scratching their heads. Their checklist of 'electric experimental music' runs the gamut of comparatively mainstream entries like Captain Beefheart and Yoko Ono through obscurities like Keith Tippett's Ovary Lodge, Swedish Zappa-philes Samla Mammas Manna and American destructo-punks Debris. Stapleton maintains that some of the groups were invented, but Fothergill absolutely refutes that. 'The Nurse list of groups was compiled with great, perhaps too great, seriousness and

after much discussion,' he argues. 'Groups were discarded if they were not inventive or radical enough, but a list of that nature is always very subjective. However, every single group on the list not only existed, but Steve or I had at one time or another almost every record that they released.' Well, the French group Fille Qui Mousse never had a record out when the list was compiled – an archive CD was released in 2002 – otherwise Fothergill appears to be right. But chances are that nobody outside Nurse With Wound has actually heard them all. Released in the summer of 1979, *Chance Meeting* was awarded five question marks instead of the usual top grade five stars in the British weekly, *Sounds*, with John Gill writing that 'Never in the history of rock 'n' roll have so few people conspired together to assault the sensibilities of The Record Buying Public in so outrageous a manner. *Chance Meeting* makes *The Faust Tapes* sound like the soundtrack to *Carousel*.'

At the time Fothergill attempted to articulate their aesthetic in a letter

to a fanzine. 'With regard to Nurse With Wound we prefer anonymity,' he wrote. 'Steve and I have been collecting experimental music of all kinds for ten years and we've always felt that although the avant-garde is always associated with progression (?) and originality, yet in many ways their music is hampered by an extraordinarily narrow restricted outlook. Much avant-garde classical music is either:

*1). clinical and sterile, lacking any aesthetic feeling for the sounds they are creating/using. Music dictated by chance or computer represents the nadir in this direction, or:*

*2). contrived and boring because it was composed to an abstract concept – the musical equivalent of concept art: Cage's 4'33" of silence may well have been effective for deflating musical pretensions and making people aware of wider possibilities, but you can't listen to it!*

*In our view free jazz fares little better, avoiding the above, yet is just as limiting because:*

*1). only completely improvised music is accepted, and*

*2). for the most part they restrict themselves to a small number of traditional musical instruments – gtr, sax, drums, violin, dble bass, piano. A few of the more adventurous accept a measure of electronics but the purists are not too happy about that!*

*We see our music as sound sculptures unhindered by preconceived ideas, where any sound may be used whether natural or manmade, untreated or treated electronically, and motivated only by aesthetic considerations. The whole jazz/classical field smacks of elitism, dominated by the cult of the style or personalities involved (witness the kind of following that labels like Incus have in this country). The music should stand alone. It is unfortunate in our case that, entirely because of the cover, what little following we seem to have in some places (particularly Germany) is clearly the cult kind of the worst order.*

Fired up by the success of the first album, the group booked themselves back into the studio in June 1980 to record a follow-up, *To The Quiet Men*

*From A Tiny Girl*. Even this early on, the cracks in the group dynamic were showing. Stapleton had entered the session with an idea for a pounding Industrial track based on the constant noise of the machine rhythms at the engraving studio where he worked. The trio cut a long improvisation based around hammering and scraping sounds, creating a thunderous cacophony. Fothergill, however, was unhappy with the result and insisted that they work the track some more, interspersing the noise with passages of silence. In the end Stapleton gave in and allowed Fothergill to reshape the track, but he was extremely unhappy with the finished piece, 'She Alone Hole And Open'. He already felt that his vision was being diluted by having to concede points to others in the group. 'The recording for the second session was much more controlled,' Fothergill explains. 'With less spontaneous improvisation and more of an idea of what would go into the recording. The finished product owed far more to the editing of the tapes afterwards than on the first one. For me, silence is very important, almost to the point where one could create tension in the music by composing silences between the sounds. Steve was less attuned to that way of working, but I was always very happy with Steve's finished results, and he was by far the most creative and inventive of the three of us.'

Tensions had also developed between Fothergill and Pathak, who had never really bonded, according to Stapleton. On their second album Pathak's input was already negligible. His tastes were never so compatible with Fothergill and Stapleton's and he decided to leave before he was frozen out. Before disappearing completely he launched his own experimental group, Hastings Of Malawi, named after a crossword clue about Hastings Banda, one time president of Malawi. 'What happened was that Heman and some friends just thought, we can do it as well,' Stapleton groans. 'They saw the first Nurse album sell out and thought they could do the same so they recorded *Vibrant Stapler Obscures Characteristic Growth* [Papal 1981] and I thought it was an appalling record. It sold about 70 or 80 copies through distributors and then they just lost interest. One of the guys, David Hodes, had them all in his house and one day his mum just tossed them in a skip down the road. They must be pretty rare now.' Following his ill-fated foray

into experimental sound, Pathak went on to work for David Vorhaus, who was involved in developing synthesizers and played in White Noise, which for a time featured Delia Derbyshire and Brian Hodgson of The BBC Radiophonic Workshop. 'I think he just lost interest in that kind of music, in Nurse With Wound and certainly in John,' Stapleton ventures. 'He just reverted back to being traditionally Indian, had an arranged marriage and went with the family flow. They had always wanted him to go into business so they put up the money and sorted him out with a hi-fi shop. Off he went. I last saw him on a bus in 1986 in Finchley and he was still the manager of a hi-fi shop. I presume he's still doing that.' Years later, when Current 93 played The Union Chapel in London in 1996, Stapleton bumped into ex-Hastings Of Malawi member John Greive. He was working as security for the Current 93 dressing room area.

*To The Quiet Men From A Tiny Girl* is bolstered by the appearance of French meta-musician Jac Berrocal, alongside the 'commercial guitar' of the omnipresent Nicky Rogers. Stapleton had been infatuated with Berrocal's 1976 recording *Parallèles* ever since he discovered it in a record shop on Paris's Champs-Elysées. 'It was the most expensive record I'd ever bought,' Stapleton remembers. 'All I knew about him was he was involved in Futura Records and that the cover looked really interesting so I had to have it. When I heard 'Rock'n Roll Station' I couldn't believe it, it was just a stunning piece of music. So I started writing to him and we became friends. I used to go and stay with him in Paris.'

Berrocal remembers the session as 'the craziest, fastest session' he's ever been involved in, claiming that the amount of drugs that the engineers consumed was 'truly frightening'. The Frenchman's contribution is fairly minimal, playing pocket trumpet, Tibetan oboe and conch shell on two live takes. Stapleton remembers him as being shocked by the fact that he still lived with his parents, while his tiny bedroom cum record library made him claustrophobic. 'I remember coming back from the studio and I didn't want him to have anything to do with my family because all they did was watch television,' Stapleton confesses. 'That was life in my home. The TV was on all the time and my dad was normally drinking, if he was in at all. If he was out he'd

be drinking. He'd come back drunk and create a scene. Have you ever seen the film *Nil By Mouth*? That was my family life. Except for the drugs – there were no drugs. So I wanted to keep my friends away from that and that's why I had made my little room, fitted locked doors and everything. Jac would come up and we'd be sitting in this tiny room and he would freak out, there was only the bed to sit on, no seats. He loved the music though. I think I'd go so far as to say that it influenced him. When he returned to Paris he was into doing different things.'

'I only had one problem with his family,' Berrocal reveals. 'One evening we were invited to eat with the family and so I asked Steve if I should get his mother and father some wine. Steve said, okay, great, so I go to the shop and I ask for wine, red wine. I buy a bottle and I go to Steve's family with the bottle and we open it and Steve says, Jac, no, it's not wine, it's syrup! I made a mistake and bought a bottle of syrup. Afterwards his father took me aside and fed me Cognac instead. I also remember Steve's sister Lisa, a very beautiful young girl. I can't speak much English and Steve couldn't speak much French, just 'Merci Jac' and 'Bonsoir Jac', but in spite of all that it was a fantastic collaboration. There were no problems understanding each other.'

During this period, Stapleton had been dating Nadine Mahdjouba for a couple of years, a half-Moroccan au pair based in Paris. Before recording *Chance Meeting* he had been spending weekends with her at her flat on the Rue De Bastille and commuting to his job in Soho during the week. 'Monday morning I had to get up and get a plane at five o'clock and fly back on the Friday,' he says. 'That's love.' Concurrent with his relationship with Nadine, he was also involved with Lesley Happe, whom he met at a Blackfoot Sue gig. Nadine contributed vocals to *Chance Meeting* and Lesley was part of a muffled group of half a dozen people reading from *The TV Times* on *To The Quiet Men*. 'It was very badly used,' Steve recalls. 'It was on the compromise track.'

'I remember the first time Steve took me home,' Lesley Happe, now Lesley Law, relates. 'I was very impressed as I was only about 17 years old. His walls were lined from floor to ceiling with 12" vinyl LPs and he asked me if there was anything I wanted to hear. Of course I hadn't heard of any of his music, except maybe Tangerine

Dream, and it made him laugh. He was – and still is – a very talented artist. At the time he was doing some work for a small company in Soho called The Sylvester Barth Company and he had the keys to the office. He took me there when they were closed a couple of times to show me what he was working on. One day I got a call to see if I wanted to come with him to a recording studio in Soho where he was making *To The Quiet Men* and he asked me to bring my saxophone. I remember reading TV listings aloud and also screaming. Steve played the saxophone.

'Steve and I were never really a couple, we had a very casual relationship, based almost entirely on the physical so we never split up as such, just drifted apart,' she continues. 'Nadine was his first love, I suppose. She was very young, a nice unworldly French girl. These days I still think of Steve as that odd bloke who just liked to shock. He was very singleminded with regards to his musical taste and it never seemed to bother him that he was out of step with everyone else. A good way to describe him would be that he walked to the beat of a different drum, an attribute I found very attractive. He was always very off-beat – he had long hair when everyone else was a punk.'

*To The Quiet Men* was dedicated to the late Viennese Actionist Rudolf Schwarzkogler who according to the sleeve note dedication, 'killed himself in the name of art by successive acts of self mutilation'. Growing out of his investigations into the S&M scene, Stapleton was becoming increasingly interested in happenings and performance art. 'At the time I was very interested in the Viennese Actionists, especially Schwarzkogler, although now I think he was a bit of a twit,' Stapleton says. 'At the time I was totally taken by him, these events that he'd do where he'd cut himself up with razorblades. To me it was a total mystery as to why anyone would want to do that and so it became a fascination. I was curious, I liked the imagery.' Through the use of such imagery and the unclassifiable nature of their sound, Nurse inevitably found themselves lumped alongside the whole Industrial boom headed by Throbbing Gristle. Stapleton himself claims he was never much of fan, despite their appearance in the Nurse List. 'I was too into the European thing to take much notice of the English stuff,' he asserts, 'although I

Nurse With Wound, *To The Quiet Men* session: Stapleton. (photo Lesley Happe)

saw them live once or twice. It just didn't gel with me but it was okay and I bought their records. I liked them a lot better than the other so-called experimental stuff like Cabaret Voltaire, who I didn't like at all. I liked The Pop Group. TG were much more actively involved in the stuff that I was simply using for imagery. It's like they were the real thing, they were professional exhibitionists whereas I was a much more enclosed person. A quiet man.' Despite Stapleton's reservations about 'She Alone Hole And Open', *To The Quiet Men* marked a confident step into new territory, but the concessions he made bothered him to such a degree that he immediately booked a session the following weekend, recording *Merzbild Schwet* without Fothergill, although he was still listed as a member in the credits. Mapping hypnagogic dream states via disembodied ghost voices, detourned easy listening and what sounds like cattle being flayed, *Merzbild Schwet*, with a title that gives the nod

to dadaist Kurt Schwitters, contains the seeds of the contemporary Nurse sound.

Stapleton and Fothergill drifted further apart with the arrival of United Dairies' first 'signing', The Lemon Kittens, an avant garde rock group led by Karl Blake and Danielle Dax. Although their album hadn't been released by UD at the time of the second and third Nurse albums, it was assigned an earlier catalogue number just so that UD would look more like a real label. 'John was getting more and more involved with The Lemon Kittens,' Stapleton remembers. 'Also about that time I'd become friends with William Bennett of Whitehouse, and Karl Blake hated Bennett, so Fothergill started to side with them.'

Karl Blake, a musician, author, poet and surrealist had come up through the tail end of the Prog scene and the fringes of punk culture. Along with Dax he was a significant player in the DIY/tape scene of the late 70s/early 80s with their Daark Inc label. A fan of King Crimson, Black Sabbath and Faust, he set out to make his way as a musician, consulting the I Ching to find out what he needed to make the music that would satisfy both himself and others. The answer was refreshingly straightforward – he already had everything at his disposal. 'This is where I disagree with Brian Eno's construct of Musicians and Non-Musicians,' he explains. 'To me anyone has the ability to be a musician, all they have to do is make noise with an instrument and for that instant they are being a musician. I disagree most strongly with people like the jerk who wrote the hugely inaccurate Danielle Dax piece in the *Rough Guide To Rock* who said that neither Dax nor I could actually play our instruments. Well, how come there's music to be heard and not silence on those records then?' After seeing The Sex Pistols at Reading University in 1976, he formed a punk rock group called Public Grenade, the latest in a long list of uncategorisable DIY groups with implausible names such as Orange Jelly Baby And The Six White Chocolate Mice. Before the Lemon Kittens, he played bass in Maggots, a jazz-rock group heavily influenced by French group Magma. Soon Blake was travelling to London from Reading to see groups like This Heat, Prag Vec and electronic punks Metabolist, a

The Lemon Kittens: Gary Thatcher, Karl Blake, Danielle Dax.

hard-edged rock band again influenced by Magma. Indeed, he was such a constant presence that Metabolist eventually asked him to join but as it would have meant moving to the capital to live in a squat on the dole, Blake chose to stick with regular meals and a fat duvet at his parents' house. 'And besides,' Blake says, 'in my estimation I wasn't up to the job. Metabolist were, along with This Heat, one of the best live acts of the day.'

The Lemon Kittens were born on 5 April 1978 to the duo of Blake and Gary Thatcher. They immediately recruited a third member, Julia Casson on clarinet, the first of many part-timers to pass through the Kittens' dazed ranks. They had already recorded their first EP, *Spoonfed And Writhing*, when they came into contact with Dax. Blake spotted her in the local paper when it ran a picture of her in prison-arrowed overalls doing a series of pavement drawings in order to attract attention and support for a fledgling community arts project. He immediately asked her to draw a Lemon Kittens cover. 'When we

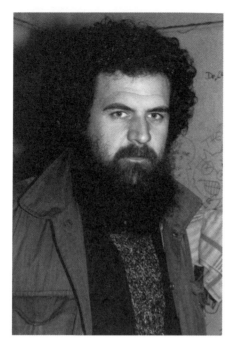

Karl Blake

first met Dax she invited us back to her room which was covered with her own painted paper murals,' Blake recalls. 'I was blown away by her talent and enthusiasm. When she told me she could play the flute and the sax I asked her to join the band. I fell in love very, very quickly. We met on a Monday and had started going out with each other by the Friday or Saturday. She also had a large and eclectic record collection. I had finally met someone who was as obsessed with music and books as I was. She passed the acid test and didn't run off after I played her my music and read her sections of my book *Slab Days [The Ballad Of Leech Ballyhoo]*.'

The first gig with Dax was under the name Amii Toytal And The Croixroads, with Dax sporting a dyed-green lab coat, green balaclava and green face paint. The chemistry between she and Blake was immediate, leaving the rest of the band feeling sidelined and increasingly unhappy with the band's new, uncompromising direction. They quit. Dax and Blake recruited a pool of new musicians to help out with live work; bassist Ian Sturgess and drummers Peter Fallowell and Mike Barnes, the latter now a music journalist and author of a Captain Beefheart biography.

'We first came across *Chance Meeting* in the basement of Step Forward, the label that Mark Perry of Alternative TV ran and that released our first *Spoonfed And Writhing* EP,' Blake says. 'We'd never heard of Nurse With Wound but the starkness of the black and white sleeve was what drew us to it. We weren't really that surprised to discover that there were other like-minded musicians doing similar stuff at the time. We knew they were out there, they just needed some finding.' The Lemon Kittens' involvement with the cassette scene had connected them with underground groups like Storm Bugs, a duo of home-recorders who utilised radio interference, synths, toys and scratched records to create excessive celestial noise and Beach Surgeon aka Graham Massey, a future member of DIY legends Danny & The Dressmakers as well as Manchester-based Techno group 808 State, who back then was penning autistic classics such as 'I Slammed Debbie Reynolds In The Solar Plexus (Twice)'. By the early 80s the British underground was a delirious mess, with punk effectively opening the floodgates to a deluge of form-destroying music, with progressive primitivists drawing on adulterated avant garde technique as much as rock, jazz or pop. The resultant brand of homemade satori was all distributed via a highly evolved network of cassette and private press labels, Xeroxed mailing lists and independent record shops, occasionally sticking its head above ground thanks to John Peel.

The Kittens sent a copy of their EP and a tape of album roughs to United Dairies. At the time Blake was unaware that his friends Metabolist also had a United Dairies LP in the offing, which never materialised after they fell out with the Nurse duo. Blake eventually received a record offer from Fothergill. The accompanying letter throws further light on the circumstances surrounding the recording of the first Nurse album, outlining the label's guiding principles.

'Nurse With Wound was the product of a 'chance meeting' of one of the group and a studio engineer,' Fothergill wrote. 'He expressed a love of experimental music and a desire to help us out. He offered the use of the studio where he worked, weekends and evenings only,

Danielle Dax

for a considerably reduced rate working out at around £75 per day. If
that sounds expensive then compare it with their normal rate of £25 an
hour; and we stretch the day to twelve hours... I can't overemphasise
the importance of a sympathetic studio engineer. Unless you are very
familiar with the studio's equipment and know in advance the particular
sound you want at every stage, and how to obtain it, then to some extent
you are losing control of a vital part of the recording process. The more
sympathetic the engineer and the less that matters. I didn't believe for
one minute that ours would enjoy experimental music, and he doesn't.
But he seemed genuinely interested in, and appreciative of, what we
were trying to do. He was at times even caught liking the music. Most
of the time he was a little bewildered by the unorthodox proceedings
but because we had a clear idea of what we wanted, he was able to

translate our aims at the controls, to excellent effect...your views on the 'record biz' were thankfully noted. We believe that musical and artistic considerations do not just come first. They are everything. Neither the machinations of the business with its emphasis on image and sales, nor those organisations for whom political or social ideals are the driving force and music simply a vehicle, play any part in our philosophy.

'The aim of United Dairies is to release LPs of very progressive/ experimental music that do not fit into the neatly labelled boxes of record company A&R men. 'Categories strain, crack and sometimes break under their burden. Step out of the space provided'. LPs which, for this very reason, would otherwise stand little chance of release.' Fothergill went on to explain to The Kittens that 'all profits would be entirely yours', insisting that United Dairies was 'in 'business' to make music not money'.

'I've no idea what Nurse With Wound's reputation would have been at the time,' Blake asserts. 'I don't think they had any. Remember, these were limited edition LPs, again with no live face and little mainstream press. I can't remember my first impressions of Fothergill but we must have liked him – this was the man who was promising the world to us. He always seemed a little startled maybe, a certain femininity of manner as well but an affected know-it-all breeziness. On one occasion we quoted from memory to him the gist of something that he had written to us very much in the first person and he, in his waffling breezy way, said, 'Oh, I was just repeating Steve's ideas – they aren't mine!' We were young or maybe alarm bells should have been ringing. I think we just assumed this was a harmless enough character fault, which in our ambition we overlooked. When we got to know him we realised that he would bullshit in this way and would use it to hide when he was uncertain about what to do but wanted to seem superior. Dax and I gave him the nickname 'Faff' as he was always faffing about. We only met Pathak once to my memory. It was on the landing of Metabolist's squatted flat and rehearsal room just off Cambridge Circus. We were just arriving as Nurse were leaving, all three of them, Heman, Steve and John. I think that this was maybe just after we had written to them and maybe or maybe not received a reply at that point. We didn't have time to talk. I just remember Steve's

little blue square glasses and John's terrible tatty Richard The Third haircut but I don't really remember Heman at all.'

In the meantime Stapleton had hooked up with William Bennett after buying the first Come album, *Rampton*, and calling round at the address listed on the sleeve. 'I knocked on the door of what looked like a squat and William Bennett answered and we went upstairs and started talking,' he recalls. 'He lived in this house with a flat mate and there were masses of beer cans everywhere and almost no furniture or carpets, just this little record player on which he would play records by Essential Logic and Kraftwerk.'

Early on, punk's DIY ethos had peeled the scales from Bennett's eyes and by the time he was 19 he was involved with Essential Logic, a clunky, post-punk vehicle for front woman Lora Logic, ex of X-Ray Spex. Through his contacts at Rough Trade and with the help of Daniel Miller, who had just started Mute Records, Bennett began to put together his own label, the Come Organisation, in order to document his twin obsessions: meticulously crafted 'pink' noise and what the Comte de Lautréamont described as 'the pleasures of cruelty', all filtered through a transgressive philosophy that was equal parts Friedrich Nietzsche and Marquis De Sade. Bennett also took inspiration from Throbbing Gristle by dint of the fact that they weren't enough. 'It was more through what they didn't achieve, what they weren't like on record or in a live situation that gave me motivation to do things in my own way,' Bennett confirms. 'It's a bit like watching a rock video with the sound turned down – everyone's jumping around, sweating, dancing, going wild. It looks exciting. That is until you turn the sound back up and you hear this lame and utterly predictable and derivative music. TG were like that – it's even more apparent now when you listen to those recordings again. Here's a group that threatened to 'wreck civilisation' and then you saw a video of them playing toy soldiers on a Hackney housing estate.' Come were Bennett's first project. While their first single, 'Come Sunday', and album, *Rampton*, were fairly exhilarating slabs of electronic noise, his next group, Whitehouse, birthed an entire noise genre, inspiring everyone from Sonic Youth and Jim O'Rourke through contemporary Japanese

groups like Merzbow and Hijokaidan, alongside the inevitable legions of hopeless power electronics copyists. Their name was a smartass play on words, referencing the cheap and sleazy porno mag *Whitehouse* (copies of which had been exhibited at COUM Transmissions' Prostitution show) and the surname of the UK's leading anti-filth campaigner Mary Whitehouse.

Bennett has consistently resisted explaining away his use of violent sexual imagery and his exhumation of such troubling historical figures as Ilse Koch, the wife of the commandant of Buchenwald concentration camp, who famously held a collection of household items bound in human skin and was immortalised on the Come Org compilation *Für Ilse Koch* (itself a parody of Beethoven's *Für Elise*) and the sadistic serial killer Peter Kürten, known as 'The Monster Of Düsseldorf', whose reign of terror in 1929 resulted in the deaths of nine people and a namecheck on Whitehouse's 1981 album, *Dedicated To Peter Kurten*. His unwillingness to provide the kind of mediating context that its status as art, anti-art, rock 'n'roll, titillation, serious investigation, shock tactics or ironic cultural commentary would lend it, is in Bennett's view a strategy to force the listener to come to terms with their own prejudices, to think about their hang-ups and desires and deal with the images without any clue as to how they're supposed to react. This aesthetic is reflected in the Come Org newsletter, *Kata*, with castrated texts detailing the workings of The Angry Brigade, chemical warfare, Herpes, maps of extermination camps, minimalist composer La Monte Young and the putrefaction of corpses all rubbing shoulders in the same issue (in this case issue #12, from 1982) without any attempt to tie them together or provide any referential background. In this way Whitehouse act as a lightning rod, bringing together all of the various sub-cultural threads that groups like Throbbing Gristle first highlighted and working through the implications of the sort of ideas first posited by Sleazy and P-Orridge in early texts like *Annihilating Reality*, where the two discussed ideas such as the relationship between serial murder and the uncontainable artistic impulse, asking questions like: 'What separates crime from art action? Is crime just unsophisticated or 'naïve' performance art?' Whitehouse set these ideas in a musical context that is both fascinating and repellent,

Acid drawings by Stapleton.

highlighting the ambiguous allure of these images and ideas while underlining them with music that's as terrifying and bleak as the violent reality that lies beneath. Unlike certain post-Industial groups who seem in thrall to the sanitised, vigorous myth of Nazism, Whitehouse tear down the facade, cutting right through to its diseased, maggotty heart, while their use of foul language and sexually explicit material can be seen as a reclaiming of language and the body in a libidinous sense, away from the constricting colonisation of contemporary gender studies.

Visually Come Org releases always looked great, with compilations like *The Second Coming* crossing punk's gobby graffiti look with dadaist aesthetics. The deliberate crudeness of a lot of Whitehouse material, especially lyrically, worked as an effective bulwark against it ever being inducted into the ranks of high art, yet the sophistication inherent in Bennett's compositions betrayed an obvious knowledge of the workings of the avant garde. Like Nurse, Bennett also had a sense of humour and early records like 1980's *Birthdeath Experience* and *Total Sex* and 1981's *Erector*, for which Stapleton supplied the controversial cover art of an

99

erect, spotlit penis, stand as some of the most imaginative electronic noise records ever produced. 'Bennett was fascinated by extreme imagery in much the same way that I was and he was much more like me than Throbbing Gristle,' Stapleton claims. 'He'd just done a tour with Essential Logic, supporting Stiff Little Fingers, and I remember him saying how it felt to have the power of being onstage. He was really into that. Of all the people I've met through the music, that includes David Tibet and everyone, I've never met anyone who really cared about the music itself. It was always the things on the side, the lyrics, the poetry, the power of being on stage. I can't think of anybody else in our whole group who really cares about the music. The actual sound of it. There's always another aspect they're more interested in. Tibet would quite happily release records of just him singing and Michael Cashmore on guitar. I add more of an atmosphere. Maybe Jim Thirlwell was more like me in the early days, but I think he sold his soul to being a rock 'n' roll star and he lost it. He did this album called *Ache* really early on and he played me all the percussion and metal stuff before he put the vocals on and it

was amazing! So fucking good! Then he put vocals and keyboards on it and took away all the feeling that it had. It was still an okay album but it could've been so much more impressive sonically. William is difficult because he wasn't into the quality of the sound, he was into what it would do to you, the power that he wanted to get. He had subliminal tones put into them to make the listener throw up. At the time we would have to leave the studio while they were being put on. We'd go over to the pub while it happened.'

'I had seen the first Nurse With Wound album around London shops and it always seemed strikingly different to anything you would normally see in a record store,' Bennett recalls. 'Steve and I eventually met and got on exceptionally well. We had a lot in common and became extremely good friends who regularly met up for drinks and meals. Having an ally like that was very beneficial. It allowed for shared influences and project collaborations that spurred on the already fertile creativity. He was a very interesting guy, a talented artist with a unique set of tastes in terms of literature, music and art. Wilfully obscure at times but always with great integrity. I also remember a great sense of humour and he was always very enjoyable company. He was proud of how offbeat and esoteric his record collection was and that there was nothing you could describe as mainstream. In a very curious coincidence, the one exception to this was that he had the Essential Logic 12" that I played on.' Exposure to Stapleton's record collection further energised Bennett and he soaked up inspiration from the likes of Alvin Lucier, Walter Marchetti, Cro-Magnon, AMM, early Tangerine Dream and Robert Ashley while in Bennett's uncompromising aesthetic Stapleton found a match for his increasingly monomaniacal vision. 'He's a real taskmaster,' Stapleton says of the Whitehouse leader. 'Whatever you do he will obliterate straightaway by turning all the levels up.' Stapleton actually joined Whitehouse for a spell and played at their first few Live Aktions where he claims, despite their confrontational reputation, nothing much happened at all. 'My first and probably only real beef with William was that a couple of years later when those recordings of the gigs were released, he took my name off them,' Stapleton claims. 'For the first couple of gigs Whitehouse were Andrew McKenzie of The Hafler

Trio or Glenn Wallis and me with William shouting abuse and David
Kenny mixing. He took our names off them when they were released
and replaced us with the usual Whitehouse crowd. That really pissed me
off. He said he thought I'd be embarrassed, which was pathetic. That's
my only beef with William, which is probably why I've been a bit hard
on him in interviews. I was a bit hurt.'

'Most of the early shows were booked by Jordi Valls of Vagina
Dentata Organ and later by Philip Best,' Bennett explains. 'They
involved conning the venues into thinking we were like The Human
League or similar and of course, there would often be trouble when
we started playing. Also, until we had Dave Kenny from IPS studio
mixing for us, the house PA guys would very much frown upon the kind
of music we played. On top of this the performances themselves were
very provocative and often there would be chaos and trouble.' 'I met
William Bennett a couple of times,' Fothergill counters. 'But strangely
what I remember most was his passion for Spanish guitar and his father's
passion for books. Not to mention the fluffy pullovers so at odds with the
philosophy of Come Org. I found Whitehouse uneven, although at their
best I thought they were much better than Throbbing Gristle.'

'It's really disturbing music with so little,' David Tibet told Mike
Barnes in *The Wire* during an 'Invisible Jukebox' test in May 2001, where
he was played 'Shitfun' by Whitehouse. 'Just an effected voice and high
and low frequencies and space to make such an impressive, unnerving
sound. I actually think it was quite subtly put together compared to
recent examples of total machine noise.' Barnes pressed Tibet as to
whether he thought the confrontational aspect of the group over-rode
the aesthetics of the music itself. 'Obviously the person to answer that
would be William,' Tibet replied. 'He really would concentrate with
great care on anything he did, from flyers, album design, live shows,
even the pressing plant. I remember one of his early texts was: 'The
listener to this album will experience the most extreme reaction possible
because this is the most extreme and brutal music of all time,' He would
also say that he came from a completely libertarian perspective, so some
people thought that he was extreme right wing. But I knew him well and
as far as I knew him, that wasn't the case. He was an expert on De Sade,

an expert on Roman decadence, a very, very intelligent and educated man. There were obviously a lot of groups who came after Whitehouse and just did shock tactics. That was really tedious. But I think William and his project, it was a super-personal thing. He followed his own star and was never bothered that magazines wouldn't do an interview with him, or that he might get banned from various things. He had absolutely no sense of compromise. At the time [in the early 80s] it was really exciting to see Whitehouse play for 15 minutes, then seeing the police dragging the audience away. They did an amazing show at a place called Roebuck. Steve Stapleton knew the form and when to get out before the blood started to flow, but even he had a glass thrown at his face and had to go to hospital.'

Gary Levermore, formerly of the fanzine – and self-confessed 'generic Industrial band' – Tone Death, witnessed the legendarily

violent Roebuck show on 1 July 1983 and while it wasn't quite as hairy as Tibet recalled it was certainly a close call for Stapleton. 'My first ever appearance on stage was as a live member of Konstruktivits, as mainman Glenn Wallis and myself supported Whitehouse upstairs at The Roebuck pub in Tottenham Court Road on a hot Friday night at the end of June,' Levermore states. 'A few minutes into Whitehouse's incredibly loud set, a beer glass thrown by Philip Best in the direction of the table where Steve and I were sitting shattered into Steve's hand, gashing it severely. Steve got up and walked in the direction of the stage, and proceeded to try and push the PA system onto Philip.' 'Watching Steve attempt to singlehandedly demolish a PA system was extremely hilarious,' Best recalls. 'Especially when he was struggling to lift the monitors above his head. I had no idea that he was hurt and thought it was his own unique contribution to the show. Also Steve was actually hurt when I threw a microphone stand, not a pint glass, into the audience. This apparently smashed a glass on his table, although I admit the difference may seem academic.'

Best had booked the gig on the pretence that Whitehouse were actually a 'synth pop group with a jazzy feel' and as soon as they hit the stage all hell broke loose. 'The landlord immediately rushed upstairs and was forcibly ejected from the room by Dave Nanavesh and Jordi Valls, who then organised the barricading of the doors,' Best continues. 'Ten minutes later two vanloads of SPG were smashing their way into the room.' On the recording of the night it's possible to hear the landlord rounding on Best as he attempts to make his escape. 'Because I was so young the police restrained him and let me go on my way,' he laughs. 'It was a true rock and roll experience,' Levermore agrees. 'Several policemen and the pub security forced their way through the guarded entrance into the room and proceeded to arrest a number of people, although not myself or Glenn Wallis. We picked up our Wasp synthesizers and calmly left the venue, got the tube back to Victoria and the train back down to Kent.'

It turned out that Steve hadn't been arrested either, although he did spend half the night in casualty getting his hand seen to. 'I had arranged

to come back up to London the following lunchtime and meet him in the John Snow pub to pick up the finished sleeve for Konstruktivits' *Psykho-Genetika* LP, which he had designed under his Babs Santini pseudonym,' Levermore says. 'I felt more than a little guilty when he showed up with his hand heavily bandaged, having spent some time that morning before our meeting struggling to put the finishing touches to his artwork!'

Everyone has a good Whitehouse story. Tibet recalls a friend of his, Mark Baker, claiming that he once sent Bennett a letter that simply consisted of his address and a sheet of paper he had ejaculated on. Bennett's reply was inspired; a sheet of paper that he had wiped his ass on. 'I thought that was very impressive,' Tibet grins. 'William had already mastered the art of one-upmanship.' John Gosling recalls a Whitehouse show at The Air Gallery on 23 January 1984 with a line-up of Philip Best, Kevin Tomkins and William Bennett. 'I was filming the gig,' he explains. 'Bennett reluctantly let me do it but it was all a bit boring, so I threw a chair into the audience to get things going. I was still filming and I could just see this guy coming towards the camera through the lens and the next thing you see is this big fucking fist coming down and the camera goes on the floor. I'm getting a right good kicking basically. Jordi Valls came to my rescue and kicked the fuck out of this guy. But then it all went off and the gig was over. One of my mates began firing off tear gas and it all got out of control. I would have thought Whitehouse would have been happy with that kind of reaction but they didn't half get the hump. But you can't play what sounds like three wasps at maximum feedback while calling everyone in the room a cunt and expect polite applause.' 'In some respects the Air Gallery show was a drag,' Best counters. 'Although predating him, the violence was of the GG Allin variety, engineered by some morons in the audience rather than being the result of a spontaneous series of events. Even today, some idiots go to Whitehouse shows with the pathetic aim of seeing some violence and that is not what it is all about. Whitehouse shows are always best when the audience has no preconceptions and are willing to go along with anything the band has in mind. Personally I'd rather play to a room full

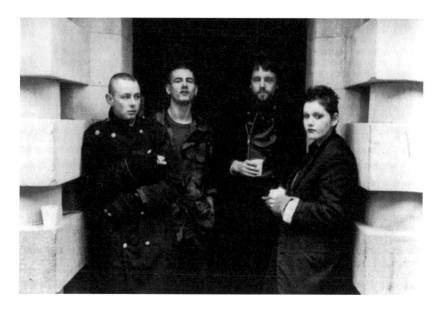

Whitehouse at the Old Bailey, London 1983: Philip Best, Alastor, William Bennett, Debbie. (photo James Barraclough)

of girls and gays than a legion of third-rate Industrial goths, all piercings and Swans T-shirts.'

Recorded on Guy Fawkes's night, 1981, the Nurse With Wound/ Whitehouse split album *The 150 Murderous Passions* is still a bone of contention between the pair, with each claiming he was screwed over by the other on it. Regardless, it's one of the most extreme records in Stapleton's back catalogue, with its sonorous clank of metal and extended sections of feedback suffocating beneath Bennett's predilection for recording everything in the red. 'At one point it would have been a very different record, at one point it was really sounding very good, quite sculptural,' Stapleton claims. 'We had one side each; although we played on each other's side, we would instruct the other what to do. When it came to mixing his side, which I thought sounded great, he just turned every knob up to the top, bass, treble, whatever and ran the whole thing through like that, just obliterating everything that was done. That was what he wanted and that was how he made his record.'

As Stapleton became progressively tighter with Bennett his relationship with Fothergill began to suffer. 'Horrible things started happening,' Stapleton claims. 'John was becoming a mouthpiece for

Danielle Dax, he was obviously in love with her and she was right and everything I did was wrong. He wasn't seeing her, but there are so many different stories. John just wouldn't tell me what was happening and things started to go really bad.' 'Although John and I bonded strongly over our shared love of avant-garde literature and music there was never any question of us having a relationship,' Dax says. 'Karl and I were very much in love and were a definite couple at that time. In fact I found John's persistent romantic interest rather embarrassing and tiresome. I didn't want to hurt his feelings but I was more concerned that our professional relationship be on a firm footing and that everything be above board.'

Stapleton hadn't been happy about The Lemon Kittens releasing their debut album, *We Buy A Hammer For Daddy*, on United Dairies, although Blake says Fothergill convinced him that Stapleton actually thought it was one of the best albums he had ever heard. At the time it was possibly the label's highest profile release, if only because The Kittens actively promoted it with a string of live performances and interviews. John Gill, writing in *Sounds*, awarded it five stars with a staggering piece of hyperbole that compared it to The Pop Group, Karlheinz Stockhausen, Anthony Braxton and The Art Ensemble, stating that 'we can now claim to have produced our own *Ege Bamyasi*'. Still, Fothergill seemed determined to keep Stapleton and The Lemon Kittens apart. 'John would niggle about things to us,' Blake reveals. 'We didn't see much of Steve so we didn't really know what he thought. I think that John kept us apart, though I'm not sure why. Maybe he thought we'd have a big bust-up or something.' Things got even cosier in August of 1980 when Fothergill moved into a flat with Blake, Dax and bassist Ian Sturgess in the Gypsy Hill/Crystal Palace area of London. He split his time between there and his parents but eventually the gravity of his family proved irresistible and he convinced the whole group to move to a flat in Richmond to be nearer his mum and dad. By this time his behaviour was becoming increasingly erratic, his obvious infatuation with Dax dictating most of his decisions. 'He became besotted with Dax,' Blake confirms. 'As far as I was concerned he was very much 'Karl is a Neanderthal ape and doesn't understand you – we are so

much better intellectually suited'. There were some confrontations between myself and John over this but they certainly didn't have a relationship.' 'It was about this time that John was beginning to realise that there was no hope of me ever returning his romantic feelings,' Dax adds. 'He became by turns despondent, angry and bitter and began to become even more secretive and evasive about our business dealings than usual.'

'Sadly, my relationship with Steve started to become distant as I became more involved with The Lemon Kittens,' Fothergill admits. 'With hindsight, this was a major mistake on my part. Danielle was very alluring and charismatic, and although I would never have admitted it at the time, I think her charms probably made me lose my head a little.' 'I parted company with The Lemon Kittens in acrimonious circumstances in late autumn 1981,' Mike Barnes reveals. 'But I have one abiding memory, which to me summed up the view held by some of the extreme art musicians against the 'normals'. One time Paul Bonaventura, who had become a driver for The Lemon Kittens, came to their flat and asked, completely unselfconsciously, 'Anyone see that Bob Marley concert on the TV last night?' Fothergill, who I had come to realise was a terrible snob towards the taste of the normals, literally spluttered in disgust. He struck me then like some crusty sergeant major whose monocle was popping out in horror. The arrogance that prompted that outburst made me feel like the best thing I could do was to ignore what he was doing musically and go buy a copy of *Catch A Fire*.'

Events peaked with the release of the United Dairies compilation, *Hoisting The Black Flag*. Named after a quote from the iconoclastic American critic HL Mencken [1880-1956] that Blake had turned up and that went 'Every normal man must be tempted at times to spit upon his hands, hoist the black flag, and begin slitting throats,' it included Whitehouse and The Lemon Kittens, as well as Nurse With Wound, Truth Club, David Cross, Hamilton & Duarte (aka engineers Nicky Rogers and Vic Ball aka The Bombay Ducks) and The Mental Aardvarks. 'I hated Whitehouse, and this wasn't a musical thing,' Blake asserts. 'It was to do with lyrical content and presentation. *Hoisting The Black Flag* was our first exposure to them. Dax was carefully writing out the lyrics

to, and information about, The Lemon Kittens' track 'Funky 7' for the planned insert when I espied a dedication to someone by Whitehouse who I had never heard of before. This person was called Peter Sutcliffe. I didn't know who he was at first because he had only recently been named as The Yorkshire Ripper. The track was entitled 'Her Entry' and I was very angry and wanted an arrow pointing to this from our place on the sheet and a disclaimer saying that we in no way approved of it. We had a very heated discussion on freedom of expression and John, in a huff, destroyed the insert so that subsequently the album was released without one.'

Bennett remains unapologetic. 'I absolutely regret nothing,' he affirms. 'In fact, I'm tremendously proud of every single thing I've ever released. I firmly believe that it is absolutely timeless, still sounds fresh and hasn't been surpassed to this date. 'Shock value' is a term thrown around very loosely for something far more complex – it is a mostly subjective reaction from the point of view of the consumer. Think back historically to the types of art that has 'shocked'. As creator, people's reactions, either negative or positive, have no immediate bearing – nevertheless some decision-making in the process of presentation can involve creating a specific effect. It's like the very moment a crime is committed, very little thought of the possible consequences are considered. The music is being created because I believe in it; it's what I love; it's what I would want to listen to; it's what expresses my interests; it's what has meaning to me... the spirit of total libertarianism pervades all aspects of the work.'

Fothergill further compounded matters by having the cover of *Hoisting The Black Flag* printed sideways so as to ensure that The Lemon Kittens' name read along the top. The group themselves were never consulted and Stapleton went ballistic. 'That was the thing that really killed me and John off,' he maintains. 'That and all this shit where he started up his own label and put out stuff like *Experiments With Ice* and The Shiny Men. He'd already put out the dreadful Bombay Ducks album, which was just Nicky Rogers and his friends. I wanted United Dairies to be a label to be proud of. He was going to put out the Two Daughters album and that was when I really put my

John Fothergill, 1980. (photo Danielle Dax)

foot down.' 'For reasons that are hard to explain now, I released two albums on 'Experimental Records',' Fothergill admits. 'The music was simply not really what I wanted to be involved with but I felt dragged along by fate and I picked the name of the label with a certain sense of irony, to make it clear that there was no musical connection with United Dairies. Chris Lavelle and his group, later called The Shiny Men, had done a wonderfully quirky song with Robert Wyatt and Danielle Dax on vocals and they also had some very nice material in the style of Wyatt and Matching Mole. However, when they got into the studio the group became very conservative, lifeless and stilted – all of their quirky spontaneity disappeared and it was a recording disaster. A salutary lesson. The only other release, *Experiments with Ice*, is a rather pedestrian rock album by Nicky Rogers and his group, which I did for them to repay the massive debt I owed Nicky and Vick for their support of United Dairies, not only with production expertise on the earlier releases but also with the material they recorded for UD

under the name of The Bombay Ducks, which was gloriously inventive and unusual.'

Things finally blew up with The Kittens after an argument about royalties and copyright, with Fothergill moving out of the Richmond flat and re-possessing equipment that he had bought the group out of their royalties, in some cases apparently without consulting them. The Kittens withheld rent for the flat, which was in Fothergill's name, as well as holding on to master copies of various UD titles. 'John gave Karl, Sturgess and myself just one week to vacate the flat with nowhere else to move on to,' Dax claims. 'So we ended up with no royalties, no equipment and no home!' 'We had begun withholding rent as we had not seen any of the promised 'profits' and we were justifiably paranoid as a result of Fothergill putting himself down as copyright owner on MCPS forms for our material. We were ignorant of MCPS and PRS stuff until Sturgess enlightened us. The master tapes we took were actually left behind by Fothergill in his covert act of fleeing the property. We held onto them and returned them to the artists involved. We had the *Hoisting* tapes as we wanted our contribution back but the means to extricate it had gone with the tape deck that Fothergill 'repossessed'.' The whole thing ended up in the hands of lawyers. A messy end to a great adventure.

'In the end it all busted up with Danielle and Karl,' Stapleton shrugs. 'He was so involved with The Lemon Kittens, any way to get close to Danielle. After it was all over John rang me up and he apologised. I was just finishing *Homotopy To Marie*. He told me a lot of horrible things that had gone on, bad things, and he was never the same again. It was like someone who had the emotion drained from him, all the shit kicked out of him, and he was totally changed. We couldn't really communicate any more. I think he had a vague idea of getting back together but there was too much water under the bridge. That was the end of that.' As soon as The Shiny Men's *Again!* LP came out on Experimental, Fothergill began to retreat from the scene, although he and Stapleton did remain in sporadic contact for the next few years. Although today his tastes are as esoteric as ever, he has not made any music since. 'My taste in music hasn't changed at all,' he reports. 'I still love experimental music and

films but 5,000 books, 500 DVDs and 500 CDs share the three hours a week when I'm not either at work, travelling to work, or recovering from work. Why? My sister gave me a key-ring 20 years ago and on it were the words 'I owe, I owe, so off to work I go'. When that ceases to be true, there will be a ceremonial burning of the key-ring. There is light at the end of the tunnel, but I think it may be from an oncoming train.'

After Fothergill's departure from the group, Stapleton effectively took over most of the running of United Dairies. Still, rather than dive headfirst into solo work, Stapleton enlisted the help of Jim Thirlwell aka Foetus and Trevor Reidy, of The Truth Club, to record the fourth Nurse With Wound album, *Insect & Individual Silenced*. 'We worked in the same neighbourhood, London's west end,' Thirlwell recalls. 'At the time I was working in Virgin at Oxford Walk, sort of like a shopping mall with speakers situated out on the street where you could blast music. I always enjoyed suckering the crowds in with dance music, then blasting them with noise. When the first Nurse album came out, Stapleton quizzed me about it, not letting on it was his record, asking what it was like. When I responded and had obviously listened to it, he divulged that it was his record and we became friends and fellow travellers in the arcane. Stapleton was heavily into Krautrock, obscure avant garde noise and 20th Century classical and turned me onto some cool things. You'll notice the address on the early Foetus records is Steve's mom's house, as I was squatting and couldn't guarantee I'd be in the same place if someone wrote to me. Through him I met William Bennett, who I had seen playing in Essential Logic, who were one of my favourite groups at the time. Bennett was obsessed with the Marquis De Sade and pushing the envelope, an original transgressor, though quite funny and charming too. Sometimes he and Stapleton and myself would go to the pub at lunchtime and have lively discussions.' Still, Thirlwell remembers little of the *Insect & Individual Silenced* sessions. 'The sessions kind of blur into each other,' he admits. 'If we were working on something in particular by the time Steve was through with it, it was unrecognisable from how it was when it began. I could never keep track of what project we were recording for. I think sometimes that was determined later, but I could be wrong. I met Trevor Reidy through working for Virgin, we

both worked at the singles counter there. He had very diverse tastes and was also into dance music, import 12"'s, as well as more out-there stuff. Trevor is a great guy, very funny and a good drummer.'

'It's a dreadful record,' Stapleton groans. 'What a pile of shit. Thirlwell was a nice guy but making that record was the worst mistake of my life. I burned the masters very soon after I made it. I'll never put it out on CD.' Bootlegs of it do exist, though, and it's certainly nowhere near as terrible as Stapleton makes out. With a title that echoes the composer Alvin Lucier's 1975 recording *Bird And Person Dyning*, *Insect & Individual Silenced* is a dirtier sounding record than the preceding three, though lacking Stapleton's usual sense of dynamics and control as bursts of percussion are haphazardly interrupted by snatches of manipulated sound and bellowing foghorns. At points it suffers from a real lethargy, almost as if Stapleton was simply putting off striking out on his own.

In contrast, Stapleton has always considered 1982's *Homotopy To Marie* to be his first 'real' record. Here's where he first discovered editing and worked out how to shape dynamics. Around about this time he had a block booking at IPS Studios, a very small, basic studio in Shepherd's Bush with an eccentric and innovative in-house engineer, Pete McGhee. Stapleton worked in the studio every Friday night from

6pm to midnight for a whole year, almost as a way of unwinding from his job. Any money not spent on food or bills was ploughed into recording time. 'That was the happiest time I ever had in the studio,' he smiles. 'It was great fun, every week I'd have different people down and it was just fantastic. *Homotopy To Marie* just came out of that.' With its CD cover art of a disembowelled doll tumbling into blackness (itself a reference to Julee Cruise's *Floating Into The Night* LP, a favourite of both Stapleton and Tibet), *Homotopy To Marie* is a uniquely disturbing record, taking its title and much of its inspiration from the composer Franz Kamin's 1980 recording, *Behavioral Drift 2 & Rugugmool*. Less conventionally 'musical' than its predecessors, Stapleton's jumpcuts set up some chilling juxtapositions. Children's voices float through the fog while gongs and metal percussion curdle the air. His use of silence is also highly unnerving, especially when it is usurped by distant groans and long, arching drones. A rigorous logic guides Stapleton's arrangements. Sometimes he structures parts around correspondences based on the slightest timbral similarity; elsewhere he triggers chains of musical

events with a single word or half-heard sound. Stapleton describes it as 'automating', a term he lifted from Twiggs Jameson's 1968 novel *Billy And Betty* (used as a euphemism for masturbating), while also giving the nod to the spontaneous automatic writing technique pioneered by surrealist Andre Breton.

'Nurse With Wound is a group that it's impossible to be subjective about,' Thirlwell insists. 'They can be crap and they can be genius and what one person perceives as crap, another perceives as genius. How can you compare it? There is no doubt a twisted Stapletonian anti-logic at work, which I occasionally glimpse. The cat does have a sense of humour.'

# EQiNoX evENT

**JuNE 21** musiciANs co-oP GlouSter av. n.w.1 CamDenT

AdVaNCE TickEts aVaiLAbLe from **PRoDuKtioN** HaiR

KEnsinGton markEt 93787

mYstERY GuEST baNd

fROm BeLGiuM

**Club MoRaL** **NUrSe** wIth **WounD**

JOHN murpHEY

PUre **A.K.E.** coiL V−SidE eTaT BRu

P.R. HALE

**dOgs bLood ORDer** RIck sHuTTer /PRoDuKTioN

LA droessE TEST DePARTMent

marY DowD&ToNI roGeRsON ANd muCh mORE

9Am. PM TiL LatE

tickEts £3 oR 2.50 in ADVanCe

# Equinox Of The Dogs

*Strange and unusual actions should sometimes be practiced in order to free the mind from its conventional trammels. The great world will then become visible* – David Lindsay

*Magic loves the hungry* – Buffy Sainte-Marie

The Equinox brought out the backwards in everyone; modern primitives, Nazi geeks, bedroom occultists, boot boys, autistic noise rockers, lager that tasted like piss. In a masterstroke of reverse logic – or maybe just a dumb mistake – The Equinox Event, *the* most significant gathering of the post-Industrial scene, actually took place on the night of the summer solstice, 21 June 1983, at The London Musician's Co-Op in Camden, missing both that year's vernal and autumnal equinoxes. It was as if they were fighting back the ascendancy of the sun with a night of lunar ritual, the whole event an occult operation for the dark. Indeed the early '80s witnessed the third great modern magical revival, following on from the late 19th Century and the late '60s, as many of the facilitating cultural conditions fell into place. A combination of the ever increasing feeling of powerlessness and disillusion with the political process that blossomed under Thatcherism, the narrowing of permissible lifestyle choices, the erosion of societal bonds and the widespread use of recreational drugs that highlighted the infinitely pliable nature of reality, resulted in the desire of a section of the population for the 'programmed alteration of consciousness within a group setting', as the OTO might describe it. The

result was that energies that might have been dispersed into more self-destructive areas were channelled into focusing disaffection via punk ritual. Secret societies and underground cells re-activated as strategies for operating away from the censorious eyes of the state became more and more crucial, along with alternative ways of organising experience and interpreting information.

In 1983 the whole post-Industrial underground reached a peak of sorts with an explosion in tape labels, fanzines and gigs. '1980 through to 1985 were great and exciting years,' claims William Bennett. 'Creatively they were very prolific. There really were a lot of interesting people in London at the time. We were doing lots of live performances where there was always great expectation and anticipation. It was something genuinely new both in terms of content and musically. One day all this stuff will be discovered, just like the Spaniards came upon the Aztecs and the Incas but as with the historical analogy, as long as it stays unnoticed, it will be better.' 'It was a very exciting time,' agrees Philip Best. 'Especially if you've run away from home and you're 15 years old. Invariably everyone I met had some kind of deviant project or half-baked scheme going on, which almost inevitably involved sex, death and some unique personal kink. Later so much of this material was commodified and became de rigueur for followers of Industrial culture. But, for a few months at least, anything seemed to be possible and a lot of people who were there would have carried the lessons with them.'

Stapleton, curmudgeonly bastard that he is, hated it all. 'It was all based on synthesizers and I can't stand them,' he claims. 'I never use them. Heman used one on the first album but that's all. I wasn't involved in that scene really. I know it looks like I was but I was still totally into the European thing, that whole Industrial thing was total shit; I didn't like any of it. Fothergill as well, he never considered what we did as having anything to do with anything else, Throbbing Gristle or any of those bands.'

Still, in the wake of Throbbing Gristle's ground-levelling work, countless fanzines and cassette labels had sprung up to document the deluge of non-musicianly art that they had first inspired. One of the

more interesting cassette labels was Third Mind, founded by Gary Levermore. 'I first became aware of Nurse With Wound via reading album reviews in *Sounds* around 1980, while in the sixth form at school, although my first album purchase by the band was *Homotopy To Marie* sometime during the first half of 1982,' he reveals. 'This was in the midst of a late teenage period of discovery when I was actively seeking out different music and purchasing anything I could find on non-commercially motivated record labels such as Ralph, Recommended and Atatak, as well as anything I may have missed on Industrial. Steve Stapleton and John Fothergill's United Dairies label therefore became a prime target for plundering and *Homotopy To Marie* was certainly different, especially to a youngster with no real knowledge of musique concrète or Dadaism or many of the other left of left of centre influences on Steve Stapleton.'

Inspired by all of the new groups he was reading about in Balance's *Stabmental* zine, Levermore decided to get involved himself, despite being stuck in a job with the Whitstable branch of Barclays Bank out in Kent. Together with a few friends he put together the almost tongue-in-cheek Herne Bay Temple Ov Psychick Youth, fired up on the initial propaganda coming out of the Temple prior to the release of the first PTV album. He also began gathering interviews for the first issue of *Tone Death* and received contributions from Chris & Cosey, The Legendary Pink Dots, SPK, Whitehouse and Nurse With Wound.

'Around the time that I was putting together the second issue of *Tone Death*, I had asked most of the groups that I had been in contact with if they would be interested in contributing tracks to a compilation cassette to highlight what I saw as a kind of second wave of Industrial music,' Levermore continues. 'I wanted to incorporate artists stretching all the way across the underground spectrum, from already famous luminaries such as Chris & Cosey and Nurse With Wound to the experimental rock/pop of Legendary Pink Dots through the mutant sequencer rhythms of Portion Control and Attrition. To my surprise, almost everybody I wrote to agreed to participate and Steve Stapleton contributed three wonderful Nurse pieces, two of which were issued on what quickly became a double cassette compilation.'

The Nurse With Wound pieces that made it onto the compilation were 'Someone Others Garden' and 'The Strange Play Of The Mouth', the latter a particularly warped torch song sung by Laura Ferrari, the Italian girlfriend of a friend of Stapleton's, David Elliott, who at the time was writing for *Sounds*. Thanks to a £500 loan by an undoubtedly bewildered relative, the cassette came out on Levermore's Third Mind label in February of 1983 entitled *Rising From The Red Sand*, a *de rigueur* paraphrase from Burroughs's *Cities Of The Red Night*. Its initial run of 250 copies flew out of the door on the back of a rave review by Dave Henderson in *Sounds*, who used the occasion of its release to launch Wild Planet! – a user-friendly map of the new musical territories in *Sounds*. Wild Planet! included entries for Nurse With Wound, United Dairies, Whitehouse, Foetus, The Legendary Pink Dots and Throbbing Gristle alongside potential precursors like AMM and The Velvet Underground. 'Underground, free-form, experimental, avant-garde, Industrial, call it what you will,' Henderson wrote. 'But there's a blossoming sub-structure of groups around the world who are attempting to produce music that is ultimately different. They are not tied together as any kind of neat

package but merely as a network of friends who are in sporadic contact with each other.' Henderson followed up the feature by curating *The Elephant Table Album*, a compilation that featured many of the acts he'd written about, all of whom he unfortunately dubbed 'difficult music', including both Nurse With Wound and Coil.

The Equinox Event was very much an attempt to delineate this vaguely articulated new movement. It had been put together by Mary Dowd and her then boyfriend John Murphy alongside yet another hairdresser, Roger Smith, and the ever present Produktion Hair trio, two of whom, Hurst and Glover, actually helped co-ordinate the event while back home in Australia. 'Mary Dowd was weird,' Balance claims. 'She went out with John Murphy and she used to wait until he was asleep, then beat him up, just punch him in the face and smash crockery on him. She was a nasty fucker then. She'd admit it, I'm sure. I remember her having a fight at The Equinox as well. She had this necklace on made of spiky balls and this shaved head and she just started laying into the audience at one point. There was also Jordi Valls going round randomly hitting people he didn't recognise. It was very extreme.' Valls can't remember anything about the event but his diary entry from the night is hilariously succinct: 'Musician's Co-Op Till 3am.'

'I knew some people connected with the LMC and somehow or other we ended up hiring that venue for a night,' John Murphy reveals. 'There was some opposition from various people involved in the whole LMC thing. I think they probably disapproved of the whole Industrial movement and the associated culture. There was some aggression and semi violence in the crowd as well, something the LMC fellow was pretty pissed off about. I recall some drunken businessmen pals of one of the acts hassling some of the other groups while they were on stage, including my own performance with Roger Smith. They seemed to object to our sound and presentation and I also remember David Tibet nearly getting into some sort of affray with one of these idiots.' 'The space at the LMC was rudimentary at best,' Dowd says. 'It was small with no elevated stage and nowhere to sit. The crowd made frequent forays back and forth to the pub on the corner partly because the

bathroom facilities there were pretty woeful, it was, after all, merely a
rehearsal space.'

The bill was a virtual who-the-fuck-is-who of the international noise
underground and Tibet used the event as the live debut for his project.
At this point the group still had a schizophrenic identity; like Coil and
Zos Kia, Current 93 was also born two-headed, as represented by their
alter ego, Dogs Blood Order.

'Dogs Blood Order came about through my increasing friendship
with Tibet in about April or May of 1983,' John Murphy asserts.
'I remember having a bit of a chat about it in the squat I was then
living in near Angel North London. We discussed possibly recording
a cover version of the Manson song 'Cease to Exist' for some sort of
single release but nothing came of it, although it's possible that we
tried to rehearse it as I have a memory of Tibet sitting in my room
strumming away on a borrowed bass guitar belonging to one of my
housemates.' Murphy's memory serves him well; Dogs Blood Order
did in fact attempt Manson's 'Cease To Exist' but it soon morphed
into an early prototype of 'Maldoror Is Dead', as evinced by the live
Equinox compilation cassette released on Produktion's own label.
'Somehow or other Roger Smith also became involved in the group as I
was seeing him quite frequently around this time,' Murphy continues.
'We did the odd rehearsal and recording of backing tracks at Roger's
flat near Fulham Broadway, probably only a few weeks before the
Equinox. There were backing tapes that Roger Smith controlled from
a mixing desk and we semi improvised around these. I played a bit of
feedback guitar, digital delay and my modular synthesizer while Tibet
did the vocals and manipulated treated bass guitar and droney horn
sounds. There may have been an aesthetic approach discussed but
I can't really remember the details and I doubt if Roger would have
been particularly interested in such things, although one thing I do
remember is that we were all determined to avoid the various clichés
that were then beginning to surface amongst many Industrial and
Whitehouse-influenced outfits, both in a musical and aesthetic sense.
A lot of these acts seemed to be regurgitating all the Industrial rubbish
about serial killers and the like and many seemed to be just using

Dogs Blood Order, live at the Equinox event. Tibet and John Murphy.

random, undisciplined noise without a great deal of proper thought.' That'll explain the Manson cover then.

'John Murphy lived a life of incredible self sacrifice in order to be a musician,' Dowd claims. 'He was in awe of someone like Stapleton and worshipped his body of work and stature. John's every breathing moment was taken up with music, in particular the kind of experimental music he has made his life's mission. At that time he lived in a semi-derelict, freezing squat in Islington with other noble aesthetes who felt the kind of insights and purity they received from living on subsistence vegetables parlayed from Islington market gutters and bones begged off butchers for boiling for some kind of insipid soup paid off handsomely. They would spend days, nights, weeks, and months in apparently creative ear-splitting acoustic, electronic free-playing musical collaborations which they'd record, catalogue and examine with fervour. Luckily the entire

neighbourhood was abandoned by anyone who was remotely functional. John could not have found a better laboratory and playground for his passions. Indeed he felt that the only way to obtain his third eye would be to renounce all worldly pleasures bar music. John's minimalist, self-abnegating lifestyle included long periods of enforced celibacy and never receiving any kind of payment in kind or otherwise for his considerable recording services, no matter who the artist was. His complete and utter disdain for the material world was voracious as was his penchant for not bathing and dare I say it, brushing his teeth, more than once every two months when the people around him (who were magnificently tolerant) could bear no more and forced him into a bath with a sliver of soap he had stolen from some public rest room. Claiming any kind of relationship to John would not be doing justice to his singleminded, seamless, lifelong devotion to his art.'

Dogs Blood Order performed 'Maldoror Ceases To Exist' at The Equinox as the duo of Tibet and Murphy, utilising tape loops, two thighbone trumpets and a pygmy headhunter's horn, along with what Tibet now describes as 'witless Crowleyan and Manson references'. Their performance was also filmed, as was the whole night, but the whereabouts of the tapes are unknown. Whitehouse had also been scheduled as the special 'mystery guest band' and were about to unveil their new 'super-powerful' line-up featuring Philip Best of Consumer Electronics and Kevin Tomkins of Sutcliffe Jugend, but Dowd discovered that on their *Right To Kill* album there was a track entitled 'Tit Pulp' that had a chorus that went 'I've got tit pulp in my hands' and ended with Best – who had briefly shared a flat with Dowd in Kensington the previous year – vowing 'Next one's you, Mary Dowd!' Dowd promptly banned them and on the night she delivered a bucket of water over Best's head by way of retort. 'He deserved it,' Balance laughs. 'He was 16 then and a funny little bugger.' 'Whitehouse had already been banned from the LMC for supposedly offending the sensibilities of the pathetic jazz hippies there,' Best explains. 'Mary invited us to play there as 'special guests' to circumvent the ban. Apparently impervious to the irony of the situation, she then decided to impose a ban of her own. Her stated reason was for being mentioned

by name on 'Tit Pulp', which had come out about a week prior to the show. Mary's behaviour by this stage was becoming increasingly eccentric – by the kindest interpretation – or demented – by the most popular. She made several attempts to attack me during the course of the evening, even resorting to ordering her boyfriend John Murphy to beat me up. Even he rolled his eyes at that one. Mary finally snapped when Bennett and myself were in hysterics at some particularly piss poor piece of Belgian performance art. She emptied a full bucket of water over my head, entirely drenching me and prompting Bennett into even more hysterics. Typically the evening ended in a big fight, one that had absolutely nothing to do with me, and Mary charged into me with a broom screaming 'It's all your fault, it's all your fault'. Of course, it wasn't...'

'I'm touched that Phillip feigns ignorance over his tightly scripted role in the performance element of the event,' Dowd retorts. 'How endearing that he would still insist his dousing was anything but part of Etat Brut's performance. The Belgian duo was the sole distributor for Whitehouse products in that country. Certainly, the audience appreciated this brief vignette, watching Phillip leap up in shock and mock terror when he was soaked from behind and most were impressed that he still managed to clutch his dangling cigarette lit between his trembling lips. The whole vignette was seen as a perfect segue between Etat Brut and the next act. Personally I thought that particular moment went seamlessly. Still more unfortunately for me, despite the fact that I've written avid fan letters to William Bennett and expressed my surprise and interest to Phillip Best that he still continues to eulogise me with 'Tit Pulp' all over the world, neither one has yet sent me a copy of the album.'

On the night the venue was filled to capacity, with brutal haircuts, bone jewellery and *Mad Max*-style outfits the order of the day. The audience also included faces like Jim Thirlwell and Graeme Revell and Sinan of metallic post-industrialists SPK. Balance remembers it as a 'severe scene'. Coil had originally been advertised as playing but didn't have time to get any music together. Rather, they fell upon the idea of positioning a leaf-blower underneath a grate so that when you came in you got a rude shot of hot air up your trousers. This would've been the

Pure: Alex Binnie and Matthew Bower. (photo Jill Westwood)

first Coil event but both Balance and his new collaborator John Gosling
of Psychic TV, who he had started jamming with at P-Orridge's Beck
Road flat, were unable to get it together. In fact Balance didn't even
turn up for the first meeting to discuss it, blaming his no-show on a
combination of 'fundamental nihilism and complete apathy'. 'It was a
very nihilistic little group of people,' he recalls. 'Yet we've all developed
and changed and our creativity has been very long-lived when it could
have gone the other way and everyone could just have committed suicide.
There were people like Paul Donnan, one of Tibet's friends whom he
occasionally shared a flat with. He was known as Paul The Thief. When
he was arrested he refused to write his confession on a sheet of paper,
he'd only write it inside the cover of Lautréamont's *Maldoror*, which
he always carried with him. I had his copy with the confession for a
while. He used to eat black meals and burn pages of The Bible, a real
Huysmans character. He was a burglar, an expert shoplifter.' Tibet, on
the other hand, describes the scene rather witheringly as 'loads of people
who couldn't play making walls of noise'. John Murphy performed a set
with Roger Smith under the name Krank as well as accompanying Tibet,

126

while there were also performances from then underground luminaries such as Alex Binnie, Alex Winsor and Matthew Bower's Pure (soon to give birth to Total and Skullflower), John Gosling and Min Kent's group Ake, Gary Mundy's power electronics group Ramleh, Etat Brut, La Droesse, Jill Westwood of Fistfuck, Val Denham's Death And Beauty Foundation and Belgium's Danny Devos and Club Moral. 'Pure and Ake made walls of noise without tape loops,' Tibet remembers. 'From what I can recall it was all noise, vaguely sub-Whitehouse, high volume, distortion and screaming or the AOR version, which was walls of slightly quieter noise with tape loops behind it. That's all I remember. Then I heard that Nurse With Wound had cancelled their slot due to someone pissing on Stapleton. I went over the road to the pub he had retreated to and Jordi Valls introduced us. Steve had vaguely heard of me via PTV and I was just totally smitten by him.'

'I used to go down to Produktion just to see Paul, Christine and Ross,' Stapleton recalls. 'I met them through William as they were huge Whitehouse fans, really sweet people. Ross was really into the camp element of it all. They were always putting on happenings and events all over the place. I was never really that interested in doing something for The Equinox but they kept on begging me. I'd just started working on *The Sylvie and Babs Hi-Fi Companion* and I'd got stuff on a cassette and so I said, okay I'll paint a picture while I play the tape – I was going to do a Rolf Harris. On the night I had all the canvas set up and ready to go when I got into an argument with some guy who pissed on me. In these Industrial gigs back in 83 there was this nonchalance, you know, fuck everything, fuck this, fuck that. Anyway, I'm sitting at the front with William Bennett and some guy just got his dick out and started pissing on the stage and he turned round and it just went all over my legs. I was getting more and more wound up inside and in those days I was really quite an angry guy. I eventually exploded and started a fight, I remember saying to him 'Get the fuck out of here, I'm going to beat your fucking head in' and he said 'I ain't fucking going until Nurse With Wound have played', so I said 'I am fucking Nurse With Wound and I'm not fucking playing' and I went over to the pub across the road and just sat there really

Tibet with Douglas Pearce.

fucking angry. I was determined I wasn't going to play, not if that cunt was in there.'

According to Mary Dowd, Stapleton had actually been dropped from the schedule several weeks earlier. 'Maybe he planned an impromptu performance but he wasn't in the final line-up,' she says. 'As I was having to placate the two convoys of police who turned up because the neighbours felt they were under siege by people who were trying to torture them I didn't get to hear or see the entire show – all six hours of it – and I didn't get to see who or what did the pee-pee. But of course I did get called by the London Musician's Co-Op to go back and clean it up the next day, so I am fully aware of the incident as the janitor there raged at me for a full hour on that cold ignoble post Equinox day and took the incident really personally.'

'It was John Gosling that tried to piss on Steve,' Balance recalls. 'He was totally smacked out and had this grey trench-coat on and he just pulled his dick out and pissed all over the front row of the audience who were just sitting there. Of course Steve didn't like that at all and stood

128

up and smashed him in the face.' Balance was left to try and break up the fight.

'It was a memorable night,' Gosling grins. 'I pissed on loads of people. I pissed on my mate first and I remember him looking at me and going, 'John, you can't do this I'm your mate!' It was during the Ake set and it was quite spontaneous. Basically nothing was working so I just went for it. I didn't realise that Stapleton was one of the people I pissed on. All I remember is someone next to him getting up and smashing me over the head with a chair. I went staggering out of the venue, all this fucking blood coming out of my head, totally off my nut, and walked straight into the arms of the police. Absolute chaos. But I can't believe Stapleton cancelled his show over that, what a fucking wus.' As well as playing in Ake and Psychic TV, Gosling's other group was Zos Kia. Ake premiered 'Rape' at the Equinox, a track that featured vocalist Min recounting the horrific events of a sexual assault she had suffered. Gosling, Min and Balance would go on to record it as Zos Kia's first single.

For Stapleton, the upside of getting pissed on was that it led to a meeting with David Tibet: 'So I'm sitting in the pub across the road just fuming,' he recalls, 'and Tibet comes up to me and at the time he was dressed in the kind of way that I'd instantly dismiss him as someone I didn't want to talk to. Lots of piercings and leather and probably a Manson t-shirt, something like that. We shook hands and he said, 'I've loved your music since I was in Newcastle'. He sat down and we started talking. I remember him saying, 'I just got hold of some Aleister Crowley readings and I'm looking for someone to put them out', and I remember thinking, you're not putting them out on my fucking label! Still, we hit it off quite well despite his clothes. He was with Paul Donnan, who seemed to be David's best friend about this time. He was a very peculiar guy, really tough.' Annie Anxiety describes Donnan as being 'the stuff legends are born of. A smart, generous, sharp boned, hip and benevolent criminal devoid of fear as we know it. Kerouac would have written volumes on him.'

Shortly after Tibet's meeting with Stapleton, he and Donnan met up with Stapleton for a drink in a pub just off Poland Street in Soho.

Stapleton left early whereupon Donnan and Tibet were set upon by a group of drunken punters after Donnan provoked them. When Stapleton heard about the attack he immediately got in touch with Tibet and this seems to have cemented their friendship. 'He was beaten up quite badly,' Stapleton recalls. 'Ever since then we just became really close. He was mad for drugs back then, mad for speed, drinking lots and getting into trouble, fairly outrageous; a very different person really. He just changed over the years, slowly grew up.'

Stapleton helped out Tibet, sitting alongside Fothergill at the sound desk for a Dogs Blood Order show supporting Death In June at the Hammersmith Clarendon on 6 October. Death In June had risen from the ashes of left wing politico-punks Crisis, a group that Tibet had been a fan of while still at university. He had been attending Death In June concerts since he moved to London, and one night he was approached by vocalist and guitarist Douglas Pearce, who recognised Tibet from pictures of Psychic TV. 'He was a really lovely guy,' Tibet remembers. 'Very funny and enthusiastic with a really powerful aura. We got on well. He asked me to write lyrics for a new Death In June album quite soon after our meeting, because it really seemed that we had a lot in common in terms of the nature of what moved us. I remember saying to Sandy Robertson, who was a journalist for *Sounds* that I also lived with for a time, that one of my favourite groups had asked me to do lyrics for them.' At this point Death In June had just released their first album, *The Guilty Have No Pride*, when Tibet met Death In June member Tony Wakeford, also a future Nurse and Current collaborator, but they didn't hit it off at all back then. Soon after Tibet began working with DiJ, Pearce sacked Wakeford and it seems that certain of Wakeford's friends chose to believe that Tibet had engineered the sacking.

'I loved Crisis so much,' Tibet says. 'I just remember the music being driving and crepuscular, powerful and not rock 'n'roll. They were punky but they had a melodic touch that I liked, something like The Buzzcocks. Death In June were very different from that but equally powerful, although the early DiJ material wasn't the sort of stuff I would have created myself. Although I don't think I shared an aesthetic with

Annie Anxiety

the group's music, I definitely had a lot in common with Douglas. I felt really close to him and perhaps parallel to him. He was a big Mishima fan and I was at the time. He had an apocalyptic outlook and I shared that but I didn't share his specific interests, for instance his fascination with the Second World War, although I had an interest in its mythology.'

Pearce went on to assemble his own cosmology, combining his attraction to militaristic imagery with elements from the Northern Mysteries, the life and writings of Yukio Mishima and an obsession with '60s West Coast pop.

Much of the Industrial scene was fascinated with totalitarianism, whether communist or fascist, because it represented the most overt example of an over-arching system of total control – exactly the kind of system that Industrial provocateurs set out to defuse. Lightning raids behind enemy lines represented the best way of gathering information. Some went further, equating totalitarian ideas of discipline with freedom. Some of TOPY's rhetoric was based on this seemingly contradictory equation. But others never maintained the same distance from this object of fascination as art interrogators like Throbbing Gristle.

Opening for Death In June, Tibet played thighbone trumpet alongside Roger Smith, John Murphy and Derek Thompson who, along with Murphy, was then working with SPK. Three people clapped. They were 'being sarcastic', according to Tibet. Dogs Blood Order dissolved after an uninspiring last show supporting Annie Anxiety in Brighton in May 1984. A track from the performance was included on the CD reissue of *Nature Unveiled*, an improvisation on the lyric of 'Maldoror', mostly consisting of lines inspired by or lifted from Comte De Lautréamont's visionary, violent 19th Century novel *Les Chants de Maldoror*. Indeed most of Tibet's early performances were based around the same set of texts, interweaving lines from 'Maldoror', 'Falling Back In Fields Of Rape' and 'Reaping Time Has Come'.

Tibet got to know Annie Anxiety in his capacity as a music journalist. 'I first met Tibet at the offices of *Sounds* magazine while he was working there,' Anxiety recalls. 'I was dropping off copies of my *Soul Possession* LP and he introduced himself in the hallway. I remember thinking at the time how sweet he was.' After moving out of the terrifying squat he was sharing with the Produktion crew, Tibet and Paul Donnan had been crashing where they could, but after meeting Anxiety Tibet moved

ANOTHER CLASSIC RECORDING by the up and coming NURSE WITH WOUND

alas the madonna does not function

£4.50 + POSTAGE
PAYABLE TO C. WALLIS

ALSO CURRENT 53/NURSE WITH WOUND ... "FAITH'S FAVOURITES" (12" SINGLE) £4.00 + POSTAGE.

FROM THE HOUSE OF

united dairies

in with her to the Vauxhall Grove squat. Affiliated to the anarcho-punk group Crass, it was the biggest squatted community in Europe. 'I first met Steve Ignorant from Crass because, well, I was going to say that Steve was going out with one of the girls in the house next to us, but I think he was going out with all the girls in all the squats, in fact I know he was,' Tibet relates. Although he was also a devotee of The Stooges' idiot agenda, Tibet was always passionately interested in British underground music and Crass had long provided a heroic paradigm. Their existence was proof that it was possible to refuse to surrender any part of your vision and not only survive but positively thrive outside the stifling environs of the 'official' channels of the music industry.

Although they're still thought of as primarily a punk group, mostly down to a few haircuts and the fact that they took punk at its word and used it as platform for their own liberating programme, Crass, who formed in 1977 and split in 1984, had roots that lay deep in the counter-cultural revolution of the late 60s. A commune of militant hippies committed to co-operative living, vegetarianism, animal rights, pacifism and political agitation via stunning, iconoclastic records like 78's *The Feeding Of The Five Thousand*, 82's *Christ – The Album* and

84's *How Does It Feel To Be The Mother Of A Thousand Dead?* Their aggressive approach to atonal jamming routinely staggered into the form-destroying realms of the avant garde through sheer exuberance alone. As they trumpeted on the sleeve of the third volume of their *Bullshit Detector* compilations: 'Don't expect music when the melody is anger. When the message sings defiance. Three chords are frustration when the words are from the heart.' They also released several other key artists via the Crass label including Conflict, Flux Of Pink Indians and Kukl, a pre-Sugarcubes group that included both Björk and Einar Örn. 'I can't think of anything that wasn't inspiring about Crass,' Tibet maintains. 'I loved the artwork, the presentation, the ideas, the ferocity of the music. The only thing I didn't like was their swearing. Not that I was prudish about it, I just felt that it muddied the message. I thought they were protesting a little too much and endless fucks and cunts took away from the clarity of their vision, which whether you agreed with it or not was well thought out and passionate. They were one of the biggest influences on me. They had a vision, a great sound and a moving aesthetic. They believed in what they did and they organised themselves and I admire that in anyone. They weren't signed to a label and they were genuinely underground and independent. Throbbing Gristle were obviously really similar and I admired them as well. They were doing a similar thing to Crass but with a different aesthetic. Although finally, musically, I preferred Crass.'

On Stapleton's invitation, Tibet first joined Nurse With Wound in the studio for the *Ostranenie 1913* album, essentially a reworking of parts of the second and third Nurse albums that Stapleton still wasn't happy with. He asked Tibet to bring down any instruments that he had lying around and Tibet inevitably dragged along his thighbone as well as a big wooden headhunters trumpet and a little bone horn. 'Steve immediately told me I could forget about using the thighbone,' Tibet laughs. 'So I just parped away on the others. To be honest I don't think Steve thought he needed my instrumental prowess, which is non-existent. He just wanted to get me involved and at that time he wasn't sure what I could do, apart from play those wind instruments.'

Gary Levermore released *Ostranenie 1913* at the tail end of 1983 as the second release on his Third Mind label. 'To this day, I remain grateful to Steve for literally giving me that record and allowing me to make 2,000 copies of it to sell and help bankroll Third Mind, which was about to become a full time concern,' Levermore says. 'I remember cutting the record at Utopia Studios in Primrose Hill with Tibet and anxiously awaiting Steve's verdict on the test pressings when he called me a few days later. To the best of my knowledge this was the first Nurse album that was not 'classically' pressed at Nimbus and the sound quality was therefore not quite up to the meticulous standard that Steve had set in the preceding years. Of course, he was already aware that I simply could not afford the extra expense that a classical pressing would involve and he was therefore happy for the final pressing to go ahead. A week or two later the three of us spent a Saturday morning in Rough Trade distribution's Blenheim Crescent warehouse putting address stickers on the white inner bag of the record prior to its release.'

'Tibet wasn't doing Current 93 full time at this point,' Stapleton states. 'That started about six months later. Before that we did a few things together in the studio as Nurse With Wound, *Ostranenie 1913* and a 12" called *Gyllensköld, Geijerstam And I At Rydbergs*.' Taking its title from an entry in August Strindberg's terrifying *Occult Diary*, *Gyllensköld* feels like a huge futuristic leap for Nurse, anticipating many of the areas they went on to explore. Despite its puzzling reputation as one of the coldest Nurse albums, the addition of Tibet's voice ushers in a more technicolour phase, with Stapleton plundering macabre readymades like fairground music and distressed voices and situating them in the context of what sounds like a studio populated by sick cartoon characters. 'Tibet had been talking of getting his own band together and previously he had thought about doing it with ex-members of 23 Skidoo and maybe Balance,' Stapleton says. 'But from the moment we got together he decided that he would just base it around the two of us.' With the final activation of Coil later the same year, the triumvirate was complete.

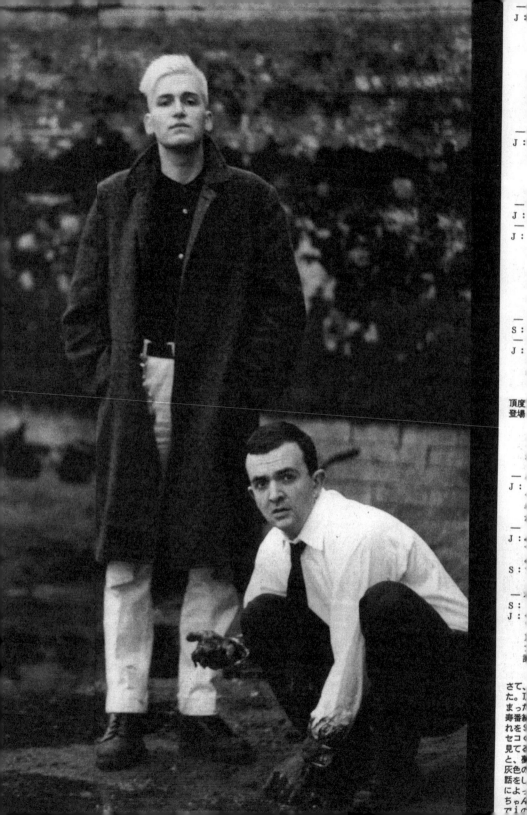

# A Fistful Of Fuckers

*In love I attach special value to everything known as perversion and vice. I consider perversion and vice to be the most revolutionary forms of thought and action, just as I consider love to be the sole attitude in a man's life* – Salvador Dali

'Our rationale is the irrational,' Balance had written in a 1983 Coil manifesto entitled *The Price Of Existence Is Eternal Warfare*. 'Hallucination is the truth our graves are dug with. COIL is compulsion. URGE and construction. Dead letters fall from our shredding skin. Kabbalah and KHAOS. Thanatos and Thelema. Archangels and Antichrists. Open and Close. Truth and Deliberation. Traps and Disorientation.' At this point Coil were merely an idea, but that's how things always started for Balance, with visions and manifestos, word plays and mishearings.

The first piece of Coil music was in fact a solo Balance recording, a primitive piece for drum machine and keyboards from 1983 called 'On Balance'. Balance had originally sent the tape to Levermore for possible inclusion on the *Rising From The Red Sand* compilation, but he had rejected it, thereby missing out on being the first label to release something by Coil. Undeterred, Balance went on to cut three further solo pieces on 11 May, 'S Is For Sleep', 'Red Weather' and 'Here To Here (Double Headed Secret)'. 'S Is For Sleep' appeared on the *Elephant Table* compilation, while 'Here To Here' appeared on *The Beast 666* cassette on Austria's Nekrophile Rekords, later showing up as the backing track on Zos Kia's first single.

NEKROPHILE REKORDS
P.O. BOX 79
1080 VIENNA
AUSTRIA

# Z O S   K I A

T R A N S P A R E N T

## PERFORMED BY COIL AND MEMBERS OF THE TEMPLE OV PSYCHICK YOUTH

C 60          NRCo5

The Coil concept was finally reified with a show at The Magenta Club in London on 4 August 1983, a duo performance from Balance and Sleazy. The event was organised around a screening of films by Cerith Wyn Evans and Derek Jarman; also in attendance were a fistful of noise and performance art groups including, once again, Pure and Ake. Balance had been introduced to Jarman via P-Orridge after Jarman had become involved in the work of PTV. Balance later met up with him at gay clubs from time to time, continuing a flirtatious relationship that was eventually consummated with some frenetic sex in the toilets of London club Heaven. 'It was the time of the miner's strike and everyone was going 'dig deep for the miner's and I was already on a hedonistic roll, a total speedfreak,' Balance confesses. 'That probably accounts for my erratic friendship count but because Derek was central I used to go and see him twice a week, just pop up and have tea with him.' The performance at Club Magenta was based on a piece called 'Silence And

Secrecy', described as 'an exercise in extended tension'. It lasted about 30 minutes with Balance petrified throughout, barely able to walk across the stage let alone provide any vocals. They played along to a backing of wolves, birds and bells, a tape that Sleazy had been using in PTV, with Balance wrestling catcalls from a treated violin in the mangling style of P-Orridge. An excerpt of this performance appears on the *Transparent* retrospective. This early on they were already attempting to create a total environment for their performances with the use of incense and strobe lights. With the stage enveloped in a hallucinatory fug, Balance felt that he could see ghosts coming up out of the floorboards.

At this point Sleazy's Psychic TV commitments limited his participation in Coil, who sometimes shared a line-up with John Gosling's Zos Kia, named by P-Orridge after a magical term lifted from barroom occultist Austin Osman Spare, who even this early on had become something of an obsession with Balance. 'We were toying around with energies but we were consciously aware of the tradition,' Balance remarks. 'At this point we'd started discovering Austin Osman Spare and I'd go out to the Atlantis bookshop with Gosling and Portobello market looking for books and paintings by him. Once I just intuitively went into this gallery and up to a stall and found about six of Spare's paintings. I sniffed them out and I've always done that. Of course we couldn't afford them then, Genesis or somebody bought them instead. But the thing is I genuinely felt this instant connection, that's why we used the name Zos Kia. It wasn't joking around; our thing was that we were going to try and follow in this guy's footsteps. It was probably the novelty of Spare that first spoke to me, though. He was never mentioned and suddenly in Atlantis all these fabulous paintings appeared. Michael Houghton, who owned the shop at the time, had known Spare and he used to tell us how important he was and how important he would be in the future and that we really should get everything we could and read it, so we did. Sigilisation became a firmly entrenched process in PTV then. It was all absorbed. Gosling and I had to open all the TOPY mail and after the 23rd of the month people would send a pint of blood through the post or their girlfriend's period. We'd be like aggahah, Jesus Christ!'

Austin Osman Spare [1886-1956] is one of the most charismatic

characters to come out of the occult revival of the late-19th and early 20th Century. A solitary shaman who began his creative life as the youngest exhibitor at the Royal Academy's 1904 exhibition and ended it as a recluse living with his cats and paintings in a rundown house in Brixton in 1956, only occasionally exhibiting his work in South London pubs. Spare was one of the greatest artists of the unconscious as well as the architect of one of the most efficacious and holistic of magical systems. Growing up in the shadow of London's Smithfield market, the son of a night duty policeman, Spare's distaste for the trappings of workaday life developed in line with a corresponding interest in the mysteries. He first delineated the basic tenets of his occult philosophy in 1905's *Earth Inferno* and further expanded it across *The Book Of Pleasure (Self Love): The Psychology Of Ecstasy* and *The Focus Of Life*. Although Spare denied the influence, his illuminated manuscripts and highly idiosyncratic cosmology situate him within the same stream of visionary English art as William Blake.

Central to Spare's system of magic was his theory of the Zos-Kia relationship. Kia he described as the state of 'Neither-Neither', the primal oneness, the Tao, the source of all. Zos is the human body, incorporating the mind, will and imagination and Spare also took Zos as his magical name. It was in the dialectic between Zos and Kia where the possibility of direct communion with eternity lay. Utilising a method he called 'atavistic resurgence', Spare would attempt to travel back through all of the previous human and animal incarnations that he believed still lay dormant in his subconscious, until he came to the beginning and was once more reunited with the Kia in the bliss of no-mind. Spare also drew on the powers of his previous incarnations in order to complete magical workings and tales abound of his ability to give shape to phantoms and conduct the elements. In order to achieve these ends in the material world, he adopted a system of 'Sigilisation' wherein he focused on creating a symbolic diagram that embodied his desires before destroying the symbol altogether in order to force the object to be consciously forgotten, thus lodging it in his subconscious and allowing it to begin its work. Of course this process of conscious forgetting was nigh impossible under normal circumstances, so Spare

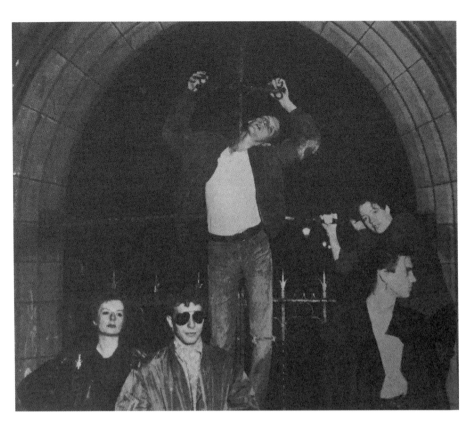

Zos Kia as featured in *Zig Zag* magazine, 1986:
*Left to Right:* Jill Westwood, John Gosling, Alex Binnie, Gail, Naines.

developed corresponding techniques to blank the mind and ease the repression of his desire, ranging from sex-magick techniques through to trance-inducing meditation. He described masturbation as 'copulating with the atmosphere' where he 'rode whores, witches and bitches of all kinds, there being few virgins'. Eventually he claimed to have received guidance from a dELpHic Oracle who instructed him in a technique for the fulfilment of magical workings, which involved constructing an urn that had just enough space at the bottom to form a vacuum when the penis was inserted. At the moment of orgasm the sigils would be consecrated while the would-be magician focused on the object of his desire for as long as possible, not easy with the intensity and length of orgasms triggered by the vacuum. In order to further ensure success, Spare advised hermetically sealing and burying the urn during a certain

phase of the moon before emptying its contents on the earth as a libation and re-burying it. Spare claimed that this particular technique, 'The Earthenware Virgin', was extremely dangerous and never known to fail.

Either way, the most important aspect of any magickal act is the total commitment and unfaltering belief on behalf of the participant that it would actually work. In this light, many of Spare's techniques can perhaps be seen as prosaic fictions intended to focus the unconscious energies of the mind. Spare extended his magical worldview into his paintings – his murky moonlit landscapes populated with dancing hags and his 'sidereal' portraits where he would skew the dimensions of his subjects in order to expose hidden aspects of their character. His system has many similarities to Crowley and the OTO's approach to sex-magick. Indeed Spare was a member for a time of Crowley's later Argenteum Astrum but dropped out after failing in his studies. Spare preferred a magical system that was flexible enough to mirror the contours of the individual's soul, whereas Crowley inevitably favoured one that was stuck on his own.

In the January 2001 edition of the British journal of the paranormal, *Fortean Times*, Balance expanded on his relationship with Spare to Mark Pilkington: 'Well, I have a very intimate relationship with Spare,' he began. 'He's my mentor. I communicate with him through his pictures and often ask his advice, as an ancestor. A lot of his beliefs were shamanic and to do with ancestor worship. I don't have a very close connection with my ancestors, my real family, other than my mother's parents. So I talk to Spare for advice. I think he still exists, in his art and in the aether. He's around as a helper. Sounds a bit flaky doesn't it... maybe I should couch it in cyber terms! Although Spare's paintings are often decorative, the intention behind the decoration often hits you first. Most people who come into contact with Spare's work come away from it with something positive. There's a massive power there. He imprinted each picture with a power, purposefully. Some more than others, but they all have a power that transmits to you, definitely. You can commune with them and they change. You look at some of the chaotic ones with one person and see certain things, and you look at them with another person and you see a completely different set of things. They resonate.

Like Burroughs or Spare, we see no difference between our philosophy, our lifestyle and our art. We are what we do. What Spare did in art, we try to do through music. This is why we do Sidereal Sound. We try to do with sound what he did with his pictures, twisting them so that the geometry appears warped, to produce strange geometries through sound, so that it comes through sideways. We do it with technology, with 3D devices, phasers, out-of-phasers, all sorts of gizmos. There's no one particular box that does it, we all do it any possible way that we can... Spare used to do speaker battles (note: he would actually draw and paint on speaker baffles, not battles) where he would project sound into the aether – which I think is a real physical thing, some kind of cosmic glue, a genuine substance, or non-substance – to connect everything and allow ideas, even things, to be transmitted.'

At the time of his discovery of Austin Osman Spare, Balance thought of himself as a proto-Chaos Magician and was already heavily involved in sex-magick. Adopting Spare's system, concrete results came thick and fast, in fact its efficiency was almost overwhelming.

'We did a sigil to find Spare's work and learn more about him,' Balance relates. 'But the trouble with sigils is it's like in *The Magician's Apprentice*; once you do it and you start it off, it's like when all the buckets of water keep coming down on their own, you have to do something to stop it. There's no doubt about it that working with sexual magick energies, copulation with the atmosphere and trafficking with denizens like that is extremely dangerous in the sense that it can quite easily become an obsession. It still is an obsession with me. It feels like some great floppy wet bat has been wrapped round my head for the last 20 years. Not in a bad way but that's one way of describing it.

'Actually, it *is* disturbing,' he relents 'But I've got used to disturbing, I've put disturbing in a box marked 'Disturbing' now. We really were playing around with dangerous things. We'd do these rituals and then, because they were all sort of chemically, psychically and magically charged as well as emotionally charged and relationship charged, they'd all get into this huge ball of energy that would go out of control. That's why Psychic TV fragmented so painfully and why some people involved became normal again and pretended they'd never been involved with

anything like that, or NF skinheads would start smoking dope and hanging out with black people; it really brought out the polarity in people's characters. That's why I became John Balance, I was aware of this pivoting ability I had to be either up completely or down completely.'

Balance's life was in a constant state of revolution. He became obsessed with the surrealists and this only served to further weight the scales, as he devoured tales of artists who repeatedly tried to kill themselves, to shoot their foot off or poison themselves with alcohol. He fixated on René Crevel, a homosexual artist whose investigations into somnambulant trance states defined surrealism's 'era of dreamwork' in the early 1920s. An opium addict and alcoholic, he gassed himself in 1935. 'He would always take opium and drink a lot and he used to get bailed out by his friends,' Balance explains. 'He'd go to an asylum in Switzerland every two years and then he'd come out and do it again, and he did it about 8 or 10 times and I realised that this pattern had set in in me. I thought, I've only got so many chances. In the end he killed himself because I don't think he was aware of his pattern. I'm very aware of my own but even then I still have to stay vigilant.'

On 24 August 1983, Coil played the Air Gallery in London, a trio show featuring Balance, Gosling and Marc Almond where they performed 'A Slow Fade To Total Transparency', a performance piece that involved Gosling and Balance giving themselves fake blood enemas, while Almond read extracts from his diary, thereby recasting the title as a paean to the making public of secret thoughts and rituals, an attempt to tear down psychological barriers and make the internal external. The audience included Nick Cave, Lydia Lunch and Jim Thirlwell, who alongside Marc Almond made up the Immaculate Consumptive revue that played three Halloween shows in Washington DC and New York that year. Almond became friends with Balance through their mutual involvement with Psychic TV. At the time of Coil's Air Gallery performance, Almond was also a mainstream pop star on the back of the success of Soft Cell's 'Tainted Love' single in 1981. Almond's career often seems as stratified as his personal relations, with groups of friends and collaborators often unaware of his other activities. Indeed, in his

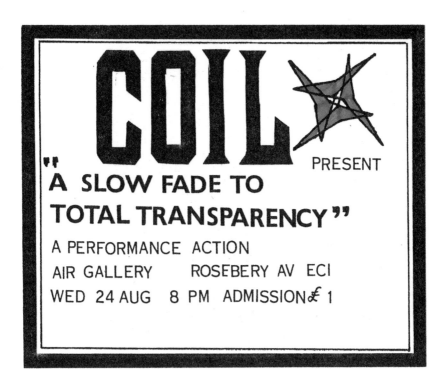

COIL PRESENT

"A SLOW FADE TO TOTAL TRANSPARENCY"

A PERFORMANCE ACTION

AIR GALLERY     ROSEBERY AV EC1

WED 24 AUG   8 PM   ADMISSION £1

biography he barely mentions any of his subcultural involvement, aside from relating his induction into The Church Of Satan by Boyd Rice. 'I actually set that up,' Balance reveals. 'It was pretty funny. Marc booked a limousine, a silver metallic one and turns up at my door to get me and says 'Are you ready? Oh and by the way can you lend me the money for the car?' – typical Marc gesture. On the way he signed a Pierre et Gilles print of himself to Boyd and splattered gold paint all over the back seat.'

The Air Event had been organised by Stapleton's future partner, Diana Rogerson aka Dido or Crystal Belle Scrodd. 'Diana Rogerson was someone else involved in that whole heavy scene early on,' says Tibet, who was the first to encounter her when she arrived in London. 'She knew Produktion and I met her through them because Produktion had a shop on the top floor of Kensington Market and Dido had a stall at the bottom selling S&M fetish material.' 'We were making rubber clothes that looked more like seaweed,' Rogerson says. 'We'd lay it all out on the floor as a solution and pin the rubber down and let it dry then add colours

Jill Westwood

to it and sew it up with slits and pieces missing. It was kind of weird and people liked it but Kensington Market was a very boring place and so I was always up chatting to the Produktion Hair people, they were the only people that didn't seem like the walking dead.' At the time of their friendship, Rogerson, along with her friend Jill Westwood, was part of the performance art group Fistfuck, dubbed by many eyewitnesses as a female Whitehouse. 'Jill Westwood was a fucking superhero as far as I was concerned,' John Gosling says. 'She had total bottle. She wasn't scared of anything. She'd get up on stage and do the craziest shit, totally wild performance art. Fistfuck were mental.' Live they certainly lived up to their name with a set that consisted of a female dominatrix ritually humiliating men, pissing on them and tying them to chairs, all to a soundtrack of extreme noise and sound collage.

'The female Whitehouse? There's a lot to be said for that description,' Tibet admits. 'Still I thought they were a lot more theatrical, although Whitehouse were theatrical in their own way but they were power trio theatrical, no props. Whitehouse boys dressed down, you know. William

146

might have had a leather trench coat on but fundamentally the idea was that they were the boys next door who dress normally but if only you knew what lurks beneath. With Fistfuck you may well have wondered what lurked beneath the tight rubber clothing but there was no way you were going to get it.' Parallel to her musical career, Rogerson was also involved in filmmaking and her most notorious short was *Twisting The Black Threads Of My Mental Marionettes*, a harrowing study of masochism that was soundtracked by Stapleton and his friend Geoff Cox. Stapleton has since destroyed the prints but those who saw it – and it was shown publicly around various art cinemas in London – describe it as being a more extreme version of the Fistfuck stage show with a lot of sexual humiliation involving hammers, razorblades and cheese graters. 'I could barely watch it,' Stapleton says. 'It was too heavy for me. I did a nice sweet soundtrack to it but it wasn't my thing. I felt totally uncomfortable watching it and even having the video in my presence. It was that heavy. If the authorities got hold of it, Dido would definitely have been put away.' 'It's synchronicity,' Rogerson ventures. 'Whatever

you're thinking about heavily you attract, and there were all these young men who were very self-destructive around me. I got quite involved in the idea that there's no ritual in our society and the film was intended to honour what it is to be a young man and lost and confused. The film was completely their own. I didn't make them do anything. There was no script. I just set up a process in a very bleak room and watched what happened.'

There was another short with a one word title, now forgotten, that consisted of a static shot of a man who brings a heart out from his clothes and starts slowly massaging it – and himself – into a frenzy before proceeding to fuck it. 'I was always attracted to the bizarre when I was a child,' Rogerson says. Indeed her childhood was an exceptionally rough one. Expelled from several boarding schools for disruptive behaviour, she eventually ran away from home and to this day barely knows her parents. 'It's still very difficult if I ever see them, they just think everything I ever did was a disaster,' she says. 'They always say, look what drugs did to you! I keep them ticking over now but I know I can never rely on them or go to them when I'm in trouble. They just don't hear me.'

'Diana did have a rather eccentric reputation and was quite a dominant and formidable character in general,' John Murphy affirms. 'She was known for being fairly outrageous. Both Roger Smith and I provided the soundscapes and background noise for at least one live performance. The live Fistfuck thing was essentially fetish performance art, with both Diana and Jill doing some sort of SM ritual with various submissives and commenting on the whole affair while it was happening. The backing was a wall of unearthly noise, sub-Whitehouse with cutup vocals and snippets from both Diana and Jill.'

The two-day Air Event, at which Fistfuck also performed, was as chaotic an affair as The Equinox had been, with Gosling misbehaving as usual, rolling huge metal drums that he had vomited over right into the audience. Balance had now re-christened him Joan D'Arc, and had taken to calling himself Legion. 'Don't have a clue where that came from,' he shrugs. 'It was one of those times where you're so out of it on drugs that you re-invent yourself every five minutes. The performance

was quite extreme though. I remember turning around and Gosling had a scalpel and was cutting round his scalp and right round his body and when he came to his tongue he went right over his tongue! This line of blood right through his tongue, all covered in glitter.' 'I was completely off my fucking trolley that night,' Gosling admits. 'For me it was all performance art, that was always my starting point, but I tried to bring a football hooligan element to it. Still, that kind of nihilism is difficult for me to explain or understand now. When I look back at myself I can't think why I would be like that. I think I'm lucky to be alive. Either I had some serious mental problems or I was just a big show off, although probably it was a combination of them both.'

'The Air event felt like a real happening and the atmosphere was charged,' Rogerson recalls, attesting to the visceral power of those early Coil/Zos Kia performances. 'It was amazing,' she says. 'These two beautiful young boys, bare-chested and cutting themselves to ribbons. Balance gave himself an enema on stage. He always teases me because I cleaned up his pooh. Balance was a very young, gorgeous boy. I knew him as Sleazy's boyfriend but he was always in the toilets with someone. I thought of him as absolutely obsessed with sex, anyone who was in the loo, no matter who, he'd get off with them. He was a teddy bear and Sleazy called him 'the puppy'. In their relationship he was the little boy and Sleazy was the mummy, but Balance used to try to create quite a lot of mystery about what they got up to. He used to boast to me that he and Sleazy had a weird room in their house where they would take boys and prod them with cattle prods! He also told me that I came up quite a lot in their fantasies and I thought, God! What do they see me as?'

On the 12 October Balance, Gosling and Min played a show at Recession Studios under the name Zos Kia. Gosling was out of his head on MDMA and spent most of the set manhandling his violin. The next month The Berlin Atonal Festival saw the same Zos Kia share the bill with Psychic TV, Z'EV and Einstürzende Neubauten. The recording of the show sees the group at their most aggressive, with the ear-bleeding sonorities of the appropriately named 'Sicktone' coming across as an all out assault on the audience. Still, other tracks border on Industrial

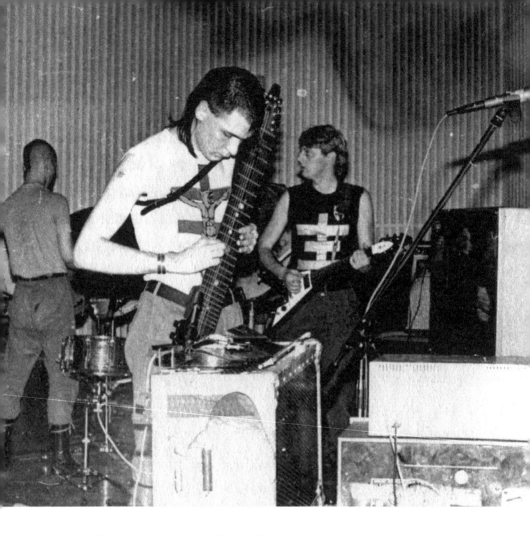

pastiche, the worst offender being 'Truth', with its unimaginative use of
Manson recordings. Indeed during Gosling's introduction at the start
of the show – 'We've been witnessing your many and varied forms of
control today. They're very effective, very pretty' – his lightly mocking
tone leaves him sounding uncannily like P-Orridge. Clearly they had a
long way to go to escape their mentor's shadow. Although most of the
tracks lack the focus of the later Coil material, there are several signposts
even here, especially in the version of the single 'Rape', whose heaving
backing track, originally intended as the first Coil release, anticipates
the kind of malevolent choral base that they would later work from on
*Scatology* and *Horse Rotorvator*.

Psychic TV, World Detour, Reykjavik, Iceland, November 1983:
*Left to Right* John Gosling, Balance, Alex Fergusson.
(photo © Genesis P-Orridge)

While in Berlin Balance and Sleazy spent most of their time in the city's gay saunas, while P-Orridge and his wife Paula hung out with Christiane F, a schoolgirl junkie and the subject of a film based around her memoirs, who was at that time dating Alex Hacke from Einstürzende Neubauten. Both Balance and Gosling played as part of Psychic TV at the festival, but Balance claims that he isn't credited on the record of the event due to his subsequent falling out with P-Orridge. Things had come to a head between them while they were in Berlin over what Sleazy and Balance saw as increasing double standards. 'In Berlin it was already setting in,' Balance claims. 'Instead of staying in the squat where we all were with mattresses in a big open room, he went off and stayed at Hacke's apartment with Christiane F.'

'When we got to NY we retaliated by going and staying in Madonna's apartment because we knew her at the time. I had been seeing her best friend, Martin Burgoyne, who died of AIDS really early on. I was hanging out with him in London and he lived in New York. She wasn't there but we did have a threesome in her bed. I even used her toothbrush.' The first Zos Kia single, an edited version of 'Rape', was produced by P-Orridge but due to the fact that he and Balance had fallen out, Balance never showed up for the mix. After Psychic TV's 1983 World Detour, which saw them stop off in Manchester, Iceland, America and Berlin, Sleazy and Balance finally decided to leave the group. 'We were really pissed off with Genesis's attitude,' Balance says. 'He felt he was two steps above us. He got the star treatment while we were doing most of the work. But Genesis always had this fantastic ability to push himself forward, this drive. I don't know where it comes from but we all decided it was difficult to stay together. I remember I told him we were leaving over the telephone. Sleazy couldn't, or wouldn't, so I got the blame.' For the record, P-Orridge claims he did stay at the squat for the first night, but stayed over at Hacke's after that because Christiane 'had some very difficult things happening in her personal life right then and needed friendship and companionship desperately.' 'It had nothing to do with being in a big open room,' he insists. 'Do you really think I care about

privacy? Give me a break. I care about integrity of friendship.' With the split Balance's involvement with Zos Kia also came to an end, as Gosling was still a PTV member and so was effectively barred from working with him. Zos Kia went on to release a string of records on Temple before Gosling gave it up for a career in dance music. Since then he has remixed Madonna and Betty Boo and worked with the likes of Goldie, Peter Gabriel and William Orbit. He remains in touch with Coil, with Sleazy appearing on his 2000 album *Relax With Mekon*, which he recorded under the name Mekon for the Brighton dance label Wall Of Sound.

In 1984 Stapleton was still holding down the day job, working at an engraving studio in Poland Street while spending most nights and sometimes entire weekends holed up in the studio. He had already started work on what would eventually become *The Sylvie and Babs Hi-Fi Companion* and was making a regular habit of trawling the bargain bins for recordings of '50s cheesecake and exotica that he could use. Gary Levermore recalls Stapleton introducing him to two girls at their regular haunt, the John Snow, and claims that it was in 'honour' of these two that Sylvie and Babs were created. He also recalls how Stapleton was absolutely desperate to get his hands on a copy of Roger Miller's 'King Of The Road' in order to incorporate it into the forthcoming record.

In the meantime Rogerson had finally heard Nurse With Wound courtesy of a tape of *Sylvie and Babs* spun incessantly at Produktion. When a friend who was a dealer mentioned that he had to drop off some hash at Stapleton's place of work, Rogerson tagged along, curious to meet the maniac behind 'Registered Nurse'. The office was closed but Stapleton had stayed late, working on the *Sylvie and Babs* cover. 'I've always found Oxford Street to be unbearable, just too full of people and so noisy,' Rogerson says. 'It was an amazing contrast when we pulled off into Poland Street and there was Steve just working very silently on his own, amidst all this chaos outside, where everyone seemed so caught up with their own image. We looked at each other and the lightbulbs went on. It was like when you meet someone that you're really going to like

and you don't know why. Suddenly the room gets brighter. It was like something out of *Eraserhead*.'

The next day Stapleton called Tibet and told him about this amazing woman that had turned up at his work calling herself Crystal, a bright red wig fixed over her shaved head and wrapped in a clinging rubber dress. 'I told him that she was in a group called Fistfuck and Tibet nearly choked,' he remembers. 'When I next saw Tibet he came up to me and said that I'd stolen his best friend,' Rogerson claims. 'He also told me that if he had been a girl I wouldn't have stood a chance. I got to know Tibet very early on and my first impression was of a very miserable person, although he also had a great sense of humour. Later I could see that he was also mischievous and mercurial, playing people off each other and playing games. These days he's much more complex. I do love him. When I see somebody in that kind of pain I recognise it immediately because ultimately a lot of my work is about pain. He'd talk about Crowley and all these things but that wasn't really it. There was something else going on with him that you could never put your finger on. He was very dark, the Leonard Cohen of the group.'

Rogerson couldn't believe her luck. Only a few months earlier she had virtually dropped out of the scene altogether, shedding most of her friends during a crisis of confidence. Now she was dating the guy from Nurse With Wound and to top it all a full page picture of her looking suitably threatening had just appeared in the London-based style Bible *The Face*. She was well and truly on her way. 'It was fantastic,' she remembers. 'I went to this dark place all on my own and suddenly I rose like a phoenix. What happened? Suddenly I was in with the 'inner circle' of the underground, Steve and William Bennett. I'd be walking along the street with Steve and Whitehouse, and they'd all be wearing these long coats that made them look as if they'd stepped out of a spaghetti western and there I was all dressed in rubber – it was like *A Fistful Of Fuckers*! Everyone on the scene had total respect for Nurse With Wound and Whitehouse. I was very much a man's woman and I knew that I was a strong individual, so I was able to sit and listen to Whitehouse do material like 'Tit Pulp' and it did not bother me in the slightest.'

Whitehouse were forever usurping expectations and Rogerson remembers a particularly striking performance that they staged at the Spanish Anarchist Centre Iberico in Harrow Road, where performance art group The Neo-Naturists had been invited to take part in the show, all curvy Earth Mother types who turned up wearing nothing but a coat of green body paint. 'It was so clever of Whitehouse because they were the antithesis of each other,' Rogerson asserts. 'They were all Goddesses and sexy and round and into making food and sharing it, whereas Whitehouse had this violent, fuck you attitude. It was a great piece of humour.'

For their first date Stapleton and Rogerson went to see Eartha Kitt, whom they both loved, at a gay club in town. It was a memorable show. Kitt bulldozed her way through the usual chestnuts until halfway through when a sudden splutter signalled the death of her backing tape, revealing that she had been miming all along. After a couple of seconds of awkward silence the place exploded with cheers as Kitt, with a fantastically disdainful little shrug, picked up exactly where she left off as the tapes kicked back into synch. The couple blagged their way back stage whereupon Rogerson approached Kitt and asked her if she'd sing on the forthcoming Nurse With Wound record. She politely declined. 'Diana was totally outrageous at the time,' Stapleton maintains. 'The stories I could tell you. When we first started going out we actually met up with John Fothergill to go and see some French film. It was a packed arts cinema and there was a guy sitting right in the middle of four empty seats. We wanted three seats together and so Dido asks him to move over and he was uppity and wouldn't do it so she whispers something in his ear and he leaps up from the seats and runs. Dido told him that if he didn't move she was going to tear his balls from his trousers.'

'It's seems bizarre now but I do remember going out on a few dates with Fothergill in tow,' Rogerson confirms. 'There was also one bizarre threesome that I won't go into. I've always had a soft spot for these really eccentric men, all the ones I knew were totally barking and so John just fitted in with that. My brothers were pretty mad so I understood him. He was always eccentric but all his pathologies got deeper as things went along and the whole bust-up with Karl and Danielle still hung very

heavy on him. I saw someone who was completely victimised by the situation he was in. Heman Pathak, on the other hand, seemed just like a regular guy. Steve and I met him on a bus once by chance, long after he'd left Nurse. He didn't want to talk about his previous life at all.'

By the end of 1983 Tibet was also busy covering his tracks. Although he was keen to rid himself of the Dogs Blood Order name, he was unsure who owned the name Current 93: Balance, Haäman or himself. But by the summer of 1984, with Haäman fully focused on 23 Skidoo and Balance working with Sleazy as Coil, he decided he had the all clear to take the name himself, despite his dwindling interest in Crowley.

When a second chance for cheap studio time had come up late in 83, Tibet had decided to commit to a version of 'Maldoror Is Dead', inviting Stapleton to come into the studio with him to help him realise his ideas. The resulting album, 1984's *Nature Unveiled*, was the first fully formed Current 93 release. Primarily birthed from his extensive readings on Antichrist, many of its obsessive themes are still present in Current's contemporary work. 'I still have the same interests I had then,' Tibet insists. 'Although I think the nature of its expression has changed. Tracks like 'Maldoror Is Dead' and 'The Mystical Body Of Christ In Chorazim' aren't very different from what I'm doing now in terms of intensity, aesthetic and vision.' The sessions for the first side once again took place at The Roundhouse. 'Tibet and Stapleton had originally laid down the foundation for *Nature Unveiled* in October of 1983,' John Murphy recalls. 'I missed those first sessions because at the time I was also playing in SPK and we were booked to appear on [Channel 4 pop show] *The Tube*. After I got back, Tibet played me the results and we returned to the studio where I added some overdubs using my modular synthesizer, while Stapleton added some very atonal piano sounds. I also remember that there were comments from others in the same building at the Roundhouse to the effect that we all sounded like a bunch of Satanists.' The second side of *Nature Unveiled* was cut early in 1984 at IPS on an eight track desk. Nick Rogers, the engineer for the session, was credited as a member and Tibet remembers that, alongside Stapleton, his role was crucial. Also present for the recordings

Nurse With Wound, live in Amsterdam, 1984. Stapleton on vocals.

were Annie Anxiety, John Fothergill and, inexplicably, Youth, from theatrical goth-rockers Killing Joke.

'Maldoror Is Dead', a track that Tibet would revisit again, later in his career, was constructed around a simple loop of Aleister Crowley chanting, 'Om'. 'I described it to Steve as being like a hypnotic dream that sped up as we came to the end of it because at that time I was obsessed with the apocalypse, I felt things were telescoping quickly, it was all just spiralling, quickly, quickly, which is what 'Maldoror' does,' he explains. 'I played Steve the loop and told him the lyrics. I stressed that it had to have the stately slow motion feel of a dream when it's starting. It's often very slow, people's gestures are like shadow puppets, full of meaning, it seems, but they're not actually doing very much. It's like a shadow thrown by a candle onto the wall, it's distorted and everything is emphasised and exaggerated. By the end it becomes frantic, like somebody shuffling or dealing cards.' Tibet would often describe what he wanted to Stapleton in these kinds of abstract terms and Stapleton was always able to translate his ideas into sound. As a working relationship it was perfect.

Nurse With Wound, live in Amsterdam, 1984. Stapleton on drugs.

Much of the follow-up to *Nature Unveiled*, 1984's *Dogs Blood Rising*, had already been recorded at the first session earlier the same year although atmospherically they are a world apart. Whereas *Nature Unveiled* is glacial and stately, *Dogs Blood Rising* approaches amphetamine psychosis. Tracks like 'Jesus Wept' were formed solely from slashing edits that Tibet had obsessively cut to fit. The record has an unpleasant power, though not all of the tracks work. 'Falling Back In Fields Of Rape' feels unnecessarily hectoring, with corny lines like 'Close the eyes/Shift the responsibility/It wasn't you' subject to Steve Ignorant's red-faced delivery, although it does make effective use of snatches of nursery rhymes and children's voices. Tibet credited himself as both Isidore Ducasse and Christ 777, appellations he would flit between according to whatever he'd ingested, and many of the other people listed had simply been hanging around the studio at the time. Diana Rogerson contributed vocals alongside Tathita Louise Raisling aka Ruby Wallis – her daughter from her first marriage – and Igs, who was the singer in a group called No Defences. 'I learnt a lot through doing the first few Current albums,' Stapleton admits. 'I did most of

the side of *Nature Unveiled* that we recorded at IPS. It was all loops and textures, stuff I'd never done before. I was utilising a lot of what I learnt from working on *Homotopy To Marie*. Having Steve Ignorant down for the second one was great fun. As Nurse With Wound, I was much more into the whole Crass side of things than Throbbing Gristle. They were just old hippies and so was I.'

After *Dogs Blood Rising*, Current 93 and Nurse With Wound took to the road for two dates in Europe. Accompanied by Annie Anxiety and D&V, they played in Amsterdam and Brussels in December of 84. Stapleton remembers it as being 'a fucking shambles'. Tibet was playing keyboard as part of Nurse and he wasn't the greatest of improvisers, falling back on ham-fingered quotes from Beethoven's 'Für Elise' that drove Stapleton up the wall. Besides, the kind of freeform chaos that Nurse were generating on stage every night was far removed from the exacting nature of his then edit-based music. Alongside Tibet and Stapleton, the Nurse line-up consisted of Diana Rogerson, Annie Anxiety, Tim Spy, and Paul Donnan, who hung around 'just for the crack'. In Amsterdam Stapleton had his first experience of cocaine and became so wired that he had to be physically removed from the stage by Tibet as he crouched on the floor screaming into a microphone long after everyone else had finished playing. Nurse had actually made their live debut the month before, playing with SPK at Coasters in Brighton. 'Looking back I suppose it was quite fun,' Stapleton admits. 'We played this ballroom in Brighton which was ridiculous. All these disco guys standing round in flares and showing no interest at all. When we finished there was just dead silence. I can remember Diana spinning around on stage, wrapping herself in plastic.'

The Current 93 shows were never any longer than 15 minutes and they would play over masses of cassettes, ranging from warped recordings of Gregorian chant through electronic noise and traditional Japanese music, all running simultaneously. Andy Leach played drums beneath a squall of improvised guitar and some howling violin from Tim Spy. Tibet would fall into great word-associating improvisations based on his readings of nursery rhymes and apocalyptic Biblical texts.

Although the reaction to their London shows had been pretty dismal so far, the European shows were much more successful, with sell-out crowds every night. In Brussels, Tibet brought a metal crucifix on stage with him, which he stuffed with cotton wool that he'd soaked in petrol and set on fire before slamming it to the ground and kicking it into the audience.

Despite Stapleton's disappointment with *Insect & Individual Silenced*, he continued to work with Thirlwell, who appeared on the latest Nurse record alongside Tibet and Rogerson. *Brained By Falling Masonry* was dedicated to the legendary European group Brainticket's 1971 classic of damaged psychedelia, *Cottonwoodhill*, a fucked aural approximation of an acid trip that sounded like Funkadelic cut and spliced by Faust and featured a female vocalist, Jane Free, who actually sounded a bit like Diana Rogerson. Brainticket went so far as to print some mock advice on the sleeve as a warning to the uninitiated. 'After listening to this record your friends won't know you anymore,' they trumpeted. 'Only listen once a day to this record. Your brain might be destroyed!' Lifting the Brainticket rhythms, Stapleton scorches them with blasts of electricity while Thirlwell gibbers through a particularly hysterical vocal. 'We did the sessions in downtime at the Roundhouse recording studios, which I remember thinking was uncharacteristically upscale for a Nurse With Wound session,' Thirlwell recalls. 'I had never heard the Brainticket song before and they didn't play it for me before I did the vocal. They just gave me the lyric sheet. In fact I never heard the original until years later. Actually I hate my vocals on it though a lot of people seem to dig it.' Thirlwell also noted some tension in the studio between himself and Tibet. 'I never took Tibet too seriously,' he says. 'He might even contend that I was mean to him and maybe I was. It was kinda my perception at the time that he was 'bum-rushing' Nurse and muscling his way in but what the fuck do I know?'

'I always thought Jim and I got on well,' Tibet claims. 'We lived practically next door to each other on Beck Road, with Genesis down at the other end of the street. He was obviously a great admirer of Steve

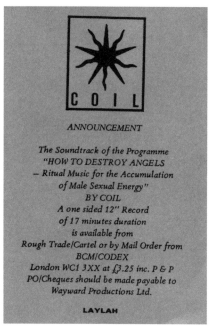

and his work and Steve reciprocated, considering him to be a master of editing and arranging. However I soon discovered he absolutely loathed me, and would say so to everyone he met that was a friend of mine or knew me. His hatred of me, which lasted for at least 15 years, totally mystified me. Steve thought it was because Jim and Steve had been close, and then I came along and Steve and I became inseparable, as we are still. Perhaps his hatred has dissipated now. He came to stay with my wife and me when he did his first major show in London, with Coil, a couple of years ago. I was still recovering from an operation, so couldn't make it to the show. But I did see a lot of his one-piece gold lamé jump-suit he wore on stage, as it was hanging up on the door to his room at our house.'

'The recordings for *Brained By Falling Masonry* were the first ones that I attended,' Rogerson recalls. 'Steve was a very intense worker, in the studio all the time. It felt like an exciting place to be. When you see Steve in action he's a fevered creature, he knows exactly what he's after. He was really on the case, changing the track and doing it again, continually repeating these loops. You'd hear him listening to stuff, going through a phase again and again and you could tell that he was

C O I L - H I S T O R Y

John Balance first worked as COIL on May 11th 1983.
During this period recorded "S is for Sleep", "Red Weather", and "Here to Here (Double Headed Secret)"
at home on 4 track portastudio.

Produced four live performances in 1983. These were:
Magenta Club, London. 5/8/83
Air Gallery, London. 24/8/83
Recession Studios, London. 12/10/83
Berlin Atonal Festival II. 3/12/83 (Played as Zos Kia).

Magenta Club: Performed a short piece called 'Silence and Secrecy' -described as "an exercise in extended tension".
Coil were: John Balance and Peter Christopherson. Also on the bill were Ake, Pure, Jill Westwood and films by Cerith
Wyn-Evans.
Air Gallery: Performance piece entitled "How to Destroy Angels" This was a collaboration between Coil and Marc Al-
mond, who read a text concerning the willful disintegration of a relationship. Coil were John Balance, John Gosling.
This event was videotaped by Cerith Wyn-Evans. (This tape is not generally available.) Also on the bill were Pure, Fist-
fuck, Jill Westwood, etc.
Recession Studios & Berlin Atonal: Coil were John Balance, John Gosling, and Min. At both performances the playlist
was "Sicktone", "Baptism of Fire", "Violation", "Truth", "Poisons". C60 cassete of Berlin gig available on Nekrophile Rek-
ords, Austria (as "Transparent"). This was also videotaped but is again not generally available.

In January 1984 John Balance and Peter Christopherson severed all connections with Genesis P-Orridge, Psychic TV and
the Temple ov Psychic Youth.

Feb 1984 recorded "How to Destroy Angels" & "Absolutely Elswhere" at Britannia Row Studios for LAYLAH 12" release.
At the same time "The Sewage Worker's Birthday Party" eventually included on SCATOLOGY. The 'Angels' refered to
are not necessarily celestial, christian or fallen angels. The title is meant to be like an instruction manual for a seeming-
ly superhuman act.

May 1984 we began work on material that was eventually released as SCATOLOGY. Several tracks from this time were
not released, or metamorphosed into something very different, inc. titles: "Ergot", "Boy in a Suitcase", "Dream Photo-
graphy", "120 Dalmations in Sodom", "Thermid'Or", "The Pope held Upside Down". "Homage to Sewage" was released
on the 1st Abstract magazine/record compilation, "Life at the Top" (included with Abstract no. 4)
"The Wheel" was selected by Stevo / Some Bizzare for inclusion on the new Some Bizzare compilation "If you can't
please yourself, you can't please your Soul" (due April/May '85).
Over the next few months a number of recording sessions at Wave Studios and Aosis Studios furthered development of
SCATOLOGY and also produced "Sicktone" due for release on LAYLAH Anti-Records compilation LP "The Fight is On"
and "Restless Day" which was subsequently donated to a collaborative Animal Liberation Front LP which has yet to
appear.

In January '85 Coil were in the studios of Videosonics, recording the original soundtrack to a new Derek Jarman film
called "The Angelic Conversation". This 80 minute 35mm feature film was premiered at the recent Berlin Film Festival.

In February '85, 10 tracks were released as SCATOLOGY the first record on our own Force & Form label, in collabor-
ation with and support from K.422, a label that also releases records by The Swans and Wiseblood. See accompanying
reviews.

April sees the release of a 12" -a de-structured version of Panic, coupled with a short track called "Aqua Regis" and
our desecratory but sensitive (!) version of "Tainted Love". A new slant is given to this title since all profits from this
EP are being donated to AIDS counciling via the Terence Higgins Trust.

COIL 9/4/85

## PETER CHRISTOPHERSON
a.k.a. Sleazy
Born 27th February 1955

Educational experience:
Mrs Burford's Nursery School, Wimbledon, London 1958-60
Chester-le-Street and Western Hill Junior School, Durham 1960-62
Durham Chorister School 1962-66
Ackworth School, Quaker co-educational boarding school, Yorkshire 1966-73
(Co-incidentally in the same class as Phillip Blakey and Debbie Layton, two key members of Jim Jones'
Guyana suicidal society.)
State University of New York, Buffalo 1973 (1 semester only)

### Work Experience:
Joined design group Hipgnosis, 1973, doing album covers and music related design work. With partners in Hipgnosis, Storm
Thorgerson and Aubrey Powell, formed Green Back Films Ltd. producing music videos and longer-form promotional music
films.

### Music Experience:
Co-founded Throbbing Gristle 1976-81, from whose work approximately 44 albums have been appeared to date from many
different sources.
Co-founded Psychic TV in 1981 and with JB split completely from them in January 1984. During that time 3 albums
were released "Psychic TV Themes", "Force the Hand of Chance" and "Dreams Less Sweet". Joined COIL in 1984. (see
COIL history).

### Other Experience:
For some years a member of Casualties Union -a voluntary organisation that provides members skilled in the make-up
and simulation of injury, for training of medical personel (ie St John's Ambulance, Police medical teams etc).
Asked to work on a project that subsequently became "The London Dungeon" but invitation withdrawn when it became
apparent that work would be too realistic for public sensibility. A considerably watered-down version was subsequently
produced and instantly successful.
With craftsman John Harwood originated and designed house style and ideology of BOY punk shop in King's Road, London.
The original window display contained items manufactured by PC that purported to be parts of a charred boy's body.
After two days the display was removed by Police who prosecuted the shop for displaying them and placed the items
in Scotland Yard's so-called "Black Museum". Photographs of the pieces were apparently also published in a book now
used by Police Forensic Departments.
At this time conceived many clothing designs subsequently taken up by well-known Punk clothing manufacturers including
trousers with straps and many T-shirt themes.
Also with John Harwood photographed two series of advertising campaigns for Glasgow Citizen's Theatre under Phillip
Prowse. The first of boys and buildings in and around Glasgow, the second called "Ways to Die" a series of photographs
of boys in positions and scenes of death and suicide.
Published a small edition of a pamphlet called "Boy Research" from amongst a much larger collection of youth orientated
photos and material 1977.

### Private Film Experience:
Produced during the '70s a number of small untitled films portions of which were edited together to produce a video
to accompany PTV track Terminus on Doublevision video compilation "TV Wipeout".  ·
Produced and directed the 58min film "Polarvision". To date unreleased.

J O H N   B A L A N C E

Born at home,
Mansfield, Nottinghamshire.
February 16th. 1962 ev
Parents in Forces.
As a consequence lived in: Germany, Lincoln, Inverness, Italy, Oxfordshire etc,
and went to eleven different schools.

## Educational experience - John Balance's Schooldays

1. (aged 12) Received psychiatric treatment after attempting to push a piano down three flights of stairs,
and strangling son of a United Nations diplomat.
2. (aged 13) Seduced by 70 year old cook.
3. (aged 13) Involved in scandal with son of famous Disney actor.
Quote from headmaster's letter home:
"I am afraid he is again becoming unhealthily obsessed with the occult and supernatural."
4. (aged 14) Brush with police after placing five pigs heads face up in the public lavatories.

## Musical Experience

While at school did STABMENTAL fanzine (7 issues) covering Clock DVA, Cabs, Residents, ABC, Lemon Kittens etc.
In many cases before the established music papers caught onto them. Also released various compilation cassettes inc.
"The Men with the Deadly Dreams". Also played in numerous groups inc. Murderwerkers, The Anti-group (1979 -prior
to Adi Newton's current project), Cultural Amnesia, A House etc.
Attended Sussex University, Brighton but left after 9 months by mutual agreement with the college, following a perform-
ance-art debacle inside the administrative building complex.
Moved to London 1982, joining Temple ov Psychic Youth as "Psychic TV Themes" was being recorded. Joined PTV proper
for "Breakthrough" and subsequently recorded with PTV and participated in PTV's 1983 World Detour, visiting Manchester,
Iceland, USA, Berlin etc. Recorded first Current 93 12" "LAShTAL" with David Tibet and Fritz Haaman. Founded COIL
1983 -see "Coil History".

## Other experience

Appeared on LP cover for Dave Ball's "In Strict Tempo" with Bee, now of "Getting the Fear".
Appeared in and worked on PTV videos "Terminus" and "The First Transmission".
Appeared in 1 hour Japanese video "Compartment" by Yuming and as an extra in various promos, commercials etc.
Made Virgin Prunes film "Rhetoric" now included in the IKON video, "Sons finds Devils - The Virgin Prunes".
Worked with PC on Marc Almond videos, "Marc Almond - Live at the Batcave"
and "Little Black Bites - Live at Drury Lane". .

Stephen Thrower, late '80s.

listening for patterns. Jim Thirlwell was around the studio a lot during the making of that record. I think he really wanted to be a rock god. He was obsessed with himself and getting on. Everything was a stepping stone. He had to get up there. Still, there was something charming about him.'

Earlier that year in Britannia Row, Pink Floyd's studio, Balance and Sleazy had been pushing ahead with the first Coil record. Balance had sketched out plans for a whole spate of themed releases, imagining a series of one-sided discs dedicated to each of the planets. He had looked up the Qabalistic attributes of each planet and every recording session was to take place in an appropriately controlled environment. The first session, on 19 February 1984, was to be under the influence of Mars. As Balance elaborated: 'Mars is the Roman god of spring and warfare. His qualities are dynamic energy combined with a vital stabilising discipline; when self-control is missing the unbalanced force results in cruelty and wanton destruction. Mars is the deification of forces within Man which can be found in every culture in one form or another, even to

Stephen Thrower, Colin Baker. (photo Keiko Yoshida)

this day.' The results were released as the *How To Destroy Angels* 12" on Laylah, titled so as to appear as an 'instruction manual for a seemingly superhuman act'. The recording was an attempt to use sound in a ritualistic and empowering way with the result that there was an almost devotional air to the recordings, which were as far removed from any concept of 'entertainment' as possible. The liners' overt homoeroticism landed them in trouble straight away, with Rough Trade refusing to handle it because they believed it implied concepts of male supremacy, despite the fact that it had been made by two gay men. Between the two of them Balance and Sleazy had sketched out a basic structure with timings for when they wanted certain things to happen and they hired 12 gongs which were dotted around the room, alongside a couple of bullroarers that Balance had made and painted with sigils. To ensure maximum potency Coil wanted to keep the situation exclusively male. At their request the building was cleared while the session was taking place. It was undoubtedly this kind of behaviour that contributed to the group's early notoriety and the misgivings voiced by people like Rough Trade.

*How To Destroy Angels* was a hallucinogenic fug of gong tones and it sounds every bit as elemental and otherworldly today. It was released as a one-sided disc, with the other side entitled 'Absolute Elsewhere' and cut to resemble one of the scrying mirrors through which the Elizabethan magus John Dee would speak with angels. The record company had several goes at it before getting it right. They kept thinking they were making a mistake and early cuts had tones and grooves on them before they perfected the clear mirror, a design that also looks forward to the portal used on the front of Coil's *Time Machines* album. 'I don't know why I'm so obsessed with that,' Balance remarks. 'It's only really one particular thread of Dee's life and work that interests me, the dramatic, dynamic relationship between him and his partner Edward Kelley. What was going on there?' What also appealed to Balance were the rigorous, systematic methods the two employed in their investigations into the reality of angelic entities. Kelley was to all intents a completely uneducated man yet during the duo's séances, he pulled a language with a consistent grammar – Enochian – seemingly from out of the air. He also convinced Dee to let him sleep with his wife. You can see how he appealed to Aleister Crowley, who would later claim to be a reincarnation of Kelley. Coil also appropriated Dee's celestial monad, a single sigil that was meant to represent a whole array of astrological, alchemical and cabalistic ideas. Its design included the symbols of all the planets and the zodiacal sign of Aries, whose attribute was fire, thus linking it with alchemical process. It also featured the sacred shapes of the triangle, the circle, the square and the cross. The late Rosicrucian scholar Frances Yates suggested that the monad would have been seen within the context of Renaissance hermeticism as a magical emblem whose 'unified arrangements of significant signs', when infused with the heavenly rays that Dee believed ordered all change in the world, would have a complementary 'unifying affect on the psyche'. In other words, the monad gives you Balance.

'I see the music in ritualistic terms,' Balance affirms. 'I'll go and look up Crowley's *777* and other reference things just to find musical parameters. It's not much different to John Cage throwing stones onto a grid and extracting music from that. It's a way of kick-starting you,

Stephen, Geff, Sleazy, early Coil photoshoot.
(photo Lawrence Watson)

Coil, January 1987. (photo Richard Bellia)

and Dee and Kelley's material is particularly inspiring in that way. The fact that they claimed to be talking to angels directly parallels the current obsession with extra-terrestrial communication and the search for intelligent life. It's not much more than a transfer of those ideas to now. But the whole John Dee thing is really just a peg to hang something on. We wanted to do music and as we did it a theme evolved, so you sort of push the points of the theme forward and if people respond I follow that lead.'

'It's not just a question of people's response,' Sleazy counters. 'To me the music that we make is all to a greater or lesser extent made in an altered state of consciousness. In the sense that we go into a sort of different mental place. For all I know all composers do this but I only have experience of myself. The headspace that you're in when you're composing music comes as a consequence of either rituals that you've been doing at the time or ideas that you've been thinking about or anything that's happened to you. What we try to do is form a certain

mental idea or state or place from which the music then flows and whether you structure it by talking about certain alchemical ideas or structure it by performing rituals before you compose or start working on it, it's all basically the same.'

By the time of Coil's debut album *Scatology* in 1984, Balance's obsession with the surrealists had resurfaced, particularly his interest in Salvador Dali and his paranoiac-critical method. You can see how this method fits in with Coil's working practices, as they're both attempts to discredit reality via focused investigations into the irrational. This is done by stimulating the brain's capability to generate delusional or hallucinatory phenomena by feeding it a theme to obsess over, whether it's the attributes of Mars or the details of Dee and Kelley's occult mission. Balance amassed a huge collection of Dali books, fully aware that deep behind the façade of the showbiz surrealist there was a beautifully complex conceptual labyrinth. Dali obsessed over little bits of ephemera, which would turn up as details in his painting; half-remembered places, railway stations, saints manifested as flies. As Coil's music became ever more texturally and referentially complex, they soon developed their own web of interrelations and reference points, where the smallest details might refer you back to something else and force you ever deeper.

Coil are still involved in a dispute over rights and monies owed from *Scatology* and *Horse Rotorvator*'s sales with Stevo, the head of the Some Bizarre label on which they first appeared. In 2001 they reissued remastered versions of them both via their own label as part of a 'Stevo – Pay Us What You Owe Us' series. At the time, however, the label seemed perfectly placed to work with Coil. 'There was a culture in the building where their office was that at the time seemed to be interesting and there were other interesting people involved in that culture like Neubauten and Marc Almond, friends of ours,' Sleazy explains. 'At the time we didn't see the negative side of the person who placed himself at the centre of this culture.' Balance takes up the story: 'The legal thing is that we had this gentleman's agreement that we could leave Some

Bizarre and take the masters with us. It was an unspecified period of time, because we didn't confirm it nor did we have a contract. So ten years down the line I thought it was time to get our stuff back. Stevo wasn't having any of it; he claimed he owned the masters in perpetuity. I'd never sign anything like that ever, never have done, never will. It's bad blood and he won't let go of it and we won't either, because it's our creative legacy.'

For the making of *Scatology*, the Coil line-up was further bolstered by the addition of a group of new players. Alongside prankster and provocateur Boyd Rice, whom Sleazy had known since he played with Throbbing Gristle, Gavin Friday of Irish androgynes The Virgin Prunes briefly joined the ranks. Balance had been friends with Friday ever since he had interviewed him for *Stabmental* and he remains a huge Virgin Prunes fan. 'I loved how completely bloody naïve they were,' Balance says. 'They would always use this phrase, that they 'didn't come down the Liffey in a bubble' but it was almost as if they had. They were like little kids let loose and they'd just frighten everybody to death with their whole entourage. I'd never seen anything like that since punk. Punk was calculated, nasty and expensive, but these were genuine articles from a Dublin housing estate. Freaking middle class women out by dressing like middle class women!' However, the most important addition to Coil was Stephen Thrower, who came on board as a fulltime member after penning Balance and Sleazy a fan letter while starving for intelligent company up in Wakefield in the north of England. 'He wanted to move down to London,' Balance says. 'Sleazy and I had been working together for quite a while so it's always good to bring another person in, it freshens things up. He was very acerbic and Mark E Smith-like; he used language as a weapon. I gave him the nickname Wyndham after Wyndham Lewis, the author of *Blast*, because he spoke like *Blast* read. I like sparring in language and a lot of the stuff was borne out of sparks flying in the studio.'

Their first contact revolved around a shared passion for Andrzej Zulawski's *Possession* and the films of David Lynch, and Balance and Sleazy immediately suggested that they meet up. Thrower was fully aware of a certain 'carnal curiosity' that soon manifested itself in both

sides' letters. 'Although there was no clumsy attempt to seduce in the obvious sense of the word,' he insists. 'What flirtatiousness there was tended to be in the form of asides and whilst I was aware of this factor, there was plenty to suggest that it was in the way of an optional extra. Looking back at the letters now, I'm surprised at how knowing my side of the correspondence was – I suppose there was an awareness that we really were quite similar in tastes and in approach to the objects of our devotions. Even as I was becoming aware of a certain currency that my age and looks afforded, there was also a wish to establish contact in a way that transcended all that. One letter I sent to Sleazy bemoaned the fact that whilst we might want to sexually exploit the audiences for 'Oi' music there was little chance of pulling these youths into the sort of experimental field we were pursuing. Of course, the PTV aesthetic had been at least partially governed by Sleazy's interest and desire for this look. I'm sure the religious abstinent aspect was more important for Genesis and although it may have had resonance for Sleazy as well, there was doubtless a great deal of playful sexual fantasy involved in the development of the PTV acolyte 'look'. Later, when we discussed these ideas in Coil, it was usually at the level of amusement, a shared pleasure in playing up to the 'sleaziness' of bands trying to seduce their fans. Naturally, any real opportunities would be taken, but it was often just a sort of game.'

Thrower first met Balance outside the ICA when Psychic TV were accompanying a reading by the author Kathy Acker on 1 August 1984. Thrower thought the music was appalling and told P-Orridge as soon as he'd left the stage. P-Orridge immediately summoned his wife Paula to his side, claiming that he was 'being attacked'. Balance and Thrower hung out after the show, alongside Thrower's friend Tiny who he was playing with in his own group at the time called Possession; Tiny would later go on to front the indie group Ultrasound. Thrower remembers Balance as being a bit anxious and not entirely there in a way that suggested he was pretty nervy. 'I was only apprehensive on a very silly, non-serious level where you would entertain the more extreme fantasies of how the 'wreckers of civilisation' might live,' Thrower claims. 'Balance and Sleazy were living in Chiswick at the time, and their house was

Sleazy. (photos Mark Lally)

certainly unlike any I'd seen before. There was a bit of a chill to certain rooms, but I really felt as if the darker aspects were already present in me and there was no feeling of personal threat. Later I would see journalists arrive at the Chiswick address, jittery and anxious, obviously convinced they were about to be sacrificed to some great phallic Goat God in the parlour.'

Regeneration is a constant in Coil's work and *Scatology* dealt explicitly with themes such as alchemy, De Sade and 'sexual experiences in Morocco'. It was made in a state of what Balance confesses was 'amphetamania'. Shit and its transubstantiation – as subject and metaphor for their alchemical treatments of base noises through ritual – never sounded so good. 'We started it at home on a Fairlight Two,' Balance recalls, 'same as Kate Bush used to use. I was really into Kate Bush at the time. You can hear that on the record – if you hear the machinery you can. I used to think that actually somehow she was stealing my ideas. I've got notebooks – this was about the time of 1982's *The Dreaming* – where I'd write songs down and then when I heard *The Dreaming* they'd all be on the album. I think that possibly some kind of parallel psychic space was being carved up there.'

By the time Thrower was inducted into the group, *Scatology* was well under way and they'd already cut versions of 'Ubu Noir', 'Tenderness Of Wolves' (with Gavin Friday singing his own lyrics), 'The Sewage Worker's Birthday Party' and 'Cathedral In Flames'. In fact the only track on the album that actually features all three Coil members playing together is 'At The Heart Of It All', a tentative yet undeniably powerful instrumental that sees Thrower blowing serpentine shapes from his clarinet above Balance's keyboard and Sleazy's piano. 'I felt as if I played a clear line through my spirit onto tape,' Thrower recalls. 'Very little conscious deliberation. There was a fragility to the ensemble playing but in a funny sort of way it was also quite robust, there was a gentleness without hesitance, which is quite a hard thing to achieve deliberately. It's as if we were taken by surprise by our accord and yet managed to avoid becoming too self-conscious for the duration of the recording.'

174

In its original, unadorned form, Derek Jarman used this first take as part of the soundtrack to *The Angelic Conversation* but for the *Scatology* mix it was further bolstered by some overly-portentous piano chords by Jim Thirlwell and some Emulator vox samples from Sleazy that slightly date it. 'At The Heart Of It All' is often overlooked in favour of some of the more obviously iconoclastic material on the first Coil album but it feels genuinely prescient and the kind of live-in-the-studio channelling that birthed it eventually became a standard working practice. Some tracks just don't work. 'The Spoiler', a chaotic mess of fuzz, declamatory vocals and martial drums sounds uptight and aimless whereas 'Clap', a flippant splurge of colour that was birthed in the studio, makes much more successful play of these ideas. 'Solar Lodge' harks back to the experimentation of *How To Destroy Angels*, with the synaesthetic use of textures conjuring a huge sound space. But on the whole *Scatology* sounds tentative. Balance is quite clearly still battling to find his own voice, whilst Sleazy is still working out how best to apply the techniques he'd developed in TG and PTV, resulting in some tracks that are over-adorned, a tendency that Thirlwell's sometimes garish production brings very much to the fore.

'He added a cartoon dimension, I thought,' Thrower recalls. 'I wasn't always that enamoured of it myself, it had the feel of a rock 'n' roll Vegas Hell's Angel parody and somehow, although it dovetailed with a certain kind of campness in Coil, I was always a bit unconvinced. But Thirlwell was great fun, he was easy to get on with, there was a lot of playfulness in the way he related to us. He would pick up on a fleeting comment and encourage a train of thought, not with any necessary outcome, but because he just instinctively interacted on the same whimsical/serious level we were playing on. During the mixing he was like another band member, in fact more so than I was at the time. He showed the resilience that you need to help a bunch of fairly wayward people through the hoops they'd set themselves, suggesting things and sometimes moving forward his own ideas quite strongly, but without any petulance or time-wasting if you really seriously disagreed. He was a lot of fun and a real lush, quite amazingly committed to draining any bottle in the vicinity, but still technically capable after guzzling his way through a

500ml bottle of vodka. There were moments when he would sniff out some uncertainty in Balance and Sleazy, and then out would come these suggestions which were basically 'I've Got Foetus on Your Coil' – some of them were abandoned because they didn't pan out, others were kept because Jim was confident and plausible enough to make his suggestions stick.'

'Sleazy's ideas were always created away from scrutiny, even away from Balance,' Thrower reveals. 'Often he'd worked up these great ideas at home and then played them, first to Balance obviously, then they would bounce them off me on social visits to their house. I was capable of being completely frank about what I perceived as weaker ideas and unguardedly enthusiastic about good ones, and that's how we came to relate to each other musically in the first year or so. I remember Balance and Sleazy playing me the earliest recorded tracks pre-*Scatology* and I was totally bowled over by 'Ubu Noir' and was praising it very highly at a time when I think they were still uncertain about what they'd achieved.' Indeed, 'Ubu Noir' remains one of the strongest early Coil tracks, with a series of queasy loops slowly accruing force, its combination of reedy pipes and martial percussion the basis of much of their first two albums. 'This was just after they'd left PTV, remember, and it was Sleazy's first time making music away from Genesis, so although they had their own resources of will and self-belief, it was still a boost for them to hear the opinion of someone whose taste they respected and who was young and arrogant enough not to be afraid of speaking their mind,' Thrower continues. 'I think there was some nervousness on their part at the start, in particular Balance who had the burden of singing and writing lyrics. And Sleazy had to step away from his conceptual collaboration with Genesis and conceive and execute his ideas without that other force alongside. TG and PTV were both rife with input from Sleazy but it was enmeshed with this very dominant ego, Genesis, so even if Sleazy was pulling a lot of strings and coming up with a lot of the fertile suggestions in those bands, Coil was his debut as a visible creative force without Genesis's big performance.' 'Panic' was pulled from the album as a single and the 12" also features Coil's funereal cover of Soft Cell's

'Tainted Love'. In one of Balances' most harrowing vocal performances, he recast the song as a lament for the many victims of AIDS and all profits from this release went to the Terrence Higgins Trust. Marc Almond appears as the Angel of Death in the accompanying video. Originally the idea was to have 40,000 flies crawling over him but by the time they had been biked over from London, virtually all of them were dead, so instead they had to settle for a dazed handful. When the Museum of Modern Art in New York began collecting videos, 'Tainted Love' was one of their first purchases. 'The Sewage Worker's Birthday Party' is Sleazy's tour de force, an illustrative sound piece that was inspired by a story in Swedish magazine called *Mr SM* featuring electronics that drip like faucets and flagellating percussion. Even at its most juvenile, *Scatology* has a brutalising rawness that still makes it feel discomforting and interrogating.

If Balance had had his way, the first Coil album would actually have been called *Funeral Music For Princess Diana*. 'That's one of the things I blame myself for in the history of Coil,' Sleazy says. 'That ever since we started Coil, Balance would intermittently try and convince me that we should do an album called *Funeral Music For Princess Diana*.' When Balance suggested it as an alternative title for *Scatology*, Sleazy maintained that it was too dangerous. 'He convinced me for that reason not to use it,' Balance explains. 'We toyed with many titles. Laura Ashley had just died and we thought of *Laura Ashley Has Fallen Down Stairs* or something like that. *Big Knobs & Broomsticks* was another but *Funeral Music For Princess Diana* just jumped out.' Although Balance originally conceived it as an idea more in the style of Henry Purcell, in the way that people used to commission their own funeral music while they were still alive, in the end he ditched it because he believed it would inevitably be perceived – wrongly – as some kind of anarcho-punk statement. 'I regret that his vision wasn't credited,' Sleazy bemoans. 'Balance quite often sees the future peeking through.'

# Love In Earnest

*Let prudes and puritans unknowingly worship Satan in their degree; they will find their mistake, for no man can base his life upon a negation.*

*I am here to save England; and my spirit shall not rest until the swine of Commerce are driven over the cliffs of Dover.*

– both Ralph Nicholas Chubb

As Coil began to feel more like a group than simply Balance, Sleazy and hired hands, Stephen Thrower took a leap of faith and relocated to London in order to further cement their working relationship, although he was equally attracted by all of the sexual opportunities that London offered in comparison to Wakefield. 'When I first arrived in London I seriously asked Sleazy how much I would have to pay rent boys to have sex with me and where I could meet them,' Thrower admits. 'There I was at 20 years old, looking more like 17 and with a certain plausibility as a bit of young trade, yet thinking I would have to pay for sex. Once it was pointed out to me that I could go to gay clubs and no doubt score for free and do so regularly, I was smitten with the London life! I started to socialise with Balance and come down to London for the odd weekend or week's stay throughout 1984 and into '85 and it soon became obvious that the social adventure of London was far more alluring than being stuck in a dull Northern town.'

Within a few weeks of meeting Balance, Thrower had been introduced to Derek Jarman and it was Jarman who most encouraged

Thrower to take the leap and fully relocate. 'Because I really loved cinema, it was wonderful to get to know Derek,' Thrower explains. 'When we met I'd only seen one of his films, *Sebastiane*, which I didn't really like but after spending a couple of days in his company I was just bowled over. He struck me immediately as a wonderful, generous and inspiring man. I took myself off to the Scala Cinema in London to see his films *The Tempest* and *Jubilee*. I was dreading that I might not like them but instead I was pleasurably surprised. I raved about *Jubilee* in particular but Derek was very self-effacing, telling me his best work wasn't the features; the Super-8 experiments were far more important to him. This was before the wave of Super-8 and video artists Derek inspired – it was a big deal for an established feature film director to turn around and say that his private, almost zero-budget short films, in the cheapest possible format, were his real work and the 'big' films were the sideline. You knew he meant it too, it wasn't just a posture. He had a huge impact on me, not just through his art but also as a truly alive human being. I came from a background where a passion for anything was rare as gold dust and here was this brilliant, funny, vigorous and alert man showing how art and a focused life force could transform everything.' Indeed, Thrower became progressively more involved with Jarman, going on to appear in three of his films, *Imagining October*, *The Last Of England* and (fleetingly) *Caravaggio*. It was also round about this time that Coil started work on the soundtrack to *The Angelic Conversation*, Jarman's first feature-length non-narrative film, shot on video and Super-8 and then blown up to 35mm. Cut to readings of Shakespeare's sonnets by Dame Judi Dench, Jarman described *The Angelic Conversation* as a 'poetic reverie', following the fortunes of two young men as they fall in love. What's most touching about the film is the quality of enraptured innocence that Jarman evokes. In the mainstream innocence is rarely associated with homosexual love, the 'moral consensus' seeing it by definition as something that destroys and perverts innocence and Jarman's reclaiming of this quality makes the film extremely touching. The title suggests both John Dee and Edward Kelley's communications with angels via their pre-lapsarian language and one of the goals of Aleister

Crowley's magical system that he took from *The Book Of The Sacred Magic Of Abramelin The Mage*, that of 'knowledge and conversation of the holy guardian angel.'

The idea for the collaboration first came about when Jarman had approached Coil to do a soundtrack to a film that he had already finished, one that consisted of a shot of a broken dome in Rome superimposed on the ticket distributor at the ICA's face. Both Sleazy and Balance thought it was atrocious and told him so. 'It was really awful and we said, well, we'd love to do some music for one of your films but can you do it again?' Sleazy says. 'And do it better. So he did. He re-shot all of it in the end and we went into a studio with him and we recorded it live to picture.' The recording was done on a shoestring budget, mostly using an Emulator keyboard, just making the best of one machine: the water sound on the recording is Jarman washing Balance's feet and hands in a bowl to time with the screen.

Balance and Sleazy still maintain that they're more fans of Jarman himself than of his work. His vision of Englishness as being much more diverse – sexually, politically and artistically – than mainstream narratives allow and the way in which his work attempted to plot this secret history helped bring many seeds to fruition. 'While we were doing *The Angelic Conversation* he suddenly gave me a first edition *Book Of Pleasure* by Austin Osman Spare,' Balance recalls. 'I had no idea he'd even heard of him. He had picked up on the fact that I liked him but he was well aware of all these magical traditions and systems himself. His library was weird, a tiny little room with shelves that you could just squeeze between with a secret section with things like fantastic vellum-bound alchemical texts. I don't know where he got them from.' Jarman was also obsessed with things like concrète poetry, Dom Sylvester Houédard in particular, a monk who spent most of his life in Prinknash Abbey in Gloucestershire and worked using typewriter calligraphy formed into pictorial Zen-like structures – 'typestracts' – that were attempts to express the inexpressible. Jarman was forever trying to convince Balance to go and see him. His enthusiasm and determination to get people together in creativity was one of his defining characteristics.

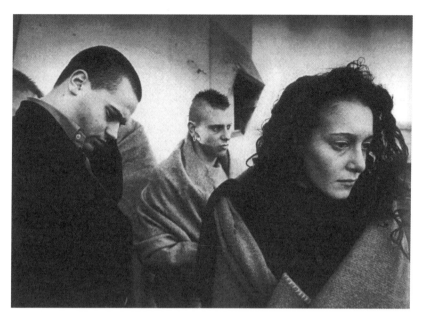

Stephen Thrower (left) in Derek Jarman's *The Last of England*, 1987.

Sleazy in particular believes that Jarman's homosexuality –
an essential part of the very fabric of his existence – allowed him
to see the world in much more complex terms than a heterosexual
artist. As a homosexual he was more immediately aware of the lie
that consensus English culture is founded on, that there are so many
integral parts of that culture that are either wilfully ignored or denied.
Indeed there's an exclusively gay continuum across the arts that has
been consistently swept under the carpet and never acknowledged.
One by-product of Jarman and Coil's work has been to expose its
insurrectionary sub-cultural strain. 'I think that gay people have the
advantage in that when they realise they're gay it's tangible proof that
the world is not the way it's represented,' Sleazy elaborates. 'It may
be that that characteristic, that facility, was only available to people
who were in their teens between 1960 and 1985 because since then
a kind of gay mainstream has evolved and it seems to me, looking
at young gay people today, that they're not conscious of themselves
as being different. If they are, it's inevitably just another flavour of
Abba. Maybe we're just lucky but that's one of the reasons that we

felt an affinity as soon as we met Jarman. Even before we met William Burroughs it was the same, we knew from the first page of his that we ever read that there was something there, a bond, something deep and important.'

The concept of 'deviance' is key to Coil as artists and they see themselves as consciously working on the edge of social acceptance, all the while chiselling away at the consensus. Through creative deviation they were able to find their own voice, a pre-requisite for developing a strong artistic vision. 'The way to find your own voice is to make sure you're not saying the same thing as everyone else,' Sleazy claims. 'It's essential that you are doing something that's unique to you.' Artists like Burroughs and Jarman were key for Coil in that they provided a kind of permission to stay true to themselves, to follow what they believed. 'It was like, if you wanted to take the hood off and fiddle about with the engine, to alter yourself, to alter your consciousness or just to be yourself in public – permission granted,' Balance adds. 'It's important that people have the example of other people doing that, whether it's in an extreme way or in a routine way, which is what Burroughs did, just got on with being his self. That had a lot of resonant power and still does.'

Sleazy first got to know Burroughs back in 1977 when he was working on the design for the BOY shop in London along with John Harwood. In New York on business, he called round to see him in The Bunker, a converted YMCA building that he lived in on The Bowery. Sleazy showed him photographs of his BOY work and while discussing the possibility of including them in a photography book that Burroughs was putting together, the two worked their way through a bottle of vodka. Two years later, as a member of Throbbing Gristle, Sleazy travelled out to Burroughs's new home in Lawrence, Kansas alongside P-Orridge to listen through his archive of tape experiments, mounds of reels crammed into old shoeboxes. The most interesting finds were released as *Nothing Here Now But The Recordings* on Industrial Records in 1981. 'For me, he was the writer who first showed me that it was

possible to have moral and philosophical systems that were outside the accepted norm of society that were workable and meaningful, although it did have a lot to do with sexuality,' Sleazy told Biba Kopf in 1997. 'At the same time it was also to do with politics, relationships and everything. His entire existence was outside, beyond the pale, and the fact that he could live it and he could write about it was incredibly influential on me.' Kopf pushed him on how he would define the moral and political systems he usurped. 'Well they were a rejection of everything that's Christian and middle class and heterosexual in a sense,' Sleazy asserted. 'But what was so great for me about Burroughs's work was that although he almost totally rejected heterosexual sex and relationships he replaced them with something which was completely his own, which was, what's an adjective to do with pan?' Balance shot him a couple of options: 'Pan, pan, pan, pandrogynous, pandrogyny?' 'Whatever, which was kind of his own creation, which had nothing whatsoever to do with the kind of American homosexual lifestyle, which has become so prevalent and which has become just as limiting and controlling and sort of sad in a way, in recent years. Americans have struggled a lot because they are dealing with a culture that is generally very homophobic and very bigoted but the tools that they have used to fight those things have been to assume a mantle of conformity and that seems to me to completely defeat the object.

'My perception of Burroughs's work is that things that happen in his books happen in a spirit world where there isn't really any self-consciousness, intellectualisation or present time really,' Sleazy continued. 'The time they take place in isn't the annihilating reality of now. It is some other space altogether and in that respect it's the same time that you occupy when you are in the throes of sex because the things that drive you are un-thought, they are completely physical and emotional, when you're doing it right anyway. From my perspective that is always the time when you have the best sex, when you are completely eroticised and your behaviour is not of an accountant from Bexleyheath. It is of a person whose being oozes sexuality and the need and the desire for lust and that is the same time that we use, when we get it together to

William Burroughs and Sleazy at The Bunker.

(photo © Genesis P-Orridge)

record, which is a kind of passionate instinctive unthinking connection with the things that are making the sound.'

Coil renewed their friendship with Burroughs in 1992 when Sleazy, in his capacity as a video director, was working on a shoot for cod-Industrial rockers Ministry's 'Just One Fix' single. The group had asked Sleazy if he could arrange for Burroughs to appear in a couple of scenes and when he agreed – solely for the money – Coil seized the opportunity to pay him a visit and make some recordings of their own. Rather than get him to replay the whole *Junkie* routine, Balance had him read some text that he had put together, consisting of short lines and words that they could later use in different permutations. They have yet to do anything with them. 'He was charming,' Sleazy remembers. 'He was like us in that he's not particularly sociable and quite happy to invite you to his house and make sure you've always got a drink in your hand but not actually talk that much, just sit for hours watching the cats. But he wasn't an unfriendly person; he was more shamanic in his demeanour. I'd have conversations with him on occasion but that was always an exception.'

'If you got him on Thursday afternoon when he gets back from the clinic in Kansas where he had his methadone or heroin he'd be dancing around like a kid, singing songs about falling in love with astronauts,' Balance recalls. 'He was brilliant on that day. His level of extrovertness was in direct proportion to the amount of time it was since Thursday afternoon.' Balance brought along a copy of Burroughs's *The Cat Inside* to get autographed and Burroughs also obliged him with a whisker from his cat, which he mounted on the first page.

Despite – or perversely because of – Stapleton's lack of interest in self-promotion, by 1985 the Nurse With Wound cultus was international in scale, with groups popping up throughout Europe working from a similar surrealist and non-musicianly base. Premier amongst these was Christoph Heemann and Achim Flaam's Hirsche Nicht Aufs Sofa, which unfortunately translated as Moose Without A Sofa. Their creation myth was also founded on a similar chance meeting in a record shop as that of Stapleton and Fothergill. Flaam and Heemann initially got talking over the used bins in their hometown of Aachen in Germany, hitting it off when their shared enthusiasm for Throbbing Gristle and Pere Ubu came to light. Flaam had just purchased a Korg MS-20 keyboard and he immediately invited Heemann over for a freakout session. 'I said I can't do anything, I have no clue,' Heemann remembers. 'He just said, oh, who cares, let's just make a record. We were really inspired by Sleazy's work in Throbbing Gristle, the way he used those mean tapes, mixing in actual recordings of people in weird situations. We tried to replicate that but we had no success at all. We didn't manage to get any interesting recordings, despite walking around for days, although we almost got into a few fights.

'We were also big fans of Whitehouse but once we heard Nurse With Wound's *Insect & Individual Silenced*, everything fell into place,' he continues. 'That was the only one you could find in Germany at the time but it was so interesting because it had no obvious theme. Throbbing Gristle and Whitehouse had real upfront themes but with Nurse they had this mystery connected to them, I think that attracted a lot of people. Also the cover was great and it really made you think, why

are they doing this, what is this?' Nurse quickly replaced Whitehouse and Throbbing Gristle as HNAS's heaviest influence, and as soon as Heemann and Flaam tracked down a copy of the first Nurse album they began to follow up the leads on the accompanying list, thoroughly acquainting themselves with the pre-history of German Rock.

Heemann had been corresponding with Whitehouse's William Bennett ever since he had come across an old issue of *Kata* and sent away to join Bennett's short-lived 'political party' NUPA. He sent over his photo but Bennett returned it, telling him he was too late. NUPA was a 1982 thing. 'Achim and I thought that Whitehouse's use of imagery was obviously a joke,' Heemann says. 'Anyone who was genuinely trying to sell some kind of message would have a different musical backing for it. They would have used something like Queen or Mahler, something that would appeal to people. It just seemed so obvious that this wasp noise wasn't being used to manipulate people. It had to be comedy, off the wall humour on the borderline that no one dares to touch.' Heemann was particularly taken with 1981's *Dedicated To Peter Kurten* and the track 'DOM', which he took as the name for his own label. Bennett also furnished Heemann with Stapleton's address and he instantly fired off a note to him, asking Stapleton if he would contribute a track towards Dom's debut release, the epochal *Ohrenschrauben* compilation. 'I remember the day I first got a letter from Steve,' Heemann recounts. 'He said that he would be delighted to send me a track and that he was already working on one called 'The Poo-Poo Song'. He also casually asked if we would like any help with doing the cover. In the end the track he sent us was great, as was the cover he did.' In keeping with the tradition of the various United Dairies compilations like 82's *An Afflicted Man's Musica Box* which placed Nurse alongside Foetus, AMM and Anima, *Ohrenschrauben* (translating as Ear Screws) was an attempt to join the dots between the European, British and American avant garde, with Whitehouse, Current 93 and Nurse joined by compatriots like Organum, The New Blockaders and Vagina Dentata Organ, German free electronic unit P16 D4 and psychotic American noise group The Haters.

Stapleton's mural for George
'Porky' Peckham's cutting rooms,
Shaftesbury Avenue, London.

After the record's release, Heemann and Stapleton spoke regularly. In April 1985, after a throwaway invitation to come and visit Aachen, Stapleton and Dido turned up at Heemann's parents' house unannounced for a three day stay. They had wanted to surprise him and, as luck would have it, Heemann's parents were on holiday. Stapleton brought Heemann a gift tape of the newly completed *Sylvie and Babs Hi-Fi Companion*. In fact, the real reason they had travelled to Germany was in order to get a Direct Metal Mastering job done on the record.

*The Sylvie and Babs Hi-Fi Companion* provides some light relief in the early Nurse catalogue, a fictitious pair of cheesecake pin-ups fronting a parody of the kind of Easy Listening LPs that lined bargain bins in the 70s and 80s. With *Sylvie and Babs* Stapleton had consciously attempted to make a very different kind of Nurse record. Although he had not intended to play on it himself, once in the studio, inevitably, he just couldn't keep his hands off and ended up playing on most of it. 'I wanted to make a record that was stolen from other people's records,' he says. 'That was when I first really discovered that I loved Easy Listening so much. I had to make a foray into the bargain bins to find all this shit and then listen through it to find the bits I liked. To my horror I loved it all. I even bought myself a James Last record!' With an all-star cast including Jim Thirlwell, David Tibet and Karl Blake, *Sylvie and Babs* sounds like the plunderphonia of Stock, Hausen & Walkman or John Oswald. His drunken lounge anthems are rendered limbless, even as

they're undermined by the dying croak of electricity. Here's the spiked cocktail party to end them all.

Although they briefly crossed each other's paths at The Equinox, Stapleton first got to know Balance just after he wrapped up the recording of *Sylvie and Babs*, even though Balance is actually credited as having played on it. 'I ran into him at Heaven, or some horrible club like that,' Stapleton explains. 'He came up to me and said that he'd wanted to meet me for years. I think I met him in the loo. Everyone meets him in the loo. We shook hands and he asked me what I'd been working on and I said I'd just finished this album with about 40 people on it and he said, can I be on it? I said, it's finished. He said, I know, but can you give me a credit anyway? I said, alright then. That was my first meeting with Balance.'

*Sylvie and Babs* also represents the first collaboration between Stapleton and Edward Ka-Spel, of fellow sonic surrealists The Legendary Pink Dots. Ka-Spel and Stapleton had been corresponding since Stapleton's teens, when they had both been contributing to *Aura*, an experimental music fanzine. 'We met a few times back then,' Stapleton recalled. 'He's a very strange, reptilian guy and he doesn't change, he'll always be a friend. I might go a year without talking to him but it'll always be Ed and Steve, and we can always go back to the way we were all those years ago. We're good mates.'

With both Current 93 and Nurse With Wound in retreat from the live arena following their European fiasco, Stapleton and Tibet initiated a new geographically non-locatable space as a setting for some of their most luciferian work: Bar Maldoror. Current 93's 1985 album *Live At Bar Maldoror* inaugurated its use although it isn't in fact a live album at all, rather a huge collage piece, assembled from the amber glow of choral synthesizers, choruses of plainsong and mile-long drones, all rendered wraith-like by Stapleton's studio logic. More formless and less focused than the preceding *Dogs Blood Rising*, it's still a fine example of early Current's sound art phase, which would reach its peak with *In Menstrual Night*. *Live At Bar Maldoror* was also remarkable in that it was the first Current 93 vinyl that Tibet released on his own label, Mi-Mort, following two previous cassette-only releases, *Mi-Mort* and

*Nylon Coverin' Body Smotherin'*. Taking their cues from Nurse With Wound, both Current and Coil eventually became fully independent, a condition facilitated by the founding of distributors and label hosts World Serpent. But despite the success of Bar Maldoror Tibet was starting to feel that the form he was working in was creatively limiting. He'd fallen under the spell of Love's great Gnostic classic, *Forever Changes*, and it had opened out his ears.

Fellow *Sounds* journalists Sandy Robertson and Edwin Pouncey had inadvertently converted him. They would spin it night and day in the office until Tibet couldn't get it out of his head. Alongside his growing interest in macabre nursery rhymes, it allowed Tibet access to a whole new musical template. 'When we first played him *Forever Changes* Tibet just sneered at it,' Pouncey remembers. 'He couldn't stand it. Next minute he's got everything by Love and now it's one of his favourite albums.' What most affected him was the superficial simplicity of the songs and the way it provided a way in to the kaleidoscopic layers of complexity that lurked beneath, in much the same way that seemingly trivial nursery rhymes were formed of centuries of accumulated cultural effluvia. He had already come to see the sidelong, atmospheric, apocalyptic soundtrack approach as becoming predictable and easy. 'Like a lot of people I looked down on three minute songs thinking it was 'just' pop and therefore not very powerful,' he confesses. 'Listening to Arthur Lee singing 'Yeah, It's alright...' was quite an epiphany. The effect was overwhelming and it was a pretty pop song.'

But in the meantime Tibet was still working with loop based sound sources. After making it up with Balance over their PTV fall-out, Current 93 and Coil came together for a split LP release; 1985's *Nightmare Culture* EP. Tibet's girlfriend Fiona Burr had come up with the sleeve, a lithograph of Caligula's horse, dead on the steps of the senate, from the film *Caligula*. The flip side was given over to a Coil collaboration with Boyd Rice called 'Sickness Of Snakes'. Tibet's interest in Tibetan language and religion was also flowering once again. After replying to an advert for people looking to learn Tibetan in the long since disappeared Tibet Shop just off Museum Street in London, he came into contact with James Low, a Buddhist scholar who became

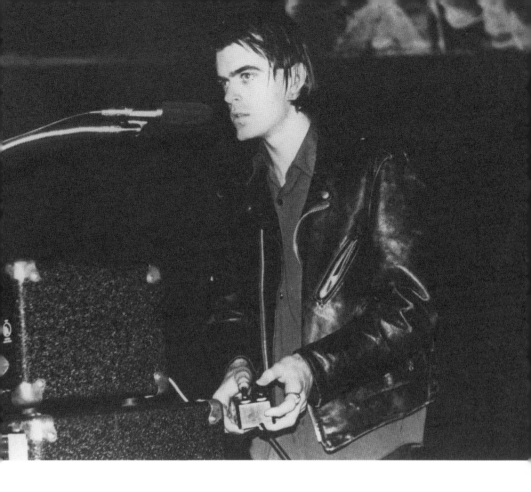

a great influence and whose book of Buddhist maxims, *Simply Being*, Tibet later published via his Durtro imprint.

Another new obsession was menstruation. Tibet was devouring books on the female ovarian cycle and how it related to the moon and supernatural power. Books like Penelope Shuttle and Peter Redgrove's *The Wise Wound*, with chapters like 'Nine Million Menstrual Murders', a title that Tibet toyed with as an alternative to 1986's *Swastikas For Noddy*, became central texts for him, and with the help of Diana Rogerson he became an authority on the folkloric aspects of 'the curse'. 'When I recorded *In Menstrual Night* I was definitely entering a more feminine phase,' Tibet concedes. 'It was moon music, very lunar and watery as an album, just like the more song-based stuff I was beginning

Current 93 live at The 100 Club, London, 23 April 1985. Balance & Tibet. (photo Keiko Yoshida)

to write. My menstrual fascination was in full flow at the time. I was getting more and more interested in folk myth and the letting of blood seemed to be a common element in it, along with the nature of the moon and the tides. That phase lasted a while but in the end I managed to sublimate it by still buying books on it but then giving them to Diana who was interested in them. So she would tell me if ones were particularly good.'

Tibet's studies stretched to anthropological accounts of menstruation in African and Asian villages where he stumbled over a concept that transfixed him. In Shaivite Tantra it's said that a crack opens between this world and the next during menstruation, when a woman is not wholly herself, and she partakes of the nature of the moon and the sea. Tibet was besotted by the idea that within somebody – not through meditation or prayer, but due to biological nature – a passage was created between them and the eternal. 'I just found something so beautiful about it,' Tibet remarks. 'The symbolism, the mythology of

it and the actuality of it. At the same time my interest in the life and passion of Christ was becoming very strong and I saw in menstruating women some bizarre re-enactment of the passion of Christ. It was a letting of blood for us because without the letting of blood there would be no birth.' He was also very struck by Christian folk myths and apocrypha such as those found in Jacobus de Voragine's 13th Century hagiography *The Golden Legend*, in particular one where a specific form of black crystal found near Golgotha is considered to be God's tears, which froze when Christ was crucified. 'When there are several competing explanations for something, I would always choose the most beautiful,' he remarks.

The idea for 1986's *In Menstrual Night*, perhaps the greatest of Current's early sound poems, was originally birthed as *Dream Moves Of The Sleeping King*, an idea that had been mooted for the Current side of the *Nightmare Culture* 12", surfacing there in truncated form as 'KillyKillKilly (A Fire Sermon)'. Tibet talks of it as originally being like a soundtrack to an imaginary Kenneth Anger film but in the end the narrative idea gave way to more of a waking dream feel, more impressionistic and kaleidoscopic. 'I would still go up to Newcastle occasionally,' Tibet relates. 'And I remember falling asleep at a party where there were people stood around talking. I was constantly moving in and out of dreams. There'd be snatches of song that you'd catch and then you'd revert to childlike images from your past, through your subconscious into nursery rhymes.'

Stapleton, on the contrary, claims it was based on his own experiences in hospital, with the cocooning rasp of life-support machinery echoing below the distant clink of surgical tools. 'The nature of the relationship between Steve and I is so close and symbiotic that a lot of ideas percolate between us anyway,' Tibet clarifies. 'He remembers it differently but fundamentally there's no paradox in that. I may have mentioned my idea to him and he might have said, that's weird, when I was in hospital I felt the same thing.'

Rose McDowall, formerly of Scottish pop-psych group Strawberry Switchblade, made her first appearance with Current on *In Menstrual Night*, released via United Dairies. Tibet had first met her through Paul

Hampshire aka Bee, whom he'd got to know through hanging out at the Skin Two fetish club after Balance spotted him in a Charles Manson t-shirt, the would-be Industrialist's red carnation. Both Rose and her then husband Drew McDowall had fallen into the orbit of Psychic TV in the early '80s through their friendship with Alex Fergusson, who they had first met in Glasgow in 1979 when he was producing Orange Juice's 'Blue Boy' single for Postcard. When the McDowalls arrived in London, they befriended P-Orridge and Bee. 'All I knew of Strawberry Switchblade was 'Since Yesterday',' Tibet admits. 'Which in a snobbish way I thought was just girly pap. In time, of course, I became obsessed with girl group material. I still love that song and we covered it later on *Swastikas For Noddy*. Rose and I became very close and I also became friends with Rose's husband Drew, who later joined Coil.' 'Tibet really wanted to meet Rose,' Bee explains. 'And who the fuck wouldn't? She had an amazing voice, she was really gorgeous and she was a lovely person. If you met anyone who was famous, Tibet would immediately want to meet them as well. He was quite sharp; he knew these people could open his market up. Back then it was a big market thing to get Rose on your record.'

Other new players entered the fold: Hilmar Örn Hilmarsson, from Psychic TV's Iceland division, played drums on *In Menstrual Night* and Keiko Yoshida, who had interviewed Tibet for a Japanese magazine, sang a Japanese nursery rhyme. In addition to the 2,000 official picture disc LPs, there were 19 test pressings released in hand-painted sleeves. The test pressings were only done because Rough Trade, who had recently taken over the distribution of United Dairies, had convinced Tibet that it'd be a good idea to send out promos of the album. But they were all snaffled by collectors and later sold for huge amounts, making it one of the least successful promo campaigns in living memory. Still, they looked great, the Nurse-made covers had a broken bit of record on the front splattered with paint and a xeroxed group line-up shot on the back, whereas the Current one had various Catholic stickers on the front and a little plastic envelope enclosing a saints sticker, as well as a Crowleyan hexagram with Anti-Christ scrawled over the sleeve.

194

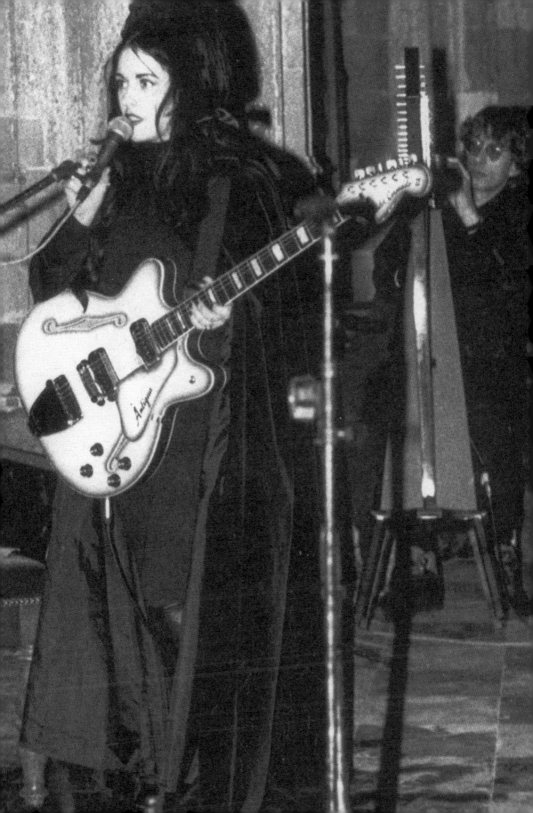

For Christoph Heemann and Achim Flaam the *Ohrenschrauben* compilation served as a great calling card to countless other musical outsiders, such as Asmus Tietchens, an electronic artist who had first cut his teeth in the ranks of the '70s avant garde, appearing on an album that the German duo Cluster had made with Brian Eno, as well as playing in the Kosmische supergroup Liliental alongside Okko Bekker, Conny Plank, Dieter Moebius and Stapleton favourites Kraan's Johannes Pappert and Helmut Hattler. Tietchens wrote to the duo to say that he'd love to contribute to any further Dom compilations, and as volume two – *Ohrensausen*, meaning 'a strange ringing in the ears' – was already in the works, they offered to include him. Stapleton had also made contact with Tietchens, releasing his *Formen Letzter Hausmusik* LP on United Dairies. That March, Stapleton and Rogerson set out once again for Aachen in order to meet up with Tietchens at Heemann's parents' house.

'We all ended up going into the studio together,' Heemann reveals. 'We recorded some stuff but Steve took the tapes home with him and now he says he doesn't remember taking them at all, so I guess they're 'lost'. It really wasn't that great, though. We first tried to do a piece by adding things track by track but that didn't go anywhere, as Asmus was really not comfortable working with other people and Achim and me were so inexperienced. So perhaps it's just as well that it disappeared.'

In August, HNAS travelled to London to stay at Rogerson's flat at 40 St John's Villas in Archway, London, where Stapleton was now living along with his friend Geoff Cox, a fan who'd written to him in 1983. Heemann and Flaam hailed from fairly conventional middle-class homes and they were both stunned when Stapleton took them back to the flat. There were fishtanks with what looked like prehistoric hangovers floating in them, walls painted in bursts of rainbow colour, shelves stacked with mannequin arms and body parts and pieces of hose protruding from the wall. 'One wall was completely covered with records,' Heemann recalls. 'Full of really amazing things. He played us so many records that we were completely unaware of at the time and there were a lot of drugs around, which I didn't really have too much exposure to at the time.'

Rose McDowall

'We 'shared' the house with an unwashed, emaciated and demented Indian who lived on the ground floor, literally knee deep in his own shit and hundreds of thousands of sheets of paper scribbled over with deluded ramblings and imaginings,' Cox remembers. 'The top floor sheltered a wizened old Irish alcoholic and his long suffering mentally deficient, much younger wife. Relationships with these were apt to become strained.'

'Cox was great to live with until we gave him acid,' Stapleton claims. 'He flipped out. We used to keep these creatures called axolotls in the aquarium, pink flesh coloured creatures with red gills. They're normally docile but if you stir them up they're incredibly vicious. Geoff loved them. He was always fascinated with bizarre creatures. He took acid and for some reason – I don't know if it was telepathic or what – he stared into the aquarium and the axolotls started killing each other in front of his eyes, eating each other and ripping their gills out. They had never done this before. They were flesh coloured and covered in blood,

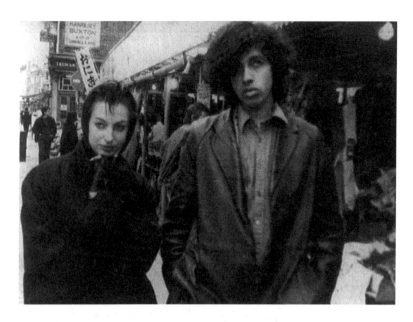

Diana Rogerson and Geoff Cox, Camden Market, London, 1985.

looking like the first creatures on earth and here Cox is, having taken his first LSD and we have to sit there with him, nursing him through it. After he came out of that trip he was never the same again, he became the eccentric he always was really. He spent his life researching extraordinary people but I think he actually became one himself after that.' 'The whole experience was a pretty dramatic introduction to the infernal world of LSD which left me a bit ravaged for a while,' Cox confirms. 'My memories in short: three minutes of ecstasy, three days of hell and a miserable month of the shakes. With the occasional reminder thrown in ever since.'

'While we were in London we wanted to go to IPS where Steve had made all his records,' Heemann continues. 'Steve then suggested that we booked an HNAS session there. After three days the music came together really well, we felt it was a big step on from where we had been before and Steve felt the same, he said he really liked it and asked if we would let him put it out on UD. We just fell dead! It was our favourite band and our favourite label! IPS was really inspiring though, the most inspiring studio I've ever been to. It was very dark, in the basement of a place in Shepherd's Bush, just two or three rooms that were all slightly decaying, it really fell apart a year after I was there. The engineer, Peter

McGhee, was really old school.' By coincidence McGhee had also trained up another engineer, David Kenny, who later went on to work for the British folk label Topic and in turn worked on several Current 93 and Nurse With Wound titles.

HNAS's *Melchior* came out of the sessions. It ranks as one of the label's best, an eerie minimalist classic that Tibet described in the press release as sounding like 'rowdy German schoolboys in the vein of Faust'. Heemann also played guitar on Rogerson's first solo album, *Belle De Jour*, although he went uncredited. Meeting her clearly had a huge effect on him, and her sweet vocal on *Melchior* – 'These are the boys in beige and blue/now what are they going to do?/They're always laughing and smiling and eating milk and chocolate/hello boys from Aachen!' – shows the feeling was mutual.

'Diana was really important to me but it was more of a spiritual thing, ideas about life, her whole attitude,' Heemann reveals. 'The fact that she took me seriously and talked to me in a different way meant a lot. She pointed out things about who I really was that I wasn't aware of. She told us about her films and music, and at the time I didn't know whether to take it seriously or not. It was hard to come to terms with for me because I had no exposure to anything like that before; I was just a completely untouched schoolboy who loved music. Diana told me I was sensitive and that I understood things and I had to build on that. She was really encouraging and that was the beginning of the end for HNAS because she made me aware of how different I was from Achim, I wanted to become an artist and he didn't. I realised that I could be an artist, that being creative was very important to me in my life. I still can't listen to any of those HNAS records though. They remind me of becoming aware of all those things that were unconscious in me before and of this unevenness between Achim and myself, where I couldn't be myself in the music. For a while HNAS worked, it was a struggle and we both felt challenged by it for a bit but after the fourth or fifth record the struggle became torture and it wasn't productive any more.'

Heemann also met Tibet for the first time while he was in London. He remembers being absolutely terrified of him. 'While we were over recording *Melchior* we went out on our second night there and there was Tibet, along with Balance. I didn't get to know him very well at the time. I found him intimidating. In fact, I was actually frightened by him. He looked really extreme, dressed in leather with his hair spiked with gel and wearing these huge boots that he liked to stomp about in. He did talk to us but I just thought, why is he interested in us? We're so boring... Plus my grasp of English was really poor so that was a handicap. In those days I couldn't make jokes in English and I only understood about half what they were saying and there were so many references, they were into so much stuff at the time: Rod McKuen, Roger Doyle, Univers Zero, Red Noise. Actually, at the time Tibet was supposed to be moving to Nepal and he was planning a goodbye party.' Once again, he only lasted a matter of weeks.

'I wanted to move to Nepal because I was becoming more interested in Tibetan Buddhism and the language and fed up with London,' Tibet says. 'I didn't know what I was doing with myself, it was the period when Current's music was really changing.' He travelled out on his own with nothing but an introduction to Charles Ramble, a friend of a friend who is now a lecturer in Tibetan. The reality of the poverty in Nepal hit him hard and lines from 'Horsey', recorded in 1989, reflect the horror of some of his experiences there. 'In Kathmandu/Tyre people drag bodies/Crippled for coin/sMan dKarl/People die for/They give up their lives for,' refers to a legless street person who dragged himself over to Tibet with the aid of an old car tire wrapped round his stumps, all the while pointing at himself saying 'sMan dKar', Tibetan for 'white medicine': heroin.

'I thought it would be like returning to Malaysia,' Tibet says, 'but it was very different.' Yet to a certain degree it was like being a kid again. He wasn't drinking much and instead spent his days touring the sights and visiting the temples. Bizarrely enough, being back in Asia brought out his English side and he'd scour the towns for greasy spoons where he could eat fried eggs on toast. 'There's a big split in me,' he confesses. 'I've never really known whether I was Asian or western. In some ways I feel 100 per

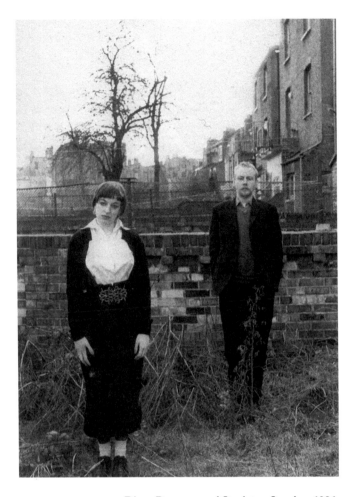

Diana Rogerson and Stapleton, London, 1986.

cent English, but in other ways I'm aware that I'm a product of a colonial family and was born and brought up in Asia.' So much of his work with Current 93 has been an extended eulogy to England and perhaps this has a lot to do with the fact that he's constantly wrestling with his own identity. Indeed his comparative outsider status makes it much easier for him to romanticise England and Englishness. This also manifests itself in a constant restlessness and an inability to happily settle anywhere. All through his life he has hatched plans to leave the country for Asia, Iceland, New York, Scotland...

Doubtlessly his trip was prompted by an increasing sense of creative aimlessness. He needed a change, time to work out what to do next.

*In Menstrual Night* had signalled both an end and a beginning and the following single, 'Happy Birthday Pigface Christus', represented a first thrilling step outside. Tibet was still immersed in *Forever Changes* and through his increasing friendship with Douglas Pearce he at last had someone capable of putting his vision to music. After priming Pearce with a copy of the Love album, they went to work. 'He was somebody whose music and voice I admired,' Tibet explains. 'And also he could play the guitar very well. Remember that neither Steve, Balance or I could actually play any instruments and because we were involved in the experimental/underground scene, nobody we knew could play any instruments either. None of us had any need to play an instrument but when I met Douglas I just thought... this is a whole new area to explore.'

Tibet's still ambivalent relationship with Christianity gave birth to an apocalyptic folk tune, wherein the gates of heaven open to reveal the gates of hell. 'Happy Birthday Pigface Christus' starts with Rose McDowall's nursery rhyme take on the lyric, sung to the tune of 'Silent Night': 'In menstrual night/When red is black/When Christus crawls from Mary's crack/Wrapped in tatters and flailing in mud/Child defiled with tears and blood...' Rose made the session despite breaking three of her ribs the night before after falling out of a tree on Hampstead Heath she and Bee had been climbing while on Ecstasy. Tibet picks up the refrain above a martial drumbeat and some tough acoustic guitar. 'Happy Birthday...' is the first Current piece to work within a conventional structure and the recording is very much the birth of Tibet as a distinctive vocalist. Naked without the usual soundscapes, his vocals are much more precisely enunciated and emotionally unguarded.

'I was very interested in Christianity then,' Tibet recalls. 'But I had an uneasy relationship with the established church and the Christian canon on the basis that the truth is always hidden and is never manifest. You always have to go into the discarded and the hidden to find it, hence my attraction to apocalyptic and apocryphal literature from when I was a child.' But 'Happy Birthday' feels much more venomous than that, more like an attempt to purge himself of all the remnants

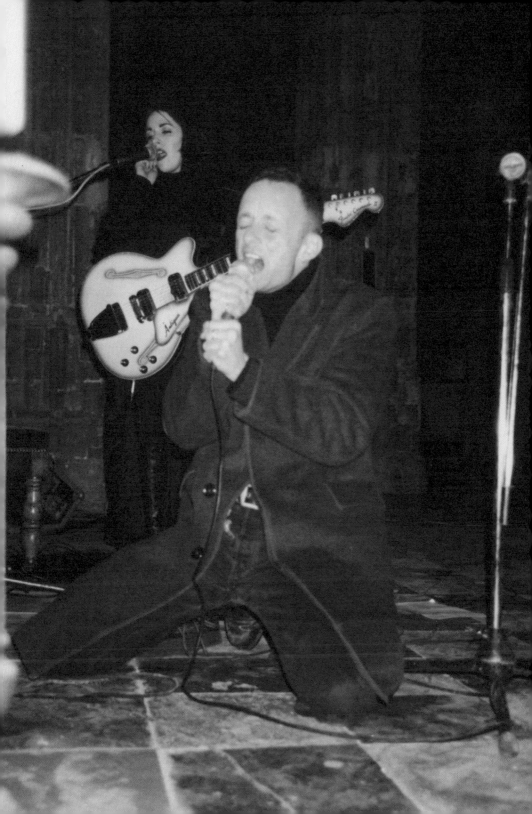

Freya Aswynn and friend.

of his Christian belief. 'Absolutely,' he agrees. 'But it only proves how obsessed I was by it. If you don't care about it, then obviously you wouldn't come out with titles like that. The Crowleyan structure sort of threw it into relief for me. There was someone who absolutely hated Christianity and could never shake it off. He had been brought up in an extreme, fundamentalist Christian sect and always claimed that he was there to overthrow it but he didn't. There are some things that one can't shake off.'

Tibet was similarly unable to make a clean break from his older working practices, and Current 93 took a last step backwards with *Dawn*, a tape piece on his new label, Maldoror, that combined peals of church bells over crunching electronics and some of his and Balance's by now slightly predictable apocalyptic monologues. Having already soundtracked the end of the world, any further footnotes seemed pointless. 'It was just so lazy,' Tibet admits. 'Terrible. I said to Steve that I'd put him down as mixing it and he said, I don't want my name on that record.'

By this time Tibet's interest in the genealogy of nursery rhymes had led him way off the beaten track. From the folk tales of The Brothers Grimm he went on to immerse himself in the traditions of Northern Europe, all the way back to their pagan roots via Norse mythology, The Eddas and the study of the Runes. Hilmar Örn Hilmarsson encouraged Tibet's burgeoning interest. More importantly, he introduced him to Freya Aswynn, a dedicated priestess of Odin and one of England's leading authorities on Norse mythology and magic. She also had a spare room in the house she owned in London's Tufnell Park, and very soon Tibet was ensconced in her former Odinic Temple, which became his bedroom.

In Norse myth the goddess Freya was said to receive the souls of slain warriors and feast with them after death. Appropriately enough, the earthly Freya received some damaged characters at her flat. 'It was a huge and somewhat dilapidated structure, full of a bizarre and everchanging assortment of bores, schizophrenics, megalomaniacs, drug fiends and even some geniuses,' Tibet remembered in his sleevenotes to The Aryan Aquarians' *Meet Their Waterloo* CD. Douglas Pearce moved into the room next door while along the hall there was a tenant who claimed the crown of Norfolk, apparently as a descendant of the King Of Wessex, and who also made replica Arthurian swords. Ian Read, a musician and student of the Northern Mysteries, lived at the other side of the corridor and he and Tibet were quick to hit it off. Read later described Tibet as 'the kind of Christian even a pagan could respect'. Read later appeared on *Swastikas For Noddy* and played in both Death In June and Sol Invictus, before forming his own group, Fire + Ice, in 1992.

'The house was full of complete crazies,' Rose McDowall remembers. 'Each person in the house was either a member of a coven or a healer or a creep pretending to be a healer. Still, Tibet and Douglas Pearce were two of the biggest crazies. One night we were all getting pissed on vodka and Tibet decided to make a pyramid of all his Noddy collection, pour vodka on it and set it on fire. The whole place almost went up. Meanwhile Douglas was convinced that he was being stalked by wolves, he would constantly see them staring in his window.'

Soon all sorts of rumours spread about the occult goings on. While he was living there, Tibet had a brief affair with a girl that he had first known while still in Newcastle, Lorraine Love. 'I remember sitting in the Tufnell Park flat with Tibet while a woman bared her chest and cut symbols into her flesh while chanting to Odin or someone,' she deadpans. 'There was another time where Tibet's friends were all sitting around having a cosy chat about Nazi memorabilia while some racket played in the background. I felt quite uncomfortable and out of place with them all. I remember wishing I'd gone to a gay disco instead.'

For all her powerful aura Aswynn was endearingly unworldly. Once, when attempting to use one of the house's two bathrooms she was stopped from entering by one of her flatmate's boyfriends, who explained that she shouldn't go in because his girlfriend had 'a really bad habit.' 'What do you mean?' she roared, 'Does she fart in the bath?' before pushing the door in to find the girl unconscious on the floor with a needle in her arm.

'I used to see this dark figure out the corner of my eye following me around,' McDowall relates. 'Every nine years it would return and I told Freya about this and she said that the number nine was Odin's number and asked me what the figure looked like. She became convinced that I was being shadowed by Odin and she started running round the house, stomping her feet and screaming "Odin you bastard! I'm your wife and you never appear to me!" I was just thinking, maybe you shouldn't swear at him.'

'When Tibet was living at my place his friend Hilmar was an Asatru priest so I began chanting the runes to show off,' Aswynn remembers. 'Hilmar looked at Tibet and said, 'You should record this'. I thought they were taking the piss. But Tibet was the first one to record these chants and he has contributed a lot to my success as well as my further spiritual understanding. He is a catalyst. Whenever someone with hidden potential crosses paths with Tibet, something happens and their consciousness is changed.' Aswynn's chanting eventually appeared on *Swastikas For Noddy* and her invocations 'to curse the fuck out of whoever was in government at the time' would open many Death In June shows.

The house's many dazed occupants attempted to live as communally as possible, with only Tibet exempt from the cooking rota because he was so hopeless. Aswynn always stood in for him. 'He was absolutely lovely and very loyal,' she says. 'But he never did any cooking. Once his mum showed up and she cooked for us all instead.' 'We got on very well,' Tibet remembers. 'Freya is a really lovely person but it was a totally bizarre place to live. She would occasionally come down and do some invocations at two in the morning if she was in a frisky mood, just start banging a drum and invoking Odin, maybe cut a rune into her body. They were interesting times.' There was a regular stream of visitors to the house, with Stapleton & Rogerson, Rose McDowall, Bee, Annie Anxiety and HÖH all living locally.

There were also a lot of drugs. Tibet was charging around on speed cut with acid, going sleepless for so long that he was regularly hallucinating. One night, perched on the roof of Rose's flat in Muswell Hill, chewing his own face off, he saw a vision of Noddy crucified in the sky over London. 'It really impressed me, as you would expect,' he told me, back in 1997. 'The next day I just went mad for buying Noddy. Before I'd seen him crucified I wasn't any more interested in him than any other kid who's read Noddy as a child. I was taking such a huge amount of speed at the time that I had a massive amount of energy, so I just started hoovering around and would come back with bin-liners full of anything with Noddy on. Rugs, mugs, jugs, didn't matter, bought it all, to the extent that I started wandering round London wearing a red Noddy hat with a bell on the end. Which was probably not a good move in terms of fashion... I was very keen on Noddy.' From this initial revelation, Tibet put together the basis of a deranged 'puppet theology', wherein Noddy, symbol of worldly innocence and the relative idyll of childhood, was suffering until the end of time for the sins of the adult world. This became the groundwork for *Swastikas For Noddy*, the landmark 1987 Current 93 album where Tibet shed the last lingering associations with his 'Industrial' past and began his headlong plunge into 'apocalyptic folk and menstrual minstrels'.

'For me,' Tibet continued, 'Noddy was the total epitome of innocent childhood. What would be the most unsuitable thing you could give to

Windowsills for Noddy. Tibet's room, Tufnell Park.

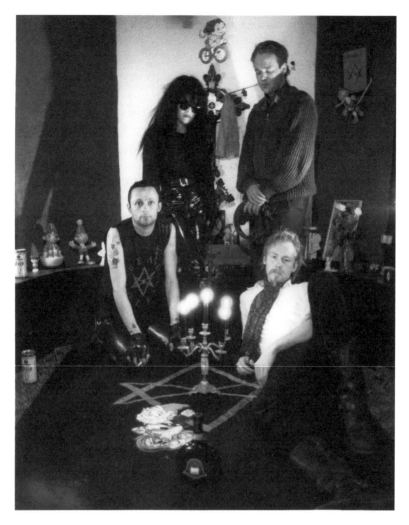

Current 93: *Clockwise from left* Tibet, Rose McDowall, Hilmar Örn Hilmarsson, Stapleton, Tufnell Park flat, London, 1987.

Noddy for a present? I felt probably swastikas. It then became *Swastikas For Goddy* on some releases because I started thinking that Noddy was – er, I was taking a lot of speed at the time – that Noddy was in fact a Gnostic icon. This was round about the same time I became interested in Punch and Judy and was seriously thinking it might be worth... I mean, I probably wasn't well at the time mentally, but having decided

that Noddy is a Gnostic deity, then it's a small step to thinking that I might as well worship Punch and Judy. Having been obsessed by Christ for so long, and since Noddy had appeared in the sky crucified, and since Christ was God, therefore Noddy was also God, so he was a Goddy. My mind started going into other ramifications – a whole puppet theology.'

In the meantime, Marc Monin of Laylah Records invited Tibet to record a solo album in Belgium. In a bid to escape the increasingly heavy scene in Tufnell Park, Tibet managed to convince HÖH and his friend James Foster (Foz), of The Monochrome Set, to travel out with him. 'When we realised we were drinking on waking at seven in the morning, we knew we had to get away,' he continued in the liners to The Aryan Aquarians' *Meet Their Waterloo* CD. 'This desire was compounded massively by the fact we were both sick to death of meeting people at Freya's flat who claimed to be the reincarnation of Crowley. They were all living in squats, were on the dole, and had no girlfriend – not, I think, a likely state for The Beast to choose for his next sojourn here. Total collapse would ensue if we ever heard the phrase 'sexual magick' again.'

HÖH takes up the story; 'Anyway most of the girls who came around to the house in Tufnell Park were committed Goddess worshippers called Galadriel and looking for something meaningful and spiritual, neither of which could be found in those two dregs of humanity who spent most of their time lying on the floor moaning and arguing about music. The ongoing and epic drinking in David's basement was usually spiced with the loony de jour who might be the reincarnation of AC, a direct descendant and spiritual heir of King Arthur who had just deciphered Malory (sic) and divined the whereabouts of Excalibur, the King of the Witches or a permutation of all three. I remember being impressed by David's encyclopaedic knowledge of obscure '60s bands, an area of which I fancied myself an expert, and recalled being horrified and amazed in equal measures by the fact that he could make a pitch perfect rendition of every guitar solo I could mention. The combination of 60s nostalgia and encounters with people who would have been so supra-normal in the heyday of Gandalf's Garden got to us in the end and we started to speculate about the greatest band there never was,

Tibet with Noddies,
Tufnell Park, 1989.

invented a background replete with pompous songtitles and bogus mysticism, and thus the first seeds of the Aryan Aquarians were sown.' The result was the truly witless 1986 Aryan Aquarians' album *Meet Their Waterloo*. To damn it as 'Industrial disco' would give it too much credit. It's an irredeemable mess of cheap Casio drum machines, weepy country-tinged new wave ('My Secret Gardener', featuring Niki Mono's excruciating sub-Diana Rogerson crooning) and the sound of drunks pissing away studio time. 'It was, unfortunately, the worst album I had ever been involved in,' Tibet admitted in the liners of the re-issue. Sometimes the drugs really don't work.

'*Spiral Insana* reduced me to tears,' confesses Edward Ka-Spel, Stapleton's longtime friend. Undoubtedly. It is one of Nurse With Wound's most powerful records: thick with an elemental melancholy, the desolate set is characterised by vivid, serpentine electronics. Despite

Tibet, *Swastikas For Noddy* photo shoot,
Brookwood cemetery, Surrey, 1986. (both photos Ruth Bayer)

his avowed desire to detach himself from the music-making process, all Stapleton's records are autobiographical to a varying degree. But this one feels particularly close to the bone.

Ironically, this most personal record was born of his first ever recording deal. By the mid-80s, The Legendary Pink Dots had signed to Torso Records, who offered to pay Stapleton £3,000 worth of recording costs up front – a huge advance for them at the time. Still, the pressures of delivering music according to a contract complicated the process. 'Every three or four weeks, they'd send a representative over to listen to what I had done so far,' he relates. '*Spiral Insana* was a sprawling mess until I put it together and edited it into what I wanted it to be. So if you play someone a bit of it and they were trying to assimilate it, they couldn't do it. It was a fucking mess. So they were really disappointed with me. When I finally finished it I was really chuffed. I liked it a lot but I don't think they liked it very much.' 'The use of drugs definitely

93 CURRENT 93
BM WOUND
LONDON WC1N 3XX

2.15 am Wodensdag

On bended knees
We pray for war
A blade drinks blood
But often tarnishes
Through blazing eyes
I see new sunsets
The sky now breathing
Different shades of red
I beg for plagues
of blazing locusts
I call for battles
To wet the earth
To cover the world
In blackened broken
In blazing stubble
With church bell wars after IX°O/O

The Final Church Of The Noddy Apocalypse

impacted on Steve's music,' Heemann claims. 'I think his music really changed when he stopped using hallucinogens, which was around when he moved to Ireland. *Spiral Insana* was maybe one of the last ones he did like that and you can really hear it. I think after that he had one terribly frightening experience and that made him stop.' Before *Spiral Insana*, Stapleton had cut his most drug-influenced and disturbing work. First released as part of a split LP with UK drone outfit Organum, *A Missing Sense* was originally conceived as a private tape to accompany his experiments with LSD, modelled on the American composer Robert Ashley's eerily beautiful *Automatic Writing*, an experiment with recording and mutating involuntary speech. Ashley's recording used to be the only music Stapleton could listen to while tripping without feeling claustrophobic. By way of giving thanks, he set out to make his own version, incorporating the sounds of his immediate environment. Designed to be played at a barely audible level, it's a frighteningly powerful piece that uncannily takes over whatever space it is playing in. Stapleton talks of how Ashley's *Automatic Writing* blended perfectly with 'the breathing of the building', when he played it late at night. *A Missing Sense* has that same ability, as the crackle of fire and the creak of wood combine with its incessant murmuring.

Tibet finally called a halt to his own increasing use of amphetamine after one too many blurred nights at London Goth HQ The Batcave in the company of Rose, Marc Almond and Kris Needs. The last straw came one Wednesday when he staggered home to re-read all the amazing ideas he'd jotted down in his notebook during the evening. His 'writing', a childlike scrawl impossible to decipher, had been executed with such force that it had indented right through the pad. 'I said to myself, this obviously isn't constructive any more,' he admits. But a few weeks after he made the decision to give up speed he fell seriously ill.

That morning he'd risen early and headed for town. It was only when he reached Tottenham Court Road tube station that things began to get weird. All of the tiles on the walls started to blur into each other, triggering a massive panic attack. A passer-by luckily came to

his aid and managed to get him above ground and into a taxi back to the Tufnell Park flat. Once home he lay helplessly in bed, soaked in sweat beneath wave after wave of panic. 'It was like the anti-orgasm,' he remembers. 'It would start at your feet and just rush through you, like massive waves of electricity. At the time I had no idea what it was and the after-effects lasted for years. One of the things I had was pins and needles over my entire body, along with complete body dislocation, not being able to get through doors without hitting the sides.' Over the next few months he saw several doctors. The first asked him if he had been hearing voices, obviously suspecting a mental breakdown. Another gave him massive doses of Vitamin C injections and then advised him to go on a grape diet. A homeopath said it was connected to the fallout from Chernobyl and someone else diagnosed it as myalgic encephalomyelitis (ME).

'I think all of them were connected,' Tibet maintains. 'It was an absolute nightmare but I didn't have a name to pin on it. I would have these terrifying dreams where there was something sitting on my chest and it was so hard that I thought I was going to go through the bed and right through the floor. Every night I'd go to bed thinking it was going to be okay tomorrow. For someone whose work is so pessimistic and melancholy I'm just an incurable optimist.' Tibet's psychotherapist today believes that it was indeed a mental breakdown, though Tibet himself has a more prosaic explanation. 'I now think it was brought on by overwork, amphetamine, drink and demons. I think I was being attacked by demons. It's just like Nietzsche says, if you stare too long into the abyss, the abyss will stare back into you. My interests were dark. I was an arrogant, cynical, interesting and funny person but the balance was wrong. I believe absolutely in the intrinsic existence of Satan and demons and just as often as people like to party with them, they like to party with us.' As he sang on 1994's *Of Ruine Or Some Blazing Starre*: 'This was the stage of reading the blackbooks.' He thought he was going to die and it was in this frame of mind that he entered the studio to record one of his most melancholy works, *Imperium*.

Side one of *Imperium* combines an imaginative approach to loops with dilatory tapes of Celtic harp, the slow dance of distant foghorns and

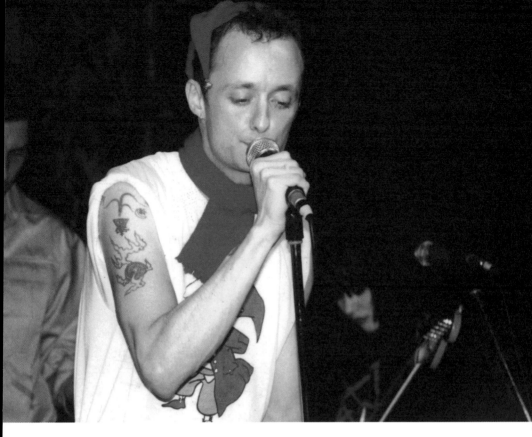

some tactile acoustic guitar. On 'Imperium 2', upsettingly clear-eyed lines taken from the Buddhist text The Dhammapada like 'Some die old and some die young/Some in the very prime of life/All people pass away in turn/Just like the fall of ripened fruit/As all ripe fruit/Always falls and rots/So all who are born/Are always by their deaths destroyed,' recall Shelley's lugubrious 'Mutability' from 1824: 'The flower that smiles today, Tomorrow dies, All that we wish to stay, Tempts and then flies... Whilst yet the calm hours creep, Dream thou – and from thy sleep, Then wake to weep.' Pearce drove Tibet to the studio each day where he would lie on the couch and direct proceedings from within a fog, as pins and needles danced around his body. 'Tibet didn't tell me he was very ill straight away,' Tony Wakeford, who played bass on the record, recalls. 'But after we completed the recording he told me he thought he might be dying. I think that really permeates the record looking back on it. It was pretty intense.'

After the recordings were finished Tibet, ill and exhausted, dragged

himself over to Iceland, in theory to record a jingle for a soft drink called Svali. Hilmar Örn Hilmarsson had talked Svali into flying over Tibet, Rose and Foz and covering their expenses with the hope of getting them to record some music for a new advertising campaign. Inevitably the recording never took place but Tibet had a great time in Reykjavík with Hilmarsson and his wife. He also got the chance to reacquaint himself with Kukl's Björk and Einar Örn, who had just become The Sugarcubes. From the airplane window, Iceland looked like the surface of the moon, all pockmarked with little volcanic craters. When Tibet got to Hilmarsson's place he turned on the tap and the water smelt like rotten eggs due to the high sulphur content. It was like being in a children's fairy story and as usual Tibet immediately made plans to move there. 'The Northern Lights were the most hallucinogenic things I've ever seen,' he recalls. 'Everything was just so clean and fresh and beautiful and expensive. It affected me on every level and I fell completely in love with it. I have an obsessive personality. If there's someone whose work I like, I want to meet them and I want to work with them. If I go to a country and like it, I want to move there.' He got himself a place on a street, Lokastígur, near the cathedral and used it as a base for a few months, all the while commuting back and forth to London. He also inquired at the Icelandic University about the availability of courses in the Icelandic language but it seemed phenomenally difficult to learn and besides, he wasn't in the best of states, both mentally and physically.

'The trouble is I've got a short attention span,' Tibet confesses. 'I loved it there but I couldn't work there because Steve and Douglas weren't there and they were the people I was working with. At that time they were both my closest friends. I was missing my friends and missing working. I often do these things just to release pressure. They are ways to revivify and think about what I'm doing. Iceland was also very expensive and I started running out of money so I needed to come back and put an album out.'

Coil, meanwhile, had begun their second album, *Horse Rotorvator*, in early 1986. The title references Balance's nightmare vision, which was

brought on by the horses that were blown up in Horse Guards Parade at the height of the Irish Republican Army's mainland bombing campaign. He had developed a corresponding obsession with the horrors of war and – in true paranoia-critical fashion – his phantasm mind was bringing on psychosis. One night he had a vision of the four horsemen of the apocalypse slaughtering their horses and using their corpses as earth-moving machines.

It may have been triggered by residual memories of a touring holiday Balance had taken as a child with his parents. While climbing in the mountains, way off any map, they had been caught in a thunderstorm and forced to take refuge in a large white church. On the wall was a mural of the four horsemen of the apocalypse illuminated in lightning. Balance became convinced that if his family touched anything or even got wet they'd be electrocuted and he spent an hour in frozen terror. When he was very young, he would worry that the static in his bed sheets would set him on fire. The cover of *Horse Rotorvator* is a shot taken by Balance of a bandstand in Hyde Park that had previously been blown up by the IRA. Balance had also become interested in places where something traumatic had happened, where you could still detect the weight of an aura.

*Horse Rotorvator* dealt with death and regeneration against electronically collaged Mexican Day Of The Dead horns, Morricone-like soundtracks, smoky Middle-Eastern drones and queered electronics. It was very much an album about endings, about 'crossing over'. 'Everyone says that's our best album,' Balance asserts. 'It's probably our most realised album in that we'd got over the anger of the first one and settled into a more pastoral or twisted lyricism. I got a bit more confident with my vocals and the themes had blossomed. We'd just been to Mexico and we'd seen how Mexicans deal with death. That's really what influenced me with the lyrics and stuff, how sacrifices were made so the world would keep turning. That's how I saw a lot of the people I knew who were dying of AIDS at the time, that's how my mind could deal with it, by believing that they'd died to keep the world turning.'

For the track 'Ostia (The Death Of Pasolini)', a rumination on the violent death of the Italian film-maker Pier Paolo Pasolini full of vivid imagery like 'You can hear the bones humming, Singing like a

## "OSTIA"
### "THE DEATH OF PASSOLINI"

also "and the car
reverses over
the white cliffs of
Dover"
into the sea / the sea
of Rome!

HOLLARIO WHO WILL GO AND
stick! "Go tell the bees
the Eldest son must tell the bees"

("! STRINGS !!")

WEDS

vocals to be done after Bills
stings are to be on/.

☑ Do excellent tender 'morrisy'? vocal
demo over weekend

☑ Perhaps to be followed by "PENATRALIA"
∴ link street End noises to
ghettoblaster / radio effected beginning for ⬆

☑
DOUBT? on a few tremelo-shimmering
Light but potent guitar stecims
like 12string acoustic sounding
shimmer in low position in total overall
picture - Nice touch! to offset dominant STRI

● Do a complete string INSTRU. VERSION
for 2nd or outake LP.

~ ADD DRUNKEN MARCH MUSIC 'ACApulco' tape
at the End — STRAIGHT !! — maybe then go into
"PENATRALIA I & II"

Bees.

Intro. tape of 'chitzen - Itza at 'Night .
• Acapulco Drunk funeral.

faster tape - to a long slow fade out .

pos.    behind your head
in stereo speakers!!!

• FINISH VOCAL GENIUS !!! —

• ↓ Keep it similar to first lines except for 'keep it tilted
to keep the world turning' — pitch it right .

•

puncture, Killed to keep the world turning', Coil built an atmospheric backing track from heavily processed acoustic guitar and slashing strings that bled into a recording of massed grasshoppers made while visiting Chichén Itzá in Mexico. Of all the tracks on *Horse Rotorvator*, 'Ostia' took the most work. 'Ostia was a matter of encouraging Balance to sing and keep trying again when he seemed discouraged by his own technical limitations,' Thrower remembers. 'And then Billy McGee's string arrangement made the backing track come alive. I can't stress how important he was to the sound of the finished work. Sleazy programmed a sampled acoustic guitar into a melody line that changes and varies over several bars rather than idly looping after a few seconds. He used a sort of sculptor's technique, programming a random sprawl of hundreds of notes and then cutting back and winnowing out until a form emerged. "The First Five Minutes After Death" and "Dark River" were written in this way too and to me they're three of the strongest Coil songs.'

Pasolini was another of Coil's many subversive touchstones, someone who spent his life pursued by the authorities, the Vatican, fascists and anarchists and who yet held fast to his own vision through a series of often harrowing books and films. He died in mysterious circumstances, possibly murdered by a rent boy. Derek Jarman had also been obsessed with Pasolini and at one point developed a bit of a Pasolini complex. He would often talk about shooting a film in which someone broke into his flat in London and tried to kill him and he went so far as to play Pasolini in a student film production called *The Death Of Pasolini*. Once again Coil were asked to provide the soundtrack but they weren't impressed with the film and refused.

By 1986 the first post-hardcore wave of American guitar bands, such as Swans, Big Black, Sonic Youth and The Butthole Surfers, had finally impacted on British audiences, and both Balance and Thrower were particularly obsessed with The Butthole Surfers' guitarist Paul Leary. 'His stage self was just this totally fried acid-drugged spazz skinhead who could just suddenly push the whole heaving racket round the u-bend and up to the heavens,' Thrower relates. 'The most ghastly comical wronghead catastrophes would turn blissful and magical and he was the handsome fucker that pulled you through – all this in the space

of one facial expression or lead burst – before launching into gnarled human train-wreckage again.' The Buttholes' influence is transparent on 'Penetralia', which Thrower describes as their "freakout" recording, with huge slabs of sampled guitar noise almost derailing the crack of the drum machine. 'I wanted to bring some saxophone into the record somehow and this track had an open, anything goes feel which was perfect for dredging some extreme guttural snarls and bellows from the reeds,' Thrower continues. 'We were getting a lot more actively into the use of the studio for composing pieces. Balance had located some monstrous sample of Spanish tap dancers clattering away en masse that we whirled around and processed to send blurs and trails out from the song.' Indeed, *Horse Rotorvator* has a pan-cultural feel, with the group drawing on everything from austere Eastern Bloc marches through South American exotica and Asian skin flicks.

'We were very keen to draw in sounds from different parts of the world,' Thrower admits. 'There were a lot of jokes between Jim Thirlwell and us about the 'Coil World Tour'. Not with that gruesome 'respect' that 'world music' claims to have for ethnic sources but with an impulsiveness and a drive to open doors between our British selves and our race memories, insinuations of other places. I know there's a debate about exoticism being exploitative but that's bullshit.' Indeed there was a lot of humour in the way Coil played with these kind of dialogues, with tracks like 'Circles Of Mania', where Balance, preceded by a tape of an announcer from the NYC sex club The Adonis Lounge cueing his next act, takes his place in the spotlight for a grotesque vocal amidst Thirlwell's burlesque stylings. Thrower describes it as the moment when 'Britain and the Brit singer and his manias become another performance on the world stage.' The cover of Leonard Cohen's 'Who By Fire' came together quickly, with Marc Almond laying down his vocal arabesques in one take, behind Balance's finely poised vocal. Cohen's conflation of personal and Biblical apocalypse suits the mood of the album well. There are lots of tiny illuminating details in the mix like the doubling effect on the line 'Who in this mirror?' and the way the sound smears for the line 'Who by something blurred?', an improvised line to cover for the fact that they were unable to make out what Cohen sang in the original.

(5) "THE ANAL STAIRCASE"

MOON.
Radical Rhythm mix
new vocals.

"NIETSCHEAN
HIP-HOP "

● Rethink LYRICS and vocal delivery.

● go for. Sherwood type Rhythm intricacy
and inventiveness — SPACEACID DUB —
the Panic/wheel 12" mix stuff.
● AMS triggered percussive outs and
shrieks as part of vocal — also strange Radio
Speaker Sound TINNY TINNY delivery + short
staccato normal vocal + Chorus Rottenesque bit —
then treat and spinoff into hyperspace — the
last vocal section ——— vocal/voice as Synth Swoops etc.

! MAKE AS massive as PENATRALIA !

● ANY more source tapes. esp.
"Hes a good Lad He is" — video perv +
Sleazy NS " HERES JOEY"

■ Stabs of ultraheavy feedback guitars Hip Hop
Hopeless noise case.

■
    Really Push it - in every way.

■ Do an ultramix -Radrall everything -See
what the new Equipt is capable of.

■ [PhLange] everything - all drums INC at
some point in the Song - ACID CHURN.
update there Facky 70's effects.

● USE MOON
● use 'he's a good lad he is 'tape + analysis  Blonde
● Possibly use EMU scratch Sounds on This.
● tape 12" Power Drill and Run DNC LP to Session.
● use triggered words - phrases -done in Mixing Room.
● Extensive drum Sound stuff. overdose Scratch Sounds
EMU sleazy Samples.

The single 'The Anal Staircase' presented a torrent of effects, cut-up rhythms and disparate imagery, from initiation rites and Kundalini to – obviously – anal sex. "The Anal Staircase' was a hard track to mix,' Thrower recalls. 'It eventually got finished at a session I wasn't at, although it had been shaped and twisted by all three of us before that. It was one of those pieces that had a certain thump and grind to it and it required some heavy duty technical work to make the most of it.' Like a previous track that had utilised 'suspect' tapes provided by a Dutch fan that so disturbed the engineer that it was dropped during the making of *Scatology*, 'The Anal Staircase' again worked in some purposefully ambiguous tapes of boys playing around. It was enough to disconcert John Peel who reputedly called up Balance and Sleazy to make sure they weren't using 'The Moors Murders tape... I've got a family, you know'. 'Slur' features one of Balance's greatest early vocals, a circular hymn to world creation and destruction that's as fevered as a passage from *Maldoror*, referencing sci-fi visionary Philip K Dick's psychotic visions of Imperium over the sound of storms and bone percussion. 'Slur' had originally begun life with a proto-typical Stranglers bass line (this version turned up on a Coil compilation, *Gold Is The Metal With the Broadest Shoulders*) but for *Horse Rotorvator* Thrower and Sleazy wanted to escape that whole feel and radically re-worked the bass part. 'Balance's lyrics were delivered over this new version and I thought this was the most successful vocal performance I'd heard him deliver to that point,' Thrower states. 'It helped that his lyrics were very strong, with a definite structural power to do with echoes and repetitions and reiterations. It's still one of my favourite Coil songs, largely because of the vocal performance. I added some weather effects, thinking more like a Foley artist than a musician.'

With its booming percussion and 'ride into the sun' Morricone stylings, 'The Golden Section' is the album's centrepiece, where the BBC's science correspondent Paul Vaughan expands on the Persian Sufi poet Rumi's views on death and transfiguration. 'To him it was just another job,' Sleazy relates. 'Come in, read it, read it again, go. At that time the voiceovers he did were for things like *Horizon*, so his voice had overtones of scientific 'respectability'. There was the underlying feeling

that what he said was demonstrably true. We think those kinds of ideas and theories should be given credence as much as any other scientific formula or theory.'

In 1986, Thrower was working in the original Forbidden Planet store on Denmark Street. A far cry from the supermarket it has since become, the FP of old was a place where you could hang out for hours, piled high with overflowing boxes of comic books and pulp novels and staffed with a team of eccentric and highly enthusiastic fans. As well as being an obsessive fan of horror cinema, Thrower was an avid reader of horror fiction and it was through the recommendation of the writer Ramsey Campbell that he first came across the work of Clive Barker. 'I read Clive's books and was bowled over,' Thrower recalls. 'They were an amalgam of horror motifs drawn from previous traditions and very daring, provocative and sexualised elements which had been cloaked or even ignored before. Without being that selective about it, I instinctively

*Horse Rotorvator* photo session, Chiswick Park, 1986: Thrower, Balance, Sleazy.

(photo Lawrence Watson)

knew that he was queer. Big deal, you might think today, but in those days it was still quite an unusual experience to encounter someone working in the mainstream whose sexual identity offered enough clues to convince you he was queer.' Sometime that year Barker dropped in to Forbidden Planet and got chatting with Thrower's friend and co-worker, Alan Jones, whose film reviews in the UK fantasy journal *Starburst* were for a long time the only source of information on obscure Euro sleaze and horror. Thrower introduced himself as a big fan of Barker's work, citing a couple of his more overtly homoerotic titles as his favourites, like 'Pig-Blood Blues', a highly sexualised account of a sacrificial cult at a boy's Borstal. 'Being young, opinionated, very shorthaired, and a fan to boot, I think I made a favourable impression on Clive and we ended up going out for a drink together,' he continues. 'Our friendship developed as we were both very intensely in love with the horror genre, and we spent many enjoyable evenings talking about our various passions in the horror field. I also remember that Clive enjoyed describing the filthier reaches of gay porn to me, as I was still craving to see something of that world. Clive was definitely up for it, sexually, but despite numerous opportunities we never took that route. We ended up as friends who shared a taste for the macabre and whilst there was sexual tension in the air, Clive was always willing to engage with me as a friend and I never exploited his interest.'

When Thrower first played Barker *Scatology*, he was particularly struck by the coded erotics of 'The Sewage Worker's Birthday Party' and 'Cathedral In Flames'. He was later quoted as describing Coil as being 'The only group I've heard on disc whose records I've taken off because they made my bowels churn'. Thrower immediately set up a meeting and Barker visited Coil in Chiswick shortly after. He particularly hit it off with Sleazy, who shared many of his obsessions and they spent most of the night thumbing through Sleazy's collection of gay pornography drawn from the darker end of the spectrum. Thrower insists that his interest was more than merely that of a dilettante. 'It was a real fascination that led to him poring over Sleazy's magazine collection,' he states. 'There was nothing so weird or perverse that Clive

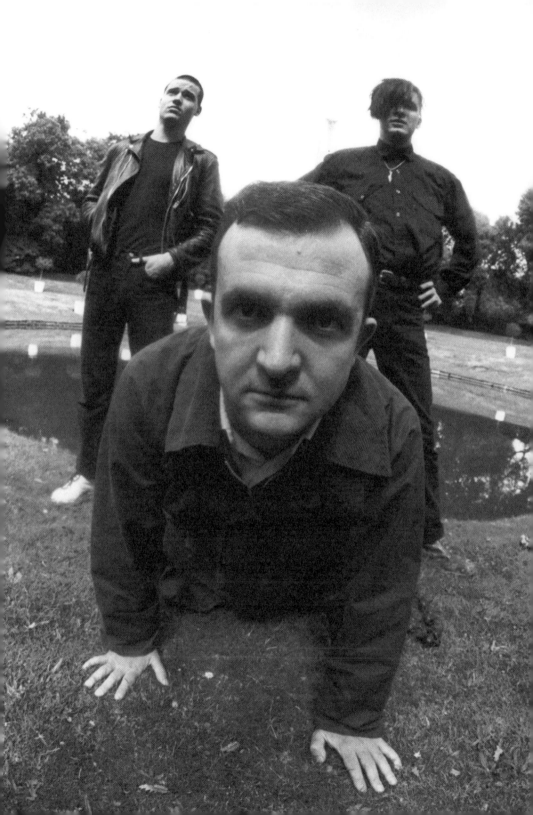

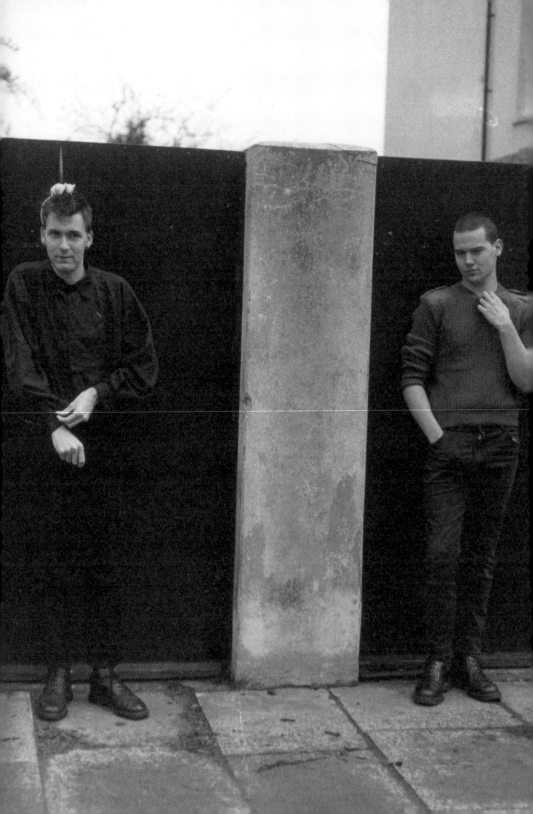

wouldn't find it interesting. What really fascinated him was Sleazy's collection of hardcore piercing mags from the USA, like *Piercing Fans International Quarterly*. They would run pictures of extreme genital piercings, images that were totally underground at that time, weird stuff like penile bifurcation and multiple cock piercings. Clive stored all this away mentally and it came out in the imagery of *Hellraiser*. He used to joke that he wanted to call the film *Sado-Masochists From Beyond The Grave!*'

'Clive obviously fancied Steve,' Balance insists. 'And Steve certainly encouraged his patronage, bright and enthusiastic in his delayed euphoria, showing him everything. Clive obviously became a bit of a mentor for him, maybe more of a tor-mentor. Clive came around to ours a couple of times and stole all our ideas. We showed him lots of S&M mags that he took a lot of his characters from, like Pinhead.' In the mid-80s piercing still hadn't reached the mainstream and as such it represented the initial stirrings of a miniature sexual revolution. Sleazy even got a picture of his dick printed in *Forum* magazine, where no one had ever seen pierced genitals before.

In *Hellraiser*'s original form, entitled *The Hellbound Heart*, the film was very English, based in an old house in North London beneath the loom of grey flyovers, all executed with crude special effects. After meeting Coil, Barker revised his original screenplay to incorporate S&M elements they had exposed him to. In return he asked Coil to do the soundtrack. Initially they provided a rough cassette of stuff for Barker to play on the set to get his actors in the mood. But midway through the shoot American distributors New Line decided they wanted something else altogether, and Barker had the choice of making do with what he had in the can or acceding to their wishes in return for a bigger budget. Suddenly Coil were out.

'At which point he sold his soul really,' Balance maintains. 'Signed in blood on the dotted line. The whole thing became Hollywood with lights coming up through the floorboards and all this 'come to daddy' stuff. He took the money and made a successful career out of it and we didn't.' Thrower isn't quite so damning. 'In the early rushes the special effects were definitely substandard,' he says. 'The initial design

Promotional cards for *Horse Rotorvator*.

of the resurrected Frank was quite crude. New Line's producers flew over from the States halfway through the shoot and saw the rushes. Before that I think they regarded the film as a cult item with limited commercial appeal. After they saw the first half of it in rough cut they realised that Clive was making something with mainstream appeal. Unfortunately they then made him an offer he couldn't refuse: sacrifice your attachment to this avant garde group and use a more traditional Hollywood symphonic scary movie score and we'll shell out more cash for re-shoots of the duff special effects. There were other demands too, which resulted in the film having this uneasy not-quite-Britain but not-quite-America feel, especially in the dubbing, which is where the damage was done. Clive was torn between the more avant garde vision he'd begun with and the commercial blandishments of New Line. I don't think any of us in Coil were really surprised when he chose to follow the money. I don't mean that to sound bitchy but we could see he was torn between an underground sensibility and a populist urge, and as his subsequent career has shown, he was following his genuine muse by aiming towards mainstream acceptance and the games that he could

232

play as a populist artist. Sometimes you have to acknowledge that even if a person starts out as a misfit, they are really better suited to life in the mainstream, even if it is with a license to be weird... he's working up ideas for the Disney people now.' In the event Coil eventually released *The Unreleased Themes From Hellraiser*. Its significance as Coil's ill-fated dalliance with the mainstream notwithstanding, some parts are reminiscent of John Carpenter's electronic themes for his 1981 Kurt Russell vehicle *Escape From New York*, but it's otherwise uninteresting.

In 1987, Coil tentatively began a follow-up to *Horse Rotorvator* under the working title *The Dark Age Of Love*. It eventually evolved into their 1991 masterpiece *Love's Secret Domain*, but some scraps from the original project turn up on *Gold Is The Metal...*, a collection of misshapes that don't fit anywhere else. It's pretty obvious from the rutting Industrial rhythm of 'Paradisiac' why Coil cleared the boards as soon as *LSD* started to take shape, for it's not much of a leap from the grind of *Scatology*. *Gold* also features out-takes from *Horse Rotorvator*, such as '...Of Free Enterprise', which enigmatically caps *Rotorvator*'s 'Herald'. Together they reference the Herald Of Free Enterprise disaster, where 193 people were killed when a ferry crossing the English channel capsized. In a landmark decision, the ferry company, then Townsend Thoreson, was charged with corporate manslaughter. Mixed in with streetnoise, martial drums and a distant, symphonic reading of 'Greensleeves', the track's queasy brass part inevitably evokes the band that played on while the Titanic went down. Another standout is 'Boy In A Suitcase', dating from the earliest Coil sessions. Featuring a rare vocal by Sleazy, it sounds like a cross between early Psychic TV and the part-time punk of The TV Personalities. Despite its makeshift nature, *Gold Is The Metal...* actually hangs together well, thanks to several heated debates between Balance and Thrower over its sequencing. Modelled on *The Faust Tapes*, *Gold Is The Metal...* is meticulously arranged for maximum impact. At the time of its release Coil also acquired a new member in teenager Otto Avery, although precisely what he did besides looking good in photos is unclear. In the event he left as mysteriously as he came, with Sleazy later claiming that he had simply 'burst'.

233

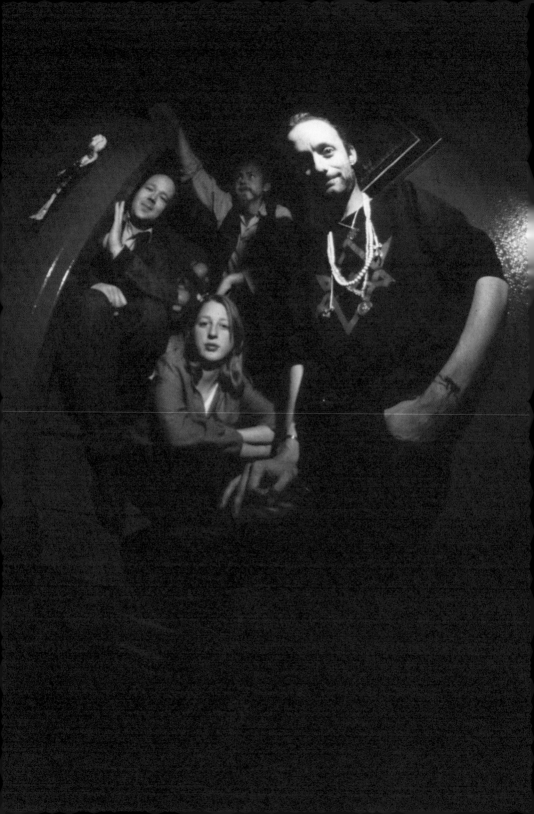

# England Has A Black Heart

*The ladies and gentlemen, they're all asking me, how many white lilies grow in the salt sea? But I'll ask them back with a tear in my eye, how many ships sail through the forest?*
– 'The False Bride', traditional

When Current 93's *Swastikas For Noddy* surfaced in 1987, many underground commentators thought it was a joke. Claiming it sounded like Simon & Garfunkel, some speculated that Tibet had lost his mind and was intent on decimating his audience. 'I thought they were all fools,' Tibet retorts. 'They were so stuck in a world where the only thing that mattered were tape loops and 20 minute pieces of music with Manson and Crowley references, a world in which there was no humour. They thought it was a comedy record, whereas I thought it was a record with black humour in it.' Tibet's retreat from Industrial noise to more pastoral moods has its precedents in the English artists who sought sanctuary from the Industrial Revolution's dark satanic mills in the edenic English landscape. With *Swastikas For Noddy*, Tibet set out to map an alternate reality.

In the meantime many things had changed on the experimental music scene. From their early freeform experiments with electronics, musicians like Chris & Cosey had abandoned the headfuck of the past and reformulated it as electronic body music, with a blur of autobahn rhythms and riotous funk. This approach in turn had been bastardised and diluted by third-wave Industrial schlock troopers like

Belgium's Front 242 and America's Skinny Puppy. Now a new wave of musicians was intent on combining the sacred and profane on a technicolour dancefloor.

By 1987 Tibet was paying little attention to the activities of his contemporaries. Instead he was attempting a rapprochement with more conventional musical form. *Swastikas For Noddy* marks the point where he opened a tentative dialogue with the mainstream. 'At this time a lot of people around me were moving into more dance-orientated stuff,' Tibet recalls. 'That absolutely dumbfounded me. Most of them were people who had shown no interest in dance music whatsoever but so-called 'Industrial' music became dance music. I can't dance to save my life but I've got nothing against dance music – Sly & The Family Stone are one of my favourite groups – but I never understood why people started dancing. So I came out with *Swastikas For Noddy*, while other people shaved their heads, put on serious glasses and bought sequencers.'

*Swastikas For Noddy* opens with an unaccompanied vocal piece sung by Ian Read called 'Benediction', a lament for the mythic 'fair land' of England that in the context of the album stands more as a metaphor for a lost state of innocence. That same loss animates Current 93's version of Strawberry Switchblade's 'Since Yesterday'. Indeed, it could be the pulse of all Tibet's work. Here, however, the pulse is sometimes buried in an album packed with so much disparate imagery. 'Beausoleil' alone references everything from the Manson murders through *Dogs Blood Rising*, Buddha, Christ, Noddy, *In Menstrual Night*, mediaeval grimoires, Love and even The Monkees. 'I couldn't articulate what I thought,' Tibet admits 'I was really angry and unhappy at that point but with no particular target. Is that adolescent angst? Who knows? Boyd Rice once said to me, and I thought it was quite amusing and accurate, that he didn't understand why people kept on complaining that they were alienated. Because if people are alienated then they must want to belong to the thing in the first place. Boyd's comment absolutely captured that frustration and sense of not knowing what it is that you're rebelling against, not knowing what we've lost in the first place but knowing that something was lost and that you were incredibly unhappy.'

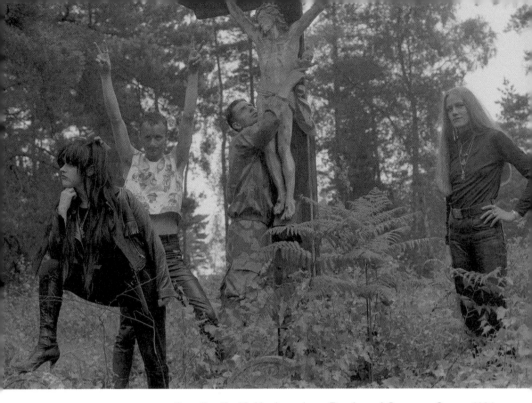

*Swastikas For Noddy* photo shoot, Brookwood Cemetery, Surrey, 1986:
*Left to Right*: Rose McDowall, Tibet, Douglas Pearce, Freya Aswynn.
(photos on this, previous and next page, Ruth Bayer)

Most of *Noddy's* tracks were co-written by Pearce and Tibet at night in the Tufnell Park flat. Pearce hit on the deceptively simple folk phrase of 'Beausoleil' straight away as a contrast to Tibet's eye-popping vocal. After the recording Pearce couldn't work out the chords he had used, meaning Current 93 couldn't play it live until their 1999 series of New York shows, when new guitarist Michael Cashmore figured it out by ear. Pearce similarly intuited a setting for the traditional 'Oh Coal Black Smith', a shape-shifting folk tune that has become one of Current's most enduring songs. Tibet had never actually heard it before Current recorded it – he had picked it out from one of the many books on English folklore and song that he was now devouring. A disturbing ballad, it's full of vicious imagery like 'Then she became a duck/A duck all on the stream/And he became a water dog/And fetched her back again.' The idea of being fetched back, pulled or falling, into violence is a Tibet

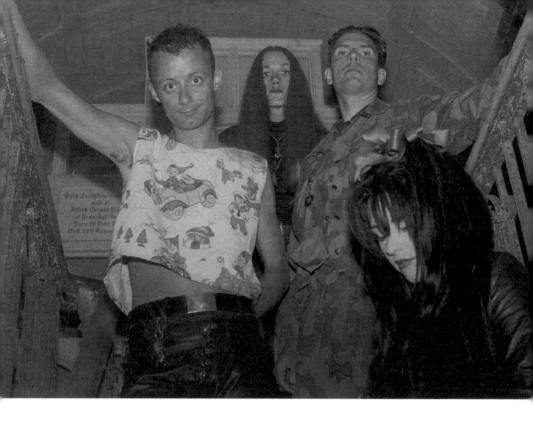

preoccupation running through his back catalogue, most obviously in
disturbingly ambiguous titles like 'Falling Back In Fields Of Rape' on
*Dogs Blood Rising*.

Talking of his childhood in Malaysia, Tibet recalls one of his
favourite pastimes. 'I loved to go into the water on the beach and just let
the waves crash down on me and pull me back into the sea and knock
me down,' he reveals. 'I was always being knocked down and pulled
back into the water and into the ground shells and the sand. It always
moved me and I felt like I wasn't in the world anymore. Like I was like a
water sprite or in a different plane of existence.' One of Tibet's favourite
poems is 'The Hound Of Heaven', written by Catholic poet and drug
addict Francis Thompson. The poem deals with the feeling of being
tracked by God and the idea that to fall over, to take the leap of faith
and allow yourself to fall back, is to believe that something else supports
you. Yet Tibet relocates Thompson's scenario in the beautiful fields of
rape that he would wander in around York when he was young, the play
on the word rape casting it in a much more disturbing light. The co-

existence of images of horrific violence and pre-lapsarian beauty is a constant in Current's material, as is the question, what supports us when we fall?

The cover version of Blue Öyster Cult's 'This Ain't The Summer Of Love', a paean to the death of the '60s utopian experiment and the bloodletting at Altamont, represents another of *Swastikas For Noddy*'s twist on this theme. Again, Tibet had first discovered Blue Öyster Cult via Sandy Robertson and Edwin Pouncey, who first spun *Secret Treaties* in the *Sounds* office. 'They loved BÖC but I loved the idea of them more than the reality,' Tibet admits. 'Still, they had moments such as 'Astronomy' on *Secret Treaties* which features some of the most beautiful lines. 'Come Suzy dear let's take a walk, just out there upon the beach, I know you'll soon be married and you want to know where the winds come from.' That haunted me and still does, one of the most beautiful lines I've heard, that fantastic juxtaposition of quite banal statements and then that really odd and numinous last line.' But most of all *Swastikas For Noddy* was influenced by Tibet's discovery of England's greatest folk singer, Shirley Collins.

'While making *Swastikas For Noddy* I was listening to Shirley's music all the time,' he enthuses. 'I was getting into a lot of British folk, things like The Incredible String Band's *The Hangman's Beautiful Daughter* and groups like Trees and COB [Clive's Original Band], but as soon as I heard Shirley she was immediately goddess, I deified her straight away. She just sounded like somebody's heart singing without coming through their mouth. The sound is absolutely pure and there's no melodrama in it whatsoever. I still think Shirley has done music that is 100 per cent perfect and totally without artifice. The category above Shirley is Jesus. In the category with Shirley are people who have manifested their humanity and beauty to absolutely the fullest degree possible of a human. She once played me some recordings she'd done fairly recently that she wasn't happy about and consequently didn't want them to be released, and when I sat down and put them on I burst into tears because I was so moved by it.' Collins later told Mike Barnes, in an interview for *The Wire*, that Tibet was undoubtedly her least critical fan. That he was falling increasingly under her spell

showed in the newfound simplicity of his work, which now mixed confessional, autobiographical lyrics with an obsession with England's culturally dispossessed.

'I do love England so,' Collins admitted when I spoke to her in September 2001. 'I love to gaze out at it from the window of a speeding train and I do have great connections to the countryside. As a child I was always crazy about history and it's a notion I've always kept with me, that history was wonderful and that what happened there was magical and the ballads speak of this in many ways. But England has a black heart. There's been so much wickedness and so many dreadful things done in its name. In the songs that I love, people are aware of what's being done to them but there is a real spirit there. I'm not sure that enduring is always the greatest thing to do but they endured and yet still managed to look out at this beautiful world they were inhabiting. Because in many ways it was beautiful, if you could only see it.'

And Collins's England still exists, waiting to be sung into existence, in the way that the poet AE Housman [1859-1936] eulogised his native Shropshire, that 'land of lost content', or the way that the tragic young author Denton Welch [1915-1948] walked in eternity through Sussex, Kent and Hampshire in books like *In Youth Is Pleasure* and *I Left My Grandfather's House*. On 1994's *Of Ruine Or Some Blazing Starre*, Tibet comes up with one of his most magical evocations of England in 'The Great Bloody And Bruised Veil Of The World', a visionary epistle to match William Blake, where he sings: 'The trees wave in England/The streams flow in England/The poor halt in England/The poor heart of England... [...] This is all paradise/Here is Garden Of upon Garden Of/ Upon, Suns and Beetles/The Ladybird lands upon my knee/The Lark is all joy/There are birds upon birds/Beyond, The great, bloody, bruised and silent veil, Of this world.'

'If anything all the work I have done and the music that I love in other people is about innocence,' Tibet states. 'What I'm always harkening back to is a lost sense of innocence, so the thing about England that I love is the England of Shirley Collins's *Anthems In Eden*. It's just lost childhood. All the people I admire the most are all innocent. Look

at Shirley Collins, Count Stenbock, Arthur Doyle or Tiny Tim – all absolutely innocent, with no complex theology or complex ideation within their worldview. Everything I love is essentially simple. I read complex theology but what interests me most are the simple phrases at the heart of it. You can go through the entire Catholic catechism or St Augustine's *The City Of God* but these are massive structures built on something simple, like The Beatitudes, or 'Love Thy Neighbour As Thyself'. I have very little patience. What move me are profound simplicities and Current's music is very simple. Sometimes, as with *All The Pretty Little Horses* or *Nature Unveiled* it sounds very complicated, but it's really not, it's simple and cyclical.'

*Swastikas For Noddy* was also an unusual Current record in that Stapleton took no part in the production. But he was never happy with Tibet and Pearce's results and pushed for Tibet to let him remix it. His re-structured version, *Crooked Crosses For The Nodding God*, released on United Dairies, gives the music more psychedelic depth but inevitably compromises the unadorned beauty of the original. While Tibet was making *Swastikas For Noddy*, Stapleton was finishing Nurse's *Drunk With The Old Man Of The Mountains*. Showcasing a variety of Nurse strategies, from percussive locked-groove workouts through long washes of associatively linked F/X and thrilling Industrial jams, it came in a strictly finite numbered edition of 30 and an un-numbered edition of 100 that featured a handmade cover and, in some cases, a beautiful, if puzzling photographic painting. It stands as one of Nurse's most collectable artefacts.

Over the years Stapleton had been slowly expanding the United Dairies catalogue to cover the furthest reaches of the contemporary avant garde and, alongside Nurse With Wound, Current 93 and Diana Rogerson, UD also provided a platform for international artists like Canadian freeform kazooist noise band The Nihilist Spasm Band, Irish electroacoustic composer Roger Doyle aka Operating Theatre and ex-Guru Guru bassist Uli Trepte, who was then living with members of Henry Cow in Brixton. Stapleton seized the opportunity to renew their acquaintance and also booked a series of gigs for him. 'The gigs I put on for Trepte

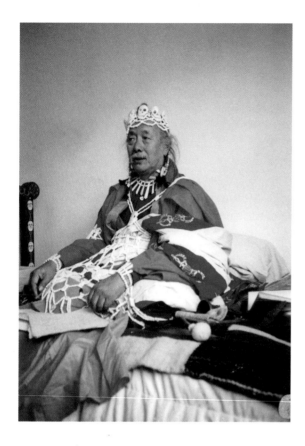

The Venerable 'Chi.
Med Rig.'Dzin Lama,
Rinpoche.

were amazing,' Stapleton states. 'Sometimes there was no one there and he'd have radio mics and he'd go right out into the middle of the King's Road and continue the gig there. It'd be blaring out the club and he'd be screaming in the road. It was just fantastic and I really wanted to record an album of his new stuff, but he was adamant that he only wanted to play bass, just solo bass. I agreed to do an album anyway but it was hell. He could only do it on acid and the acid had to peak at certain times. Suddenly he would notice a tiny bolt rattling somewhere in the studio and we'd have to take the panelling off the wall just to stop it so he would continue. It just went on and on, he had all these arguments with the engineer because he insisted that he had to be cued by a count of 1, 2, blue, 4. That still haunts me, that thing.'

The making of *Swastikas For Noddy* and his concurrent illness served to further exacerbate the spiritual crisis that Tibet was experiencing.

Through his friend James Low he obtained an introduction to The Venerable 'Chi.Med Rig.'Dzin Lama, Rinpoche. Low had lived in India where he had studied under Rinpoche for many years. He was a high ranking Lama of the Nyingmapa tradition, perhaps best known for having appeared on the cover of René de Nebesky-Wojkowitz's famous *Oracles And Demons Of Tibet*, a catalogue of Tibetan deities and tutelary spirits. Nyingmapa lamas are often referred to as black magicians by their enemies and Rinpoche certainly had a reputation imputed to him by other dharma students. 'The lineage he was a member of were non-celibate and he was also a ferocious meat eater,' Tibet told Mike Barnes in *The Wire*. 'I took him in to record some Tantric rituals. There's one called Chod. Originally this would be done sitting on top of a corpse in a graveyard. Chod is the Tibetan verb 'to cut' and the point of it was to surround yourself with terror and then to cut the ego; cut yourself up and then reassemble yourself in a purer state. He said, 'Can you go and get me a snack, David?' The engineer was a vegan and I'd earlier told him I'm bringing in a highly respected Buddhist lama chanting some of the truly important Buddhist rituals. I came back in with a blue plastic bag of raw steak that had been chopped into big cubes. So Rinpoche was there eating all this raw steak whilst blowing on a thighbone trumpet and banging a skull drum with blood trickling down his chin. I wish I had it on video.'

Tibet took refuge with Rinpoche and became a committed member of the Buddhist community, studying particular texts under his guidance and receiving the accompanying empowerments, basically the spiritual right to practise them. The effect was extremely powerful and many of the rituals have stuck with him to this day. 'There was one called Zhi.khrod, which is an initiation into the mandala of the peaceful and wrathful deities,' he remembers. 'These deities are the ones that appear to you in the bardo after you die – it was an initiation into that realm of experience that is discussed in *The Tibetan Book Of The Dead*. They call it Bardo Thodrol, liberation through hearing in the intermediate state between life and death. That had a great effect on me, as I'd always really been obsessed with hypnagogic states.' At an early age Tibet had devoured Walter Evans-Wentz's groundbreaking English translation of

*The Tibetan Book Of The Dead* and was fascinated by the experiences it described. Tibet later released the recording of Rinpoche's chants, prayers and invocations as *Current 93 Present The Venerable 'Chi.Med Rig.'Dzin Lama, Rinpoche*.

1988 began with another trip to Iceland, where Current 93 played at Hótel Ísland in Reykjavík with Annie Anxiety, SH Draumur, Megas and Johamar. Tibet describes Megas as 'an Icelandic Bob Dylan', and his set featured both Björk and Rose as guest go-go dancers and backing vocalists. He also worked with Hilmar Örn Hilmarsson on pieces that eventually appeared on Current 93's 1991 *Island* album. 'The sessions for that album spread out over a very long time,' Tibet recalls. 'At first we didn't even know it was called *Island*. When I would go to Iceland, Hilmar would book the studio and we would just go in and see what happened.' *Island* is a one-off in the Current catalogue in that it's a heavily synth-laden recording with a nasty new-age sheen, complete with a Lou Reed-like bass sound redolent of the mating calls of whales. Still, Tibet's songwriting is strong, especially on 'The Dream Of A Shadow Of Smoke', where Hilmarsson's evocative arrangement peaks with a glacial choir of opera singers, levitating through atmospheric lines like 'in my mind is the sound of rudderless ships', taken from a long, early draft of what eventually became 'The Sadness Of Things'. The opening track 'Falling' creates the illusion of deep, black space with the effective use of droning synths and Björk's wailing backing vocal. But what really lets *Island* down is the subsequent CD release, which includes extra tracks like 'Crowleymass Unveiled', 'Paperback Honey' and 'The Fall Of Christopher Robin', all lightweight synth pop that sees Tibet hamming it up for all he's worth, especially on 'Paperback Honey', which approximates the sound of some sweaty cabaret club, complete with electro-bongos. 'I think the big mistake with *Island* when it came out on CD was not making a big space between the first eight tracks and the more lightweight tracks like 'Christopher Robin' and 'Paperback Honey',' Tibet concedes. 'Although I always liked 'Paperback Honey' it would have been more effective

if we hadn't put that on. *Island* was an interesting album but the trouble with any keyboard or synthesizer-based album is that they date rapidly.'

After his return from Iceland Tibet briefly moved in with Paul Donnan, until a room came up in Tony Wakeford's flat. 'The first night Tibet broke the telephone and flooded the bathroom,' Wakeford sighs. 'It was all downhill from then. I thought, oh what have I done? I heard this voice from the kitchen – 'oh, Tony, how do you boil an egg?'' Since his dismissal from Death In June, Wakeford had disappeared from the music scene, falling into a self-destructive spiral of drugging and drinking that landed him in London's criminal underworld. He was also involved with the IOT, The Illuminates Of Thanateros, a Chaos Magic sect that Balance had also flirted with. 'I was dealing drugs and had got

Shirley Collins and Tibet on their first meeting, November 1992. (photo RM Bancroft)

heavily into the whole seamy South London gangster scene,' Wakeford confesses. 'We were selling weights of dope the size of a concrete block and my partner had a gun. It wasn't big stuff but it was big enough to end in tears. It was getting worse and worse and I woke up one morning thinking, if this carries on then I'm going to end up dead. I was so pissed off with Death In June for so long that I couldn't imagine doing my own music again, but I realised that music was about the only thing I was good at. So I went into town and bought an acoustic guitar and came back and started writing. It was just one of those moments, you know? If I hadn't got that guitar that day I'd be in prison now or dead. The first stuff that I wrote became the first Sol Invictus songs.'

Until now Wakeford had supplied bass for Current 93. But since Pearce was increasingly busy with Death In June and out of the country for long stretches, Wakeford stepped in to work up music for Tibet's

lyrics on acoustic guitar. In the meantime Current released their heaviest and most rock-relevant album, *Christ And The Pale Queens Mighty In Sorrow*, which took a side step from the new folk sound of *Swastikas For Noddy*. Wakeford's electric bass and Pearce's incongruous drums leave parts sounding almost new wave. The phrase 'The Pale Queens Mighty In Sorrow' comes from the writings of the Enochian research group Aurum Solis and appears in their *Mysteria Magica* as a description of entities conjured up using John Dee's system of calls. Taking the idea of the Church as being Christ's betrothed, Tibet recast them as embodiments of Christ's mistresses, ladies of sorrow attendant to his passion. 'I thought it was a very de Quincey-like phrase, although it was obviously written before him,' Tibet explains. 'The idea of the sorrowful mysteries is absolutely the point. They're passing sorrows and are actually the key to a greater joy, although it's one of those phrases that initially look very melancholy, perhaps very gothic. I think the whole album always felt quite schizophrenic, almost as if it was thrown together and a lot of it just fails to move me.' Even so, the lengthy title track is a fantastic exercise in controlled hysteria, with Tibet baying the Enochian phrase like a mantra and talking in tongues while the group build and build with no hint of release. Live, it was even more effective, with Tibet often taking off into vocal improvisations and dropping in lines from Love's 'Mushroom Clouds Are Falling'. 'Tibet always liked me to bleed on stage when we played 'Christ And The Pale Queens',' Rose McDowall recalls. 'From my hand, I should add. He wanted me to play guitar with my knuckles and I had to wear my white guitar so that you could see the blood. But I always had to make sure that witches didn't get hold of any of it.' 'I think 'Christ And The Pale Queens' was objectively an impressive track,' Tibet concedes, 'but I just feel it could have been a thousand times more powerful. Arthur Machen once said that though he dreamt in fire he worked in clay. It's a beautiful phrase which I think captures the essence of every artist, that what they've actually put out didn't live up to the ideal they had of it in their mind.'

In 1988, housemates Tibet and Wakeford came up with a mini-album *Earth Covers Earth*. Aside from its sole original track, 'Rome For Douglas

P', and the traditional 'Dilly Song', *Earth* was assembled from supernal settings of 17th Century English metaphysical poems, with Wakeford translating Tibet's singsong ideas into workable guitar parts. Exquisitely melancholy, it remains one of Current's most enduring releases. Again, the matter of Britain looms large. Tibet stumbled upon the phrase 'Earth Covers Earth' in a sociological text on attitudes towards death in post-Christian Europe. 'I just thought it was so beautiful as a Biblical reference,' he explains. 'From dust we come and to dust we return, we become earth and to earth we return.' Its mirror, the track 'Time Tryeth Truth', was named after an inscription Tibet and Pearce found on a tomb in Brookwood Cemetery just outside London. Both tracks were based on the song 'Fields', which Wakeford had composed and recorded for Lex Talionis, Sol Invictus's contribution to a triple LP box set alongside Current 93's *Horse* and Nurse With Wound's *Lumb's Sister*.

'Fields' was inspired by the sight of row upon row of war graves witnessed by Wakeford during his continental travels. 'The land was very flat, quite a boring landscape surrounded by fields, 'fields the colour of her hair',' Wakeford recalls. 'Then suddenly seeing all these crosses coming out of nowhere 'like arrows crossed pointing to the sky' made me think of a carved walking stick that a relative had been given by a concentration camp inmate as a thank you for liberating him.' When Wakeford played it to Tibet back at the flat, the song's combination of images of Dresden and Coventry in flames with fields where 'fathers, brothers and lovers lie' over a simple, descending guitar part prompted Tibet to immediately announce that he would cover it on his new album. In the end he substituted Wakeford's lyrics with 'Sic Vita', a poem by Henry King [1592-1669] ruminating on man's fleeting presence in eternity.

Tibet's interest in the whole area of vanitas art and literature, which symbolised the brevity of human existence, had already manifested itself on the cover of *Christ And The Pale Queens Mighty In Sorrow*, with its collection of skulls and mirrors. Inevitably, this led him to investigate 17th Century metaphysical poetry. For *Earth Covers Earth* he immersed himself in the writings of Andrew Marvell [1621-1678], John Hall [1627-1656] and Henry King, most of which he first read in the three

Japanese *Earth Covers Earth* session, 1988: *Clockwise from bottom left*: unknown, Ruby Wallis, Hilmar Örn Hilmarsson, Tibet, Stapleton. (photo Ruth Bayer)

volume Oxford set *Minor Poets Of The Caroline Period.* Having already set the words of the visionary Christian abbess Hildegard Of Bingen on the preceding record, Tibet's recourse to other people's writings on an otherwise quintessential Current 93 album indicated that he was struggling to consolidate the direction Current had taken with *Swastikas For Noddy.* Yet the mood of *Earth Covers Earth* was more devotional than earlier releases. Here Wakeford's acoustic guitar dominates, with his big reverberant chords propelling the songs ever onwards, catching them up in the unrelenting rush of time. 'That was one of the records I was really happy with,' Wakeford beams. 'But Tibet is such a miser in the studio! If you made a mistake he would just say, oh, it'll be alright. It's very hit and miss when you're recording with Current. He would

just call round and say, 'I've got these lyrics, shall we record?' God! He might try and describe what he wants and get you to go through the three chords you know until he picks the two and a half he wants. When I was in Current I can't ever remember having a rehearsal, so you never knew what each record was going to sound like.'

The mini-album's sole Tibet original, 'Rome For Douglas P', is a beautiful song that shed the stiffness of the studio version in later live performances. By the time Current 93 played a series of New York shows in 1999, it had become a set highlight. The song hangs around the mantra of 'When Rome falls, falls the world', derived from some Catholic theologians' belief that the Church would be the last bastion of Christ left standing after the great battle of apocalypse, and the destination of his victorious returning army. Also addressing the idea that the world will fall from the bosom of Christ once the Church loses dominion over it, the song signals the awakening of some kind of Christian conscience in Tibet, in the wake of his infatuation with Crowley and Antichrist. 'And what did you give me?' he asks in the lyrics. 'A rusted bent death's head/A black flag that lies bleeding/A dawn that lies dying.' And 'Will anyone catch me/When I fall as I must?' Yet the dedication to James Low and the back sleeve emblazoned with 'May all sentient beings be happy' make it clear that he was still heavily involved in Buddhism. *Earth Covers Earth* was also dedicated to Comus, a progressive British folk group, whose demoniacal 1971 album *First Utterance* was a big influence on Tibet, not to mention Stapleton and Christoph Heemann. Indeed, Current 93 later covered Comus's 'Diana' on 1990's *Horsey*.

In a tribute to the cover of The Incredible String Band's 1968 album, *The Hangman's Beautiful Daughter*, *Earth Covers Earth* features a timeless portrait of the extended Current 93 family, with Tibet flanked by Balance and Stapleton, as well as Rogerson, Pearce, Wakeford, Read and Rose McDowall. The original idea, however, was to replicate the psychedelic Victoriana adorning the Irish electric folk group Trees' second album, *On The Shore*, but the Current family was too big for

that shot's Hampstead Heath location, and they eventually settled for a sheltered clump of trees on the other side of the Heath. On United Dairies' vinyl edition, photographer Ruth Bayer's deliberately blurred shot emphasises the album's out-of-time feeling. But the light-flecked clarity of the CD cover shot is arguably even more bizarre, with Rose sheltering beneath a red umbrella in full sunshine. 'It was a real hippy gathering,' she recalls. 'It was significant in that it was the first time that all those people had come together in one group. It was also the first time I really met Balance and we hit it off straight away. Such a beautiful day.'

Printed on the CD itself are two corn dollies, the plaited fertility figures of European agricultural rituals. Both Wakeford and Tibet were obsessed with such figures, which they strung up from the ceiling all over the flat. Indeed, up until 2001 Tibet kept a sheaf of corn dollies, clustered around the foot of a Tiny Tim poster in a shrine above his stairs. 'I always had a fascination with corn dollies,' he reveals. 'When I was living with Tony I was obsessed by the film *The Wicker Man* and it partly came out of that. When I was younger, my mum knew one of the main corn dolly makers in York and I'd buy a lot from him. I was interested in mummers as well, but I think hearing Shirley Collins sing about the 'true-love knot' fired up my passion for that kind of 'vegetative rite', as she mixed it up with the fate of sweethearts.'

On her 1967 album *The Power Of The True Love Knot* Collins cast the knot of corn, used at the end of the harvest to represent seasonal rebirth and to guarantee the next year's good crop, as a symbol for an otherworldly knot reuniting lovers after death. 'Within the old love-ballads can be seen the idea of true love as a power outside society's control, ungovernable, irresistible and inviolable, and because this idea still forms the basis of all romance, the songs keep the power to stir us,' she wrote in the sleevenotes. 'The love-knot which in ballads unites the star-crossed lovers after death is a very ancient piece of lore. It was certainly a traditional symbol of love, faith and friendship when the Danes brought the root-word 'Trulofa' (I plight my faith) to Britain. Has the true-love knot any real power? The songs record that

the church was willing to sanctify marriages of convenience arranged to keep lands and fortunes intact: that the armed forces of the crown took husbands and lovers away whenever cannon fodder was needed to defend the cause of trade and territory. In spite of all this we still look for signs and symbols to assure ourselves that whatever society does to lovers (let alone what lovers do to each other) love itself can never be harmed.' In Tibet's personal cosmology, 'the true love knot is found at the death of the corn', thus tying up death and rebirth through love in the symbol of a primitive cross. He became increasingly obsessed with the idea, evolving variations on it through the many Current 93 tracks that marked the tentative shift from his earlier confused satanic paganism to his eventual embrace of Christianity. As he wrote in the liners of *Thunder Perfect Mind*, 'This is the great wheel of birth and death. Tie it up and make of it the True Love Knot.'

Near the end of 1988, Current 93 travelled to Japan for two shows at The Loft, Tokyo. When they were over, the organisers took everyone out for some drinks in a nearby bar, where Tibet got talking to Aki Okauchi, a girl who was only vaguely aware of his work. The two hit it off immediately and – yet again – Tibet was on the move. He stayed in Japan through the first half of 1989, first in a hotel and then with a Korean friend Yongsou Cho and his Japanese wife Yuko Idei in the outskirts of Tokyo, before moving in with Phillippe Brochen, a friend of Current's Japanese promoter based near Kamakura, where he taught English as a foreign language. He also met the group Magick Lantern Cycle, all Current fans, spending many days on the beach with their vocalists Ayame and Konori. 'I loved Japan at first but the intricacy of its social culture got to me after a while,' confesses Tibet. 'I became overwhelmed by the number of people, the salary men pouring out of Shinjuku.'

Yet isolation from his friends and all the other distractions of home induced Tibet to start writing again. In Japan, he came up with the first sketches for his 1992 breakthrough album, *Thunder Perfect Mind*. Current also half-heartedly began a proposed Japan-only album for The Supernatural Organisation, the label behind a Japan-only version

254

Rose, Tibet, Douglas.

of *Earth Covers Earth*. But the relationship foundered when the organisation's Keiichi Kakiuchi promoted a second series of Current shows in the summer of 89 without paying the group, leaving Rose without a yen and Pearce stranded in a hotel until the bill was paid. 'It was clear to us that something was going very badly wrong,' Tibet says. 'He had originally suggested going into the studio to make an album for him and we'd started recording. NON were also in Japan, and Boyd Rice and Michael Moynihan were in the studio with us when we were working on it. As soon as we realised we weren't going to get paid, we decided to pull the old trick of saying that we needed to take the tapes away with us to work on and then just keeping them. Unbelievably it worked.' Meanwhile Rose and Pearce held up Kakiuchi's record shop, dragging any stock that belonged to them or their friends into the rain to be destroyed. And by way of a calling card, Rose pissed all over the front door of his office before scrawling on it in red 'Kakiuchi Is A Motherfucker'.

# Cooloorta Moon

*It is loneliness that has led me to create*
– Inscription in the ornamental sculpture garden of Maurice Lellouche

By 1988 Diane Rogerson was sick of partner Steven Stapleton's daily routine of working in an engraving studio by day and locking himself away in the studio all night. She gave him an ultimatum; choose between his job or her. He was forced to make a leap of faith, a tactic that Rogerson repeated with several people as a way of enabling them to fulfil themselves by giving them the push they were unable to administer themselves.

'I wanted her, I really did, but I had no faith that I could still bring in enough money to live on from music, it was ridiculous,' Stapleton despairs. 'So I started signing on, but before I could do that I had to work six months' notice, and that's very difficult to do once you've decided that you don't want to be there.' In a bid for full control of their finances, Rogerson and Stapleton bit the bullet and attempted to run a properly accountable record company, assisted by a government back to work scheme. The result was Idle Hole Records, whose first release was 1989's gorgeous triple LP set, *Soliloquy For Lilith*, originally billed as a collaboration between Rogerson and Stapleton. Named in celebration of the birth of their first child, *Soliloquy* is Stapleton's most consistently rewarding work. Its soundworld evolved out of a series of serendipitous accidents, engineered with a rack of FX pedals. Linked together, the pedals generated an unearthly hum, which he discovered he could alter

SOLILOQUY
FOR LILITH

NURSE WITH WOUND

A NEW TRIPLE L.P BOXED SET - RELEASE:    MAY 1988

by moving his hands above them, like playing a theremin. 'There was no music actually going into it, it's creating its own music,' Stapleton marvels. 'As it cycles, it creates a loop which slowly becomes rhythmic, mantra-like and perfectly controlled by your fingers six inches above it. Wonderful! It's always changing. It's never the same. That record is fucking amazing.' For the drawings on the later CD issue, he fantasised a series of deep sea organisms, which corresponded perfectly with the music's slow, primordial depths. The medieval choral music conjured in its quietest moments sounded like it came from an ancient wiretap into the visions of Hildegard Of Bingen. One of Nurse With Wound's biggest selling albums to date, it funded the Stapleton-Rogerson family move to County Clare, Ireland in 1989.

Living together in an Archway flat, the couple had been becoming more and more disillusioned with life in London, and after both Rogerson and Stapleton were mugged at knifepoint in the space of a few weeks they decided to emigrate. 'I never used to care where I lived really,' Rogerson says. 'I just wanted to be where I was but we ended up

All Cooloorta photographs by Andrew Thomas at Forge.

in this rough council flat, with people dying around us. This guy had his car outside our door and he just revved it the whole time. We were sitting there most nights unable to breathe from the fumes. Ultimately I said, the one thing that's free in this life is air and I can't even breathe in my front room. Fuck it. Bottom line. We found ourselves spending most of our time in the park and then, when we stayed with one of Steve's friends in Wales, we were blown away by seeing him living out there in the wilderness. We thought maybe the wilderness was for us. We thought that if everything we ever loved was the cutting edge of something then to go out to somewhere which we thought felt like the edge of civilisation would be a great new challenge. For us to survive, we had to keep on pushing it. I still feel scared out in Ireland sometimes but I like it. It's like when Tibet got into Noddy, it made you understand him a bit more. It was like, there's a strange world out there and wouldn't it be great if there were some way where you could go out to the edge and then report back to yourself as a very innocent child. 'Huh! It's like that! We've got to check everything out because we don't want to be shocked!' Face the demons! Obviously I was quite feminist, every intelligent woman is, but I had no problem standing at a gig listening to William Bennett

screaming about 'Her Entry'. I can stand up there and have a laugh. I'm not going to get scared. Maybe it is a childhood thing, because my dad was often violent. But I think that the relationship that Steve and I have is quite alchemical. When two people are strong and very polarised, they can actually make each other grow. And I know that I did a huge growth spurt through meeting him and then coming out to the wilds of Ireland. Just pushing the limits, like, can you face that?' Rogerson's life strategy and her insight into Tibet's uncannily echo Rinpoche's performance of the Chod ritual, as witnessed by Tibet: At risk of tearing yourself apart in the quest for a purer, more realistically balanced state, actively seek out the terror in order to neutralise it and put it behind you.

Passing through on her way to India, a friend dropped in on Rogerson and Stapleton at their Archway flat. When Rogerson rehearsed a litany of their urban woes, she offered them the use of her caravan in Clare, incidentally mentioning a house for sale just down from her. When she started describing the house, Rogerson and her daughter Ruby's jaws dropped. For several months already, mother and daughter had been sketching out their dream house. Their sketches almost exactly

Two Stapleton assemblages
at Cooloorta.

matched the building described by their visitor, even down to its big
double doors. Accompanied by Tibet, Rogerson and Stapleton travelled
to Clare and bought the house on sight. 'It was weird though,' Rogerson
insists. 'While we were in London, all the people who eventually became
our neighbours in Ireland serendipitously came through our lives. The
last person, who hadn't even moved at the time, I gave a lift to while I
was making my final drive to Ireland across on the boat. He was hitching
a lift and I picked him up.'

So in 1989 Stapleton and Rogerson wound up in Cooloorta, County
Clare, their house hidden down a dirt road that forks off from the main
drag in and out of Boston, itself a tiny huddle of cottages with a post
office cum general store, the sole local amenity. For supplies, they had
to make weekly runs to Ennis, the nearest decent-sized town. Previously
a shebeen, their house is so isolated that the only way to get there is by
following someone to it. When they first arrived they weren't exactly
welcomed with open arms. They had various threats made against
them, intimations that any English people in the area would have their

houses burnt down. Stapleton tells one terrifying story of being trapped in a pub not far from their house and being forced to drink a pint that consisted of everyone's dregs while toasting 'his Queen'. In the event he made a run for the door and didn't look back.

'We lived in the house for a bit but it was done very cheaply,' Rogerson recalls. 'It had an asbestos roof and very bad wood that would have broken. The electricity supply was a hotbed that would burn. It just wasn't safe. It was unbelievable, like the beginning of a marriage when it's all new. Talk about anarchy! In England you phone someone up when something goes wrong. Over here you do it yourself. Everything had to be made or repaired by our selves. It's more European standard around here now but back then even getting a screw was difficult. Ridiculous!'

While Stapleton worked on the house, the family moved into an old single decker bus parked in the front garden. In its setting of surrounding fields, where the family keep goats as well as horses, they now live in a huge, self-built visionary environment that rivals outsider artists like Howard Finster's Paradise Garden, Simon Rodia's Watts Towers or the secret gardens of Nek Chand. An experiment with time, completely cut off from the modern world, it reflects Stapleton's art and music so accurately that it could well be his greatest creation.

As you enter the gate, beneath huge, overhanging trees, there's a little green US mailbox that reads 'Cooloorta' and next to it, sculpted onto the gate post, is a bizarre miniature grotto, obsessively dotted with blue plastic gemstones and half-formed clay creatures. Off the path towards the house on the right hand side there's a wooden washhouse, draped with drying tie-dyed clothes and attached to a stable full of riding gear. The walls are studded with plastic beads and hundreds of beer bottle tops, spiralling across the walls like cobwebbed Smarties. In the front garden, Stapleton has constructed a tree house, accessible via an iron ladder and a rope frame and hung all around with old candleholders and lanterns. The main building's wood and asbestos roof has long been replaced with corrugated metal, topped by a chimney made from broken tiles.

By far the most fascinating extension, however, is Stapleton's workshop. Despite its superficially chaotic appearance, a closer look reveals just how thoroughly organised and exacting their creator is. There are shelves of old jam jars – about 60 – and each one is assigned to a different sized nail or screw. From the ceiling, various plug extensions are bundled according to size; paints are neatly stacked in shelves on the other side. Many of the exhibits that made up part of Stapleton's installation at The Horse Hospital, London, that he and Tibet held in 2002 hang from the walls, most imposingly a huge horned animal skull painted green and wrapped in flexed metal called 'A Portrait Of Balance'. Next to the door and propping up a dusty leather-bound edition of *The Complete Works Of Shakespeare* is a disembowelled statue of Christ with the head replaced by the bleached skull of a bird with various disturbingly altered dolls hanging sentinel above it. It's like a tiny museum of the macabre, a place of spells.

In the main body of the building, the front door opens onto an open plan living room and kitchen area, with a huge stone fireplace as its centrepiece. To the west is Rogerson's study, where she works as a homeopath, with her desk at the foot of a massive, pyramid-shaped stained glass window constructed mosaic-like from hundreds of differently sized and coloured shards. Rogerson's office is overgrown with green plants stood in altars carved from the wall, her laptop and reference books resting on a series of sensually curved wooden tables. The sleeping quarters are upstairs and to the east – behind a thick wooden door painted with what looks like a psychedelic vulva, a cross between the cover of Coil's *Love's Secret Domain* and Stapleton's own *Spiral Insana* – lies Stapleton's record room, every bit as claustrophobic and self-contained as his old bedroom in Finchley.

'I think the word 'Automating' sums Steve up for me,' Rogerson states. 'He doesn't necessarily get entertained by what's on offer, so he needs to make his own entertainment. In a way there's quite a lot of selfishness there, automating really means 'for myself'. I can see a lot of Steve in his music. I interpret it as when he was young he made that bedroom for himself to survive quite a difficult home life, where there

was a lot of fighting for a sensitive boy. He was obviously attracted to creative things from a very young age. He collected cactuses and was a marvellous painter. At school, some of his teachers picked up on this and introduced him to bizarre music at a young age. That was very important as they opened up a path for him, and he set off on it as a young boy, went all over Europe collecting bizarre German music. It was feeding him. He was very, very individual. I find that the little room thing still exists. I thought it was highly symbolic that when we all lived on the bus, that was the first room he did up. It was like, I've got to have my little nest where I feel safe from the clatter and the clamour of the world. I think on some level his stuff is a survival posture, like, this is the way I've learnt to survive with what I find difficult around me.'

In Stapleton's room, his looming walls of records are somewhat strangely filed according to country of origin – Swedish experimental music, Japanese noise and, of course, his beloved Krautrock – like Stapleton was attempting an atlas of his musical pilgrimages across the world. 'I don't really have much interest in contemporary music,' he sniffs. 'I'm getting old now, I haven't got the same enthusiasm

to search out stuff, because with interesting music you always have to search for it, it's always under the surface, never right there for you to pick up. I had 20 years of searching for interesting music and now I've almost had my fill of it and I really don't feel like searching for more.'

The Stapleton household is situated in the middle of the Burren, one of the sparest and loneliest landscapes in the world, 300 square kilometres of ice-carved karst limestone, which looks like the flesh of the soil has been peeled back to reveal huge furrowed brains. It's a remarkable area, lorded over by bands of wild marauding goats and dense with ring forts and megalithic structures as well as countless lost Stapleton sculptures, birthed from the days when he would take off for a walk across the stones with nothing but a bag of Blue Circle cement under his arm. As we drive past low lakes and deep pools, Stapleton points out and describes the many statues now submerged under water. The whole environment is testimony to Stapleton's overwhelming urge towards creation. 'When it comes to creativity, whether I'm building a wall, mixing cement, making a sculpture, painting a picture or making music it's all the same,' he

declares. 'The same energy goes into it, the same creativity goes into it and there's no room for anybody else, which is why Nurse could never be a band because I'm not interested in compromising at all.'

In 1989, meanwhile, with the rebuilding and the birth of his second child, Nyida Louis, Stapleton announced his temporary retirement. 'For years I always said that Nurse With Wound was total experimentation,' Stapleton told me when I first spoke with him in 1997. 'It was cold, it was emotionless and if someone said to me that there was a soul in there, I'd argue against them and say, no there fucking isn't. I realised fairly soon after that that I was just deluding myself, it wasn't like that at all, I was putting a lot of effort into those records, a lot of soul, if you like, and now I believe there is some kind of communication there. I don't know what it is or why I'm doing it. I'm still making the records to please myself, but I know now that there are people out there who listen to it and who wait for the next release and are interested. I can't help feel there's part of me that makes it for them in a way. At any moment you could just stop and think, well, right now someone is listening to one of my records. Something's getting across somewhere, but what? What am

I actually sending out there? I don't feel any responsibility, though, for what people think of it. I have no idea. People come to me with all kinds of interpretations and feelings – you know, this made me dream about that, I wanna kill my mum, I wanna make love to my sister – all these mad things and you think, did I do that? I lock myself in my little room, I make my music, put it on a CD and it just goes out into the world, and then I hear nothing. I rarely get reviewed. I don't get anyone writing to say what they thought about the music. After ten years of replying to mail I decided I wasn't going to do it anymore, so I don't hear anything. I stopped hearing. There are still hardly any reviews. It's weird, you put all this creativity into something and it just disappears...

'The composer Morton Feldman said that the best environment to make music in is one in which nobody cares,' he continues. 'When he was young he said nobody cared about his music, his parents, his friends, his brothers and sisters, and he said it was the most creative period of his life. He was left alone to do what he wanted to do without influences from the people around him. I feel very much for that. I've almost done that by stopping replying to mail and stopping being involved in musical discussions with friends to a degree, shutting myself off in Ireland. I find it's just the best way for me to work, completely alone when it comes to my music.'

As a parting shot Stapleton released the Nurse With Wound 12" *Cooloorta Moon* in celebration of his new home. Recorded with Wakeford, Pearce, Tibet, Rogerson's ex-husband Chris Wallis, Organum's David Jackman and saxophonist Bradford Steer, it was dedicated to *The Oimels*, a 1970 jazz-skronk/mutant-pop hybrid recorded in Germany by jazz pianist Wolfgang Dauner and his quintet. It sounds like *Hair* cut by a bunch of tweed wearing lecturers with a plastic mainline to alien space brains. Over a loop lifted from Dauner's version of Gershwin's 'My Man's Gone Now', Wakeford lays down a circular bass part as Steer lets loose with a hectoring saxophone solo. A fresh departure, *Cooloorta Moon* reflected Stapleton's increasing sense of contentment and the new pace of his life in Ireland. 'There was a change in that it became more musical,' he agrees. 'Less abrasive and easier to listen to. I was

happier and calmer in Ireland. Music became simply one of the many other things I was doing, not in a secondary way but at this point I was really channelling energies into other things as well, like working on the house.'

In 1990 Vinyl Experience released *Psilotripitaka*, a limited four LP retrospective that re-issued the first three Nurse albums plus *The Ladies Home Tickler*, an EP that gathered together a couple of compilation appearances. 'They totally ripped us off on it,' Stapleton claims. 'Didn't pay me a penny. That was the time that Tibet, Tony Wakeford, Death In June and William Bennett all lost every penny working with Vinyl Experience. They just shut down operations and didn't pay any of us. That's how World Serpent was born, the guy who ran Vinyl Experience, Mark Hayward, employed them. They were doing the day to day record business. Mark was increasingly paranoid, a really strange guy, and he just shut down operations, convinced that he was being ripped off somewhere. It was deliberate, so he could rip everybody else off. Alan Trench, David Gibson and Alison Webster packed it in and became People Who Can't. Then they changed their name to World Serpent and they took us all with them.'

But Stapleton is quick to distance himself from the majority of World Serpent's roster. 'Not that I was a fan of all of those groups or even felt that I had anything in common with them,' he spits. 'I fucking hated what Douglas Pearce did, Death In June were just derivative shit. I really have no interest in that sort of thing at all. I could never understand Tibet singing on those things, they always sounded so derivative. Douglas and Tibet were best friends at one point but I don't think I've met Douglas more than six times in my life. He played on *Cooloorta Moon* because he was around at the time, just E-Bow guitar on the B-Side, 'A Piece Of The Sky Is Missing', but he did a nice job. I don't think he'd ever done anything like that before but we weren't friends at all. I'd never have anything to do with Death In June.'

However 1990 did see Nurse With Wound join forces with Tony Wakeford's Sol Invictus as well as Current 93 for a three LP box set on Cerne Records. Sol Invictus's *Lex Talionis* includes Wakeford's striking version of 'Fields', while the Nurse With Wound entry consists

of soundtrack material from Chris Wallis's still unfinished 16mm film *Lumb's Sister*. Inspired in part by Ted Hughes's 1977 poetry collection *Gaudete* and by the music of Nurse With Wound, Wallis describes *Lumb's Sister* as 'a narrative film based on mythology and landscape and how landscape has its own story to tell.' Shooting began in Wiltshire in the late 80s but all of that footage was scrapped, and Wallis began the film again on The Burren in 1992 when he and his partner Sarah Fuller moved into Stapleton's old single decker bus, just across the tracks. It took another six years before the full unedited 90 minutes was in the can. It stars Ruby Wallis as 'Mary', a girl who 'goes on a time journey and can see into the future'. Stapleton plays Lumb, a 19th Century alchemist. 'He's the dark side of the character and the young girl Mary is the light,' Wallis explains. 'Ted Hughes created a character called Lumb, a dark priest. He was taken to the underworld and they replaced him with a double made of oak root, so he's very unbending, like a stick. But I wanted something more flexible for the female part so I created

Lumb's sister. Lumb's always there where she is, on the edge, he's never seen to interfere directly but yet he seems to affect things or direct them. At the end we filmed a scene at a stone circle in Cork in midwinter. Mary loses a baby – not her own – and you're not sure what has happened but something has. Lumb brings the baby back to her during the ritual of the winter solstice and the union of the light and dark completes the whole circle.' Mary has a vision where she sees Lumb chase and kill a soldier, played by Tibet. She subsequently becomes his spirit guide as he lies 'in the ruins of himself in London'. The soundtrack is deeply suggestive of night on The Burren, with wild horses circling in the shadows and the howl of banshees illuminating the horizon.

Current's contribution to the Cerne Box is *Horse*, with its title track centrepiece's long meditation on the dangers of heroin use, interspersing memories of Kathmandu with images of people from Tibet's past. '*Horse* was just thrown together really,' Tibet explains. 'Like *Christ And The Pale Queens*... I never really felt that it was a complete album. I think the track 'Horse' was great, although when it came out a lot of people hated it because they said it sounded like Crass. I wanted to do something that was harder and heavier. I can remember writing it in a bar in Tokyo in Shibuya and I was with Aki and friends, and they were all talking together and I was sitting at the bar getting quite drunk and depressed and I started scribbling 'Horse' down on stray bits of paper napkin.' Recorded live in Japan with a backing group of Japanese musicians, amongst them Magick Lantern Cycle guitarist Makoto Kawaguchi, they sound like a barely competent teenage metal band partially redeemed by Tibet's committed vocal. The same year saw the inauguration of Tibet's Durtro label, replacing Maldoror. Durtro is derived from dur. khrod – the Tibetan for 'cemetery' – but Tibet uses its more esoteric meaning as a nexus between this world and the next. Besides releasing his own records, Tibet would use Durtro as a non-profit launch pad for various fringe artists, from modern minimalist Charlemagne Palestine through to the dark torch songs of Antony & The Johnsons and Baby Dee. However, the first Durtro release was Current 93's *Looney Runes*, a grab bag of studio re-workings and live material taken from their Tokyo shows in 1988.

Current 93 started the new decade in Iceland with a 1 January show plagued with sound problems – no surprise considering Stapleton was lodged behind a mixing desk that was virtually out of sight from the stage. In March they played The Hellfire Caves in Chislehurst, England, introducing a key future collaborator Joolie Wood on violin and recorders. Tibet met her via her then boyfriend, James Mannox, who used to live above the Tibet Shop in Coptic Street, at a Mind-Body-Spirit exhibition at London's Commonwealth Institute. Wood remembers their first meeting slightly differently. 'James and I were both working in the basement of Rough Trade records at the time and we were playing the *Earth Covers Earth* album a lot,' she recalls. 'James was also designing album covers for bands and started doing some artwork for Current 93. I played the violin in a bar on Friday evenings with a friend of mine and one night Tibet came along to the gig with James. My first impressions of him were that he was highly eccentric, very funny and very intelligent. He needed a violin player, and we got on really well and I already knew the music so it seemed perfect. For the Chislehurst Caves show I mainly just played what had been written before with a small amount of improvisation, but afterwards I got involved in the recordings so had the chance to make up my own parts in my own style.'

That December the latest line-up, Tibet, Wood and Pearce augmented by Mannox on percussion and another fan, James Malinde-Lafayette on harp, were invited to play at La Lune des Pirates in Amiens, France. At the last minute other commitments forced Pearce to pull out. Wakeford was similarly unavailable. In desperation Tibet called Michael Cashmore. Cashmore had recently begun corresponding with Tibet and they'd collaborated through the mail, with Tibet providing a vocal for some music that Cashmore had come up with called 'Hooves' – essentially a shorter version of 'Horse'. Otherwise Tibet's knowledge of Cashmore's work was limited to a tape of vague soundscapes. He called him up and asked him if he knew how to play any Current songs. 'I know them all,' Cashmore deadpanned.

Cashmore grew up in Walsall in the West Midlands, in a 'pretty standard' working class family. The UK's spreading punk menace inspired the 13 year old Cashmore to administer a DIY haircut and pick

up the old classical guitar he had bought for a fiver from a friend of his brother's. 'At the time punk seemed really good,' Cashmore ponders. 'When you were trying to break out of your childhood it seemed exciting but now looking back it just seems really negative. Punk undoubtedly transformed music but for someone growing up it was a really negative thing to be involved in. I always wonder whether it affected me in a deeper way than I actually give it credit for. I always remember the Sex Pistols singing 'No Future!' When you're 14 having that rammed down your neck and identifying with it, it's not the greatest role model to have but maybe that's looking too deeply into it. Those years go quickly and at the time had no particular relevance and seemed unimportant but in retrospect they seem very important in shaping you as an adult.'

Cashmore's interest in punk soon dwindled and while fishing around for something a bit more esoteric he chanced upon the second Psychic TV album, *Dreams Less Sweet*. 'That was so important because it was so eclectic,' he says. 'That really appealed to me and the fact that it was fairly unstructured. I hadn't heard that before in music because I wasn't a massive music collector so I hadn't searched through a lot. I got into the whole TOPY thing very quickly, whatever it was. I still can't really say what it was, it was kind of vague but in a way the vagueness was part of what made it attractive. The nature of it was that it was trying to gather information on things that weren't easy to find out about then. That was a lot of the attraction – maybe it was conscious on their part but the enigmatic nature of it made people super-desirous of it. I wrote to TOPY and got as much stuff as I could. I'd chase up all the influences they would cite in interviews and that was really a brilliant thing. I liked the fact that music could be more than just a piece of vinyl that you bought and played along to. I wasn't particularly involved in the magic stuff but my interest in Crowley came through that, and it was certainly the first time I'd heard of William Burroughs. He became my big thing at the time, reading his words, the whole idea of electronic revolution. I was making music on my own using tape players and acoustic instruments, and finding William Burroughs gave me some amazing ideas of what I could do with that. What PTV said was that there were

other people who felt like this, even if they were all expressing it in different ways.'

After leaving school at 16, Cashmore took a job as a lab technician in an optician's, a job he still holds today. 'I was one of these people who had no idea in life at all,' he shrugs. 'In everything, really, but especially in terms of career. I still don't. No clue.' Still, his experiments with tape recorders continued. In the absence of anything like a sampler he would use the little red and white cassettes that you would get inside early answer machines, recording stuff onto them before respooling the tape onto reels and stretching it. He would then weave intricate melodic guitar patterns over the resultant sprawl of sound, his main influence being early Current 93.

'*Live At Bar Maldoror* was my first purchase,' he says. 'I particularly remember bringing it home and having to slit the record open because there were stickers sealing it. I remember bringing it out of the sleeve and the labels were blank. It may have been because of costs or something but at the time I just thought this is exactly what a record should look like. This does not involve the egos of the people involved in it and that was a major thing for me at the time. I wanted to be on that record and even more than Psychic TV, Current 93 were what I wanted music to be. I wanted stuff that totally did away with anything like song structure. I remember buying another Current 93 record with my friend and he had no clue as to who Current were, but I remember saying to him 'I'm going to be in this group one day'. It seems such a strange thing to have said now, I can't think why I said it.'

By 1987 Cashmore was playing as Nature And Organisation, a phrase he plucked out of a textbook. On the pretext that he needed some advice on where to send demos, he wrote to Tibet and was surprised to get a mail back asking him to call him, as Tibet said he much preferred talking on the phone. 'So I called him but I was mega-nervous,' he admits. 'After listening to the first Current 93 record, you don't know what to make of the sort of people who might make something like that, apart from the fact that they could be absolutely disturbed. Still, I knew I had to do it and I remember being really surprised that there was someone articulate and friendly on the other end of the phone.' When the German Cthulhu

label came forward with an offer to release a Nature And Organisation 7", Cashmore approached Tibet to ask if he'd supply a vocal. Tibet was enthusiastic but when they both listened back to the finished 'Hooves' they agreed that it was just too good to throw a way on a one-off single. It eventually turned up on the Current 93 compilation *Emblems: The Menstrual Years* in 1993. Then, out of the blue, Tibet asked him to play with Current 93 at Amiens.

'I came down to London and Tibet was waiting for me at Euston with James Mannox who was a percussionist at the time,' Cashmore remembers. 'My first impression of Tibet was that when he talks he sounds exactly like the records, so everything he was saying sounded like it was the new album. He was really friendly and we got on really well. The next day we were travelling and we went by mini-bus with Sol Invictus who were supporting us. I was nervous about first meeting Tony Wakeford and Karl Blake, because they were just these huge black figures in the street as the van pulled up and I was wondering what I'd let myself in for but they were really nice. I'm never particularly comfortable with new people so I wouldn't say I was immediately comfortable but I was as good as I can be. The concert was actually pretty easy. We were doing songs from previous albums so I knew what they were. What was most amazing for me was it was the first time I'd seen a large amount of people who were interested in the same kind of music as me. For a long time it had been a solitary interest and all of a sudden we played this concert and all these fans were there.'

On *As The World Disappears*, a recording of Current's Amiens show, Cashmore's contribution is striking and the whole group immediately sound more regal and confident. The dolorous way Cashmore has of teasing out the simplest of melodies makes the music much more unselfconsciously antiquated than before, while his advanced technique gives Tibet's lyrics the kind of bold yet uncluttered foundation that they had previously lacked. Most importantly, Cashmore's light, tumbling arpeggios opened up more space in the music, allowing Tibet's vocals their full expressive range. The set was longer than Cashmore's only rehearsal yet in this little star-crossed moment, the new Current 93 sound was born.

# O Rose, Thou Art Sick

*I've been living in the past since I was 13 years old, when I made a
decision to go backwards instead of forwards*
– David McDermott

Coil are unashamedly a drug group. Cosmonauts of inner space, they
declare their interest in chemically altered states in the deep detail of their
music and the precise imagery of their sleeves. Indeed Coil packages can
be seen as facilitators – launch pads to elsewhere. Although both Balance
and Sleazy had been using Ecstasy since 1981, well before it hit the UK
masses in the mid-'80s, the drug's impact finally began to show in their
music on records like *Love's Secret Domain* released in the early '90s.
But its effect on their memory kicked in much earlier. The years 1988
through '90 are a blur for both Sleazy and Balance, who were ingesting
copious amounts of chemicals and clubbing almost nightly. 'We were
never really into mass gatherings though,' Sleazy shudders. 'Most of
the places where we used to do loads of drugs were obscure clubs that
opened at five in the morning and were filled with gorgeous rent boys
on acid who were snogging you and selling you drugs and then sitting
talking for two hours or undercover policemen sitting opposite and not
knowing what to do. It was a different reality altogether, I really have
no interest in jumping up and down with 10,000 people.' For Sleazy the
Ecstasy experience was more than an obliterating head rush. Rather, it
was a whole other state of existence and had more to do with reaching a
place between life and death, between this world and the next. 'Ecstasy
affects the perception of the people around you and the place that you're

*Previous page:* Stapelton & Tibet, Crouch End, 1990. (photo by Ruth Bayer)
*Left:* Sleazy, self portrait.

in and the colours of the landscape,' Sleazy explains. 'And that's what I expect to find after I die, for a few minutes anyway. I'm sure if I were to take Ecstasy today I'd go to the same place. Either that or a temporal anomaly or wormhole opened up back then and for a moment it was possible to cross over.'

'I was never very impressed by the club thing,' Thrower maintains. 'I always wanted to turn up, score with someone and then get out as soon as possible and go have sex with them. I never liked the dance scene. I just saw it as something that was getting in the way of cruising. I enjoyed some techno records if they were particularly brain-mangling but it really didn't matter that much to me. I always felt it relied too much on the old mama heartbeat, as Captain Beefheart would say. It also seemed to have this unfortunate effect of sucking people's musical tastes into it like a fucking black hole. I noticed that friends whose musical tastes used to be very wide ranging were now listening to nothing but boom-cha boom-cha boom-cha techno-ish things that just bored me to tears. When aspects of the acid house rave music thing started creeping into Balance and Sleazy's recordings, I was dismayed and didn't like it at all! I thought a song like 'The Snow' was a total waste of time and just sounded like any old dance record, I'd never even notice if it was mixed in at a club with everyone else's dance crud. Anyway, as it turned out, the dance influence was a fairly short-lived thing in Coil music but we had some 'heated debates' on the subject. They probably thought I was being a joyless fucker and I thought they were turning into disco bunnies who were on so much 'E' they couldn't tell what was good anymore. I just felt there was a homogenising thing going on in that music, and I

didn't like to see my friends get sucked into it, losing their idiosyncrasies in some wretched 'movement'. I guess at some point Balance and Sleazy must have felt that too, because they abandoned that influence and took a more innovative, personal path to be where they are today.' 'It might have been a mass-delusion,' Balance adds. 'But it felt right to fix your eyes on it for a while.'

The sessions for Coil's 1991 album *Love's Secret Domain* were so intense that by the end of it, the players had been brought to the point of mental collapse. Boasting one of Stapleton's finest cover paintings, executed on an old wooden door he found in Cooloorta, it bears the motto 'Out of Light Cometh Darkness', and to be sure Sleazy's memories of it are hazy at best. 'I can remember Balance and Steve having these mad arguments that would go on for 48 hours without sleep over which sequence of words should be used,' he recalls. 'By that time the automation on the desk would have blown up and they'd have to start from scratch. It was pretty mad. It was worse for me as well because I was directing commercials at the same time. So I was living a schizoid life, doing one thing in the day and another at night.'

Balance remembers visions of larval shells rearing up like huge mummies in the booths. It was almost as if they'd found their way into one of the backrooms of the British Museum, as rows upon rows of 10 foot tall Amazonian warriors and Babylonian kings appeared to march through the control room. 'I'd see them sitting there,' Balance recounts. 'Touching each other and talking to each other. Everyone could definitely psychically sense that there was stuff going on all the time. Me and Steve were just sat looking back into the control room at all these entities pretending to be deities and Steve said, fuck that, we're not going in there. We didn't come out for four days straight. I remember staring at a curry and watching moles spring out of it, but I realised I'd been looking at it so long the thing had grown fur. Four days, just too scared to go into the control room because there were all these kings sitting there, twitching.'

'We were sprawled in a total drug-fucked daze in the lounge adjoining the studio mixing room and yes, we were visited quite relentlessly for a few hours in there,' corroborates Thrower. 'Whereas hallucinations of

figures and faces usually flicker and come and go, these figures were proliferating and starting to crowd the room, they didn't recede as you looked directly at them. The window through to the studio where Sleazy was mixing one of the tracks was being visited by a succession of kings and holy men. I was getting Aztec figures too, as well as some possibly Nordic people. Balance and I found that we were seeing each new figure in perfect synch with each other. As we lay there we would compare what we were seeing and there was an amazing degree of agreement, the confluence of mind was so steady. The experiences were as verifiable as reeling off the colour of passing cars together in broad daylight. It went on for ages. You would see a figure and then the other would describe it exactly, there was no question of it being the power of suggestion, we had lots of time to study what was happening and that wasn't the answer. It was one of several experiences that cleared the way for a more inclusive mystical viewpoint for me, after quite a while spent chasing the existential zero up its own arse, which is just the mind finding endless ways of describing a dead end. This experience of the *LSD* sessions and some powerful later visitations led to me changing my way of thinking.'

'My recollection of it is that most of the mixing was done at night,' Sleazy states. 'Our understanding of the equipment and the equipment itself was progressing so that more things were possible. I mean, Throbbing Gristle were basically guitars and tapes, with me and Chris Carter having to actually build any electronics from scratch. How Coil actually sounds is often a function of the state of technology at that time. So a lot of the more freaked out tracks on *LSD* are that way because we wanted them to be but also because there were advances in technology that would take the sound to places where it hadn't been possible to take it before. We took in a lot of our experiences in clubs, certainly, but *LSD* was much more about the places that you went to when you were at these places.'

More than drugs, what *LSD* is most influenced by is England's lunatic tradition – that is the English underground in all its sexual, cultural and artistic variety. On *LSD*, Coil drew on the art and lives of outsiders and visionaries like Charles Sims, Derek Jarman, Austin Osman Spare,

Joe Orton and William Blake, factoring them into their psychedelic gazetteer of England's hidden reverse.

'The place where we were mixing it was in Bloomsbury,' Sleazy explains. 'In this weird basement and we would pass the British Museum and many of the song's influences were from that tradition, I'd think of Nic Roeg's film *Performance* or The King Singers, examples of eccentric English culture or English culture that was perverted or bent, so the environment seemed to refer to it.' Charles Laughton, the English born actor who starred in *Mutiny On The Bounty* and played Quasimodo in *The Hunchback Of Notre Dame*, before going to make *The Night Of The Hunter* (1955), his only film as director, is another of *LSD*'s alternate touchstones. *The Night Of The Hunter*'s rogue preacher character, played by Robert Mitchum, provides the spoken part on 'Further Back And Faster', a psychotic electrohymn to temporal displacement. 'He's another example of an English eccentric who is successful creatively until people get scared,' Sleazy points out. 'There's a repeating thing here isn't there?' 'Before he died in Hollywood, he ended up in Whitby, where Dracula enters the UK in Bram Stoker's novel,' Balance concurs. 'Living with a 15 year old boy in a boarding house. Trying to live his own life. Blake is also very important to me but I think he's so misrepresented, he's become this caricature of a visionary artist, living with his wife and seeing angels in the apple tree.' It's vaguely surreal to witness Blake's headline status at the Proms, a jingoistic celebration of the figments of empire. With the title track's act of reversal, Coil restore Blake's true rebel status.

'I don't think these kinds of artist are specifically and intentionally excluded,' Sleazy states. 'If English culture was able to circumvent the kind of minor embarrassment and hesitation which causes it not to embrace the underground artists of which we consider ourselves a part, then there would be a much more complete embracing of this kind of culture because this is what Britain really is. Generally English culture nowadays is dull because a few people in the media have a sort of squeamishness about them and are just unable to take the last step with us. If Britain in general could overcome that last hesitation we would be a much more potent artistic voice as a country because all of the truths

285

that these kind of artists espouse would be accepted. I would consider us as part of some kind of general English esoteric tradition although I don't think necessarily that English people have the copyright on that particular thread. There are lots of people, Americans like Burroughs, for instance, whom we'd consider part of the same movement, but I think English people are pretty good at it. English society has such a culture of eccentricity, like the village idiot or the wacky professor and English people who put themselves in this position in public haven't suffered the same ignominy and abuse that eccentrics tend to suffer in the USA, for example.'

Following on from Blake, Coil connect with the psychogeography of London's terra incognita – secret places, mystic alignments, old buildings hidden away beneath the modern. Tracks like *LSD*'s eerie instrumental 'Dark River' and *Black Light District*'s 'Lost Rivers Of London' – its title taken from Nicholas Barton's book of the same name that traced the trails of the Fleet, the Tyburn, Stamford Brook and Walbrook beneath the pavements of the capital – are attempts to map the secret city. 'If London still has any magic that's where we find it,' Balance maintains. 'It exists somewhere else really. It's one of the few reasons I can tolerate it. It's been a sacred place for a long, long time. One of the reasons I like Spare so much is that he's a London artist. Although when he once claimed to be the reincarnation of William Blake he was obviously being tongue-in-cheek, he certainly saw himself in that mystic tradition and I see ourselves as being like that. Me and Tibet more so, we read these things and we immerse ourselves in it.'

Sleazy warms to the theme: 'Whenever you find a culture that has strong regenerative music it's always a culture that has a tradition of mysticism and mystic individuals. I'd have to say, though, for me there's no difference between chemically altered states and magic. Psychedelics specifically. It opens you up to something that objectively exists. Well, all experience is subjective, there is no other kind, but the places that you go to with those drugs are just as real for you as... Croydon.' Balance takes up the thread: 'I mean, these places have been accurately mapped by certain people, including John Dee. Certain people can access these areas, like Amazonian shamans, Terence McKenna, certain people.

ps. Can you remind Mix Mr. Morris to copy that Voice Synthesis disc please!

# THRESHOLD HOUSE

## NEWSLETTER
## SUMMER EQUINOX
## 1994

We've just done mixes for SCHAFT. 'visual cortex' and 'olive'
and Re-mixed 'Eraser' and 'The Downward Spiral' for NIN.
love GEFF

Some people, using their 'maps' precisely, will go to the same place and have comparable experiences – the equivalent of geographical regions. You go there and you see what is there.'

*Love's Secret Domain* remains one of Coil's most lucid glimpses of the other side. With the help of co-producer and engineer Danny Hyde, Coil took the new dance music and subtly altered its DNA, re-configuring it as concrète punk. Sleazy jokingly describes it as 'the party album' and there are a couple of incongruously straight techno sides, like 'The Snow' and 'Windowpane' that leave you scratching your head. Balance, however, still loves it. 'Certain people don't like it because it's got so-called 'disco' elements on it,' he smiles. 'We never considered it disco, we weren't trying to do House or dance… no way. We started listening to a lot of dance music but we wouldn't let it in to the records at all. It was, like, hermetically sealed off. Eventually we let it in on *Love's Secret Domain* but we weren't trying to do dance music.

'That whole rhythmic thing is moronic, totally moronic,' he contends. 'We intended these records to be psychoactive – to be music to take drugs by. The title and everything points to that… how obvious could we make it?' What separates Coil's use of rhythm from mainstream dancefloor music is that on the whole the beats don't lead the track – they're another background texture, spiralling chaotically inwards. At points there is so much blurred movement that it almost sounds like an aural action painting. The album features guest vocals from Annie Anxiety, Rose McDowall and Marc Almond. Ex-This Heat drummer Charles Hayward adds the frenzied percussion to 'Love's Secret Domain' itself, as Balance pierces the veil and England's black heart stands exposed; 'O rose, thou art sick!' It functions as a damnation of the rotten state of British culture, a celebration of perversity and a Blakean call to arms.

Rose can barely recall anything of the sessions. 'I do remember getting paid in Ecstasy for doing it,' she laughs. 'They were all off their head, everyone was smashed. They gave you a tab every time you did a vocal take. When you're around Balance he always sees a lot of things and Balance is my doppelganger, the male Rose, so I would tend to see what

he was seeing and be able to know what mood he was in.' Almond's performance on 'Titan Arch' is the record's centrepiece. He pulls off a vocal that walks the line between fallen and damning as ominous loops of guitar and thudding electro-bass circle like wonky halos. Annie Anxiety sounds like a Puerto-Rican stand-up comic during her stream-of-consciousness vocal on 'Things Happen' and Sleazy's fractured compositional logic reaches new heights on the indescribably melancholic 'Chaostrophy', building rhythm patterns from the sound of someone rapidly dialling through late night radio. He blends glimpses of these broadcasts into orchestral shapes that are shadowed by a gorgeous arrangement of oboe and strings scored by Billy McGee. An ode to Tesla's invention of the wireless, 'Chaostrophy' gives form to some of the telegraphic shapes zig-zagging the capital's skyline, while also referencing Tesla's own coil, developed in order to transmit electricity through the air.

The cinematic instrumental 'Dark River' was the last track to be completed and it almost never made it. 'When Sleazy wrote the first version of 'Dark River' it was one of the pieces that really fired me up for the album, I thought it was fantastic, the complete opposite of 'The Snow' which I loathed from day one,' Thrower reveals. 'It was a long, dreamlike piece and one of my favourites, but it was about ten years before I could listen to it again on account of the hell we went through mixing it. It was such a delicate, precisely balanced piece that the slightest error or over/under-compensation would wreck it. Mixing it was like operating on the innards of a squid. There were technical faults happening throughout the day and the desk wasn't automated so consequently everything had to be spun in and mixed by hand. All four of us – Sleazy, Balance, Danny Hyde and myself – were clinging to the mixing desk, struggling to get every nuance right during take after take, only to have some mystery gremlin fire sparks off somewhere inside the desk as we were within seconds of a complete 'pass'. We'd already been awake for three days and this final effort took on Herculean proportions. It's a mesmeric, otherworldly piece at the best of times, but under these conditions the River Styx associations were really getting the upper hand! We were in an expensive studio for the last stages of

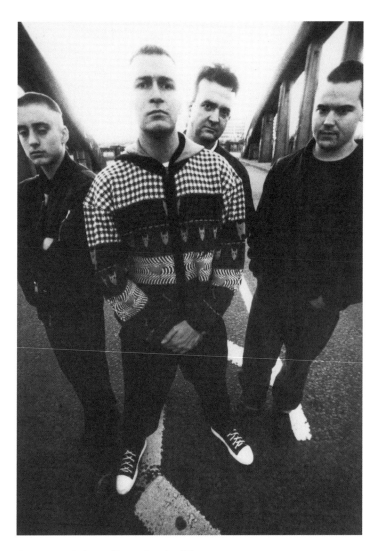

Otto Avery, Balance, Sleazy, Stephen Thrower.

*LSD*, the album absolutely had to be finished that day, our minds were approaching complete meltdown, our bodies weren't taking the strain any more and we kept falling over and gurgling. Without the intense concentration on the mix, my mind was turning to mush there on the carpet, so you'd haul yourself back to the desk and go through the 'Dark River' journey one more time… and again…'

By the close of the *LSD* sessions all of the players were feeling emotionally and physically drained and combined with an escalating and incompatible appetite for drugs – Thrower's speed and acid up against Balance and Sleazy's use of Ecstasy – things came to a head. 'I think Coil and I started to drift apart on a musical level, in part because our sensibilities, as filtered through and heightened by drug use, were diverging quite severely,' Thrower recalls. 'The drug-taking which fuelled the *LSD* period just carried on afterwards and it started to get rather destructive.' Thrower's relationship with Jeff Hildreth, who had been his boyfriend since 1987, was falling apart and the drugs were only exacerbating things. 'It was a situation that was bound to happen after a while,' he admits. 'In fact I think I was lucky to enjoy such a long period, a good five years of heroic excess, without any major horrors. But I was entering a fairly black time in my life in the early 1990s, with a lot of personal demons to deal with and the collapse of a long-term relationship, an obsession with the rottenness of things that was leading to some very self-destructive habits. The drug use was compulsive but the fun was starting to go out of it all. In early 1993 I split up with my boyfriend and soon after I fell out with Balance and Sleazy too.' The split happened halfway through assembling *Stolen And Contaminated Songs*, a collection of inspired effluvia from either side of the *LSD* sessions. Balance dubbed it 'the garbage of love' and it features the last track that Thrower cut with Coil, 'Wrim Wram Wrom', a mile-high wall of undulating groan and sonorous cello.

With Thrower caught in the freefall of a severe depression, Balance found him increasingly difficult to be around, perhaps seeing Thrower's breakdown as presaging his own mental collapse. The pair had clearly taken things as far as they could go together. 'Things really had to change,' Thrower says. 'There were very few options left after the *LSD* sessions; I'd say death was a very real presence at the end of that particular feast.' Although Thrower's depression clouded the early '90s, he continued to maintain his involvement in fringe culture, forming Identical with Gavin Mitchell and Orlando, a group based around saxophone, trumpet and sampler, and working alongside Andy Diagram and Andy and Howard Jacques in Put Put. He also launched

Stephen Thrower,
London, early '90s.

*Eyeball*, the journal of 'Sex & Horror In World Cinema', a magazine that combined Thrower's passion for the cerebral kick of art cinema with a taste for trash, writing in a conversational yet incisive style about everyone from Jean Luc Godard and Alain Resnais through Dario Argento, Joe D'Amato and Lucio Fulci. Indeed his passion for Fulci resulted in the publication of *Beyond Terror*, a lavish large format book that plotted the wayward career of the Italian director. In the late 90s, he formed Cyclobe with his future partner – and future Coil member – Simon Norris (henceforth Ossian Brown), a group that have taken Coil's experiments in psychedelic electronica into ever more formless realms with austere drones and improvisations that rise like breath in clouds of cumulous F/X. Their second disc, 2001's *The Visitors*, sounds like they're giving birth to galaxies.

William Blake also appeared to David Tibet in 1991, a bloodied vision of waste and death: 'Lilith is smiling at the corpse of a cow/ And in that

Cyclobe, Stephen Thrower & Ossian Brown, 2010. (photo Ruth Bayer)

corpsey cow/The corpse of another, And so on and so on/And perhaps forever/If times were not folding and falling/Over each other/And so on and so on and so on/And certainly endless,' and again, 'I slept I dreamt I dreamed a dream:/London bright fires smiling and burning/Light roads road through the starlacked night/Many dark suns are falling falling down/London Bridge is destroyed.' 'All The Stars Are Dead Now', from 1992's *Thunder Perfect Mind*, sees Tibet's interest in the complexities of apocalyptic prophecy start to wane. He follows details of Blake's visitation with scabrous cries of 'Dead dead dead dead', both a confirmation of the eschatological nature of his vision and a refusal of its negative power. *Thunder Perfect Mind* would function as a farewell to

the convoluted end-time theology that so dominated previous releases and see Current 93 move into much more personal realms. As Tibet pulled together more and more material for the album, he found himself focusing on the tracks that spoke of his relationships with his friends and of his childhood, and from that he began to assemble his own highly personal cosmology, all framed by gorgeous arrangements of acoustic guitars, recorders, dulcimers and harps. The end result was a far cry from how he had first envisioned the album. Originally entitled *The Tale Of The Descent Of Long Satan And Babylon*, it had been projected as the last Current 93 album ever. 'I had decided I was going to give it up and start another project,' Tibet says. 'I was just unhappy with everything that I had done.'

Tibet had written the first manic draft of 'The Descent Of Long Satan And Babylon' while at a girl group concert with his girlfriend Okauchi in Japan. Unimpressed by the group, he had hunted down a seat at the back at the bar and begun to write, chasing his idea about two emissaries of the devil at the end of time through page after page of his notebook. 'Satan sends his two servants to Earth – Long Satan and Babylon,' he wrote. 'Christ has given to Peter the keys of heaven (Matt 16.19). He himself keeps 'the keys of hell and death' (Rev 1.18), which he later gives to the fifth angel (Rev 9.1). BUT – Satan has stolen from him the key of earth. Christ has been locked out of His kingdom on earth until the Rapture; he can only wander impotent following LS & B (carrying the key). Centre around the Patripassianist heresy: until the end of time Christ continually re-enacts His passion till the end of time. Christ is continually dancing between the spaces and the worlds. The key of earth unlocks the spaces so he can come out of the spaces and into matter itself. But: LS & B have already used the key to unlock a space on earth. On doing so, they see Christ Immaculate in 3 forms; logos, man of sorrows, and in the Patripassianist form! He is bleeding heavily, his throat is parched and it seems as if the body is dancing and spinning, fading in and out of this world. Satan is father of lies (John 8.44). He has convinced LS & B that Christ is totally beyond this world and that the key is merely to unlock the negative energy of the earth. But LS & B have seen that Christ cannot leave the world – He is locked in it through His Passion till the end.'

Originally conceived as an insanely heavy concept album – an 'apocalyptic *Tommy*' quips Tibet now – he effectively condensed its fascinating if convoluted ideas into *Thunder Perfect Mind*'s evocative opener, 'The Descent Of Long Satan And Babylon'. Set as a delicate acoustic ballad, Cashmore's intricate guitar is suspended amidst droning pipes and tinkling bells. Around this time Tibet was having a series of dreams that involved his girlfriend from Newcastle, Suzanne Riddoch, along with his nightly visions of the coming of Antichrist, which he transposed into 'A Lament For My Suzanne' and 'Hitler As Kalki (SDM)', the latter perhaps the purest manifestation of his apocalyptic obsession to date.

'Hitler As Kalki' explores the terrifying idea, first put forward by the Hindu social Darwinist, Holocaust denier and Hitler worshipper Savitri Devi Mukherji ('SDM' as Tibet refers to her in the title), that Hitler was in fact the final avatar of the Hindu God Vishnu, and the initiator of apocalypse. Devi interpreted the rise of the Nazis according to the cyclic understanding of history implicit in Hinduism, believing that the world is born in perfection before degenerating to destruction and initiating the cycle all over again. There were four 'yugas' or ages in this process. The final stage, the one leading up to destruction, was the Kali Yuga. Just as Salvador Dali had dreamt of Hitler as Maldoror, Devi saw in Hitler echoes of Rama and Krishna, a warrior mystic who would free the world from the decadence of the Kali Yuga in a great cosmic battle and thus return the world to the perfection of its birth. For Devi, Judaism, capitalism and liberalism were the signs of the endtimes. Indeed Devi believed Hitler was Kalki, the tenth and final incarnation of Vishnu who ushers in the apocalypse on a white horse. In many respects, this is very close to Christian eschatological theology, the only difference being that Christ's coming marks the end of human history whereas Kalki's marks an end and thus a new beginning of history with the advent of the Krita Yuga. Tibet's lyrics are a great damburst of apocalyptic imagery that draws on all of his readings in Christian and Hindu scripture up to this point, while referencing Odinic rites, magical ritual and all the varied forms of God, impotent in the face of Hitler's terrifying violence; 'Oh my dear Christ/Carried broken from sad brown

earth/Teeth. Teeth. Teeth. Teeth. Teeth/Hitler as Kalki/Kalki as Hitler/ Hitler, Kalki.' It's one of the most disturbing treatments of Hitler's reign of terror ever committed to wax and Tibet dedicated it to his father 'who fought Hitler.' 'I am in no doubt,' he wrote in the liners to the live album *Hitler As Kalki*, 'Hitler was Antichrist; Jesus killed Hitler – eventually...'

'Hitler As Kalki (SDM)' was worked up by Tibet and his new friend and collaborator Nick Saloman aka underground psychedelic guitarist The Bevis Frond. Tibet was introduced to the music of The Bevis Frond by his friend Alan Trench, who at the time worked in the Vinyl Experience record shop. Like Tibet, Saloman ran his own label, Woronzow, and relied on an alternative network of underground fanzines like the UK psych bible *Ptolemaic Terrascope*, leftfield distributors and word of mouth recommendation in order to get his individual soundworld across. Tibet picked up two Bevis Frond albums, *Triptych* (1988) and *Any Gas Faster* (1990), and was immediately floored. 'I thought they were fantastic,' he enthuses. 'Not so much the psychedelic jamming, which was never my thing but the songs that Nick was writing were melodic and moving with lyrics that were funny and sharp.' As ever, Tibet was keen to make contact with a like-minded soul. Inevitably, they began collaborating on songs. 'Hitler As Kalki (SDM)' was the first to bear fruit. Using percussive punches to sound the rhythm, Tibet sang the lyrics at Saloman, who quickly worked out a guitar piece, a sinuous motif that coiled like smoke throughout the track.

Tibet had written the lyrics to 'A Song For Douglas After He's Dead', another of the central tracks on *Thunder*, during one of the earlier *Island* sessions. Caught up in listening to some of the rough playbacks he began to think about Pearce and about how he would remember him. 'That was always a very powerful song,' Tibet maintains. 'There's an album by Death In June called *The Wall Of Sacrifice* and on it there's a picture of Douglas looking at the camera holding a knife and behind him there's a mask on the wall and that's what brought it on. Also, he would always squat on the floor at soundchecks while we were waiting for stuff to happen (check the booklet of the live *Hitler As Kalki* CD for proof of the squatting Pearce) and I suddenly thought, 'He crouches on the floor, there's a mask on the wall and he leafs through the pages of a

book...' He meant so much to me.' It's a very sexual song, with Tibet's emphasis on the line 'This is a song for my Douglas' making explicit the homoerotic undertone. Live, Pearce would always play it for laughs. When Tibet would point to him after peaking with the line 'His mercury dances!', he'd respond with a totally unmoved, deadpan expression and a desultory shake of his hand bells. Again, during the *Thunder* sessions, Tibet sang the lyrics to 'A Song For Douglas...' rhythmically, this time to Cashmore, who put the hymnal sounding backing track together, while Wood bowed the death march at the start. 'In The Heart Of The Wood And What I Found There' was originated the same way, with both Wood and Cashmore helping to piece it together.

The phrase 'The heart of the wood' comes from Russell Hoban's post-apocalyptic novel *Riddley Walker*, a book that had a huge effect on Tibet at the time. Hoban, an American-born writer resident in London, was inspired to write *Riddley Walker* after visiting Canterbury Cathedral and coming across a reconstruction of the 15th Century wall painting *The Legend Of Saint Eustace*. According to the story, Eustace was originally a general named Placidus serving under the emperor Trajan during the Second Century who was converted to Christianity by a vision of a stag with a glowing crucifix between its antlers. His martyrdom occurred when he refused to join in praising the Roman Gods after a victory in battle. He was burnt to death alongside his wife and sons. An idealised reliquary, claiming to have actual fragments of St Eustace's skull, still resides at the British Museum although due to the apocryphal nature of his tale the saint is still unrecognised by the Catholic and Anglican churches.

After seeing the wall painting in March 1974, Hoban began *Riddley Walker*, eventually completing it in 1979. The book posits a post-apocalyptic world where all of the 'triumphs' of modern society have been wiped out and the population had only degenerated folk myths to inform them of the 'Bad Time'. The Legend Of St Eustace was one of the new society's founding myths, as was the story of 'The Hart Of The Wood', although through the degeneration of language it had become confused and conflated with several other histories, both pagan and

scientific. The main character, Riddley Walker, is a 'connection man'; a priest-equivalent who interprets the Punch & Judy plays performed by travelling government representatives. The whole book is written in an invented pidgin English and reads as though it was dictated.

'I thought *Riddley Walker* was stunning,' Tibet confesses. 'Stapleton recommended it to me and it moved me profoundly. It was apocalyptic, pagan and Christian, all things that interested me. 'The Heart Of The Wood' must have come from that. I'd already read *The Golden Legend* and I was interested in St. Eustace and as is often the case synchronicity came into play. I was also collecting Punch & Judy material because of my interest in *The Wicker Man* and Corn Dollies.' Bizarrely enough Steve Ignorant of Crass had begun working as a Punch & Judy man and Current hired his puppet show as the support act for their show at The Mean Fiddler's Acoustic Room on 12 April of that year.

*Thunder Perfect Mind* was in many ways Current 93's breakthrough album. For the first time Tibet was writing about how he actually felt and about the people around him, framing these portraits with aspects of his readings in mystic Christianity, Buddhism and eschatology. It was also Current 93's biggest selling album to date. 'Before *Thunder Perfect Mind* I wouldn't have felt comfortable writing about my own thoughts and feelings,' Tibet says. 'I was confused, I felt like I was in a fog a lot of the time. For me my illness, or my breakdown or whatever it was, was a major turning point and although at that time I was studying more under Rinpoche, I had also started reading Christian theology again, only now thinking about it as reality rather than academic discursive talk.' What most affected his worldview was reading Pascal and Kierkegaard. 'I felt that in the shadow of what they were saying, nothing else was important,' he maintains. 'They pointed out what I now saw as simple truths and simple facts. I felt that we'd all been judged and all found wanting. After reading them things couldn't be the same again, everything took on a new light, so I'd look at my early material and though I'd be proud of it as experiments in sound and form, I didn't want to be involved in anything that wasn't specifically dealing with one's own soul. The state of the soul became of paramount importance. With *Thunder Perfect Mind* I was still reading and thinking about it and wondering.'

'*Thunder Perfect Mind* is my favourite,' Rose McDowall maintains. 'There are so many gems on there, the lyrics are really good and the melodies are fantastic. Tibet was in a good place in his life at the time and I think he grew up a lot musically as well. With his old way of working he would simply book a studio and then come up with something once he was in there but with *Thunder* most of it was pre-planned and I think that Joolie and Mike were key to that because they were both highly accomplished musicians. Tibet didn't care about things like being out of tune though. I'd point it out but he would just say that it sounded great. Sometimes he likes things that are a bit off, like wonky nursery rhymes or something.'

*Thunder Perfect Mind* was also the most expensive album Current had made, as they were now using the legendary folk label Topic's studio in London, due to the fact that David Kenny, a member of the old IPS team, was now the in-house engineer. It was also through the Topic connection that Tibet was able to get his hands on a contact number for Shirley Collins, who had cut several sides for the label in the '60s and '70s. 'I rang up Tony Engel, the brains behind Topic, and he knew me because I was recording at the studio and so he gave me her number,' Tibet explains. 'I called her up and left a message on her answer machine. I told her I was in a group and obsessed by her music, that I wanted to release something – anything – by her and that I'd love to meet her. I called her back several times, I was really insistent. I still refer to myself as her longest-term stalker. She had no rest until we met up.' Collins eventually recorded a spoken word intro – 'A Beginning' – to *Thunder Perfect Mind*; 'I went down to the forest to gather fine flowers/but the forest can yield me no roses/but the forest can yield me no roses...'

Shortly after completing the *Thunder* sessions, Tibet and Stapleton began *The Sadness Of Things*, a landmark release in that it's credited to Steve Stapleton and David Tibet rather than Current 93 or Nurse With Wound. It had started life as a Current 93 track, with the body of the work being recorded in Stapleton's record room in Cooloorta. 'Then we went up to Colin Potter's ICR studio and we started working on it there,' Stapleton recalls. 'I put so much work into it that I said to

Tibet that I'd really like us to share the credit on it. I was really proud of it and so was David; it was a total 50/50 job, so it was fair to bill it as Stapleton/Tibet. I love it, I love all the duo ones.' Its mood is more melancholy than most Nurse With Wound recordings, with Tibet dropping lines such as 'What colours do they dance in, the torn banners of yesterday?' while a leaden drum machine moves relentlessly forward. Also included on *The Sadness Of Things* is 'The Grave And Beautiful Name Of Sadness', a collaboration between Stapleton and Geoff Cox (whose calligraphy often adorns Current 93 and Nurse With Wound sleeves). It was originally recorded as a film soundtrack to Rogerson's *Twisting The Black Threads Of My Mental Marionettes*, but the music fits perfectly with 'The Sadness Of Things', another long tone piece that moves from celestial breath to churning, gnarled electronics.

One of Stapleton's few outside production jobs is Spasm, a group led by James Mannox. Halfway through, and aware of how long it would take to finish the record, Stapleton came up with the idea of releasing a split album instead. After all, the album he shared with Organum had been a success. For his side, he offered up one of his looniest creations: 'Creakiness'. "'Creakiness' was cartoon sound effects, heavily influenced by Tex Avery,' Stapleton laughs. 'I like to go into a studio without any idea what I'm going to do. I don't take any instruments in and whatever is there I just use it. I was there on my own and there was this tape of these things there and I started making rhythms of scratching sounds and doors opening from it and it just evolved into what it is.'

In 1991 Tibet was dating Christine Dörner aka Thorn, a German fan who had first got in touch after purchasing a copy of *Swastikas For Noddy* in September of 1990. 'I rapidly became one of Darmstadt's biggest Current 93 experts and fans,' Dörner recalls. 'I first wrote to him because I was fascinated by his lyrics and felt drawn to him even though I couldn't tell you exactly why. I just had a gut feeling that Tibet was going to play an important part in my life, which he still does to this day, although we don't communicate on a regular basis.'

The Current 93 song 'They Returned To Their Earth', recorded during the *Thunder* sessions and featuring lines like 'When serpents

Ossian Brown, early '90s. (photo treated by Balance)

come, They cover the Christ Thorn,' was dedicated to Dörner after she pointed out how her name was closely related to Christ Thorn, with Christine meaning 'the anointed' and Dörner coming from the word Dorn or Thorn in English, hence her nickname. 'The biggest coincidence was that he had written the song before he met me,' Dörner says. 'We both took this as a sign. I have never been in a relationship where signs and symbols mattered so much as it did with this one. Tibet is a very generous person and provided me with symbols and things that were meant to protect me, like a lock of Rinpoche's hair or a Thor's hammer from Iceland. He was exceedingly charming, very witty and had a vast knowledge of mythologies and strange, obscure stories. He could also tell the best jokes but at the same time he was often very depressed. I always thought that was strange, although I was only 19 at the time and I guess I used to think that being depressed was 'cool'. I don't think so now. Still, I have never met anyone before or after Tibet who was more romantic than he was. I received letters every day with

the biggest proclamations of love ever imaginable. No one else has lived up to the standard set by Tibet. That's actually a bit of a problem for me now. In time I lost all of the symbols that were meant to protect me, although they meant so much to me. When the last symbol was gone I knew that the relationship was over. And it was shortly afterwards.' Tibet and Dörner's relationship was brought to a sudden and premature end by the arrival on the scene of Kat.

Kat had been born Janice Ahmed in Melbourne in Australia but grew up in a redneck city in the middle of nowhere called Cavalry. At the age of 15 she ran away to Perth and then on to Sydney. After suffering a mental breakdown in 1982, she was packed off to a family friend who was training to be a doctor in Scotland. In Edinburgh, she got involved in music, attending gigs by the likes of The Rezillos and The Exploited, living with an ex-member of Postcard group Aztec Camera and playing alongside future Shop Assistants guitarist David Keegan in The Drunken Christs. After nine months she was back in Sydney, where she hooked up with Alexander Karinsky, who ran underground cassette label Cosmic Conspiracy Productions, dedicated to documenting any domestic post-Industrial rumblings. One of their first signings was John Murphy, who was back in his native Australia after his sojourn in the UK. When Kat told him that she planned a stopover in London on her way to Amsterdam, Murphy suggested that she look up Tibet.

Kat first met Tibet at a Current 93/Death In June show at New Cross Venue in May 1991, the London leg of a year long series of gigs undertaken with Sol Invictus and Death In June. 'I had heard the albums but had no idea what Tibet was going to look like,' Kat recalls. 'Somehow I had the idea that he played guitar but of course he was actually this strange person running around holding up a Noddy rug. After the gig he was sitting down at the table next to me talking to his mum. I thought it was his wife, which shows you how confused I was about his age.' Her opening gambit was priceless. 'I went up to him after the gig and said, 'Hi, I'm a friend of John Murphy's and I want to talk to you about Chaos Magic, here's my phone number',' she laughs.

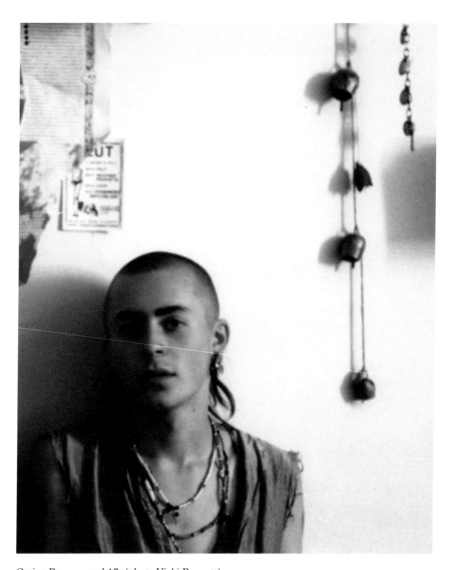

Ossian Brown, aged 17. (photo Vicki Bennett)

'Three weeks later he phoned up and we met a couple of times and just chatted. He told me Chaos Magic was a lot of shit and convinced me to abandon it. His favourite line is, if all these magicians are so great and powerful why are they all so broke and don't have girlfriends? Tibet and I met for a few weeks and I guess we both started fancying each other. He was interested to hear news about John Murphy and we talked about Malaysia a lot. I'm half Malaysian so we have this very strong linked background. We had a lot in common and it just clicked into place for both of us.'

In time Kat was determined to get him. 'I was desperate for us to get together,' she confesses. 'I was praying, although I use the word loosely, that it would happen. I thought he was a very important personality in terms that I could learn from him. At the time he was going out with Christine. She was very young and still at school and there was always a jealousy thing going on because I supplanted her. She was still living in Germany but was planning on coming over to London, so Tibet had to tell her on the phone that although she was still welcome to move to London he was now going out with me.' Tibet and Dörner had already arranged to move into James Mannox and Joolie Wood's place at the Mile End Buddhist Housing Co-Op. In the end, Mannox and Wood took Dörner in and Tibet and Kat took a place next to them. The Co-Op, called Phoenix, was a cheap refuge for all sorts of misfits, and soon another ex-TOPY boy, Ossian Brown, joined the ranks.

Brown had left home when he was 16 in 1985. 'I was very strong-minded and uncompromising with the result that I was always having intense arguments with my parents all through my teens and it caused a lot of trouble for our relationship,' he says. 'I didn't want a job, I wanted to be a musician and I wore nail varnish and jewellery and dyed my hair. I did almost everything that my dad didn't want, so the second I was able to move out I did. I also wanted to live in London because I felt that it was more likely that I'd meet people there that I could feel an affinity with. I also wanted the opportunity to meet other gay men, which was never going to happen in Hertfordshire. I didn't realise that I had as little in common with most gay people as I do with most straight. I was fairly naïve but that was the shining goal that got me out of that hole.'

On arriving in London he made friends with someone who worked for All The Madmen records, then based just around the corner from P-Orridge's Beck Road home. Brown had been a fan of Psychic TV ever since hearing the *Themes* record that came with *Force The Hand Of Chance*. Now here he was, calling up P-Orridge to ask if he could help out with office work. He soon became a central figure in TOPY – 'the perfect warrior priest', P-Orridge called him.

'We met him at rallies and disconcerts, through sigilising and TOPY gatherings,' P-Orridge elaborates. 'He had a marvellous strong, open, determined energy. A kind of TOPY fundamentalist. Often, the hardcore TOPY people had skills that were useful to integrate into the ever growing record, live events, mail order, merchandise, booklets and propaganda activities that were a vortex of manifestation welling out of Beck Road. So the tribe grew organically and as skills came in with new dedicated individuals, so the emphasis and products of the group would switch and change with them and their needs and suggestions. Simon was a great modern primitive; a group motivator, graphic artist and general all round reliable individual with an uninhibited grasp and enthusiasm for sexual ritual, who submerged himself totally into the matrix of TOPY. His main connection with PTV, as I recall, was to execute finished graphic designs for Temple Records, man merchandise and propaganda tables at our big events and to proselytise the TOPY way of life. He co-founded a TOPY ritual house in Brighton with others that was a think tank, and a really disciplined and ascetic battery. Someone should write a book about the Brighton houses and how rigorous and demanding the systems of living TOPY 24/7 were, and how much joy and how much magick was generated. Simon was a free thinker who chose to work within our system and gave his all to the belief we had.' Brown's graphics adorn such 'hyperdelic' period releases as *Allegory & Self*, *Love War Riot*, *Towards Thee Infinite Beat* and *Beyond Thee Infinite Beat*.

'Not long after I first visited Genesis and Paula I moved into their house in Hackney, where I lived above the Temple offices,' Brown explains. 'It was always incredibly busy there, we worked everyday

either on artworks, press, Temple records, or Psychic Youth mail. I was being introduced to so many new worlds and different ways of thinking. It was my first introduction to the work of Austin Osman Spare and Brion Gysin, both incredible visionary artists whose work I later went on to collect, as well as other writers and artists, some of whom I was already aware of but had never read because of their scarcity. Genesis had accumulated an incredible archive over the years, rare articles on Gunter Brus, first editions of Spare, rare Process Church material... For the first few years there was a very positive energy. Genesis was always buzzing with lots of ideas, sparks flying in all directions and he was very articulate and interesting to talk to. I found him very motivating at a time that was essential for me, a great instigator. I guess because I was so young the relationship did feel almost parental in a bizarre way, and on a couple of occasions he said so. He could be very tender. I have very warm memories of him back then, but on the other hand he could also be quite a tyrant, lots of lectures and screaming fits. Everything had to be in its right place, at the right time, he was very demanding like that.'

When the TOPY organisation upped and moved to Brighton, Brown felt that things had changed for the worse, with the destructive mind games, bullying techniques and pecking orders that plague every large-scale organisation eroding any notion of real community. 'There was a mob mentality developing where someone would fall out of favour and a pack would form and slowly they'd get pushed out of the circle,' he sighs, 'A hierarchical system had wormed its way in. As much as it could be said that Genesis had placed himself in a leadership position, some people around him had also put him there. They wanted and expected that of him and he took on the role, whether consciously or not. This gradually took place over a long stretch of time, there were lots of games being played, secrecy and manipulation – it was very sad. Disillusionment was unavoidable, something I'd found very inspiring and magickal had degenerated, in my opinion. I slowly became more estranged from the pack, as I believe they did from me.' By 1991 Brown had drifted from TOPY and on his return to London, James Mannox set him up with a place at the Co-Op. Brown had befriended Tibet before he moved in –

indeed, he had supplied the figure of Kalki appearing on the back of Current 93's *Thunder Perfect Mind*. He had also attended the album's recording sessions, where he first met Douglas Pearce, who subsequently asked him to play with Death In June.

'I loved Tibet's sense of humour,' Brown says, recalling their first encounter. 'I found him very funny and he was always telling jokes, one after another, often to the point of exhaustion. I usually find being told jokes pretty terrifying, so Tibet's long, intricate stories were both hilarious and devastating. He also used to drink a lot more then, and I recall Jägermeister was a favourite. He was very opinionated and critical of certain tastes in music, film and literature, which I found a bit intimidating at first. There's very little indifference in Tibet, if he doesn't like something he hates it! He's very passionate. He also has a very queer, sometimes camp, sense of humour that's uniquely his. A real sweetheart.' Through Tibet, Brown got to meet Balance at Current 93's Mean Fiddler gig. The two immediately hit it off and Brown often joined Sleazy and Balance hanging out at gay clubs like Heaven or FF, and staying over a night or two at their house in Chiswick. FF was a particularly heavy and notoriously drug-addled club night, run by Marc Almond's boyfriend Mark Langthorne. 'It seemed to attract a lot of the misfits in the gay scene,' Brown remembers. 'People who hadn't slept for a week. The music was always very intense, lots of beats juddering in and out of time, staggering and stuttering your breath. The DJs were very aware of the mind states of the clientele and played with that. So one minute you could be following a fairly squared beat and then the next you'd find yourself being squeezed down into a distorted wormhole. Marc Almond was often there and we'd usually all find a corner to shiver in, occasionally being visited by satyrised friends and squat goblins or hair-lipped queens flaring their nostrils and offering us poppers or more Ecstasy. We'd stay there till Balance couldn't stand up anymore or Sleazy thought he might die.'

'It was full-on back then,' Drew McDowall confirms. 'We were tripping all the time, getting totally fucked up on Ecstasy and acid and whatever else was around. Most of the time we'd be hanging out in clubs, not

happy acid house clubs but ugly places with dodgy characters. There were nights when you didn't really know where you ended and someone else began, fucking scary shit. It was inspiring though because we'd just riff on each other, someone would start babbling and someone else would take off on it and months later it would become a Coil lyric. It couldn't help but impact on the music. The thing about Coil is everything is really lived. There isn't much separating Balance from the world – he's like a very porous membrane, whatever is going on around him ends up in his music. I wouldn't even call it an ability because I don't think he can help it – it's a trait – it makes for really amazing shit but I really don't know how healthy it is in the end.'

Back home at Chiswick they'd stay up most nights and do drawings together, passing the same sheet between them and elaborating on each other's details. 'One evening that had been particularly heavy, more so than usual, we'd had snowballs, a particularly vicious mix of MDMA and some other unknown chemicals and had to go home because Balance was in a very extreme state,' Brown recalls. 'We couldn't understand a word he was saying, he almost sounded like a cut up tape slowing down and speeding up. It was very peculiar because there was a confidence behind the delivery, it wasn't like he was trying to talk but couldn't, he was definitely communicating something to somebody, but not us. When we got home we helped him upstairs and he lay straight on the bed, and I sat down on the floor next to him. Balance looked like he was having some kind of fit, at times it seemed like he'd gone back to being a small baby, and at other points he'd be thrashing around like a mad bird trying to fly, panicking as it tries to raise itself off the earth. It was like psychic epilepsy, almost as if deep inside he was living the life of something else, a completely different animal, an ancestral backslide, akin to a drug induced shamanic journey or possession.'

The effects lasted all night and into the next day, with Balance demonstrating an armoury of high nasal whines, bird squawks and mutterings, none of which Brown or Sleazy could understand. He spent the whole night in a state that was closest to what Austin Osman Spare describes as the 'death posture', the position an aspirant assumes in order to work with the technique of atavistic resurgence. It was as if the

drugs had caused a psychological spasm that had triggered a regression, with Balance embarking on a Spare-like journey back through the previous animal incarnations that existed deep within his subconscious. 'We'd all been pushing it as far as we could that night,' Brown affirms. 'I remember sitting there slurring in and out of time, occasionally watching him and asking if he was okay, whenever I could push the words out of my mouth. But I think he was a bit beyond talking. It's an experience that, when it comes up in conversation now, he still says is something he's dealing with.' Balance wrote of the experience later, in his notes to 2000's *Musick To Play In The Dark Volume 1* on the Brainwashed website: 'I once regressed to BIrd MIND and only squarked and chirriped for three worrying days [sic],' he recalled. 'I was away with the birds.' Later Coil tracks like 'Strange Birds' and 'What Kind Of Animal Are You?' – the latter with lyrics co-written by Brown and Balance – can be seen as attempts to more fully integrate and articulate the night's harrowing initiation.

## Lucifer Over London

*Nothing Short Of A Total War*
– Throbbing Gristle sticker

On the morning of Sunday, 16 February 1992, David Tibet was walking with his parents around Portobello Market in West London when he picked up that day's *Observer* newspaper. 'It was really odd,' Tibet remembers. 'In the top left of the front cover there was a column that said a video had been discovered that finally provided evidence of ritual abuse. I just knew that something was wrong. My heart sank when I opened it up and saw that they'd reproduced the big PTV testcard with the skull. I knew something unpleasant was happening.' The paper was previewing a TV documentary from Channel 4's *Dispatches*. The programme makers claimed they had video evidence of a satanic cult performing ritual sacrifice. From the reproduced graphics, Tibet immediately recognised it as a short film that TOPY had staged in 1982, called *First Transmission*, which he had starred in, alongside Balance, Sleazy, P-Orridge, his wife Paula, Derek Jarman and the voice of UK body piercing, Alan Oversby aka Mr Sebastian. Once home, Tibet learned from Balance that he and Sleazy had already seen the article, and they'd contacted their lawyers, the same team that successfully defended WS Burroughs's *The Naked Lunch* against charges of obscenity in the 1960s. Simultaneously, P-Orridge's neighbour Fritz Haäman called Tibet with the news that the police had raided Beck Road and P-Orridge's base in Brighton the day before, removing

*Previous page:* Geff and Sleazy, Burma, 1987.

*Left:* Mr Sebastian

two tons of 'evidence' including his 300 year old Tibetan thighbone trumpet, family photo albums, the whole of the Coum and TG archive, tapes of William Burroughs, unreleased Derek Jarman shorts and the DAT masters for an upcoming Psychic TV album. Indeed, the police in Brighton had turned up with a camera crew in order to video the raid but they were foiled in their attempt to capture the scene of them breaking down the door when P-Orridge's lodgers opened it and let them in. Fortunately P-Orridge, along with Paula and his kids, was out of the country visiting Thailand where he'd been working in a soup kitchen. The camera crew swept through the house, studiously avoiding shooting anything that looked too cosily domestic – the pet rabbit or the garden pond – and instead focusing on anything with 'occult' overtones, like the Wolf's head on the wall or the pet snake.

It transpires that *The Observer* had been handed a video copy of *First Transmission* with the misguided claim that it showed firsthand evidence of satanic abuse, including scenes of rape, child abuse and

body mutilation. Reporters spoke to three female 'survivors' provided by the programme's researchers. Purporting to have taken part in the filming, Louise Errington aka 'Jennifer', said that the video showed forced abortions and genital mutilation and that she had been raped, drugged and scarred by P-Orridge and co. The article also plugged a new book, *Blasphemous Rumours*, claiming Christian Fundamentalists were right and that satanic abuse did exist. It so happened that its author Andrew Boyd was the presenter of the *Dispatches* documentary featuring the 'damning' clips from *First Transmission*.

For these so-called satanic abuse 'experts' with their Bible-belt agenda, something like TOPY's *First Transmission* was heaven sent. It had been birthed through Sleazy and P-Orridge's interest in underground filmmakers like Kenneth Anger and Jack Smith and in the artistic portrayal of ritual. It had been purposefully shot in a way that gave it a blurred, hesitant, underground quality. The introduction had Jarman reading from Chaucer, while Mr Sebastian's voice was dubbed out of synch over the top, in a bid to make overt the ease with which the media could be manipulated to contort and control. Now they were seeing it in action. However, it was the bulk of the next section that caused the problems. Shot at P-Orridge and Sleazy's houses, it faked an arcane ritual incorporating sex, cutting and genital mutilation, alongside a scene of a bound and hooded John Balance being urinated on.

'We did most of the filming while I was still a member of PTV,' Tibet reports. 'Down in what Genesis called 'The Pussy Room' in his house in Beck Road, which had an old dentists chair in it and cameras on the walls so that you could watch on a monitor upstairs. We also filmed at Sleazy's place, which is where I first met Balance and, as he recalls, pissed on him. Of course that was also filmed. Nothing ever went to waste in TOPY, everything was grist to the archival mill. Genesis had mentioned Sleazy to me already, telling me that he was this great guy who would lock himself away for days indulging in solo blood sex rituals. Of course at the time I thought it all sounded absolutely fascinating. When we first went to Sleazy's house, where he was then living with Balance, I was really struck by his bedroom, which was painted totally black and

had lots of pages from De Sade's *120 Days Of Sodom* photocopied and stuck to the walls, all splattered with this theatrical blood that he used to make. There was nothing else in the room apart from a mattress that was lying on the floor covered in rubber sheets. I remember thinking that this was hopefully just his solo blood-sex ritual room and not where he actually slept all the time. I hoped he had a cosier place somewhere else in the house.

'Everything on *First Transmission* was simulated apart from the cutting and sex,' Tibet insists. 'I wasn't having sex in it but Genesis and Paula did. When *Dispatches* came on TV later that week, I refused to watch it. Kat watched it next door while I did a Tibetan Buddhist ritual

to deflect all negative energies and to try and change the programme as it was being transmitted. Through a long series of mantras and invocations I built a wall around me.' In the documentary, Tibet was seen drinking theatrical blood from a skull cup and doing a bit of shamanic drumming. Though his face was blacked out, the secretary at the Mayking pressing plant recognised him the next day when he called in for a meeting. 'I asked her how she knew it was me,' Tibet recalls. 'She said she had recognised my body and gait!'

The day after the *Dispatches* broadcast a clutch of reporters camped outside Derek Jarman's house to get a statement, even though Jarman was unwell and suffering from full-blown AIDS. As he told *The Independent*: 'At first I was horrified and then very, very angry that they had so misrepresented scenes from the TOPY video. I did not see the video but what Dispatches showed from it did not in any way show what they claimed it represented. It was not at all about child abuse or murder. It seemed too much when you had a lady on the telly, blacked out, saying she had killed her child. I mean, doesn't anyone smell a rat?' Ironically, *First Transmission* had been partly funded by Channel 4, who had broadcast excerpts some years earlier in a late night feature on new British underground cinema. The channel quickly back-pedalled when this fact was revealed, claiming it knew the *Dispatches* allegations weren't true. So why did they air it at all?

The company behind the documentary, Look Twice Productions, was a front for a Christian fundamentalist group led by presenter Andrew Boyd. Their star witness was satanic abuse 'survivor' Louise Errington, who had been groomed by the programme's consultant Peter Horrobin, a born-again Christian obsessed with Satanism. On 1 March 1992 *The Mail On Sunday* published an interview with Errington revealing that her story had been invented. Errington had suffered from mental illness for some time when she experienced a conversion and checked into Horrobin's 'healing centre' at Ellel Grange in Lancaster on the suggestion of an evangelist as a way of escaping her alcoholic husband. One day Horrobin told her that one of his prayer team had had a vision. 'He said he had seen a mind-picture of me standing over a tiny baby, helping a devil priest to wield a knife,' she continued. 'We cut

into the baby's chest and the blood was collected and we drank it. The baby's body was a sacrifice to Satan.' Until that moment Errington had no idea that she had even had this baby. 'I screamed and pleaded with them to please stop saying it,' she said. 'I had a sort of fit, and had to be held down. I fought people off physically. Finally I broke down and confessed it was true. I said: 'Yes, I did it. I killed my own little daughter and helped others to kill their babies.' Horrobin passed her on to Boyd as a witness who was willing to confess to anything.

The *Mail On Sunday* described it as 'one of the most misleading and deceptive documentaries to appear on British television for many years'. Indeed, the *Dispatches* episode was the culmination of a smear campaign against P-Orridge related activities that had started back in 1988 when UK gutter rag *The People* ran a PTV 'exposé' under the headline "This Vile Man Corrupts Kids". Alongside a photograph of the extended PTV family that included Sleazy, Balance and Tibet and paragraph headings like 'Groping' were claims that P-Orridge 'INDULGES in pornographic rituals with members of his temple. EXPOSES his two young daughters to sickening scenes of kinky sex, flagellation and ritual scarring. SENDS similar video cassette scenes through the post to his temple "worshippers." It also farcically detailed how *People* girl Sue Bishop was menaced by P-Orridge, who turned up at her door 'dressed in the gold top hat that he wears on stage'. Terrifying. After *The People* story ran, Balance's grandmother refused to speak to him again, and they remained estranged until she died. "I was living at Beck Road when *The People* thing happened,' Ossian Brown reveals. 'I had to hide Temple ritual objects in boxes, pretending they were old stage props just in case the police decided to raid us. We were all on tenterhooks waiting for it to happen, it was very stressful and emotionally draining not knowing where these awful stories would lead. Journalists had been harassing Genesis and Paula's neighbours and trying to interview fellow parents at their kids' school, desperately hunting down scandal. It was sickening.' Mr Sebastian, who had provided the voice over for *First Transmission*, had warned P-Orridge that something was going

down back in 1990, when he was raided by police officers mounting Operation Spanner against the sexual underground. On the grounds of the some fictional letters that Mr Sebastian had received from someone who fantasised about being castrated, his tattoo parlour was turned upside down and his materials confiscated. Among the documents seized was an appointment book that included photographs of piercings and a list of names of people who had purportedly suffered 'malicious wounding' at his hands. 'In other words they'd got 'piercing' written next to their name in his book,' P-Orridge asserts. 'My name was on the original list of 'witnesses' to be interviewed and possibly prosecuted for allowing actual bodily harm to be done to us. After a few weeks the only name that suddenly disappeared, with no explanation, was mine. It turned out that it was because the same cops and their cronies had decided to single me out for special attention later. Mr Sebastian actually warned me that it was a bad sign that I was not harassed then. They continued with the *Dispatches* set-up behind the scenes. All the other people were contacted and made to feel very intimidated that they too would get prosecuted, and that they should give evidence against Mr Sebastian.'

In the event Mr Sebastian was prosecuted with fourteen other gay men, most of whom didn't know each other, yet they were portrayed as being part of a gay S&M sex ring. With the subsequent sentences the presiding judge, Judge Rant, established the precedent that performing any S&M act was illegal because no one can actually consent to be assaulted. When the case came to appeal in 1992 Lord Lane upheld the convictions, although five of the fifteen defendants had their sentences reduced. Lane also widened the interpretation of assault by including love bites or scratch marks made during rough sex as well as spanking your partner. The police went as far as to raid the premises of a spank magazine in London. 'The defendants had been hauled up in court to answer for a series of totally isolated, separate incidents which were then cobbled together maliciously and portrayed as a 'conspiracy' of S&M,' P-Orridge relates. 'It was a travesty of justice and a sheer witchhunt to distract the UK public from Thatcher's Britain and its hypocrisy, a right wing attempt to victimise any unorthodox lifestyles

simply for being unorthodox.' He also adds his personal theory that the upper classes moved against the 'democratisation' of S&M because they resented the popularisation of their previously exclusive fetish practices.

Despite the evidence that Mr Sebastian had simply been practising his legal profession he was still found guilty of ABH and was handed down a fifteen month sentence, suspended for two years. This landmark case essentially laid down that it was now only legal to have decorative piercings; any that could facilitate sexual pleasure 'for the satisfaction of a sadomasochistic libido' were effectively illegal. P-Orridge believes that he was dropped from the initial investigation because his presence would have weakened the case for a gay conspiracy. His presence would have changed the texture of the media attention, allowing him to 'exploit the bigotry to reveal the diseased pseudo-morality of the establishment'. Judge Rant actually went out of his way to deny that the trial was anti-homosexual. 'This is not a witch hunt against homosexuals,' he pronounced. 'The unlawful activities before the court would result in prosecution of heterosexuals or bisexuals.' Instead he claimed that the courts were simply drawing a line between 'what is acceptable in a civilised society and what is not'.

Trapped in Thailand, P-Orridge was warned that should he attempt to return to Britain his family would be taken from him. The upheaval took its toll, eventually resulting in the break-up of his marriage to Paula. To this day, he lives in exile in the United States, though since 1999 he has returned for a series of events. As to his former PTV associates, 'Sleazy's lawyer had said to him and Balance that they should be prepared to be taken in for questioning after *Dispatches* ran,' Tibet says. 'The problem as far as I was concerned was the part in *First Transmission* where Genesis did some scars on me and I did some scars on Balance. The way that the law had just been changed meant that even if the people were still assenting, it could still constitute ABH. Patently the entire premise of the *Dispatches* documentary was absolutely disgraceful but I think the reason for it was that Genesis had made enemies in various areas, including, I believe, in the police forces because of his subversive

activities with TOPY and, I was also told, because of protests against the Brighton Dolphinarium that he had been involved in. A lot of people had it in for him and this insane Christian fundamentalist movement from America was suddenly becoming very active over here. They were seeing witches and warlocks and satanic child abuse in everything, things that had absolutely no connection at all, such as children's toys. There was an amazing book called *Turmoil In The Toybox* that was an examination of the satanic influence on every single toy you could imagine, concentrating primarily on Dungeons & Dragons and going on to absolutely innocuous stuff like My Little Pony. Considering they were able to find evidence of satanic goings on in these kinds of things, *First Transmission* was just a gift.

'We all felt that Genesis was being persecuted,' Tibet continues. 'He'd wound a lot of people up but they were coming out with absurd things, like he was involving his kids in sexual rituals. At that time there were very strained feelings between the ex-members of Throbbing Gristle, Psychic TV and TOPY and people weren't in any mood to feel amicable towards him. But at the same time everyone knew these allegations were complete bullshit, that both Paula and Genesis were excellent parents and, if anything, spoilt their children. It was evidently a set-up. They decided to pick on Genesis and it was a time when the police seemed to be going insane, they'd been infected with the belief that there was a satanic conspiracy everywhere. They themselves must have known it was all bullshit and that there was no evidence for it, no one has found any evidence for it apart from people popping up on American talk shows who are evidently insane and/or have an agenda.'

The impact on Tibet, Balance and Sleazy was immediate and frightening. All of their mail was opened. Unmarked cars were stationed outside their homes. They believed their phones were tapped. 'We were all paranoid anyway,' Tibet admits. 'The basis of all of our natures was that we were all really paranoid before that and so now we had something to really be paranoid about.' Balance and Sleazy say they no longer felt comfortable holding onto anything that might, however unjustly, be construed as pornographic, licentious or scandalous, and

carefully destroyed everything that left them vulnerable. 'We had a fire burning in the grate for a day,' Sleazy recalls. 'Burning photographs, artwork, videos and films. Nothing necessarily illegal per se but stuff that in the wrong context could have caused people to confiscate things. After the Spanner operation police were regularly seizing collections of things that were completely harmless.'

The police, it seems, felt they had no option but to be seen to be acting in light of the *Dispatches* and *Observer* revelations. 'I know the police didn't believe it,' Balance says. 'But they had to investigate. Of course Genesis took the martyr's course and became self-exiled, a political prisoner in another country and it was all right for him because he could then claim credit for all the groundbreaking work and for being a video revolutionary, whereas we were left in the position that if we'd stood up to be counted we would've had our hands chopped off. That's how we suffered, he continued to be abroad and out of harm's way while we continued over here to rebuild our profile as artists and people in the shadow of this thing he'd buggered off and left us with.' The feeling of being constantly under scrutiny left Balance with such a sense of guilt that it brought on what he believes was a nervous breakdown and his first extended bout of alcoholism, a disease that he's still fighting today. Back in 1977 Throbbing Gristle had demanded 'Nothing Short Of A Total War'. The *Dispatches* episode represented The Establishment's first retaliation.

At the time of *Dispatches*, Ossian Brown was unemployed, making ends meet via the occasional bit of rent for a few older men he had been involved with in Brighton. 'I'd initially been in a lot of the homemade porn films that they used to distribute between a small circle of them and I'd kept up contact once I'd moved, returning to see them when I needed to,' Brown explains. 'But I wasn't that happy living in the Buddhist Co-Op. I felt I needed to be in another part of London. My life felt very stale.' Balance suggested that he move in with him and Sleazy. 'It all seemed to make sense,' Brown shrugs. 'Although I was a bit nervous at the idea of living with a couple, I was becoming very fond of Balance and Sleazy, and felt that the move would change my life considerably,

even though it was only a move from east to west [London]. I needed stimulus, which was there aplenty. I enjoyed the period I spent with them, it was important that I had made close friends with people who were gay as well as stimulating to be with. I'd never met anyone before who was gay and also shared the same interests. It was definitely an aspect of my life that I was not happy with. I had always felt alone on that level up until that point.'

In Chiswick, many days passed with everyone recovering from the night before, so much so that Sleazy and Balance moved their bed down to the living room so they could all sleep off the drugs together. Stephen Thrower was still about, occasionally dropping in to put together the early layouts for his *Eyeball* film magazine on Sleazy's computer, but at first he and his future partner barely spoke. 'Steve and I first met on a very bizarre evening at Chiswick,' Brown recalls. 'We'd all been up tripping on these small yellow and white capsules we'd been given, strange and much more hallucinatory than Ecstasy, very overwhelming. We'd come back from FF and were sitting on the floor staring into the haunted air.' Thrower had been out elsewhere the same night but had done the same pills and he turned up at Chiswick in the early hours of the morning in a terrible state. 'He just stayed sat on the chair,' Brown continues. 'All the while I was watching dildos crawling around the floor like caterpillars. It was such a strange way to first meet someone, I think we barely talked beyond the initial hello.' Thrower was in the last stages of splitting up with his then partner. Soon after they'd finished, he bumped into Brown at a gay bar in St Martin's Lane and something immediately clicked. 'Something about the experience of meeting away from Balance and Sleazy's place made the energy between us clearer and stronger,' Thrower says. 'We spent the rest of the day getting more and more involved with each other and things just escalated from there. I had a lot of problems at this time and I think it was through my engaging with Ossian and his calmness and steadiness that my life eventually stopped seesawing into the dark.'

In Chiswick, meanwhile, Coil every so often attempted to restart recording, with engineer Danny Hyde coming over, and he and Sleazy disappearing into the studio on the top floor to work on a series of singles

Balance, early '90s.

and EPs that more directly mirrored their club experiences. With the recording of *LSD*, Hyde effectively became Coil's 'secret third member'. 'He was there bringing his own psychosis to the activities,' Balance mocks. 'He was a good engineer and so we stuck with him. We gave him more freedom to contribute and some of the things he came up with were very good. But he also had aspirations to become a music writer and his tastes were heading towards a place that seemed good at the time but in retrospect wasn't good for us.' Hyde's influence is heaviest on obsessively complex, trance-inducing electronica like 1994's 'Nasa Arab'. 'We tend to blur the boundaries too much when we work with people as to what their actual position is,' Balance confesses. 'There's a certain point where you have to pull back and say, wait a minute we're Coil and you're the engineer. We're not very good at hiring and firing. We can do it all at home now but there are certain things, like compressors and banks of equipment, and if you get that and the right engineer combined, then it can sound much better than it would here. It's always great to have someone to bounce ideas off or show you something, just do that process for you.'

Sleazy and Balance boast a close, intuitive relationship where there's often an unspoken understanding about how the music should develop. Although this can just as often lead to unspoken misunderstandings

# EXCUSESEXCUSES...

HERE, FINALLY, IS THE CD "STOLEN AND CONTAMINATED SONGS" (LOCI CD4). ALTHOUGH ALWAYS 'BY SUBSCRIPTION', OUR ORIGINAL ESTIMATE AS TO HOW LONG THIS PROJECT WOULD TAKE IN THESE DIFFICULT TIMES WAS OPTIMISTIC. IT TOOK FOREVER!

HOWEVER IN THE TIME ELAPSED SINCE ANNOUNCING THE PROJECT WE HAVE RECORDED SEVERAL NEW PIECES WHICH ARE INCLUDED AS WELL AS EARLY AND REWORKED VERSIONS OF SONGS FROM "LOVE'S SECRET DOMAIN". AS ALWAYS COIL, AND EVERYONE AT THRESHOLD HOUSE, GREATLY APPRECIATE YOUR CONTINUED INTEREST, SUPPORT (AND PATIENCE!) WE SINCERELY HOPE THAT THE DELAY IN DELIVERY OF THIS PACKAGE HAS NOT CAUSED YOU TOO MUCH GRIEF.

WE RECOGNISE THAT A FEW PEOPLE MAY BE MISSING OUT AS THE CURRENT RELEASE IS CD ONLY, AND IN SO RESPONSE WE WILL BE MANUFACTURING 1000 NUMBERED VINYL LPs IN A SPECIAL PACKAGE TO BE SOLD AT THE SAME PRICE AS THE CD. OBVIOUSLY THERE WILL ONLY BE APPROX 45 MINS OF MUSIC ON THIS FORMAT RATHER THAN THE 62 MINS CONTAINED HEREIN.

IN ADDITION TO THIS PROJECT, WE HAVE IN THE LAST YEAR RECORDED THE MUSIC FOR "THE GAY MAN'S GUIDE TO SAFER SEX" A VIDEO SPONSORED BY THE TERRENCE HIGGINS TRUST, WHICH REMAINS HIGH IN THE VIRGIN VIDEO CHART FOUR MONTHS AFTER RELEASE, AND FOR A VIDEO CALLED "SARAH DALE'S SENSUOUS MASSAGE" FEATURING THE MASSEUSE WHO USED TO RENT NORMAN LAMONT'S BASEMENT FLAT. WE HAVE PRODUCED A CD OF NEW VERSIONS OF OUR FIRST RITUAL WORK "HOW TO DESTROY ANGELS" INCLUDING A MIX BY STEVEN STAPLETON OF NURSE WITH WOUND AND COVER ARTWORK BY DEREK JARMAN. THIS ABSTRACT BUT POTENT WORK IS AVAILABLE FROM US BY MAIL ORDER (SEE LIST OVER).

CURRENT PROJECTS INCLUDE A SINGLE ON THE CLAWFIST LABEL, A TRACK FOR A NEW SUB-ROSA COMPILATION ALSO FEATURING LIGETTI, MUSIC TO ACCOMPANY A GRAPHIC NOVEL "UNDERGROUND" TO BE PUBLISHED IN THE U.S. BY DARK HORSE, REMIXING A TRACK FOR NIN (NOT YET RELEASED), AND DIRECTING VIDEOS FOR AMONGST OTHERS GAVIN FRIDAY, BJORN AGAIN AND MINISTRY, WHICH INCLUDED FILMING WILLIAM S. BURROUGHS IN KANSAS. WHILE THERE WE TOOK THE OPPORTUNITY TO RECORD W.S.B FOR A FUTURE COIL RELEASE. WE ARE ALSO LOOKING FOR CONTRIBUTIONS (TEXT, PHOTOS OF TATTOOS ETC) FOR A BOOK WE WILL BE PUBLISHING ON THE SYMBOL OF THE BLACK SUN

LASTLY, WE ARE WRITING MATERIAL FOR OUR NEXT ALBUM, PRESENTLY TITLED "INTERNATIONAL DARK SKIES".

COIL, LONDON. OCTOBER 1992

they're very much in each other's mindfolds. Such intimacy isn't so healthy when their demons get together and conspire against them. 'In that way it's really helpful to have other people there,' starts Sleazy, 'because when you're forced to communicate to an 'outsider' you actually have to remember what words are and how to... See, I'm having difficulty even expressing it. Just to talk like a proper human being.' When Balance and Sleazy are working alone, however, their roles are fairly well defined: Balance directs and Sleazy makes it happen. The presence of collaborators like Danny Hyde and Stephen Thrower – and more recently Drew McDowall, Simon Brown and Thighpaulsandra – forces the pair to justify their creative decisions. Working in a state of 'inspiration' might be a Coil norm, but analysis is often part of the creative process. 'Other people might say, well, what exactly do you mean by this and what is it that you're trying to say?' Sleazy elaborates. 'In putting a voice to the answers, it probably shows us how to make what we're doing better.' Indeed, Coil 'membership' is a far more complicated process than simply being asked to join. Somebody who intended to turn up but didn't actually make the session might still find their name in the credits. That they were expected was enough for their presence to be felt in the music. Stapleton follows a similar practice, as Balance learned through his 'appearance' on Nurse With Wound's *Sylvie and Babs*.

'Me and Balance would sit in the room below and listen to what was going on,' says Brown, recalling the atmosphere of the first post-*LSD* sessions. 'Balance would run upstairs every ten minutes or so to tell them what he thought of it, where they should be trying to take the piece or what kind of sounds he felt it needed, just injecting different compositional ideas and visual triggers. Sleazy is very driven. In fact, you could say that he's a workaholic. He's quietly obsessive and would often disappear for hours on end, learning a new piece of software until he knew it inside out or playing around with studio gadgets all night.' During these sessions Coil first developed the recording process they dubbed Sidereal Sound after Spare's system of sidereal portraiture, on tracks like 'Baby Food', a haunting collage of perforating owl-calls named after the slang for the drug Ketamine.

'Sidereal Sound means appertaining to the stars but also means sideways,' Balance explains, 'and that relates to the way that Spare would tilt his portraits slightly sideways as if to reveal aspects of the person that you wouldn't normally see. He would paint pictures of ghosts, elementals and spirits and these are sidereal portraits. We're trying to do the same with sound, to sort of skew it to the side so as you can see the things that you wouldn't normally perceive. It's the musical equivalent of catching a glimpse of something peripheral in your vision.'

About the same time as the sidereal breakthrough, Coil started working on the rhythm tracks for their *LSD* followup *Backwards* with the help of Hyde and Tim Simenon of Bomb The Bass. Mick Harris, of Napalm Death and Scorn, laid down drum tracks before the group moved on to Swan's Yard Studios in Islington. According to a Threshold House Newsletter at the time, 'Early signs indicate the album will be vintage Coil – churning noise constructions. Sounds stripped down and built back up for power and raw poetics. William Burroughs guests on a couple of tracks alongside contributions from Terence McKenna, Tim Simenon, and Marc Almond as well as a very diverse and unusual instrumentation from traditional Celtic Bodruns to Theremins to John Lennon's actual Mellotron recorded for us by Trent Reznor of Nine Inch Nails in the very room where Sharon Tate and dinner guests met the Manson Girls one night in 1969.' Coil became involved with Industrial stadium rockers Nine Inch Nails when Sleazy made a couple of videos for them. Reznor, it transpired, was a longterm Coil fan. In 1992 they remixed 'Gave Up' for NIN's *Fixed*. Reznor mentioned that he'd like to release the new Coil album on his Nothing label. But the group were already conscious of the weight of expectation following the success of *Love's Secret Domain*, and the resultant pressure was creatively crippling.

'What happened with the *Backwards* material is that we took in a bunch of songs with a start, a finish and a build and that was precisely what we were trying to get away from,' Balance says. 'There was an insanity that was good about the original 1992 *Backwards* sessions,' claims Drew McDowall. 'But it wasn't anything new, it was certainly the least successful thing they'd done to date. I felt that whereas with

*Love's Secret Domain* they'd taken elements of what was happening all around them, the club scene, the fucked up amphetamine dance music, and given it their own touch, with *Backwards* it was just too much of its time. It sounded too much like everything else that was happening back then.' The others felt the same and they surreptitiously shelved the whole thing.

In the meantime, with Sleazy often away directing videos, Balance and Brown spent their time scouring auction houses and bookshops and listening to Arvo Pärt, The Watersons, Tim Buckley and, most of all, Kate Bush. 'It was strange when I first moved in because I really didn't know how I'd fit in,' Brown says. 'They were so close and obviously living in someone else's home is hard as you don't know where to put yourself or how to make it your home as well. I remember feeling very uncomfortable for the first week or so, but we soon slipped very organically into a way of being with each other that was very reassuring, an uncontrived closeness between the three of us. It was more like being part of a family. We were able to enjoy the silence with each other as well as talking, it didn't feel like we had to use every available bit of quiet and fill it with unnecessary words.' As ever, Balance was a major source of energy. 'Balance is very extreme with most things,' Brown remarks. 'If he's going to drink he'll drink bottles, if he's going to take any drugs he doesn't have one or two he has ten or eleven. If he's interested in an artist he's completely obsessive and has to see or have everything he can, the same with writers and musicians that he admires. He's very much a hunter-gatherer, a magpie, as much for new ideas as for artefacts. He's always looking for new triggers. He also has a lot of extreme mood swings, including a raging temper but it can soften as quickly as it ignites. I've never seen so much broken crockery in my life.'

During the making of Current 93's *Thunder Perfect Mind* Stapleton had a dream where he was handed a copy of the new Nurse With Wound album bearing the same title, which Tibet had originally taken from the early Gnostic text *The Thunder: Perfect Mind*. Tibet and Stapleton agreed to share it, with Current 93 and Nurse releasing

sister *Thunder Perfect Mind* albums. The Nurse album was the first that Nurse With Wound recorded with engineer Colin Potter at his ICR (Integrated Circuit Records) studio in York. Potter soon became a key floating member, further reifying Stapleton's abstractions. He had come up through the 1960s and 70s working in electronic music as a way of reconciling his twin obsessions for leftfield instrumental rock and science fiction. During the cassette explosion of the early 1980s, Potter began to release his own electro-pop recordings on his own ICR label, which also documented the activities of a small circle of friends and contemporaries. He has since played in several key experimental groups, most significantly Ora, with sound artists Darren Tate and Andrew Chalk.

When he first set up his own studio in York in 1982, Potter offered a tape duplication service that Current used for several early releases. With Tibet's parents living near by, he often called in at the studio. Through the Tibet connection, Potter also got to copy tapes for United Dairies. Finally, Tibet and Stapleton chose to work at ICR while 're-structuring' *Swastikas For Noddy* as *Crooked Crosses For The Nodding God. The Sadness Of Things* was also completed there but *Thunder Perfect Mind* was the first full album conceived and finished at ICR. 'Colin's great at sound-twisting,' Stapleton enthuses. 'He's got so many effects and he runs things through effects for me because a lot of the time I can't get over to his studio, it's such a long journey. He has the masters there so I'll call him and say, run me off this backing tape, put it through wah-wah, do ten versions of it and send it over to me. I then pick the bits I like and edit them. He's great to work with, really open-minded and nothing like any other engineer I've ever encountered.'

'*Thunder Perfect Mind* was recorded over the winter of 1991 but wasn't released until 1992,' Potter says. 'I remember Steve saying that he wanted to make a 'very electronic' piece, so we started with very dry electronic sounds, although it did seem to change and mutate as the recording progressed. Most of it was just Steve and myself but the others listed on the sleeve [including Rose McDowall, Joolie Wood and Balance] came in to do their contributions at various points and

So much Silence
Breathing above or
Around me too
Spinning about ?
Has it deafened me ?
Has it closed my ears ? ,
Has the Silence itself
Brought about rapture
Between Silence + Sound
Between the cry and the call
If Man raises one voice
I'll raise two then
One for loss, one for losing
One for death, one for birth
I may hang bloodyborn
Off tree or moss
Through the grimace
Cuts the grin
I die triumphant,
I'll rise triumphing
You won't catch me
I fly unseen
Through the winds of the world
Missiles cut Space
Spearing the flashlight
Marking the moon
Mate of the marsh
Give me two reasons
Too stayed here
Lostlight lostlove
Smudge the trails
And smoller the stains
Of the fire of the fear

LS + B ?

3/6/90

Between Statue and Stone.

Christ Speaking I

Now
Now
Now
Now

At the grave of MR James, Eton, 1994. Tibet with Richard Dalby and David Rowlands.

in some cases Steve had their contributions already on tape.' Reprising Stapleton's fascination with machine rhythms, *Thunder Perfect Mind* is a kind of Industrial pastiche consisting of two frigid soundpieces, 'Cold' and 'Colder Still', carved from huge monolithic blocks of cleaving electronics. 'I like to work in unconventional ways and share a similar background and taste to Steve,' Potter maintains. 'The way he works usually involves starting with a clear 'base' for a piece, with certain components that are to be added in a vaguely pre-ordained way. But there's also an organic quality to the way he allows things to grow. Often things happen by accident, by the discovery of a new sound or rhythm, or the way one element juxtaposes with another. I've lost count

of the number of times where something has happened that seems to be a chance meeting but which then goes on to alter the whole piece, setting it on a different tangent or sometimes suggesting a completely new piece. Sometimes it's just one small sound at the core of a piece that is gradually built on or changed. I contribute by suggesting sounds and sound treatments – quite often something done with sound processing changes the direction of the track. Basically there is never a set way of doing things, things are planned and things happen.'

Despite his essentially solitary nature, Stapleton thrives on collaboration. Virtually all his albums have been enlivened by the contributions of friends and family. His 1992 duo album with Tony Wakeford, *Revenge Of The Selfish Shellfish*, also recorded by Colin Potter, is one of his most accessible recordings. Held together by Wakeford's hypnotic guitar parts, the songs are soaked in a choral half-light that's almost gothic. Stapleton's intention was to involve Wakeford in a totally stupid project, in contrast to his own unrelentingly serious work with Sol Invictus. Transposing his face onto the body of a green mollusc for the cover shot undoubtedly did the trick. 'Stapleton suggested we do something together and booked a week of studio time with Colin Potter,' Wakeford remembers. 'I had a few lyrics and Steve had hired an Emulator and it was just a week of pissing about really. When it came out it fell between two stools. A lot of Nurse fans hated it because I was on it and it had guitars, and a lot of Sol Invictus fans hated it because it was a bit off the wall. Still, over the years the people who have ears have picked up on it.'

By 1992 Balance had become a major collector of Austin Osman Spare's paintings. He'd also talked Tibet into starting a collection, despite the latter's ambivalence towards the work, introducing him to UK outsider art specialist and dealer Henry Boxer. Tibet left their first meeting with a couple of Spares, one of which he later used on the cover of his *Tam Lin* 12" (1994). But what really caught his eye was 'Entrenched', a painting by the insane cat artist Louis Wain of a wide-eyed cat in uniform with a cigarette dangling from his mouth, waving home from a First World War frontline trench. Tibet was particularly taken with some lines scrawled

on the back, reading 'Safe from the match-making mamas – Hello, you girls! How are you?', which inspired the following passage from 'The Bloodbells Chime' on *All The Pretty Little Horses*: 'Tommy Katkins still sends his regards/frozen for ever on some animal Somme/The last thing on his mind is marriage/but the call of Home and Heart.'

'I looked at that and it really did it for me,' Tibet says. 'I bought a few Spares because that was why I'd been there but I kept thinking about the Wain so I went back and got two or three Wains, and then after I sold the Spares I went insane over Wain, who I still think is the greatest artist of all time. It's impossible to articulate why his work means so much to me, the most profound things are always things we can't articulate – they speak directly to our heart, no explanation necessary. I still spend hours looking at my pictures or going through books of reproductions. Sometimes I look at them and I'll be moved to tears by their innocence and beauty.'

Born in London in 1860, Louis William Wain started publishing his drawings at the age of twenty-one. In the beginning, he mostly drew realistic wildlife portraits, before turning to dogs and, finally, to cats, following the death from cancer of his own cat Emily, with her mate Peter The Great at her side. The popularity of his cat art floated a series of successful children's annuals, while his images featured on a slew of merchandise. However, Wain's bad business sense meant he never properly benefited from his success, leaving him short of funds to look after his five sisters. One of them entered a mental hospital in 1900, believing she was afflicted with 'deadliest leprosy' and claiming she had witnessed several murders. In time, Wain's own mental health deteriorated, leaving him violent and convinced that spirits were projecting ethereal currents at him. And, like his beloved cats, he believed he was 'full of electricity'. The year his sister entered the asylum, he wrote: '[My cat] Peter is a small electrical battery, my wife a larger one, the larger one attracts electricity from the smaller one; the passage of the fluid from one body to another generating heat [...] Its main object in washing, to my mind, is just to complete an electrical circuit.' From 1924 he spent the rest of his life in various mental institutions, where he conceived most of his great works. He died in 1939.

Harvey Sucksmith and Tibet, 1994.

'By the time of his confinement, he is placing the cats in front of elaborate and Italianate buildings, perhaps dream views of his surroundings amongst the spacious greenery of the various institutions he inhabited,' Tibet wrote in an article on Wain published in the spring 2000 issue of *The Witness*, Nick Cave's in-house fanzine. 'Arched Cats; wide-eyed, electric. Whilst Wain would scribble the titles of his early pieces on the back of his paintings as a guide to the printers, by the late 1920s, he would be reciting the litany of his ecstasies and pains: 'Bounce the Ball still, softly round it on all sides. The goal is in each Kits eye. The ball fixes each eye open: It roles to each paws love; Bounced home, where it hides'. [sic] The doors of Catland had opened wide, and he hurried inside, to his true home.' That Wain litany opens Current 93's *Of Ruine Or Some Blazing Starre* album, evoking his benign spirit as Tibet attempted to follow him into a paradise 'even when the gateway in was marked Bedlam'.

Other ghosts of Tibet's childhood were also manifesting themselves. He was once more immersing himself in the weird fiction of England's ghost story writer MR James [1862-1936], whose most famous collection, *Ghost Stories Of An Antiquary* (1904), was the model for an invisible school of supernatural authors. James's tales mostly revolve

round a learned scholar immured in the cosy environs of a classic English school, where his belief system would be destroyed in an inexplicable encounter with the other side. James's prose is spare and precise, his horror more implied – a vague form briefly glimpsed, perhaps – than clearly described and all the more terrifying for that. Strangely nostalgic, his stories offer a reassuring glimpse of a world long since passed, even as they reveal nothing is quite what it seems and only the flimsiest of barriers separates us from the world of the noumenal. Tibet first read James at school, where unsurprisingly his terrifying 'A School Story' had the biggest effect on him. The success of *Thunder Perfect Mind* stabilised Tibet's finances, and he started collecting first editions of MR James, as well as obscure Jamesian writers like HR Wakefield [1888-1964] and ANL Munby [1913-1974], whose books rarely got as far as a second edition. Through these literary pursuits, under the guidance of his former *Sounds* colleague, friend and fellow collector Edwin Pouncey, Tibet cultivated a new circle of friends that included Rosemary Pardoe, publisher of *Ghosts & Scholars*, a journal devoted to the activities of what she termed 'The James Gang'; writer Mark Valentine, who co-founded The Ghost Story Society: and Richard Dalby, a leading authority and major anthologist of supernatural fiction. And as ever, Tibet's enthusiasm carried him beyond collecting – he launched a new imprint to champion his most beloved neglected artists and writers, publishing their work in beautifully produced editions commensurate with his respect for them.

'I founded Ghost Story Press in 1992,' Tibet relates. 'I'd got in touch with Richard Dalby and he sent me a copy of his HR Wakefield anthology. I was really after a copy of *Tedious Brief Tales Of Granta And Gramarye* by Arthur Gray who had written it under the pen name of Ingulphus, but I just couldn't find a first edition. I discussed it with Dalby and Kat and said, why don't we start reprinting them? And I did that. Typically as soon as *Tedious Brief Tales* went to the printers, I got two copies of it, one in a dustjacket and one signed by the author. Things are alive, you know?'

Writer Stewart Home recommended the printers Anthony Rowe Ltd, who prepared the facsimile edition of the Ingulphus book as Tibet's

first publication. He followed it with Kate and Hesketh Prichard's boys-own toned *Flaxman Low, Psychic Detective*. Thereafter, GSP editions became progressively more extravagant with each new publication. He used one of Balance's Spare paintings, 'Head With Green Hair In The Depths Of Hell', on the dust wrapper of James Platt's *Tales Of The Supernatural*, and a series of oblique and disturbing visions by Stapleton over a clutch of titles. 'I think they're all beautiful but some I didn't care for as items to read,' Tibet confesses. 'I don't think I ever got through James Platt's book, it was so purple and ornate, but it was a really rare book and I'm glad we did it. Ron Weighell's book *The White Road* is fantastic, as is Harvey Sucksmith's *Those Whom The Old Gods Love*. They were the only two living authors we published. Sucksmith had originally sent Dalby a manuscript and he thought we should do it, whereas Ron Weighell was well known on the small press scene and had been publishing lots of little pamphlets. When the Sucksmith came out it got terrible reviews, everyone hated it. Consequently it's now one of the rarest, as most people got rid of their copies.' Indeed Weighell and Sucksmith do read like anomalies, what with their archaic prose and tales set in dusty old bookshops or lost stately homes. Yet in the eccentric arc of their prose, Tibet read the contours and outer form of a lost little England as the battleground for God and Satan, with London as the eternal city. But none of these writers had quite the force of vision as one of his greatest obsessions: Welsh occultist, author, journalist and exuberant chronicler of the life of the soul, Arthur Machen.

'Towards the end of GSP I'd really lost interest in the ghost story generally,' Tibet admits. 'I became a massive Arthur Machen collector. Again, I'd always liked a couple of his stories while younger and something I've always liked is signed and inscribed copies. I always like that connection with the past, that the author has touched it. Once I got all the signed Machen, I thought I might as well get the others. By that time I had books to trade because I'd pick up any supernatural titles and buy duplicates of rare books. Sometimes you'd find a book for 50p that might be worth a thousand pounds.'

Rosemary Pardoe, *left*, publisher of *Ghosts and Scholars*, 1985.

'Machen would never have seen himself as a ghost story writer,' asserts his biographer Mark Valentine. 'In fact, there are few ghosts in his work. He acknowledged the particular influence of Poe but also of de Quincey and Stevenson. Romance was his preferred term. Horror often plays a key part but so does mystery, the picaresque, black humour, the fantastic. He likened himself to a carver of gargoyles on a great cathedral. That is how he saw his relation to literature. *The Hill of Dreams* is his best work, essentially because he came closest in it to his own ideal that language should itself be a rare instrument for the transformation of the soul, akin to music. He belongs to a very particular English tradition, that of the radical conservative. They combine a hatred of commercialism and big business, mercantile and bourgeois values, with a strong affection for tradition and continuity, individuality and the 'good life' in the widest, most all-embracing sense.' Indeed Machen was equally at home writing about the joys of taverns and good food as he was invoking the great god Pan or tramping the hidden by-ways and pathways mapped out in his *The London Adventure Or The Art Of Wandering*, published in 1924

well before psychogeographers codified the practice. Machen was also a member of The Hermetic Order Of The Golden Dawn, a magical society founded by William Woodman, William Wynn Westcott and SL MacGregor Mathers via direct transmission from supposed 'secret chiefs', with a membership including poet WB Yeats, Aleister Crowley, Algernon Blackwood and AE Waite. But most of all Machen eulogised the hills and valleys of his boyhood home of 'noble, fallen Caerleon-on-Usk, in the heart of Gwent'. Machen sang of the liminal borderland between England and Wales in countless pieces like *The Hill Of Dreams* and *The Secret Glory*, which, he believed, caught a glimpse of the eternal. But it was his short, supernatural stories like 'The Inmost Light' that first snared Tibet.

Originally published in 1894 as part of *The Great God Pan and The Inmost Light*, it concerned an experiment to capture the lifeforce of the soul in an exterior object. Tibet appropriated the phrase to describe the secret fires and energies of the noumenal world, itself the essence of our own. He delineated this worldview across *The Inmost Light Trilogy*, consisting of *Where The Long Shadows Fall*, *All The Pretty Little Horses* and *The Starres Are Marching Sadly Home*, made between 1995 and 1996. 'I just thought it was such a magical phrase,' he explains. ' I think in fact that *The Inmost Light* is the reality that permeates everything, it's the fundamental nature of this physical world, of all the worlds that are existing at this moment. And it's the only thing that is important. Time is limited and death comes quickly to us. If we don't realise how quickly time is running out for all of us and don't at least attempt to see *The Inmost Light*, then that's it.'

1993 was the year Tibet stopped moving: in spring he and Kat bought a two-storey terraced house in North East London. Stapleton claims that in his early days Tibet used to boast that he could fit all his belongings into a single black binbag. But with all the paintings and books he was amassing, he needed somewhere to keep them. The need for a stable base additionally prompted Tibet to take stock before pressing on with new challenges. 'I think after 1993 my work became a lot more reflective,' Tibet ponders. 'It still had bursts of manic energy but it became more

Stapleton with tree house, reflected in a pond,
Cooloorta, 2000. (photo Petr Vastal)

composed and thoughtful. Certainly much more Christian, although I
don't like to use that word, because it implies a much more doctrinaire
and dogmatic approach. Basically I was happier.'

Kat and Tibet moved into an old worker's house built in the 1880s,
which the previous owners had stripped back to its original features,
in a road once called Cut-Throat Lane. 'The overall feeling was very
dark, cool and woody,' Kat recalls. 'A bit cottagey in some respects and
very Victorian Dad in others. At that time Tibet was collecting shitloads
of ghost story books and so he also had to start collecting vintage
bookshelves to keep them in. On the walls there were plenty of Wains
but not so many of the psychedelic landscapes which he got into later.
Tibet would work at this old desk that he found in the street, under a
novelty Noddy lamp, seated on an incredibly uncomfortable wooden
chair.' The two ginger tabbies Mao and Rao were the first cats to share
their new home. Winter came early that year, and Kat remembers how
she and Tibet observed the cats uncertainly treading holes in the snow,
which they'd never seen before. 'The rooms were scattered with icons,
crosses and Noddies,' Kat adds. 'Although the back room was reserved
for the Tibetan pantheon, out of public view, of which we had various
Taras, Padma Sambhavas and other deities.' Tibet spent most of his first
year in the new house stuck in his study working on a long prose piece

that eventually became Current 93's greatest work, *Of Ruine Or Some Blazing Starre*.

In late 1993, there were also new moves afoot with Steven Stapleton, who manifested a newfound interest in rhythm on *Rock'N Roll Station*. He had acquired the taste through his immersion in the work of Cuban-American pianist and bandleader Perez Prado, whose immensely popular 1950s recordings, such as 'Que Rico El Mambo' and 'Mambo No 9', were forerunners of Latin jazz. 'I heard him for the first time in 1992 and was obsessed by him,' confesses Stapleton. 'I was frantically collecting any Perez Prado material. It's heavily rhythmic and that's what I spent the much of the 1990s listening to. It certainly influenced my music. I mean, I've no interest in dance music. I don't dance – my hat would fall off. Even the stuff that's on *Rock'N Roll Station* and *Who Can I Turn To Stereo* [1996] that are sort of rhythmic, I certainly wouldn't dance to them. It's for concentrating on, a movie for your ears, an adventure which will hopefully surprise you.'

'*Rock'N Roll Station* has a peculiar history,' continues Colin Potter. 'What I sometimes did in the studio was to 'over-use' effects and processors to totally mutate a piece into something completely different. Steve asked me to do some remixing on a couple of sections of *Thunder Perfect Mind* that he wanted to work on, spend a couple of days by myself, working on the material in any way I saw fit. He seemed to really like the results and asked me to do some more, only this time even weirder. So I did. It was really liberating to be told to 'do what you like' and go completely mad. I generated hours of stuff, some of which was undoubtedly bollocks but some of which was rather good.' Indeed it was, for *Rock'n Roll Station* spawned a companion album, *Second Pirate Session*, to mop up the great material left over from these sessions. But not all longtime Nurse fans shared Stapleton's new enthusiasm. 'It was all pretty rhythmic, in a very relentless sort of way, which I don't think went down too well with some of the more blinkered Nurse fans,' Potter shrugs. Stapleton took up the story with Leicester Kraut and Prog rock experts Alan and Steven Freeman in the Spring 1994 issue of their *Audion* magazine: 'The album came about because of a dream I had with Joe Meek, Jac Berrocal, myself and Graham Bond, who were

in the grounds of a very expensive, very large house. We were pleasantly talking, as if we were friends and we got into a discussion about bicycle maintenance, and this ends up with an argument over a puncture repair kit. Then suddenly all four of us were lying on the ground, naked in a circle, with our legs to the centre and our penises pointing to Venus. And that was the dream. I thought a lot about that dream. There's a track on the album called 'Two Golden Microphones', which is a dream a guy called Pete Brown [poet and Progressive rock lyricist] had about Graham Bond. It was almost as though telepathic messages were sent over to Colin. I'd started an album with Colin that was never finished. He sent me some vague mixes, which were just what I had in mind. So, from that basis, I started putting the album together. I was really affected by the life of Graham Bond, by his biography. A strange thing happened, when I started reading that book I was at Finsbury Park station and I realised I was sitting on the same platform where he killed himself. I thought there's something meaningful here. Actually, the whole album is about Graham Bond. I wanted to do a few experiments with rhythm and they ended up on there, like 'The Self Sufficient Sexual Shoe' track, and I always had a great love for Jac Berrocal's *'Rock'n Roll Station'*, which I think is an absolute masterpiece – I could never better it. It's a homage to a great piece of music.'

The minimal, repetitive electronica of *Rock'n Roll Station* gives the nod to the sci-fi sound that characterised pioneering pop producer and svengali Joe Meek's cartoon futures. The title track is a fairly faithful reworking of the beguiling piece that first appeared on Berrocal's *Parallèles* album. On the original, the lead vocal is by Vince Taylor, a British rock 'n' roll star, acid casualty and self-proclaimed messiah exiled in Paris, who reputedly inspired David Bowie's Ziggy Stardust character. Over the metronomic thump of a cheap drum machine and some deep electro bass, Stapleton speaks a monologue that conflates disparate times and places with snatches of misremembered facts and verbal ellipsis. 'A rock'n'roll session is a session where we can do what we want to do,' Stapleton deadpans. If the title track simultaneously works as a deconstruction and a celebration of the liberating rock'n'roll urge, elsewhere the album touches down in some darker places, like

'Finsbury Park, May 8th, 1:35pm (I'll See You In Another World)', which imagines the mental state of the aforementioned Graham Bond, a Progressive blues musician and occultist integral to the British rock scene in the late 60s, at the moment he threw himself under a train in North London. Stapleton creates a maze of echoed sounds, where the screech of Tube trains and the crackle of the tannoy systems are slowed into a series of freeze-frames that unfold the track's death narrative with sluggish yet inexorable fury.

Comfortably ensconced in his new home, Tibet was issuing new titles through his Ghost Story Press at an increasing rate. In 1994, GSP brought out one of its strangest collections, which also happens to be one of Tibet's favourites, LA Lewis's *Tales Of The Grotesque*, first published in 1934. Lewis, who was born in 1899 and lived until the age of 62, spent most of his life in the Royal Air Force, his career nurturing an obsessive respect for the power of the skies, where most of his tales concerning haunted aircraft take place. However, his most disturbing tale, 'The Tower Of Moab', is about a mysterious tower left half-completed in the centre of a busy town, all that remains of an architect's attempt to realise a modern Tower Of Babel. A succession of terrifying visions brings the narrator to the realisation that the completed tower does indeed exist for certain individuals, who can see it overflowing with degenerate demons and astral organisms. 'It was The Tower Of Moab,' Lewis wrote. 'So tall that no horizon can hide it – the fearful link forged in Man's defiance of God's ordaining, that has not only made contact with the higher realms, but given lease to the beasts of the Pit'. Lewis's tale meshed with John Balance's vision of hell paved with horseflesh in the sleevenotes of Coil's *Horse Rotorvator*, inspiring Tibet to write 'Lucifer Over London' at a single sitting. 'I pulled up the computer, drank a bottle of wine and it all came flying out,' he says. 'Absolutely a drunken ramble but focused at the same time. It's exactly as I wrote it, nothing was changed apart from punctuation.' Tibet sent the words together with a CD of South-East Asian ritual music to Michael Cashmore, triumphantly announcing, 'This is 'Lucifer Over London'!'

The resulting *Lucifer Over London* EP stands as one of Current 93's most hysterical works. The title track opens with guitarist Nick Saloman lifting the riff from Black Sabbath's 'Paranoid', which gives way to Cashmore's wheeling acoustic guitar and an eye-popping Tibet vocal. As 'He who fell' appears in the skies over the capital, Tibet flashes on John Balance, who 'sits in western parts/And piles spare Spares in his gabled room'. Stapleton treated the whole thing to one of his most hallucinogenic productions, and Cashmore set the song's coda, a sick childhood hymn with a scabrous chorus of 'And sixsixsix/It makes us sick/We're sicksicksick/Of 666'. 'That was my statement of how I was so utterly sick of the negativity and foolishness of much of what I'd been interested in and involved with myself,' Tibet avows. 'My occult, literary and musical interests. I felt like throwing up, I was so sick of it all. Throwing up all the garbage that had been poisoning my soul.' But when a Greek black metal band called Rotting Christ cut a thunderously heavy version of 'Lucifer Over London' on their album *Khronos* in 2000, they didn't feel the need to follow Tibet in renouncing Satan and instead dropped the coda.

Current 93's *Lucifer* EP also included a cover of The Groundhogs' 'Sad Go Round' (from their 1974 album *Solid*) and Tibet's terrifying 'sequel' to Coil's *Horse Rotorvator*, called 'The Seven Seals Are Revealed At The End Of Time As Seven Bows: The Bloodbow, The Pissbow, The Painbow, The Faminebow, The Deathbow, The Angerbow And The Hohohobow'. Over an infernal loop that bleeds into a contorted scream, Tibet evokes a Bosch-like hell, where 'the stench of the universal uric acid fills all the worlds ever ever existing', and 'A grotty rotty mass of children's and horses' grey flesh/death in all its mumbling and dull colours, step or crawl right up for the Deathbow'. Tibet dedicated the track to the soul of his beloved cat Mao, who perished in the winter snow: 'Out of my window, beyond Mao Rao and Yao what seems to be the sun over the arch of Bedlam, shining. Louis Wain is there. I can see, if I stretch my eyes far and further, William Lawes dead ded dead on the plain dead ded dead.'

While writing 'Lucifer Over London', Current 93 were just finishing off *Of Ruine Or Some Blazing Starre*, which was released on

21 January 1994. Here Tibet combined revelatory autobiography with mystical Christian speculation in a long prose poem about innocence lost and regained, a process he mirrors with the idea of the mythical death of England. A key figure in its realisation was the aforementioned 17th Century composer William Lawes, whose music Tibet was now immersing himself in.

A close friend of King Charles I, for whom he composed a number of works, Lawes died for the Royalist cause in Chester during one of the bloodiest battles of the English Civil War. When Charles first heard news of his death he is said to have wept. Like his predecessor John Dowland [1563-1626], he built on a musical tradition that addressed sorrow in mystical terms, conceiving a state of graceful melancholy with slow moving meshes of viol.

'Lawes's music was absolutely the death knell of a certain England, the England that was ruled by a divine monarch,' Tibet states. 'It was the soundtrack to the ending of absolute monarchy. The English Civil War was a stake in the heart of the tradition of mystical authority, which after that obviously continued in the Catholic Church but died out in Europe.' In Tibet's reading, this concept of divine regency was tied up with the very fabric of an England that passed away with the execution of Charles I in 1649, just as another England died out after the First World War when, as Shirley Collins has pointed out, war memorials to the countless dead replaced the Maypole as the central monument in towns up and down the country.

'Lawes's music is very melancholy,' Tibet continues. 'But there's a knowingness about it, a regret, as if he's seeing that England pass, as if he was one of the few that was actually aware of what was happening at the time.' That he was slain by a musket bullet while fighting for his king also had its appeal for Tibet. Indeed, when he and Kat visited a ghost story convention organised by *Ghosts & Scholars* in Chester in 1994, they went out to the city walls to look for the spot where he fell.

With its title taken from Lawes's 'Beauty In Eclipsa', a setting for a Sir Henry Moody lyric, *Of Ruine Or Some Blazing Starre* also owes a musical debt to the composer. Indeed, Tibet played Lawes to Cashmore as a flavour of the atmosphere he was looking for. Unlike *Thunder*

348

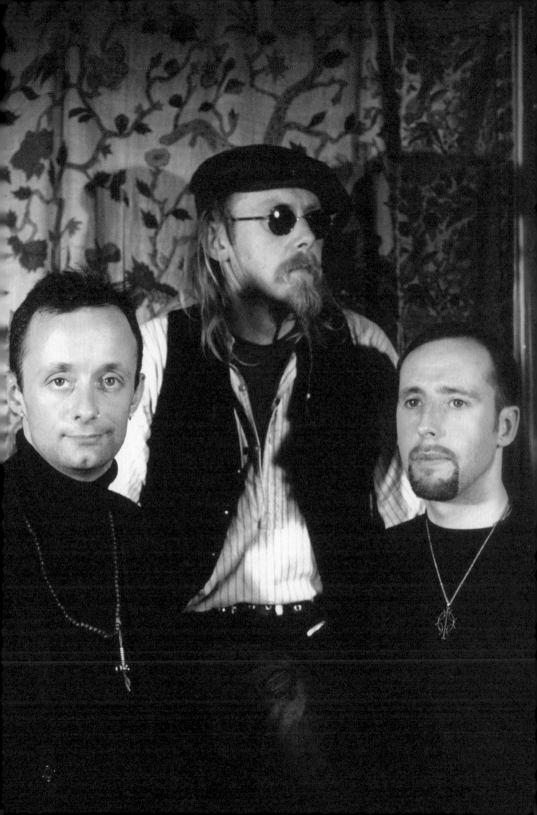

*Perfect Mind*, where Cashmore mainly strummed acoustic guitar, for *Of Ruine* he devised an ornate fingerpicking style that immediately gave the record its more courtly feel. In contrast with the extended family used on the *Thunder Perfect Mind* sessions, this one was recorded by the Current core of Tibet, Stapleton and Cashmore, with occasional contributions from Phoebe Cheshire and Kat, here credited as Starfish.

Opening with Phoebe Cheshire's recitation of Louis Wains's heart-breaking litany, 'Bounce the Ball still, Softly round it on both sides. The Goal is in each Kits Eye...', *Of Ruine*'s tracks cohere into a single composition around its centrepiece 'The Great, Bloody And Bruised Veil Of This World', where Tibet outlines his vision of an eternal England. Its period feel is established with a setting of 'Steven And I In The Field Of Stars', adapted from 'The Funerals' by Elizabethan composer Anthony Holbourne. Over its spare backdrop, Tibet recalls an epiphany in Cooloorta when the stars above seemed to join the dance. 'Moonlight, You Will Say' steps to a peculiar, slightly staggered time as a result of the musicians – Cashmore on flanged guitar, Kat on bass and Stapleton flying in various horn sounds – originally playing along to some Mediaeval pilgrimage music, which was subsequently dropped out from the track. Taking in the 'gorgon grinned arches/Of London's great vaults' through 'the sunpuckered roofs of Kathmandu' and onto Shirley Collins's 'Higher Germanie', 'The Cloud Of Unknowing' is an autobiographical gazetteer that essentially lists places Tibet has lived in or visited. Singing 'In the Heart of the Wood/Oh there have I understood', he takes the *Riddley Walker*-derived symbolism even further, with the heart of the wood now combining a child's wonder at the dark recesses of the forest with one of his favourite quotes from Kierkegaard: 'Do you not know that there comes a midnight hour when everyone has to throw off his mask? Do you believe that life will always let itself be mocked? Do you think you can slip away a little before midnight in order to avoid this?' 'The heart of the wood was a place where you no longer needed a mask,' Tibet elucidates, 'where you were face to face with your own soul and the reality of what Kierkegaard says in that phrase.'

'Dormition And Dominion' breaks the melancholy spell with an affecting vocal from Tibet that's shadowed by Cashmore's beautiful

guitar figure, translucent with tremolo and echo. This time Tibet references Pascal in the lines, 'You shall not find the history of His personal visit/Sewn into the linings perhaps/ Neverthless I have understood'. When Pascal died, his epiphany was discovered sewn into the lining of his jacket just above the heart. Tibet embroiders his own in the lining of 'Dormition And Dominion': 'I say there is no death/ No death/We have lived before and shall live again/And again/We have slept before and shall sleep again/We have danced through the shallow pools/And shall rejoice once again/To those who say there is no hope/I say liars, Liars, Liars you are...'

When Derek Jarman died from complications due to AIDS On 19 February 1994, Coil issued a special limited edition 7" to commemorate him. Called *Themes From Derek Jarman's Blue*, it features tracks recorded over the Winter Solstice of the previous year for the soundtrack of Jarman's last film *Blue*. Reflecting Jarman's near blind state when he made the film, *Blue* projects an unchanging blue screen, accompanied by a rich sound soup consisting of snippets of music, snatched voices, incidental noises and Nigel Terry's narration of Jarman's diaries.

Coil have made a habit of recording music that accorded with the stations of the sun and moon, as marked by the solstice and equinox. For 1994's autumn equinox, they intended to resurrect Black Light District, a project that Balance had been discussing for years with Drew McDowall. Their first attempt at a Black Light District record in 1989 resulted in what McDowall now describes as a 'bad trip take on acid house'. Though it was never released, McDowall was invited back as a full Coil member for the *Love's Secret Domain* sessions. But he never made it. 'I had been given this really fucking strong acid,' he shudders, 'and I ended up in a completely different part of the country. I wasn't in London, that's for sure.' Hence Balance's sarcastic aside on the sleeve of the Windowpane 12", thanking McDowall for 'almost being on it'. In 1994, Coil further developed the liberating concept of Sidereal Sound, and McDowall finally settled into the group's ranks. This latest incarnation first manifested itself on the B-side of the 'Nasa Arab' 12", called 'First Dark Ride'. The epic 10 minute track

that slightly overreaches itself, when its silvery Morse code rhythms fed through a tunnel of F/X lead to a disappointingly flatfooted Techno denouement.

'The concept of Black Light District was always changing but it was supposed to be something darker and heavier than Coil,' explains McDowall. 'When we first talked about it, it was probably as some Krautrock meets acid house insanity.' Chances are Black Light District was also another strategy for creating music free of pressure and expectation. And indeed, the project's revival in the wake of *Love's Secret Domain* feels like a diversionary tactic. Regardless, once the Black Light District sessions started in earnest, something was clearly amiss. They felt the presence of something trying to make itself heard. Balance initially feared the same entities that occupied the control room during the *LSD* recordings had returned, but it soon became clear that this was something they hadn't encountered before. They responded by shelving Black Light District, concentrating instead on channelling the new arrival via the mixing desk. 'We immediately changed tack, left what we were doing and got on with what suddenly seemed really important,' Balance whispers. 'For a week it really felt like something opened up above us and poured into us. We were constantly inspired and then, just as abruptly, it finished transmission. We felt it go. It was a bit like that part in *Close Encounters Of The Third Kind* where he's making mountains out of potato. It was something that at that moment we had to do.' Released as *Coil Vs ELpH*, these extremely minimal recordings sound like primitive, slurred speech pulled from the aether and etched in white light. Transmissions resumed the following year, triggered by Sleazy's chance discovery of a battered old reel-to-reel tape. This time it felt like ELpH had entirely taken over their environment, disseminating directives and signals through a television, old cassettes and 'malfunctioning' studio equipment. The glitches and flaws endemic to digital and analogue media popped spaces in the sound, and the past streamed through them to point the way forward. Coil simply acted as an antenna for its signals. They dubbed the project *Worship The Glitch*.

'It really felt like we were channelling something,' McDowall confirms. 'Or at least that's an idea we allowed ourselves to play with.

The whole thing with *Worship The Glitch* was to see how much we could take away from it and it still retain some kind of structure. That's why some of it is so sparse and ghostly. But the reel-to-reel with the woman singing on it was just such a beautiful and odd find, and that's what inspired the whole idea. We thought, why fuck with this? I think we messed around with it a little bit, but it was so amazing just as it was, this found object. It really feels like a transmission. It's one of those instances when you know something is going on – I mean how do you 'just find' something like that?'

Most of *Worship The Glitch* is not so much music as the aural equivalent of a séance conducted in a back parlour somewhere in Islington in the 1960s. What sounds like conversations overheard across the years are cut up with hieroglyphic soundforms and field recordings animated by rhythms of language. It's the closest Coil have got to pure documentary and it's all the more disturbing for that. Crucially, *Worship The Glitch* provided its participants with a creative kickstart for a host of inspired side-projects, if not the confidence to yet consider a full Coil release.

Earlier in the year, Balance had checked himself into a private drug and alcohol dependency unit in Wiltshire in an attempt to head off a calamitous crash. He came out the other side of kicking his physical addiction feeling invigorated. Over the winter of 1995/96, Balance, Sleazy and McDowall finally cut the Black Light District album, now called *A Thousand Lights In A Darkened Room*. Coming over like a soundtrack to a drowning, it takes you on a strangely unfulfilled nocturnal journey downriver. Pity the CD reissue didn't incorporate a key navigational aid, 'Lost Rivers Of London', which was originally recorded for *Succour: The Terrascope Benefit Album* and later included on Coil's *Unnatural History III* compilation.

'We were really obsessed with rivers at the time,' McDowall confirms. 'It was just a short walk to the Thames from where Sleazy and Balance lived and at least two or three times during every session we would take the dogs for a walk down by the river. We were also obsessed with the ideas of London's lost rivers, it was a constant topic of conversation, the idea that London had all these rivers that coursed

through it that were eventually covered up, like the Fleet.' The largest of the Thames's tributaries, the Fleet rose from springs on Hampstead Heath and ran five miles down to Farringdon Street, before flowing into the Thames beneath Blackfriars Bridge. Archeological digs have unearthed anchors, indicating that the Fleet used to be navigable before it was partly converted into a canal and eventually covered over after the Great Fire Of London in 1666. For Coil, city rivers are not only a source of primal energy, they are also arteries circulating the city's pulses. Covering a river up must cause parts to atrophy, while subtly altering its psychic balance.

'We felt that the fact that London had all these secret rivers running through it gave it a dark energy that we could tap into,' McDowall expands. 'We were always really aware of London being a living thing, something else apart from just its geo-political identity. It was always a belief with me that the great cities of the world were living entities, and Balance agreed with that. London has got a powerful dark energy, especially in East London, parts that don't even exist anymore, where the only pointers to what they once were are in the street names. With *A Thousand Lights In A Darkened Room*, we were digging in and trying to find the London that lay buried underneath.'

Creatively recharged by Black Light District, Coil attempted a second pass at *Backwards*. In autumn 1996, Trent Reznor, who was now bankrolling the album, flew them out to his studio in New Orleans, where they reworked raw material from the album's first session. It still wouldn't budge. 'The session with Trent was really unsatisfactory,' McDowall sighs. 'No one was happy with it. *Backwards* was always something that Balance and Sleazy felt they had to do. Trent had given them money and now it was almost an obligation to complete it, both artistically and financially. By the time we got to New Orleans, they weren't really feeling a lot of it. Obviously it's hard to just pick up where you left off a few years ago. In the event we radically reworked a lot of the existing material and did a few new tracks.' To his credit, Reznor was totally hands off about the album. 'I wasn't a big fan of Nine Inch Nails,' McDowall admits. 'But I came to respect him because he left us alone. It was a nice big studio, lots of recreational facilities, a bit of a rich man's

Tibet, Balance and
Drew McDowall.

toy really. Trent would sit and play video games when he was there. He
liked to just hang out.'

In retrospect, McDowall feels that Coil would have done better to
totally scrap the earlier *Backwards* sessions and start with a clean slate
in New Orleans. 'Instead they were just adding more and more things
to the original tracks, which were already pretty dense in the first place,'
he says. 'A lot of them were manic by Coil standards. I remember a track
called 'Elves' that was really full on, but overall I felt that the tracks were
a little bit too much of their time, totally dance orientated. By the time
we went to New Orleans, they sounded dated. Some of it sounded like
Underground Resistance, really bass drum heavy, driving four to the
floor rhythms, very heavily compressed. It sounded as if they had been
paying too much attention to what was around at the time.'

Nevertheless Balance was upbeat about New Orleans when he
reported back in a Threshold House Update. 'We spent September in
the USA, partly in NYC and partly in New Orleans, where we completed
the recording and mixing stage of our next Magnum Opus, at the studios
of Trent Reznor and Nothing Records,' he revealed. 'They were really
friendly and helpful, and short of actually appearing on the album, did
everything they could to make it work for us. We have by the way agreed
to make five albums for Nothing, which they are to distribute worldwide,
so this should solve the availability problems some people have been

having, and also will fund some of our more extreme projects... We think we did some really good songs, 14 or 15, in the classic Coil mode, although they remain to be edited and finished off into a Total Work. This is the album we were going to call *International Dark Skies*, but thanks to a rather cheesy sub-X Files TV show in the US, is now called something different. This new title will be revealed in due course! We expect to deliver the master tapes, artwork etc to Nothing by Christmas, and therefore will probably be released worldwide by them in the Spring.'

Coil left New Orleans with the intention of finishing *Backwards* at home. But other, more interesting projects kept getting in the way, and once again the album – and with it the Nothing deal – was effectively abandoned. However, 'A Cold Cell', which was started and finished in New Orleans, made it onto a free CD given away with *The Wire* magazine, as well as appearing on one of two Coil anthologies – *A Guide For Beginners: A Silver Voice* and *A Guide For Finishers: A Golden Hair* – originally put together to commemorate their first Russian concerts in 2002.

With a *weltanschauung* taking in Noddy, neglected cat artist Louis Wain, The Venerable 'Chi.Med Rig.'Dzin Lama, Rinpoche, and English composer William Lawes, Tibet's beatification of the outsize American oddball specialty singer Tiny Tim came as no surprise. Those who vaguely remembered Tiny Tim's 1968 freak hit 'Tiptoe Through The Tulips' often as not formed a fuzzy image of a vaudeville throwback peddling a wavery falsetto and ukelele act like the talkies never happened. However, the soaring if somewhat wobbly soprano Tibet heard emanating from Tiny Tim's ungainly male frame had the sweet virgin innocence of a 17th Century castrato, its unsullied purity at once surviving and transcending the purportedly seedy entertainment origins of some of his material. In truth, Tiny Tim was not only one of the 20th Century's sweetest balladeers, he was also a walking treasury of popular song encompassing music hall, showtunes, radio days, jukebox music, Spector pop and more. Tibet recognised Tiny Tim's indomitable belief in goodness and his capacity to redeem shopworn dreams and heartaches from the most cynical teen lyric. As such, he readily fitted in with the alternative canon of outsider artists and musicians championed by Tibet through his independent record

Tibet meets Tiny Tim, 1995.

label and publishing companies. Tiny Tim's one big break came on TV comedy duo Rowan & Martin's first ever *Laugh-In* show, where he stole hearts with a teary rendition of his signature song, 'Tip-Toe Through The Tulips'. With the freak flag flying high, he signed to Frank Sinatra's Reprise label, scored his solitary hit with 'Tiptoe' and released an affectionately remembered debut album, *God Bless Tiny Tim*, before slipping back into obscurity. By 1995, Tiny Tim was playing to handfuls of hardcore fans on the nostalgia circuit, when he was brought to Tibet's attention by Californian noisemaker Boyd 'Non' Rice, a connoisseur of non-conformist cultural spirits and contributor to Re/Search magazine's *Incredibly Strange Music* and *Films* volumes. Like most everyone else, Tibet at first dismissed Tiny as a one-hit freak show. 'Then one day I went into Rhythm Records in Camden and saw *God Bless Tiny Tim* in the racks,' he relates. 'I couldn't find anything else to buy so I picked it up. As soon as I dropped the needle on the record my jaw hit the ground.' Bearing the sad, dream-lit quality of old ballroom standards, *God Bless Tiny Tim* just wasn't made for times

that were more in step with The Rolling Stones' 'Street Fighting Man' than his 'Ever Since You Told Me That You Love Me (I'm A Nut)'. For Tibet, however, he spoke directly from the heart. 'His music was absolutely without artifice,' he asserts. 'Totally truthful. He was a man without any dishonesty in his soul. When I finally met him, I thought that he was Christ-like.'

At once fabulously complex and miraculously simple, Tiny Tim was a fervent Christian, albeit a far from orthodox one who believed that the earth would eventually be invaded by aliens. Just before he died, the self-described impotent troubadour told Tibet that he wanted to cut an album serenading the loveliness of women on other planets, as he had almost exhausted singing the praises of the earthbound species. And this from a man who believed earthquakes in San Francisco were caused by women using birth control and the availability of condoms in schools. Not everyone in the Current circle swooned before Tiny Tim's bigheartedness. Douglas Pearce took his views on homosexuality as an excuse to irrevocably cut all ties with Tibet, on the grounds that friendship with both Tiny Tim and himself was incompatible. 'Tiny Tim was innocent but at the same time he was aware that people thought his ideas were strange and he wasn't above harping on a bit,' Tibet admits. 'But they weren't formulated to shock. He could never have played Tiny Tim, because all there was was Tiny Tim. There was no reference. Tiny couldn't be anyone else.'

On Rice's suggestion, Tibet made contact through Big Bucks Burnett, who ran Tiny Tim's fan club. To his surprise, Burnett suggested that Tibet call Tiny right away, as he loved to talk on the phone. It was the start of a beautiful long distance telephone relationship. 'I rang up his hotel, where he had checked in under the name Peter Poker,' Tibet recalls. 'Straight away he was like 'Hi, Mr. Tibet, nice to speak to you, have you got a girlfriend? What does she look like?' His phonecalls always lasted at least an hour.' Tibet and Tiny Tim only met once, when he flew over to play at London's Union Chapel in 1995, in a mismatched line-up that featured *Red Dwarf*'s Norman Lovett and Al Murray, 'the comedy landlord'. As a result, *Time Out* listed the

concert in their comedy section. 'I went down to meet him at the airport with Kat and Henry Boxer,' Tibet says. 'Tiny came through the exit barrier and I'm sure he was wearing the same jacket that he had on stage at The Albert Hall in 1968. The pocket was full of pens and there was white face powder all the way down his jacket, he looked just phenomenal.' Unperturbed by the bill, Tiny Tim's fantastic performance walked the audience through 'A Century Of Song'. Tibet recorded and later released the concert on his Durtro label as *Tiny Tim Live In London*. Tibet and Tiny Tim stayed in touch, often speaking of collaborating on something, but by the time of Tiny Tim's death nothing had come of all the talk except the talk itself. A few recorded telephone conversations formed the basis of 1995's deranged Nurse With Wound/Current 93/Tiny Tim collaboration 'Just What Do You Mean By 'Antichrist'?'

Tibet was the last person to speak on the phone to Tiny Tim, who signed off with, 'You've got to weather the storm, Mr Tibet,' Tiny died later that night, collapsing from a heart attack after one final performance of his signature tune, 'Tip-toe Through The Tulips', at a benefit for his mother-in-law's charity on 30 November 1996. 'He met Christ with a ukulele in his hand,' Tibet smiles. 'We'll never see his like again. He got so much ridicule and like Christ himself just took it. I never heard him say one bitter thing.' Tibet still cherishes his copy of Tiny Tim's 1968 *Concert In Fairyland* album signed 'To Mr David Tibet – this album killed me in the record business'.

In 1995, Current 93 launched their most ambitious project to date, the *Inmost Light* trilogy, with the release of *Where The Long Shadows Fall*. Sonically, the trilogy was designed to build in intensity through the accumulation of detail across its three parts. It follows that *Where The Long Shadows Fall* is very much the calm before the storm. Set in an eerie soundscape dominated by a rising and falling loop of a castrato singer, the rich, imagistic flow of Tibet's lyrics draw from many of his obsessions, among them the MR James story 'The Rose Garden' and spiritualist and artist Madge Gill's presiding demon Myrinerest, who, she claimed, transmitted the bulk of her automatic drawings and

writings. But the predominant spirit here is that of artist Charles Sims (1878-1928).

An associate of the Royal Academy by the age of 30, Sims was a hugely successful painter in his youth. He drew on late romantic landscapes and resettings of myth for his early, beautifully realised evocations of England. But Sims never recovered from his First World War experiences as a war artist in France. Upon his return, he radically changed from a realist style to ecstatic allegory. In 1926, he resigned his post at the Royal Academy Schools and embarked on his most enduring and idiosyncratic series of paintings, which proposed visions of the presence of God in everything and the eternal battle between the elemental forces of good and evil. His most striking canvas, 'The Rebel Powers That Thee Array', depicts a Christ-like figure, reputedly modelled on himself, suspended in light, as daemons circle him like flies

and God bathes his head in gold. Much of his later work formulates the constancy of God's love in the face of man's indifference in paintings and sketches of children gazing up at angels while adults, their bodies buckled in sorrow, avert their eyes. Sims's insistence on the co-existence of a different reality parallel to our own was sufficient to brand him a madman in the eyes of the art establishment, effectively burying his later works. In 1928, after a long battle with mental illness, Sims shot himself.

Tibet had already used two Sims paintings on the front and back of *Of Ruine Or Some Blazing Starre*. On *Where The Long Shadows Fall*, he finally put the artist to rest: "My pain beneath your sheltering hand, He cried/And gave himself up to the Tempter/The rebel angels (he thought and knew)/Would indeed array him with robes of water/But not mad/But clear.'

'That whole last section is about Sims's death,' Tibet elucidates. 'He went down to look at the water and shot himself. I felt that at the end, finally, he wasn't mad. He suddenly saw with terrible clarity and that was why he took his own life.' John Balance was in the studio during the recording, and asked if he could contribute a line that had suddenly come to him. Tibet gave him the go ahead and Balance rewarded his faith with the perfect refrain, 'Why can't we all just walk away?'

*All The Pretty Little Horses*, released in March of the following year, is a much more complex work. Described by Tibet as a 'hallucinatory patripassianist song', its dream narrative is floated on intoxicating arrangements, mostly by Cashmore, of choral chant, entwined electric and acoustic guitars, distorted children's voices and bells, with Stapleton working his customary magic with the mix. As is often the case with Current records, the whole album eventually cohered around one particular sound source. Here, the album's binding agent is the wheezing of a sinfonie, essentially a prototype hurdy-gurdy. Recording once again at Topic, the Current core of Tibet, Stapleton and Cashmore attempted to model the album, originally called *The Inmost Light Parts 1-6*, after the organisational logic of two Tibet favourites, The Incredible String Band's *The Hangman's Beautiful Daughter* and Comus's *First Utterance*. But weird coincidences kept pushing the music into new,

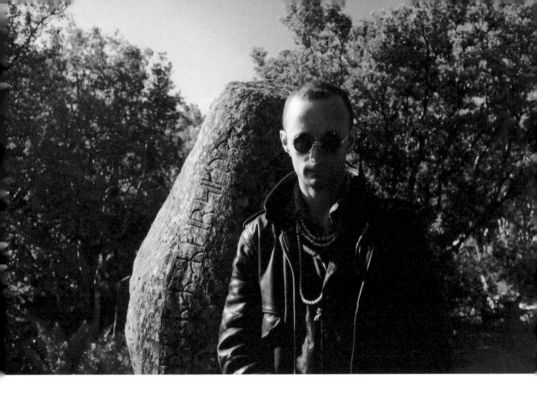

unexpected areas. 'When we were mixing 'The Inmost Light' one of the tapes came off due to a loose spool,' Tibet recalls. 'For a minute the whole track started to wobble. We just listened to it and thought, that's it! It was the hand of God and it worked perfectly.'

'Twilight Twilight Nihil Nihil' features the voices of John Balance and Timothy d'Arch Smith, author of [poet and demonologist] *Montague Summers: A Bibliography*, antiquarian bookdealer and supplier of rare and arcane British and occult texts to Tibet, Balance and Edwin Pouncey.

On *All The Pretty Little Horses*, Current reverted back to the extended family feel of *Thunder Perfect Mind*, with contributions from the ghost story author David Rowlands, playing Hawaiian steel, Joolie Wood, Geoff Cox, David Kenny, Stapleton's daughter Lilith and Nick Cave. Tibet had been introduced to Cave by their mutual friend Cox. 'Cox suggested to Cave that he should meet me because I had a large collection of Wain paintings,' Tibet explains. 'We got on well and there was a while where we'd meet once or twice a week and go out for dinner

or go to auctions together to look at Wain stuff.' Tibet asked him to do two tracks on the album – a version of the Appalachian lullaby 'All The Pretty Little Horses' and a reading from Pascal called 'Patripassian'. 'Cave came down and he did three different versions of the title track,' Tibet recalls. 'I liked the first one but when we listened back to it he just said, no, it's too Bing.'

'We became quite close friends because we have similar interests,' Cave told *Seconds* magazine. 'He has very strong Christian notions about things... Anyway, he started giving me a lot of books to read, a lot of information – about his ideas and so on. And so I just went and sang on his record to return the favour.' The interviewer touched on Tibet's occult reputation. 'I think he went through that, and pretty much exhausted that area,' Cave replied. 'He's genuinely a good person. He's just ended up being more interested in that sort of thing. I don't really know too much about his spiritual growth, but he has some tattoos and stuff that betray certain other things I've certainly never really been interested in.' In 1999, Cave told me what he loved most above Tibet was how 'he makes the art that he does regardless of what Century he's living in'.

Cave's reading of the title track is fairly straightforward, while Tibet's take gives it a disturbing new slant. Spoken in a ghostly whisper, the Tibet reading brings the nature of the horses' 'prettiness' into question. They may well be the four horsemen of the apocalypse. Between them, the two versions work as the perfect mix of innocence and sinister intent. That theme runs through the album, starting with the accompanying booklet's heartbreaking pictures of all of the participants as children, and continuing in lyrics that describe children with knives rising through pools of saliva. Again, such images draw on Tibet's Malaysian childhood: memories of a drowned child in the pool, and a kid whose legs were crushed by a steamroller are both revisited in one of the album's most disconcertingly beautiful tracks, 'The Frolic'.

The album's key track 'Patripassian' features Cave's narration from Pascal's *Pensées* over a heavily treated choral loop: 'Jesus will be in agony until the end of the world,' he reads. 'There must be no resting in the meantime.' Concluding the album, it casts a shadow over all

that preceded it, reaffirming Tibet's intention that all its events appear to have taken place in dreamtime. 'For me the last track makes the point that all of this trilogy, and all of existence generally, is lived out under the passion of Christ,' he affirms. 'For me we're living in the endtimes, although not in a narrow, prescriptive sense. But Christ is on the cross, he was crucified but he hasn't ascended to the father yet.' The excerpt from Pascal states that all of our actions on earth either add to Christ's agony or assuage it. Patrtipassianism claims that when Christ was crucified, God was crucified. The relation between Christ and the divinity within him is a hotly debated theological issue but it follows that if it was indeed God who was crucified, God is by definition immortal and therefore he's not dead. 'Therefore we're all merely acting out some strange, dreamlike play,' Tibet concludes. 'We're given some lines and we're improvising others, but it's not the nature of the plot that brings the curtains to a close, it's God himself. When Christ dies, the curtains close wherever we're at. So we are living under an Imperium and the forces of Satan and evil are at loose.'

Geff, Chaos, Dingo & Sleazy, at home in Chiswick, early '90s.

Released the same year as *All The Pretty Little Horses*, *The Starres Are Marching Sadly Home*, *TheInmostLightThirdAndFinal*, is the instalment that most bears Stapleton's thumbprint. It opens with the creak of ruptured decking, evoking an abandoned ship adrift at sea, which gives way to some disturbing, heavily modulated voices that Stapleton works into thin howls of wind, while a broken rhythm loop of the castrato singer from *Where The Long Shadows Fall* circles in the background. For Tibet the loop symbolises that there is no resolution, and the lyrics are correspondingly bleak: 'And this life – Though I have shielded myself/with a rosaried wall, I came to see/ No meanings, But loss and death/Endings, all endings.' However the clouds part towards the close, when Shirley Collins enters singing her own version of 'All The Pretty Little Horses'. Despite the surrounding turmoil of sound, Collins restores the track as a song for children, full of compassion and hope.

# A Lunar Ascension

*Time is a mortal thought, the divisor of which is the solar year*
– Mary Baker Eddy

By 1997, Coil were feeling the Moon's pull. They regularly took nocturnal walks along the Thames, crossing the fields as they headed for Hammersmith Bridge, while the Heathrow airport traffic screamed past overhead. Their night time jaunts made them conscious of just how tidal the Thames was, its movements closely mirroring the phases of the moon. The return of Balance's lunar obsession, combined with a series of lucid dreams, prompted Coil to do something that reflected the dreams and feelings generated by their nocturnal ramblings through the city. They decided to cut a series of EPs, each of which would be recorded at the exact time of the solstice or equinox, thereby formally enshrining an already well-established working practice. For Coil, these were special liminal times, where channels were briefly opened between this world and the next. The concept might have been a fairly arbitrary peg on which to hang a new project, but they were careful not to desecrate tradition. If the solstice took place at exactly 8:06 in the morning, then that's when they'd start. They'd work over what they got at a later date, eventually completing the track the next year. Most importantly, with a framework to focus and structure their sessions, Coil were hard at work again. *Backwards* had collapsed for the lack of such an exo-skeleton. Eventually calling the series *Moon's Milk (In Four Phases)*,

they programmed the sessions in a way that allowed them almost no time to think or overintellectualise the project. Founded on real-time improvisations, Balance came up with most of the *Moon's Milk* lyrics on the spot, stringing together fragmented images from whatever he sang off the top of his head. Once again, they were tapping into the stream of unconsciousness that had animated their early records.

As an exercise to facilitate writing without an interior camera monitoring their every move, Sleazy and Balance began keeping diaries, resolving to fill three pages daily before breakfast with whatever came into their heads, be it repetitive, puerile, vicious or self-defeating. Their ability to create spontaneously thus sharpened, Balance matched some of his most inspired lyric streams with fine vocal performances. The next phase of Coil music was well under way before they knew it, their lunatic soundtracks this time unhindered by the self-consciously reflective processes that stymied *Backwards*. 'I don't claim responsibility for what comes out,' Balance maintains. 'It might be other people or other beings or it might be me repressing me. I'm quite aware that a lot of what we've done before has been me forcing something out, forcing this whole concentrated thing to come out. Now we had a different way of doing it, just letting it all pour out and then sifting through it afterwards.'

On the *Moon's Milk* recordings, Sleazy, Balance and McDowall recruited William Breeze on electric viola. Breeze's fascinating history includes sharing a group in 1978 with the late Angus MacLise, the free-wandering poet, percussionist and drummer who quit The Velvet Underground when he learned it was a paying gig. Two years earlier Breeze had failed an audition for Richard Hell's Voidoids. He briefly joined Psychic TV for their 1996 CD *Trip Reset* and, a year later, he was passing through London on his way to Europe when Big Bucks Burnett of the Tiny Tim Fanclub invited him to Current 93's Union Chapel concert on 3 May. He had already pencilled in studio sessions in London for a project organised by Burnett, and Hamburg with Euro-goths The Cassandra Complex, when Tibet invited the viola player to join Current 93 for the show. 'I think I was originally introduced to Breeze through Balance,' Tibet ponders. 'I already knew of his formidable reputation as a scholar of Western occultism, and as an expert on Crowley. Through

Breeze I met Kenneth Anger, who was also a close friend of his. Breeze is one of the few people I have met who is a genius. His towering intellect and knowledge of the strangest categories of esoterica cohabits easily with a very, very dry sense of humour. He turned up at the Union Chapel with a hauntingly beautiful woman, Amanda, who was a Tarot reader and wonderful artist. They were an impressive pair, and you could see a horde of imps following them hoping to get their attention. Breeze was a superb player, classically trained to a very high standard. I think we got on very well. We made plans to publish a collection of previously unpublished poems by Crowley on Durtro, with notes by himself.'

'I spent the day of the show with Jimmy Page,' Breeze deadpans. 'Another mutual friend Bucks and I share, then went to the Union Chapel and met Tibet, as well as Balance and Sleazy, for the first time. I liked the show. Tibet is a gifted performer and his band is extremely good live. I nearly missed playing at all, as I didn't hear the cue to go onstage, but I made it and it was great fun. I've no idea if it was any good, but the Coil boys asked me over the following day to play, and that was the *Moon's Milk* session. Basically my audition is what was released.'

'William Breeze was great,' McDowall affirms. 'Sleazy and Balance knew him through his occult connections and he was totally cool. I liked him because he looked really straight, like an accountant. Not an expensive corporate accountant but some shabby cheap one. His viola playing was stunning. I loved it – it was good because it was a little incongruous.' Indeed, Breeze's viola dominates the *Moon's Milk* sessions, giving them a more conventionally lyrical feel than other Coil recordings. You can hear Tony Conrad and Cale-era Velvets in his droning bow work, to which McDowall, Sleazy and Balance responded with some coruscating electronics and folk melodies to create a weird Anglo-American polyglot of traditional folk and contemporary avant theory.

'We recorded the whole Solstice series upstairs at the top of the house in Chiswick,' McDowall continues. 'There was a tiny window up there and we could see out over the park as we played. Balance was directing the sessions but he wouldn't use musical directions – he would describe

William Breeze, Sleazy and Balance, *Moon's Milk* sessions.
(photo Amanda Fisher)

an atmosphere or an idea that he wanted us to express in sound. Still, the whole session is a blur to me now. All I can really recall is 'A Warning From The Sun', where the whole room was just bleeding with noise.' Breeze remembers things a bit more clearly. 'Every one of the sessions was different,' he maintains. 'Balance sometimes had definite ideas and he had either already indicated them through earlier tracks or did so semi verbally. He's very telepathic to work with. Sleazy is a brilliant musician in the studio, which is his instrument really, and as a producer he makes one very comfortable. The track 'Moon's Milk' was a first or maybe second take. I don't think there's overdubbed viola on that, though it sometimes sounds like it as there's a great deal of double-stopping, playing two-note chords while bowing. They had already recorded the vocal drones, so it was a question of fitting in.' With *Summer Solstice*'s 'Bee Stings', Balance hummed his idea to Breeze, who extrapolated a backing track of scorched seesawing patterns to realise Balance's image of endlessly rolling summer fields dancing with the drone of insects. Balance was in part referencing one of his favourite writers, the Irish writer-mystic George Russell (1867-1935) aka AE or Aeon, a lifelong theosophist who saw the embryonic forms of gods behind the eyes of Irish farmers, and felt the presence of supernatural entities everywhere in his homeland. 'When I sing 'Don't believe AE, See for yourselves the summer fields', it's a plea for experiential outings, pilgrimages etc,' he wrote in his notes to Coil's later album *Astral Disaster* on the Brainwashed website. 'Get out there – travel! It's in both the journey and the destination.'

*Autumn Equinox*'s 'The Auto-Asphyxiating Hierophant' is essentially a showcase for Breeze pulling a sequence of violent melodies from the air. 'After we recorded 'Hierophant', Sleazy asked me where that had come from,' Breeze recalls. 'And I remember relating it to my trip out through London, with all of the war and ruin and pestilence that the place had suffered over the centuries, from Boadicea through WWII. I was definitely picking up on that at the time. The *Autumn Equinox* sessions were more from scratch. Most of the time, Balance was downstairs asleep or otherwise engaged – yet still present, he can do that – while Sleazy, Drew and I worked. With those cuts I had more

Balance at Cooloorta.

leeway, as there was less recorded to define the harmony or melody. So 'Hierophant' and that version of 'Amethyst Deceivers' sound more compositional – to me anyway – though they were entirely improvised. I had fun playing guitar, for a change. Balance's lyrics later used flaws in the work as a springboard, while no doubt covering for me. For example, my getting wobbly and out of tune was made to coincide with the song's character walking drunk, and my getting a bit screechy was covered with a sly reference to cat's gut. They obviously listen very hard and very well when they craft their final songs.'

'Amethyst Deceivers' was named for a mushroom and conceived as an evocation of 'the places they take you to'. Offering a plethora of alternative readings, the track has since become central to Coil's live show. As the birthstone for February, the amethyst relates to both Balance and Sleazy. Like Elizabethan occultist John Dee's monad, it reputedly gives you balance, ensuring strength and stability. Believing it could cure drunkenness, Romans drank out of amethyst-encrusted goblets. Indeed, some people still believe that an amethyst dropped into a glass of wine will prevent you getting drunk. In this last respect, at least, the amethyst wasn't working. The songs' opening lines, 'Pay your respects to the vultures/for they are your future,' echo Beat poet Lew

Welch's great final poem, 1971's 'Song Of The Turkey Buzzard', where he sang of his desire to re-enter the food chain, picked apart by buzzards. 'Not the bronze casket but the brazen wing/Soaring forever above thee o perfect/O sweetest water o glorious/Wheeling/Bird.' The poem earlier detailed the death that he wished for himself, 'With proper ceremony disembowel what I/No longer need, that it might more quickly/Rot and tempt/My new form.' Welch called on a different form of magic than Spare and Balance, but their destination was essentially the same. In May 1971, he walked off into the mountains of the Sierra Nevada carrying a gun. His body was never found.

'A White Rainbow', on *Winter Solstice*, features one of Balance's finest vocals. His paean to lunar inspiration articulates the 'speed of thought' creative process that characterised the sessions in lines like 'Moon's milk spills from my unquiet skull and forms a white rainbow'. The series concludes with a beautiful cover of the traditional 'Christmas Is Now Drawing Near At Hand', with Rose McDowall on vocals. Coil based their arrangement on The Watersons' version featured on their 1965 Topic LP, *Frost And Fire: A Calendar Of Ceremonial Folk Songs*. Commonly sung amongst gypsy families, the folk archivist AL Lloyd described it as a 'moralising carol much used by beggars and others towards Christmas time'. The irony wasn't lost on Coil, who turned in a deeply reverent version, with McDowall's vocal eerily double-tracked above the gull cries of Breeze's viola.

In 1997, Coil's exceptional musical progress starkly contrasted with Balance's ongoing struggle with alcoholism. He booked himself into a treatment centre in Surrey for a minimum six week stay. After three and a half he escaped. Seeking to help offset the escalating costs of Balance's treatment, Stapleton, Tibet and Sleazy put together a benefit record, *Foxtrot*, which included contributions from Nurse With Wound, Coil, Current 93, Peter Christopherson and The Inflatable Sideshow. The album's outstanding Nurse track features a hilarious sample of Robert Sandall, host of Radio 3's experimental music show *Mixing It*, as he struggles to describe Nurse With Wound's alien soundtracks. 'Think jazz,' he ventures, 'think punk attitude.' Balance cast the album's sleevenotes as a confession. 'For many the drug alcohol can offer comfort, sociability

& solace, but for the alcoholic, it eats away at the creative spirit. It traps
and possesses it, petrifying and rotting away any human potential... I am
an alcoholic. I am addicted to the chemical substance Ethyl Alcohol. It
is my demon. My ugly spirit. I suspect I am locked in a lifelong struggle
with it. Over the last few years my experiences have intensified and
darkened. Only the support of my friends and loved ones has enabled
me to reach periods of clarity... I thank them from the bottom of
my heartworms.'

The process of making *Moon's Milk (In Four Phases)* seemed to
alter the very DNA of Coil. Whereas *Love's Secret Domain* was
characterised by a blur of movement, from 1997 onwards Coil
reconfigured themselves with acts of stasis. This approach reached
its apex with 1998's *Time Machines,* one of Coil's most magical
projects. *Time Machines* was partly inspired by the longform drones
of minimalist composer La Monte Young, while Angus MacLise
provided much of its conceptual impetus with his 1962 calendar poem
*Year,* published by the Dead Language Press. Renaming all 365 days,
*Year* was both a work of fiction and an elemental act of magic: its
act of renaming allowed anyone who lived according to MacLise's
*Year* to step out of time. That such a simple act could effectively
annihilate consensus reality was immensely inspiring for Coil, whose
*Time Machines* sought to create drones that would literally kill time.
'You create a space in which to breathe for a while just by renaming
the days,' Balance marvels. 'But you need someone who is willing to
live that out with you and I think I'm more likely to do it with Simon
Norris than Sleazy. Can you imagine: 'I couldn't come into work today
because it was Green Chicken day!' *Time Machines* was supposed to
cure you of time. In the sense that time is an affliction, everything is
speeding up and there's no time and everything is compressed. Your
time isn't your time anymore. It belongs to somebody else and they
pay you for it and then suddenly you find you haven't got it. So you
borrow it from somewhere else. It's a commercial enterprise, time.
*Time Machines* was an attempt to create a space where people can
stop and have gaps.'

But it was also designed as a time machine, a portal through which you could jump. The cover artwork features a replica of John Dee's scrying mirror, while the basic components of his celestial monad were included as a series of 'flashing' stickers. 'There are many possibilities,' Balance expands. 'Sacred music does that, it takes you out of yourself, stops time, takes you somewhere else. There's a real sense of non-corporeality, good sacred music has the intention of doing that, the same with certain aspects of the psychedelic experience, escaping time, playing around with infinity.' And when you come down there's always the thing of re-engaging with clocks – like, what time is it, how long were we away? Balance and Sleazy did a lot of drug research for *Time Machines*, matching the drug experience to the contours and effect of the drone. With other Coil recordings, like *Love's Secret Domain*, drugs were used during their genesis in order to get themselves inside the music's microstructure. With *Time Machines*, however, they were taken at the end in order to make its workings explicable. 'When we were calibrating the drugs and the drones it was more of a feeling thing,' Balance asserts. 'There was a definite sense between us that we knew

when timelessness was starting to appear, the drones weren't just drones for the sake of it. You could feel a slippage and a blurring of edges. Stuff starts to blur and that's when we knew we were on the right track.'

'*Time Machines* came about because I was fucking around with these modular synths that I had in my own place in North London,' asserts McDowall. 'We were always aware of the idea that a certain tone could cause you to have an interesting experience, where you'd hit a certain frequency and sustain it, and through that you'd get mood or mind altering effects. I was messing around with this modular synth and setting up tones that would continue for ages and thinking, wow, there's something going on here that is really interesting.' McDowall took the equipment round to Coil HQ to try the experiment on them. When they immediately started zoning out without any chemical help, McDowall knew he was on to something. McDowall and Balance had already been fascinated by the occult power of the 17th Century organist and composer Johann Pachelbel's *Ciacona In F Minor*; now when they listened to McDowall's eternally sustained organ drones, they flashed back to previous conversations about the time-dissolving qualities of the Pachelbel piece. Here, they noted, they had the makings of their own time machine.

'We all agreed it was worth pursuing,' McDowall continues. 'It was originally going to be just one CD-length piece of extended tone and we decided to use only modular synths, nothing digital, all these real old instruments that had a life of their own just through being used for so many decades. The circuitry gets fucked up and they become random in a way you could never fully replicate via any other means. A lot of them were longer than in the final recording, we singled out the sections that we felt were really transporting us in time.

'For me the only thing I didn't like was that we gave the tracks drug names,' McDowall sighs. 'It just seemed to be so after the fact. I felt that the pieces were psychedelic experiences without drugs. It wasn't like I cared that much at the time, I just went along with it but afterwards I felt it cheapened it a bit. Obviously drugs are a major part of the Coil experience and full on ferocious psychedelic experimentation is a lot of what Coil are about but that record wasn't about that. I think Balance

Hilmar Örn Hilmarsson

was still trying to hook it into the idea of Coil as psychedelic explorers, so I'm sure it did have a real resonance for him. I don't want to put down his feeling for it, because I know that that idea is very dear to him. Still, there was a drug there that none of us had even tried, Telepathine. You can't get that shit! That's a fucking reed that grows in the South American jungle. It's not even supposed to be that good a psychedelic experience, people take it in conjunction with DMT to give it a different spin, it just sounds good. But we were already broadcasting our thoughts straight to each other anyway. We didn't need it.'

By the time Current 93's *All The Pretty Little Horses* was released in 1996, Kat and Tibet were in the process of splitting up. 'We just grew apart,' Kat ventures. 'It was very hard. I was kicking myself during the six months after we split and I was desperate to make it work as it was winding down. Literally praying to this Tibetan goddess, please let us get back together. I wanted to fall in love with him again and I knew

380

he was going through the same thing. We were out of love and it was just time to move on. We finally split in May 1996, when Christoph Heemann was over staying with us. I was telling Tibet at that stage I thought it was coming to an end and I had to move out. It wasn't that I wanted to destroy the relationship. I wanted to keep it going but I did want to get out of the house. I felt crowded out by dark halls, pictures, antique furniture and the presence of Tibet in the house all day, every day. It was just so overwhelming. It was all Tibet. It was his house even though we bought it together, and it had his personality in every corner. I was suffocated. He needed more than I was able to supply in terms of personal care. I think Andria is more concerned for his welfare than I probably was, I think she's definitely better for him in that sense.' Tibet met his future wife Andria Degens through the management office of Nick Cave, where she would answer the phone when Tibet was calling for Nick. A few months after Kat moved out, Degens moved in.

One way or another, the year ushered in many a new Tibet obsession. He and Degens were having dinner with d'Arch Smith, when Tibet let slip he was becoming tired of collecting supernatural fiction, what with its sometimes parochial, little England worldview. To restore his appetite, d'Arch recommended that he track down Count Stenbock's *Studies Of Death* for its fantastic supernatural stories. Stenbock's uranian verse had already figured in d'Arch's study of late nineteenth and early twentieth Century boy-loving poets, *Love In Earnest*. Stenbock, he explained, was a drug addict and alcoholic who died in 1895, aged 35. He also pointed out that Edwin Pouncey had a copy of this incredibly rare book.

'I just had to get the book,' Tibet says. 'I asked d'Arch to use his phone, called Edwin and told him that I had to have it and asked how much he wanted for it. He paused and then without another word he named his fee, which was pretty huge. I hadn't even seen it at this point, I didn't even know what it looked like, but I said, yes. I went round to his place the next day and it turned out that *Studies Of Death* was about the size of a ladybird book. I was so excited it started to vibrate in my hand. Edwin asked me what I thought of it and I said straight away that I'd take it. He asked me if I wanted to read some of it first but I said, no, I had to have it. I really owe Edwin a lot. Through his generosity and

humour he introduced me to one of the major influences on the latter period of my life.'

'I'm glad that I sold it,' Pouncey says. 'It was clear that Tibet was off on a quest. Like Shirley Collins, Stenbock was another spirit that was calling out to him and that he could connect with in the same way. It's like he has these icons, living and dead, that somehow talk to him, somehow communicate in an artistic way.' 'Stenbock descended from heaven into my soul to help me bring him back into the public consciousness,' Tibet deadpans. 'I believe that 100 per cent.'

It's easy to see Stenbock's appeal to Tibet. For one, he was consumed by the spirit of melancholy and died tragically young. More significantly, when Stenbock realised that his hopes for the world weren't attainable, he chose to retreat into his own immaculate universe. In *Stenbock, Yeats And The Nineties*, his biographer John Adlard writes how Stenbock invented his own religion from a compound of Buddhism, Catholicism and idolatry; his book also describes Stenbock's life in the family's ancestral home in Kolk, Estonia, surrounded by a menagerie of parrots, doves and 'a smelly monkey'. Towards the end, when Stenbock was dying a slow death from cirrhosis of the liver caused by his alcoholism, he was accompanied at all times by the smelly monkey, a dog and the life-sized doll he had christened 'le petit comte'.

Stenbock's writing can be clumsy but his lop-sided rhythms, obsessive themes and oddly structured sentences only serve to more accurately map the contours of his soul. Stenbock's entire published oeuvre consists of *Studies Of Death*, three books of poetry and an article in a contemporary magazine, all of which Tibet has since republished through his Durtro imprint. 'When I first got the book from Edwin, he told me that I'd never be able to get the poetry books,' Tibet remembers. 'Indeed, in *Love In Earnest*, d'Arch Smith mentions in the appendix that there are only two known surviving copies of his first poetry book, 1881's *Love, Sleep And Dreams: A Volume Of Verse*. I just knew that they were there somewhere and they were mine. Not only did I get them all, I got multiple copies inscribed by the author.' Antiquarian bookdealer Martin Stone, formerly a member of the UK thug-psych group Pink Fairies that had so obsessed Tibet in 1977, helped him complete his

Stenbock collection by turning up a copy of Stenbock's last and best poetry collection, *The Shadow Of Death* (1893) in a book catalogue in Ireland. The copy had originally belonged to a friend of the poet WB Yeats, who used to be an acquaintance of Stenbock's. 'The negotiations were quite lengthy for the book,' Tibet recounts. 'I was sitting by the open window in my study and it was a beautiful summer's day. Every time Martin would ring back with a quick query, a blue butterfly would come in through the window. Every time I put the phone down, it would fly away and every time it rang it would come back. Of course Stenbock writes about butterflies in 'The True Story Of A Vampire'. I knew that this was Stenbock appearing to me.'

Though Stenbock didn't directly influence Current 93's music, he did inspire Tibet to construct, with the help of Stapleton and Degens, a demoniacal soundtrack to be issued with a Durtro reprint of Stenbock's previously undiscovered gay Black Magic story, *Faust*. A writer who made a more significant impact on Tibet's work was the contemporary horror novelist Thomas Ligotti. 'I consider Ligotti to be the greatest living writer,' Tibet asserts. When he read 'The Frolic', the opening story in Ligotti's *Songs Of A Dead Dreamer*, he found it so disturbing that he couldn't read the rest. 'But the book kept on obsessing me,' Tibet continues. 'I eventually started having dreams about it, so I eventually read the rest of it and I felt that this was a man with a ferociously intense and unique vision.' Ligotti's bleak view of humanity notwithstanding, Tibet was impressed with the intensity and force of his vision. 'There was a beauty, an intelligence and a passion that I completely admired and identified with,' he insists. 'So I sent him a stack of CDs and said, I love your work, I think we share a vision and I'd love to collaborate with you.'

'Tibet was right,' Ligotti confirms. 'Despite the different ways in which we expressed ourselves and the different kinds of subjects that moved us to expression, there was a definite affinity between us – a ferocity, a rage, and, of course, a great sadness. To talk about Tibet's work in aesthetic terms is relevant only to a limited extent. Like other artists whose work is in an expressionist vein – I'm thinking of poets like Georg Trakl and prose-poets like Bruno Schulz and Thomas Bernhard

Two Cooloorta scenes.
(photos Andrew Thomas
at Forge)

– you can take him or leave him, but he absolutely stands above criticism because he is completely true to his visions, beliefs, obsessions, whatever you want to call the substance of his songs. This is not to say he isn't technically or aesthetically adept at what he does, because for his purposes David Tibet is as good as any widely recognised figure like Bob Dylan or whomever you want to name. It's simply that Tibet is working in another realm entirely. He's alone in what he does, and that makes any evaluation of him in the conventional terms of music or literature beside the point.'

The pair's first collaboration was the 1998 CD/book release, *In A Foreign Town, In A Foreign Land*. Tibet had asked Ligotti to write a text that Current 93 could then illuminate. Inspired by a line from the early Current 93 track 'Falling Back In Fields Of Rape', Ligotti produced four stories based around a 'degenerate little town'. At first Tibet attempted to compose a cycle of songs around the text, but out of fear that it would turn into a musical, he decided on a long, atmospheric instrumental that would serve as an abstract imagining of the stories. Designed to be heard 'at a low volume, at dusk, whilst reading the text', it was recorded by Stapleton, Heemann, David Kenny and Tibet, with brief vocal contributions from Andria Degens and Shirley Collins. '*In A Foreign Town* is probably the one I did the most

on,' Heemann reveals. 'I brought my own sound sources and mixed parts of it because Tibet was so in love with Andria that he was on the phone most of the time. The music was really between Steve, David Kenny and myself. When it was finished, everyone felt it was just too distracting to read while the CD was playing and Tibet wanted us to do it again. He would always share his opinion with us, obviously, but he was not directing that record. Everyone else involved was equally directing it.'

'Do You Have A Special Plan For This World?' – the last question a doctor asks to determine whether a patient is psychotic – opens Current 93's second Ligotti collaboration, *I Have A Special Plan For This World* (2000). It consists of one long track, based on Tibet's narration of a Ligotti prose poem amidst the clack of cheap tape recorders and the sound of mutated speech. The disc was inspired by Ligotti's discovery of a set of disturbing cassettes, left at random locations around the downtown area of Detroit where he used to work. With titles like 'Sing A Song Of Wellness' and 'Devil Plus Teens Equals E=MC2', they featured what Tibet describes as 'strange spoken word art brut soliloquies by a man whom, judging by the tapes, may have been a Vietnam vet, involved in some kind of self therapy or part of a programme connected with mental health'. Ligotti had

Stapleton painting *Santoor Lena Bicycle* credits, 2000.

already drawn on the tapes for the story 'The Bungalow House', collected in *The Nightmare Factory*, which details the discovery of a set of cassettes in an art gallery, with each newly discovered tape unfolding a more terrifying chapter. Enthralled with the idea, Tibet commissioned Ligotti to write a fictional manifesto for the mysterious tape distributor.

Recorded by Christoph Heemann in Germany, Tibet's voice sounds like he's broadcasting from another time, as his tone flits between arrogant defiance and total resignation over a psychotic soundtrack put together by Stapleton, Degens and Colin Potter. The project is all the more chilling for the inclusion of some of Ligotti's original cassettes. But Stapleton's not a huge fan of the end result. 'I'm not very keen on the text-oriented stuff he's been doing with Ligotti,' he admits. 'I'd much rather just have the ambient music on its own. Which is why *Faust* was so good – it hasn't got the bloody text over it. I'm still a sound purist.' 'Both Tom and I had a few letters from people saying they were unable to listen to it because it was just too disturbing,' Tibet relates. 'I understand

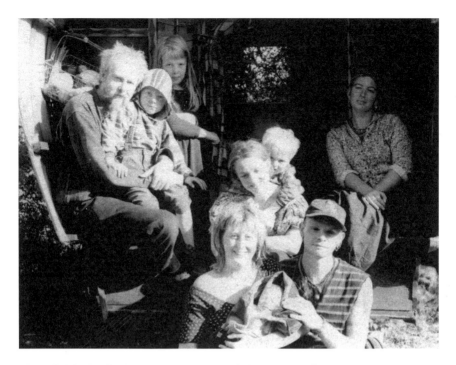

Extended family, Cooloorta, 1996. *Front row:* Ruby Wallis and Peat Bog with baby Freddie
*Back row Left to Right:* Stapleton, Nyida Louis Stapleton, Lilith Willow Stapleton,
Sarah Fuller, Django Bojangles Stapleton, Diana Rogerson.

that, because I was unsure about releasing it myself.' In time, Ligotti supplied the creative seed that germinated the 'official' Current 93 album *Soft Black Stars* (1998), their follow-up to *The Inmost Light Trilogy*.

Out in Cooloorta, the community was expanded with the arrival of Petr Vastl, a gypsy violinist, and his then partner Maja Elliott. As Aranos, he would go on to cut purple swathes through a whole slew of Nurse discs. Chris Wallis first came across him at a local festival where he was immediately blown away by his playing and invited him to a barbecue at Stapleton's the next weekend. 'He asked what I did and I gave him a few albums and he was knocked out by them,' Stapleton says. 'He'd never heard anything quite like them before. He got the bug and wanted to do something immediately. His music was traditional folk before he met me and now his music is very influenced by me, he has taken the whole thing on. I got him a deal and helped

Tibet at home, early '90s, Tiny Tim shrine at left.

him as much as I can and the two collaborations have certainly put him up a notch or two.' Aranos grew up in Bohemia in the Czech Republic, performing in dissident theatre groups before fleeing to the West after the Russian invasion. He spent several years wandering through Europe gardening, teaching yoga and bottling booze before settling in the south of Ireland, where he met Maja Elliott. 'I first saw Petr busking on the street in Galway and was attracted by his smile and charisma,' she recalls. 'I used to pass him every evening when he was playing opposite the piano bar where I was also playing. I found him fascinating as a person. He had an amazing intellect and I could really share things with him, and soon I found myself falling in love. Through Petr, I met Chris and his partner Sarah, and through them Steve and Diana. Before I met Steve, I had heard tales about this enigmatic man and his experimental music. When I met him I was so impressed by his musicality and creativity. I love his house and his whole way of life.'

Aranos first worked with Nurse With Wound on 1996's *Who Can I Turn To Stereo*, the heavily rhythmic follow-up to *Rock'n Roll Station*.

'We recorded in a studio in Ennis,' Aranos remembers. 'I hadn't heard any of the music beforehand and so I asked Steve what he wanted me to do. He just said, start off slow and then get fiercer as you go along. I asked him what the record was supposed to be about and he told me it was about bicycles. There are these two guys having a normal conversation until one of them mentions bicycles and they both get really angry. I said, okay. While I was playing, I could see Steve in the control room, flapping his arms to tell me to go crazier. When it was finished I asked them if they wanted me to try again – I really had no idea what it was sounding like, to me it was just noise – but Steve said, no, it's great.' In the event, Stapleton held the track over for *Acts Of Senseless Beauty* (1997), where it appeared as 'A Window Of Possible Organic Development'. 'Steve is amazing to work with,' Aranos affirms. 'He has no ego about his music at all and has so many great ideas. When I finally got to hear *Chance Meeting*, I couldn't believe it. In twenty years no one has improved on it. It's frighteningly good.'

Credited to both Aranos and Nurse With Wound, *Acts Of Senseless Beauty* consummates their working partnership, with Aranos's stealthy violin negotiating a sea of sonic depth charges and machine gun rhythms. It's much closer to live duo improvisation than anything else in Stapleton's back catalogue. The last track is particularly evocative, with Aranos drawing little serrated melodies from his violin over nebulous clusters of gong tones. True to form, Stapleton can't resist puncturing the atmosphere with some cartoon humour. Once the track has faded into contemplative silence, he drops in some doctored dub that sounds like it was recorded on helium. By the time of their third collaboration, 2000's *Santoor Lena Bicycle*, Aranos reveals his firm grasp of the language and codes of free improvisation, matching Stapleton's sense-destroying jumpcuts with percussive twonks, scrabbly spider patterns and grinding offcolour drones. *Santoor Leena Bicycle* was a tie-in with the duo's exhibition – Stapleton's first ever – of collaborative paintings in The Town Hall Studio in Galway. The pair attacked a series of wooden doors with plumes of coloured paint, and after the exhibition was over they cut them into square segments to use as packaging for the CD.

Stapleton was now a magnet for anyone living in the west of Ireland who was interested in vaguely leftfield music. It was in this role that he met guitarist Peat Bog and his group The Inflatable Sideshow. Stapleton had long talked of cutting a record in the power trio style of his heroes Guru Guru. The Inflatable Sideshow turning up out of nowhere gave him the chance. When he got together with the group, he attempted to direct their jams towards the explosive zone first navigated by Guru Guru. After editing a clutch of improvisations, Stapleton and Peat Bog took the tapes over to Colin Potter, whose ICR studio was now based in The Water Tower outside Preston, a huge red brick structure that had been built in 1890 to supply water to the locals. 'At ICR we worked on putting individual 'songs' together from the jams,' Potter explains. 'We also created some new songs from samples, whose origins I couldn't possibly reveal. I think Steve wanted it to sound like a band playing but it's a pretty damn strange one.' The results were released in 1998 as *An Awkward Pause*. On 'Two Shaves And A Shine', Nurse sound like a slightly less cosmic Funkadelic, with a looping bass riff scissored into 93 sections, over which guitarist Peat Bog lets sparks fly. Tibet's vocals are hilarious, erupting with surreal couplets like 'And block out the sound of chicken's wails/defeathering them on beds of nails'. By way of contrast, the closing 'Mummer's Little Weeper' is one of Stapleton's most beautiful compositions. A heavenly slice of euphoric acid rock, it could be the comedown of one of Timothy Leary's jams with The Cosmic Couriers. For all its virtues, however, it wasn't quite the power trio record that Stapleton had in mind. He now describes that particular project as an 'after I'm dead' release.

In the wake of *The Inmost Light Trilogy*, much had changed in Tibet's life. Thanks to Degens's calming influence and her interest in yoga, he began to feel much more settled, and his interests were becoming more focused. His personal cosmology now consisted of equal parts Kierkegaard, Pascal, Stenbock, Ligotti and Wain. He was also starting to pare down his music. From its trilogy base through the number of musicians and the density of the text, *All The Pretty Little Horses* was the most complex Current record to date. By the time they had completed

the trilogy, both Cashmore and Tibet felt totally overwhelmed. 'I wanted to strip everything back and make the simplest and most evocative manifestation of what I really felt,' Tibet declares. 'I wanted to remove everything that I thought was extraneous. As I fell more and more in love with the things that really mattered to me, and as I fell more and more in love with Andria, I wanted to concentrate completely.' Stumbling across the phrase 'soft black stars' in Thomas Ligotti's short story 'Teatro Grottesco', Tibet immediately knew he'd found the title to launch his new phase. Out of a desire to make the album sound as different as possible, Tibet recorded the music in Ireland at Aranos's new studio, set up in the 19th Century cottage he was renting with Elliott in County Galway. But as soon as they arrived, the omens weren't good. On route to the cottage they passed a dead cat on the road, prompting Tibet to panic. To compound it all, an outbreak of parasites on Stapleton's farm had infested all of the bedclothes, causing Tibet, Degens, Cashmore and his then wife Yukia to rent a cottage further down the road and drive to and from the studio each day.

Both Tibet and Cashmore had envisioned an album that consisted simply of piano and vocal. It was down to Elliott, a concert-trained pianist, to transpose the parts Cashmore originally wrote for guitar. 'They wanted me to play as if I had stumbled across a neglected piano in an attic, tentatively bringing to life these lost melodies,' Elliott recalls. 'Nothing flashy or virtuoso, just very tender and sensitive.' Most of the tracks were based on straightforward ascending and descending, call and response themes, sometimes with a very simple chorus added on. They threw all the windows open when they recorded the piano parts, with Elliott playing along with the birds. Everyone was out sunbathing in the garden while Aranos laid down some experimental violin tracks. It was only when they took the backing tracks to Christoph Heemann's studio in Aachen, where they intended to do the vocals, that they decided to drop most of Aranos's contributions. 'The violin was excellent,' Tibet points out. 'He went for this primitive gypsy feel but when we started recording the vocals we realised that the violin was taking away from the simplicity of the album.' However, you can still hear it bleed through certain sections of the album.

Meditating on memory and time, the songs of *Soft Black Stars* are deep personal illuminations expressed in simple, clear poetics. Gone are the convoluted theology and the endless chains of reference that made *All The Pretty Little Horses* such a dense work. Here Tibet shed all his armour. The figure of Lazarus is central to his writing of this period. In 'Larkspur and Lazarus', he sings, 'If I could have one wish/ As in the fairy tales/I would unmake my past/And rise like Lazarus', and elsewhere he goes over in his mind all of the past that's set in stone. Tracks like the single, 'A Gothic Love Song', 'Mockingbird', and 'It Is Time, Only Time', consider the death of previous relationships. In one sense, the album asks much the same question that inspired 1986's *In Menstrual Night*: Where do dreams go when they die? Most harrowing is the final track, 'Judas As Black Moth': 'In the middle of the night/As the cats cry in the street/And the scent of flowers is heavy in your hair/The car sweeps by with the murdered child/ The car sweeps by with the violated girl/The car sweeps by with its

trunkful of death/What monsters we have become/What monsters we have become.'

The following March, Current 93 – now Christoph Heemann, Cashmore and Tibet – took *Soft Black Stars* to New York for a three night residency at Tonic, an intimate performance space with a solid reputation for presenting leftfield music. The concerts were Ticketmaster's fastest selling shows by a band they'd never heard of. For his part, Tibet wasn't in great shape. 'When I first met Tibet he seemed very nervous,' recalls Joseph Budenholzer, who auditioned to play piano at Current 93's Tonic shows, only for the group to settle on a piano-less line-up. 'We were trying to find a restaurant in New York and every one I took him to he'd find something he disliked about it and we were just wandering around for ages, passing up about twelve different places. He hated all my favourites before he even went in the door and Laura [Kraber, Budenholzer's then girlfriend] was starting to mutter under her breath about him. She thought he was creepy. Andria was in a really bad mood the whole time because she was running around behind Tibet trying to keep him from falling apart. I could tell she was walking on eggs thinking he was going to crack up. It was that rock star girlfriend co-dependency thing, where the guy's falling apart and the girl is trying to keep him together and it's just impossible. But as soon as we found a place he was willing to eat at, he became really charming. We got into this big debate and it really had a profound influence on me. We started getting into arguments and discussions about things like *The Night Porter*, all these counterculture sacred cows. I like a lot of that stuff but he was against all of it. He really made me think that perhaps I am just sort of following the counterculture party line and not really thinking about things too much. Then when dinner arrived he made the sign of the cross and started saying grace over dinner! He has obviously gone through this whole journey, starting off back when he was into a lot of dark magic stuff and eventually coming round to a whole different way of seeing things. Again it really struck me that I needed to think about my own connection to a lot of these things. Later when I was putting him into a cab he gave me a hug and kissed me on the lips. I now know that that's what he does but the first time he did

that I was like, what the hell is that? He was just totally disarming and nothing like I thought he would be.'

'The second night at Tonic was probably the most intense Current 93 show I've seen so far,' Heemann relates. 'It was Tibet's 39th birthday and everybody, including himself, was emotionally involved in it. A photographer from *New York Times* kept using his flash and Tibet is really sensitive to it, and he wanted him to go away. But he felt it was out of his power so eventually Andria had to get up and tell the photographer to stop. Tibet started crying onstage, he was just overwhelmed by the situation and he also seemed to be reexperiencing the feelings he had when he first wrote the lyrics. He was so close to his own words again. I think that's the best thing that can happen to a performer.' For the first two nights the support acts were Annie Anxiety and Jonathan Padgett, a ventriloquist who was a member of the Thomas Ligotti fan club. Tibet instructed him and his puppet, Reggie McRascall, to stick to traditional 1920s vaudeville material rather than play up to Current's audience, feeling that the performance would be all the more macabre for it. At the last of the Tonic shows, Tibet premiered one of his most evocative apocalyptic narratives, 'The Sea Horse Rears To Oblivion', dropped at the last moment from *Soft Black Stars* but finally issued as a limited edition 12" in November 2002. It was also later re-recorded for the Nature & Organisation album *Heather*. 'The lyric was very dense and very much in line with 'The Seven Seals...' on *Lucifer Over London*, and so I originally thought that it might gum up the album,' explains Tibet. 'I showed it to Mike before the Tonic shows and he suggested doing a really simple version of it, just using atmospheric, sweeping chords.'

Reviewing Current 93 in the *New York Times*, Ben Ratliff wrote, 'Current 93, a British Goth-folk band led by a thin charismatic poet named David Tibet, is a perfect little cultural operation. It has a small core of fans whose devotion runs shockingly deep; the group lies so safely and cosily within a nook of the underground rock economy that it is never exposed to attack or unrealistic sales expectations. And the band doesn't operate on anyone else's field: though it pumps out two albums a year, it doesn't play at festivals, it rarely gives interviews and it fulfils

a deep need among fans, who crave the mordant comfort of fantasising that the world is one great barren moor. On Friday when Mr Tibet took the stage in a colourful vest and closely cropped hair, accompanied by his guitarist, Michael Cashmore, the crowd fell deadly silent. Mr Tibet doesn't sing, but reads his poetry to the quiet accompaniment of acoustic guitar minor chords with a perfectly enunciating, lissome voice. His work is fixated on God and on blood, not blood like a horror film, but more metaphorically and with less gusto. He comes across as a perfect modern equivalent of a consumptive turn-of-the-Century poet turned drearily obsessed with his illness. He bent his knees and bobbed up and down a bit, quivering with feeling, declaiming lines like 'the great bloody and bruised veil of this world' and 'sell all you have/ give it to the kittens/and pour the milk on Louis's grave'. He was wide-eyed and unnervingly fragile and serious. Expanded later with a second guitarist and a violinist, the music became a heavily stylised relative of old English ballads.'

'When the *NY Times* described him as looking like a consumptive 19th Century poet, I thought it was really close to the mark,' Budenholzer remarks. 'But for me there was something even weirder going on. He was doing this thing where he bounces up and down so quickly that he was starting to blur. Combined with this 19th Century appearance, it was almost as if he wasn't quite in this dimension. It was like he was substantiating before us while performing. Laura was sitting with me and she has no reference for this stuff at all and was totally repelled by his performance. He was completely raw and perhaps that would put off someone who was expecting to be entertained. But I thought it was just incredible. I had goosebumps standing up on my arms. It was one of the most profound performances I've ever seen of anything. This was like a shamanic ritual we were watching, like seeing a ghost.'

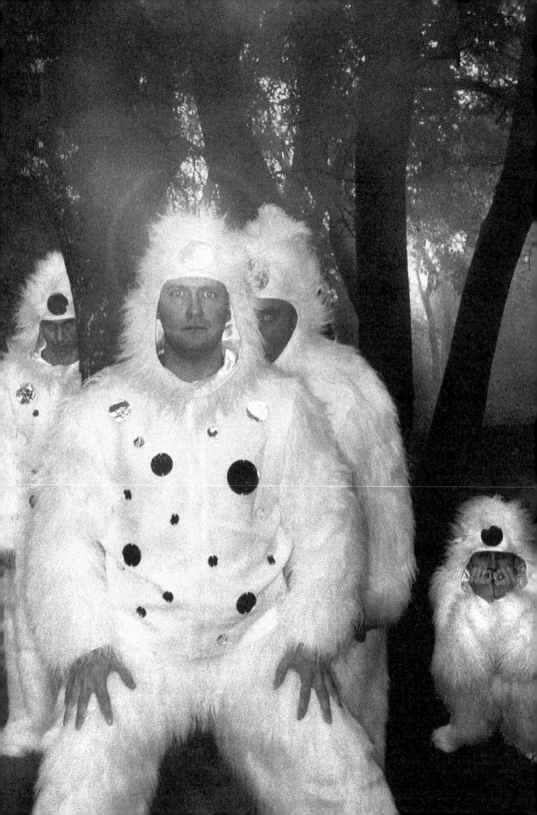

# Niemandswasser

*For as from our beginning we run through variety of Looks, before we come to consistent and settled Faces; so before our End, by sick and languishing Alterations, we put on new Visages: and in our Retreat to Earth, may fall upon such Looks which from community of seminal Originals were before latent in us.*
– Sir Thomas Browne

'To me the *Moon's Milk* records refer to immediate history somehow,' Sleazy says, looking back at that particularly concentrated period of work. 'I can't quite put my finger on what I mean by this but the context of them, the setting, seemed very much situated there. Black Light District as well. It seemed like they reflected on or almost came from a culture, like the track 'Lost Rivers Of London', that was a very Peter Ackroyd, secret London type of thing. Since then we seem to have moved much further backwards – and forwards.' Where the *Moon's Milk* tracks addressed the last two or three hundred years, if Coil refer to history at all since moving to the West country in 1998, it's in terms of millennia or centuries, like the Egyptian, Aztec and UFO imagery on *Astral Disaster*. Out on the coast, the spirits are much more primeval.

The first version of *Astral Disaster*, a limited edition of 99 LPs released on the Prescription label in 1999, was recorded the previous year in Suffolk, in Gary Ramon of Sun Dial's studio beneath the Thames level. It feels like a transitional record, with Coil preparing to leave London and already anticipating the new horizon. The second

version, completed after the move and made more widely available through Coil's own Threshold House label, appears to have stripped away the London thing. Having followed the moon out to the coast, Coil finally opened their drones to the skies. McDowall was involved in the first version of *Astral Disaster*, but after the move Thighpaulsandra, who also played with Spiritualized and Julian Cope, also came on board. Thighps was partly responsible for the shift in sound, bringing a new sci-fi edge to the production and encouraging Sleazy's love of over the top progressive keyboard sounds and analogue equipment.

'I bought *Horse Rotorvator* back when it was first released,' Thighps remembers. 'Once I discovered the track 'The Anal Staircase' it was 90mph all the way home and continuous play on my auto-changer for several weeks until I became completely sick of it. I never bought another Coil record again. When Balance made contact with me in 1996, I had no idea that we would have so much in common and that our fates would be so inextricably linked. Coil is a very comfortable group to be in. I am totally free to create the music I love and I am also able to channel Balance's exceptionally powerful energy and vision. Sleazy provides a buffer and a very stabilising influence. They are creative giants. Working in Coil both in concert and in the studio is always an invigorating experience and I consider myself very privileged.' However, he's quick to disassociate himself from any English esoteric tradition. 'I am a complete isolationist,' he declares. 'I have very little respect for the conventions of society and tradition and I'm constantly horrified by the poisoned semen of consumerism – the herd mentality of large parts of society and the bleak choices offered by governments and media. I would live free from the constraints of the calendar and as far away from other people as possible. Travelling in the UK is difficult as we have two centres of evil, London in the south and Leeds in the north. I try to avoid these areas at all costs.'

'Thighps was very important,' McDowall confirms. 'At the time Balance was getting really obsessed with Julian Cope as some kind of fellow traveller. Not necessarily about his music but just the fact that he was putting himself out there without any thought for whether he was making a spectacle of himself. Balance thought that was really

admirable. Thighps just brought this whole other dimension to Coil, a much more musical dimension. None of us were actually musicians and could really play anything. He also gave the whole thing a prog rock sensibility, which was really good.'

*Astral Disaster* is much more filmic than the *Moon's Milk* recordings, with epic tracks like 'The Mothership And The Fatherland' moving out into the kind of meditative soundspaces explored by German groups like Popol Vuh and Tangerine Dream. Balance claims it was partly an invocation of the lunar goddess Kate Bush. 'MU-UR', an extra track

Balance and Sleazy visit Aleister Crowley's Abbey Of Thelema
at Cefalù, Sicily, 1999.

added after the move, is a piece of genealogical gymnastics worthy of Julian Cope, conflating the legendary ancient continent of Mu with the prefix Ur meaning 'proto' in one great primeval grunt. The album's central track 'The Sea Priestess' features Balance reading a text mostly adapted from Aleister Crowley's descriptions of the wall murals he had painted in The Room Of Nightmares in his Abbey Of Thelema, which he founded in Cefalù, Sicily in 1920. These Crowley paintings first came to light when Kenneth Anger made a pilgrimage to Cefalù in the '50s and brought back a stunning series of photographs. Balance recites their titles like a litany. But when he and Sleazy visited the abbey in 1999, they found the murals in a state beyond repair. Still, Balance's refrain was prophetic: 'Do not lose sight of the sea.' They're now settled in a new house named Oak Bank nestled into the cliffs above the west coast of England, where they gaze out over the Bristol Channel and on towards the Atlantic. 'When we were looking for a place we thought that by the sea was the place to be and we thought of the alignment of the house, North to South,' Balance says. 'Here you see sunrise and you see the sunset. You see the procession of the seasons as the sun goes right round the peninsula.' Originally built as a boy's school in the 1850s, the house was perfect for Coil. It still had working elevators, along with a grand stone staircase that sweeps up to the first floor. In the 1930s Haile Selassie was billeted there for a short time.

With 1999's *Musick To Play In The Dark*, Coil continued their inexorable lunar drift. From the mysteries of London, back in time and out to the coast, Coil now began to map a new reality, something distant and unmistakably alien. Sleazy's covers unfurled the new landscapes they had set out to explore. 'That's partly us reacting to our environment and partly us stripping away the layers of immediate history and getting to something deeper,' Sleazy explains. 'The landscapes on those sleeves were in some ways references to other landscapes in history, Caspar David Friedrich for example. But at the same time they were designed to have that alien, otherworldly quality and have a sense of infinite space.'

'I think the move was vital to the changes they've introduced,' Steve Thrower speculates. 'I'm not sure it's as simple as the move causing

the changes though. I think they felt the need to move away from the rotten Metropolis and relocate in the country, and that knowledge of a need to move was the seed of their new work. Once they'd done it and bought this wonderful house overlooking the sea, they reaped the benefits they'd anticipated and their work entered a new phase. I'd say the two *Musick To Play In The Dark* albums have rejuvenated their artistic credibility. They resonate with a new kind of energy, a new lease of life. Balance has done something that's really difficult for a singer and that's to redefine his vocal persona, completely overhaul where he's coming from as a vocalist. The lyrical concerns aren't so much what's changed, it's the fact that he's found a new voice, in terms of timbre and phrasing he's at last found somewhere that sounds right for him.'

'I think that moving out of London affected them in many different ways,' McDowall adds. 'It gave them space to do what they want, but in a weird way it's really isolating and they collapse more into themselves. I

think you can hear that musically as well, but paradoxically it has given the music more space. I also think Balance gets bored and drinks more. It's very painful to see what he is doing to himself. But he was doing that in Chiswick anyway. Regardless of where he is, he is going to find a way to do it, and it's not like he is even having fun, it's fucking miserable. It could be really extremely painful working with Coil because of having to watch Balance destroy himself. I mean, we all had issues like that with chemical dependency or whatever, but Balance's problems were just so in your face. Most alcoholics exist in some kind of steady state where they maintain a level of drunkenness by topping themselves up every so often. But with Balance there would be really long periods where he was beyond hammered and it could get really ugly, with him just lying on the ground when we're trying to work, crying. It was really heartbreaking. He would get so drunk that he'd just lie there screaming and having tantrums because Sleazy had hid the booze and would be telling him

that he couldn't drink or have cocaine. So that's where a lot of the dark came from...'

Undoubtedly, the number of alcohol-related incidents increased after the move, peaking in a heart attack scare that saw Sleazy rush Balance to hospital. Luckily it was a false alarm. 'Balance had been very depressed, drinking lots again, deeply unhappy and self destructive,' Osisan Brown relates. 'He was balancing on cheese wire. It was an awful period. We usually talk pretty much every day, sometimes two or three times, but through this period he was getting hard to reach and hard to talk to.' During a particularly psychotic episode, Balance began to cut himself, bleeding all over several blank album sleeves that were later enterprisingly issued as a special 'trauma edition' of *Musick To Play In The Dark Volume Two*. 'An accumulation of events led to a serious breakdown and a massive panic attack,' Brown continues. 'Balance got taken to hospital and the doctors wanted to keep him in to run tests. They initially thought it was a heart attack but once they learned that it wasn't, they still wanted to keep him in for several days. It was a very black period not only for Balance but for Sleazy as well.' Yet Balance's identity is so intrinsically tied up with being an artist who works through autonomic states induced by sensory derangement, all the while firing back epistles from the other side, that it was impossible for him to renounce such hedonistic behaviour, even when it was threatening to destroy him.

Balance proposed one reading of the title of *Musick To Play In The Dark* to Ian Penman, in an interview in *The Wire*. 'When I was young I was really quite scared of the dark,' he explained. 'I think my parents taught me to be and I remember the deciding thing was, I turned around and said: I'm going to go to the woods at night and walk into the darkness and embrace it and if I die, I die. I remember doing that and... nothing happened. I suddenly thought: I now know fear of the dark is wrong. In fact, it's comforting. So at that point in my life I embraced – literally – the darkness. I mean, not in a sense of evil. I'm on a lifelong mission to get rid of this equation 'dark is evil and light is good'. It's all to do with discovering the point that we don't need lights. Light – illumination – comes from within the darkness, not from electrical lighting. I think

Christian based society's got that very wrong. They think that as soon as Britain's lit up, it'll be a safer place to live – if you can see it you can capture it, control it – and they're absolutely wrong. It's the other way around. If we plunged into the darkness everyone would be safe.'

Indeed, Balance's journey deep into the heart of the wood parallels that taken by many of the players in the post-Industrial underground. This initiatory approach to experience has been a recurrent theme through Coil's work, going as far back as 'Panic', their hymn to the God Pan, on *Scatology*. As Balance wrote in John Sanders and Mick Gaffney's *A Coil Magazine* in 1987: 'It's saying create a situation where fear is generated and use the vortex of negative energy to catapult yourself somewhere, to perform psychic surgery on yourself.' But the risks are high; stay there too long and you might never return. In this light, *Musick To Play In The Dark* becomes a soundtrack to the process. It opens with 'Are You Shivering?' The juddering cutup vocals that provide the rhythm were an attempt to recreate the teeth-chattering effect of a pure dose of MDMA, as the first euphoric fountains of silver shoot up your spine. Working with a preset synth sound that in lesser hands would sound ridiculously portentous, the keyboards are completely over the top. Here, somehow, it works. On much of the album, Sleazy rips little digital holes in the fabric of the music, allowing glimpses of the future to come through, in much the same way he let the past in throughout *Worship The Glitch*. 'Broccoli' features a rare vocal from Sleazy. Over a series of wraith-like vocal loops, he sweetly sings a set of Balance lyrics about 'greens and ancestor worship as revealed to me through spirit discourse with Austin Spare and my granddad (deceased)'. The greens in the title are held to contain sub-atomic secrets that help combat cancer. 'The Dreamer Is Still Asleep', meanwhile, is a call to the mythic warrior kings, buried beneath England's still sacred landscape. 'It's King Arthur,' Balance told Penman in *The Wire*. 'There's supposedly three lots of King Arthurs somewhere. What are they waiting for? Why wait? Britain needs them now!'

*Musick To Play In The Dark* was originally planned as a subscription-only album, with the intention of re-establishing Coil's database. They took 2,000 orders straight away. 'We always had quite a schizophrenic

approach to these kinds of things,' Christopherson confesses. 'On the one hand, as collectors – and Balance is one fullstop – he likes to have things that are unique and limited whereas I would prefer that the thing was available to anyone who wants them.' It was quickly reissued in a more widely available form.

In the wake of the re-release, McDowall split. 'By that time I had had enough with what we were doing really,' he sighs. 'I wasn't feeling it much any more.' He had moved to New York during the recording of *Musick To Play In The Dark*, making occasional trips back to the Coil house to finish things off. On his first visit back to London he met Paul Donnan, who gave him a bottle of liquid opium as a present. 'So I would be unconscious every day,' he laughs. 'I'd wake up at night, take enough opium to make it interesting and then go to work on *Volume One* without any reference to what Balance and Sleazy were doing. Our sleep schedules were totally out of synch with each other. I would just work on stuff with the computer program, tweaking a tiny piece of sound all night long, and I'd leave all these audio files on their hard drive for them to use during the day. I had no idea what it actually sounded like until they sent me a copy. I felt the sessions were really fractured and it was

definitely our least collaborative record. But Thighps came in and gave it a lot of the musicality that it has.'

The trio of Balance, Sleazy and Thighpaulsandra completed *Volume Two*. It has its highlights – 'Something', 'Tiny Golden Books' and 'Paranoid Inlay' – but it feels a bit like an afterthought to the first instalment's thorough mapping of the territory, like they've simply creep-crawled the landscape. Talk of a third volume was soon dropped when they began to feel uncomfortable about working in the shadow of what had gone before. Instead they launched a series of limited CDs – *Queens Of The Circulating Library*, *Constant Shallowness Leads To Evil*, *The Remote Viewer* – intended as notes and rough sketches for Coil performances deploying electronics that weren't pre-programmed or sequenced. 'The process of making sound with analogue equipment, where you actually have to turn the knob to get the sound to change seemed more visceral and more present and something we were able to do because we don't play keyboards in the conventional sense,' Sleazy explains. Although Coil had been talking of playing live since McDowall joined the group, they simply had no idea how to go about it. But with Thighps on board,

he brought all of his experience and all of the contacts that he had built up while touring with Spiritualized and Julian Cope. For the first time Coil live was a real possibility.

'Still, we wouldn't have done it if we hadn't been prepared to be convinced,' Sleazy counters. 'A lot of the technology had come a long way since the '80s, so it was possible to do stuff that had a spontaneous element but also had an element that could be relied upon to function even if we couldn't. Another thing was that now we had the ability to produce images on the screen that were synchronised with what we had in our heads. More than just that; I was sufficiently experienced and Balance was sufficiently visionary that we could come up with these things and be able to afford to do them. Only recently is it possible to do them and not have them look like a matte black video with footage of driving through Tokyo or something similarly uninteresting. There are even more pitfalls and more need for taste when it comes to projections and light shows than there is in the music, because there are more crap things you can do. It's a question of exercising vision and taste, and the same process that goes into computer manipulation of sound goes into computer manipulation of picture. Only in the last two or three years has the software become available to do that.'

Coil's first two live appearances were at Julian Cope's Cornucopea event on 2 April 2000 at London's Royal Festival Hall, and at Barcelona's Sonar festival on 17 June, where they were billed as Time Machines. Debuting a piece called 'The Industrial Use Of Semen Will Revolutionise The Human Race', the trio were joined, at last, by new member Ossian Brown. They looked fantastic, decked out in furry white space suits designed by Nichola Bowery and David Cabaret that made them look like a cross between Wombles and Eskimos. 'I've greatly enjoyed the London gigs,' Thrower admits. 'It's good to see them making a success of something that I always thought should have been part of the Coil entity. The best moment was at the London Time Machines concert when they came onstage for the very first time dressed in those weird furry suits. The audience were holding their breath and there was a palpable tension as people waited to see how Coil were going to present

themselves after such a long period denying live performance. They walked onstage slowly and there were a few nervous titters – you felt the response could go either way. It looked either ridiculously pretentious and portentous or extremely weird and exciting. Just as you feared the former view was going to prevail, they gathered together in a circle and hugged each other like huge furry toddlers. The audience laughed; there was a strong feeling of relief that the moment had been snatched from the jaws of embarrassment by this gesture of humour and vulnerability. From then on they had the audience in the palm of their hairy little paws!'

At Sonar they were joined by William Breeze, and they began to work up what would become a staple of most of their live shows, a semi-improvised piece entitled 'The Universe Is A Haunted House'. Before the show they met composer Karlheinz Stockhausen, who was opening the event. 'The Coil boys, particularly Thighpaulsandra, were really excited and a bit in awe of him, I think,' Breeze relates. 'Thighps is a serious student of his work, and while Sleazy denied any conscious tribute with some of the recent analogue stuff, like the second half of 'A White Rainbow', I think he would acknowledge the influence – nobody

Coil with Karlheinz Stockhausen, Barcelona, 2000. (photo William Breeze)

doing serious electronic work can escape Stockhausen's influence. I just said hello during intermission and asked the boys if they'd like to be introduced after the show. He enjoyed the attention. They got on very well, and he seemed to know who Coil were. He hadn't heard any CDs but most probably had noticed that Coil was more or less at the top of the bill in that year's Sonar, and we were described as electronic in the programme. On an impulse – and more than half in fun – I asked him if he'd care to be an honorary member of Coil, explaining that Coil were one of the earliest serious experimental electronic bands, that he was an influence on all of us in different ways, and that it might be fruitful to collaborate sometime in the future. This is a bit like a touring English string quartet asking Beethoven to be an honorary member in the early 19th Century, I suppose – many people are not fully aware of Stockhausen's standing among living German composers but it is comparable. The implied humour wasn't lost on him, nor was the intent to honour him, and he accepted immediately, delightedly, asking

*Time Machines* at the Royal Festival Hall, London, 2000. (photo Johnny Volcano / *The Wire*)

Sleazy questions about his synth techniques. I think Balance explained the Time Machines project to him, which he approved of. Finally, he asked for CDs and invited us to visit in Küerten. I took a group photo to commemorate the occasion. I think that Balance was a bit surprised by all this, but he understood it. While most people don't really understand the isolation composers work within, Balance certainly does. I sensed that Stockhausen is at that stage of his life where he is enjoying being lionised – belatedly in some countries – and is up for some fun. His critical reputation is certainly secure and as I remarked to Sleazy, we could certainly do better by him than Spooky Tooth did in their collaborations with Pierre Henri.'

'Every night is very different live,' Brown elaborates. 'In Leipzig, for instance, we came on stage and immediately felt very calm and focused, whereas there have been other times where we've felt very aggressive. It becomes quite otherworldly. You're trying to communicate on so many different levels with as many different senses as you can. You're at pains

just thinking what kind of incense to burn. Your whole mannerism colours and projects the sound in different ways. There's a feel of purging, of cleaning. I remember coming off after the first Festival Hall show and I just felt like a wreck. I burst into tears after the second one.' For their second London Royal Festival Hall appearance in September 2000, the Coil stage set now resembled Bedlam. The group wore open straitjackets, with fake cuts and bruises visible beneath them. In Balance's case, the injuries were real. A drunken incident left him with a spectacular black eye. Dangling rows of bare light bulbs illuminated the stage. Balance's onstage persona was growing ever more delinquent, his arms flailing at invisible insects as he stomped around. This was the first of the 'Constant Shallowness Leads To Evil' shows, an attempt at total sensory overload with flesh-penetrating electronics and a light show that peaked with the repeatedly flashed plea of 'God Please Fuck My Mind For Good', a phrase lifted from Captain Beefheart's 'Making Love To A Vampire With A Monkey On My Knee'.

'Constant shallowness does lead to evil,' Balance affirms. 'I truly believe it. It was a point in time when I'd had enough of the newspapers and I thought the volume of information I'm receiving from these does not equal the effort. I think the whole society is suffering because these things exist. The same with nearly all the music magazines. They no longer deliver information. Now it's more like copies of what they remember it used to be like. It's a facsimile of itself. Everything feels really Karaoke now, everything. It's celebrity versus integrity and individuality, really quite a horrifying spectacle to be immersed in it. I have to monitor the evil as well, which means I will buy glossy mags – pure evil – yet I'm attracted to it, an updating of the good angel/bad angel; buy *World Of Interiors*, don't buy *World Of Interiors*.'

'I don't know if this is to do with us or the decay of everything else,' Sleazy adds. 'But it seemed to us when we were in London that the values espoused by a lot of that culture had some value and since we moved here it's become much less so. It seems the values espoused by *The Sunday Telegraph* or even sensible papers like *The Guardian* or *The*

*Independent* have become more facile and less important. I don't know to what extent that's a function of how we've changed but I even let my subscription to *Wallpaper* lapse!' 'Consumer patterns in London are survival patterns,' Balance maintains. 'They'll buy a magazine to survive the tube journey or compensate for the fact they've had a shitty day and they're all survival. Even up to the level of Damien Hirst's paintings – they're just cultural pacifiers. When the baby starts crying just shove a Hirst painting in its mouth. Keep it quiet for a while.'

Further tours witnessed Coil fuck with the blueprint even more. For Balance and Sleazy, it felt like a second coming, with the pair rebirthed as travelling exorcists. They followed the 'Shallowness' tour with a series of shows called 'Anarchadia'. With Thighps out of the picture due to his other commitments, the group now featured Cliff Stapleton on hurdy gurdy and Mike York on Breton pipes. The sound was huge, with churning Cro-Magnon rhythms and walls of oscillating tones that brought to mind minimalist composer Terry Riley's all-night flights. The music was damp, dark and full of earth mystery, combining contemporary improvisations with wildcards from their back catalogue.

With the return to the fold of Thighps they reverted back to irregular programming. Psyched-up over their successful re-invention as a live group, they planned their biggest European tour to date for October 2002. Accompanied by Piers and Massimo, a pair of male dancers that they'd picked up in a German brothel, they went out on the road for almost three weeks. But the longer they were away, the weaker the broadcasts became. 'We did maybe three shows that we were very happy with,' Brown acknowledges. 'Gdansk, Stockholm and Prague. In Stockholm we played at the Fylkingen which had much more of a Cabaret-on-Ketamine mood, more melancholy.' They even made use of the venue's grand piano, accompanied by an old modular Buchla synth, for their cover of Sonny Bono's 'Bang Bang'. The rest of the short set drew on what Brown describes as the 'stranger, more skeletal pieces' like 'Are You Shivering?' and 'The Universe Is A Haunted House'. 'Gdansk was in a beautiful old gutted church,' he continues. 'We had some problems there with the organisers worrying about the content of the show. They were petrified that we might have male nudity, as

the Church still owns the building and was loaning it to them for art performances with Catholic provisos. In other words, if we upset them with anything at all blasphemous or disrespectful, the promoters would no longer be able to use the venue and would have to move. The Church is still very strong there and it's quite baffling as to why they'd ask Coil to perform, knowing what we're like. Anyway, Piers and Massimo ended up performing with their genitals wrapped in Clingfilm. Just as pretty, I thought. We were very pleased with how 'The Universe Is A Haunted House' gained form throughout the tour, it's an interesting and new way for us to compose by improvisation, gradually developing an idea from night to night. It ended up being quite a complex piece and maybe one of the most enjoyable to play, Sleazy created new rhythm loops while Thighps and I wrote new sounds and piano pieces, and Balance got into his 'I've got liquid LSD in my eyes' mantra.'

On a personal level, the tour was far from easy. Balance's drinking problem had returned with a vengeance, and for most of the three weeks he was swimming in alcohol. In addition, the rate at which they'd been consuming ideas had turned on them, with the group becoming increasingly consumed by their ideas and in the process losing much

of their spontaneity. No sooner had they reinvented themselves as a touring group than they announced they were giving it up at a specially convened 'lecture' the day after their Vienna show. Balance didn't even make the announcement. 'Although there were definitely some good shows, we left it behind feeling quite dispirited,' Brown sighs. 'In the future Coil will only be performing one-off concerts. I really don't think we're suited for touring and benefit far more from having the time to concentrate on one-off special events, both sonically and visually, and in terms of morale. Personally, I think when we perform so many shows next to one another, it feels like the magick we can generate becomes more diluted, only occasionally pulling focus again and creating a psychic environmental change, a place out of time. The repetition that's inherent to touring is too vampiric, the possibility of the otherworldly diminishes due to tiredness, and the specialness is in danger of becoming more pedestrian.'

Tibet's father Cyril hadn't been well for some time when he finally got the phone call that he had died just after he had turned 75. Ironically, at the moment he died, Tibet had been in town buying a mobile phone so he could be updated at any time about his father's condition. He had smoked all his life and finally developed emphysema. During his last few months, he was in and out of hospital suffering from oxygen starvation. 'It was odd when it finally happened,' Tibet relates. 'I always loved my father but because I was in boarding school and he was often away working, I can't say I ever really knew him. It wasn't as if I spent a lot of time with him, so it wasn't that I missed seeing him or speaking to him regularly. When I spoke to him on the phone he would often say 'Hi Dave, here's mum' and just pass me over. Sometimes I still expect him to pick the phone up. I still think he's gone to God and that's how I felt at the time. Just because a person is no longer there in the physical form, it doesn't mean that they're not there at all. They're there in a different sense, it's not a tactile sense, it's a subtle sense. After he passed, I was looking for the [Chinese] death money that I later used for the cover of *Sleep Has His House*. I had 140 of them somewhere and was desperate to find them, but I couldn't and suddenly a voice in my head just said,

417

'They're under that pile of comics beside that green plastic folder'. I looked and they were there, where my father said they were.'

Dedicated to the memory of Tibet's father, Current 93's 2000 album *Sleep Has His House* ran a photograph of him on the inner sleeve posing in a parachute after a test flight. He looks uncannily like his son. Although the album wasn't solely about Tibet coming to terms with his father's death, his presence is all over it. The title track is a hypnotic elegy that lists all of the stations of his father's life, and he crops up in more coded form elsewhere. In 'Good Morning Great Moloch', he appears as the 'Bloodfather' and in 'Immortal Bird', named after a ghost story by HR Wakefield, lines like 'I left something of myself in you' refer to their relationship. In 'The Magical Bird In The Magical Woods', Tibet conjures some of his last memories of Malaysia, playing at his father's tin mine, where he 'saw the metal buckets/Fatigued and buckled/With nimbus of rustflowers/In sheds by the lake/I was already falling and fallen and lost/And it was not at your cost...'

The track 'Niemandswasser', literally 'No Man's Water', was initially inspired by a short story by Robert Aickman, whose *Collected Strange Stories* Tibet republished in partnership with Tartarus Press. In Aickman's story, Niemandswasser is a patch of water of immeasurable depth that exists unsurveyed and unmapped outside the boundaries of any state. Occasionally half-familiar ghost ships are seen coursing across it. Rumour has it that if you cross it as your life is due to end, even on a calm night, you are taken forever. In Tibet's reading, his father has crossed over the water, and his son asks him to 'wait for me at Niemandswasser/As I watch the flowers bloom/And trail the horseflies as they scream/The songs we'll never know/It shines: That we're all dust, It shines: We're all dust, We're all dust...'

Recorded at Colin Potter's studio, the album was assembled around the sound of the Indian harmonium, mostly played by Cashmore, while Tibet crouched on the floor and pumped it. Stapleton's fairly straight mix allows Tibet's vocal to dictate the atmosphere. Indeed, the album features some of his most affecting performances, especially on 'The Magical Bird In The Magical Wood', where you can hear his voice crack with emotion. But Cashmore feels that the album was released before

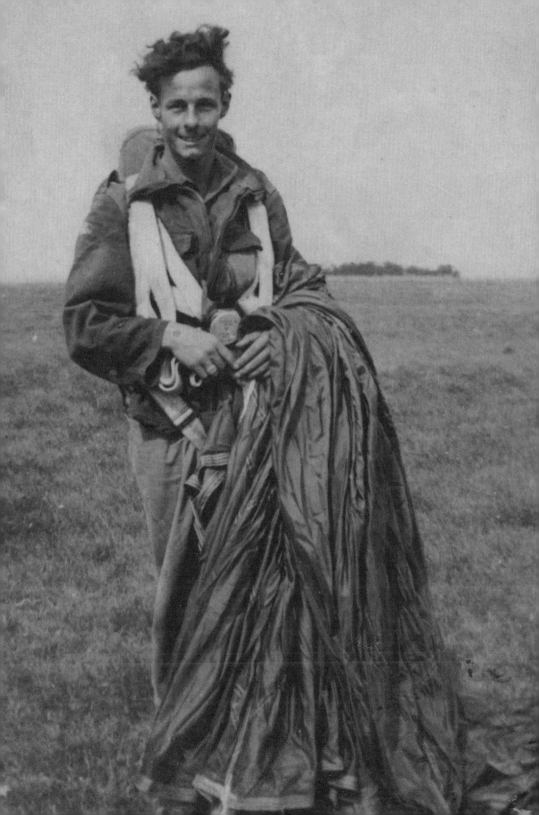

it was properly finished. 'He's probably right,' Tibet agrees. 'Perhaps we could have made it more subtle and given it a bit more shade and light, but in the wake of my father's death I just wanted it to be finished. I didn't want anything more to do with it really. I think it is a really powerful work but even looking at the sleeve now makes me feel low. It was the album I had to do at the time, but I don't think I could ever do any of the material live again. It's a very sad album and I still can't bear listening to it.' Yet the track 'Sleep Has His House' has undergone a live re-invention. Over the two nights that Current played at St Olave's Church in the City Of London in April 2002, it became the focus of the set, with Maja Elliott's piano replacing the harmonium and tracking Tibet's vocal in the build-up to a powerful crescendo.

In the wake of *Sleep* Tibet once again fell into the kind of emptiness that always beset him after completing a big project. He began to paint again, this time pictures of cats giving birth. He also started a series of obsessively detailed text pieces, where layer upon layer of calligraphic loops blurred into indistinct shapes. He completed several over the space of a few months, giving them titles like 'It is finished' and 'In the beginning, sovereign, was the word'. One Sunday in August, Tibet was sitting in Degens's study, having a beer and eating olives, when he began to feel unwell. As the afternoon progressed, his legs became increasingly uncomfortable and his stomach started to bloat. He found he was unable to urinate or defecate. That night the pain became so bad that Degens woke to find Tibet lying on the floor of the library massaging his stomach with an electrical sander wrapped in a cloth. She immediately took him down to the Accident & Emergency ward at Whipps Cross in East London. By the time the doctors got to see him, he was vomiting small brown grains that looked like dried blood. 'I was starting to hallucinate,' Tibet recalls. 'But I was trying to be lucid and keep control, and then this woman surgeon asked me what was wrong and I pointed down to my stomach and said, it's here. She sort of tapped around a bit and asked me if I'd been to the toilet, looked in the bucket and saw what I'd been throwing up and said – peritonitis, operate immediately!'

Tibet was wheeled straight through to the operating theatre clutching an icon of St Panteleimon. As he disappeared on the trolley he asked

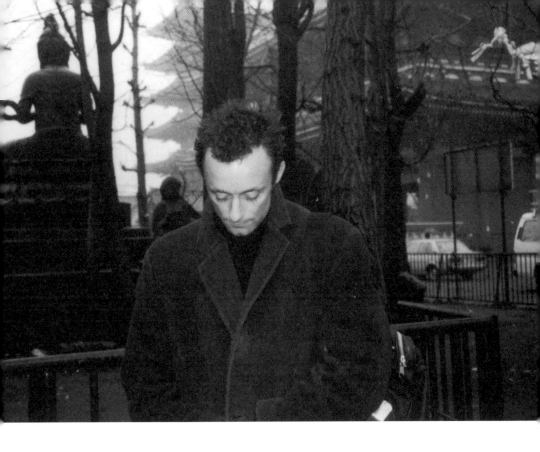

Degens if she would marry him if he came through. She said yes. The operation lasted five hours. As they wheeled him back to the ward, he was aware of a faint buzzing in his ears. Looking up, he thought he could see a swarm of tiny black helicopters swooping after him. 'They followed me back to the ward,' Tibet maintains. 'I was immediately put on epidural morphine. I was still in a hallucinatory state but it was a lot more pleasant because of the morphine.' All of the men on Tibet's ward were gravely ill and every night he struggled to sleep through a chorus of moans and cries. A few beds away was a man who Tibet believed had been taken over by the spirit of his father, an ex-serviceman who woke the ward with the repeated cry, 'What brave men they were!' In the middle of the night one of the men started choking on the mucus in his lungs. All day he had repeatedly pulled the tubes from his nose and throat, to the point where one of his fellow patients screamed at him 'Are you a man or a mouse?' He died that morning, and as soon as

the nurses had wheeled away their equipment, Tibet saw the Angel of Death, Samael, descend through the ceiling.

'I literally saw it,' Tibet claims. 'It was like a shaft of decadent purple light. It wasn't a figure, it didn't have a face but it had a dynamic. It came from the ceiling in a diagonal slant and went straight down. For a brief moment it was stretching from the side of the bed to the ceiling, but then it closed in on itself and disappeared, leaving a big black cube, which to me had the quality we read about of black holes. It felt like it was made of ultra-lead and it was sucking in energy all around. I was told, and I don't know how, that this was the psychopomp. The Angel of Death had come down but he doesn't take the soul, he leaves the psychopomp to guide the soul. It's interesting because in many cultures they say the soul remains in the body for several days. Obviously some people will say I was still on morphine. But I was very clear, I was lucid. What I found happened with the morphine was that when I was injected with it, I would have this most wonderful journey, but not for long. You very quickly come out of the hallucinatory part while the painkilling quality remains. The visitation happened about three in the morning, long after they'd topped up my epidural with the morphine. I was in some pain but I was aware of what was happening.'

Arguably every Current 93 and Nurse With Wound album is a collaboration of some sort, so closely entwined have the two groups become. But 2001's *Bright Yellow Moon* – Tibet's attempt to come to terms with his near death experience – was the first to be billed as a *genuinely* joint project between the two groups. Whereas before, Stapleton's role in Current 93 had been to simply illuminate Tibet's crepuscular musings, here he blows them open with a hallucinatory soundtrack that exaggerates and distorts Tibet's terrible visions. The opening 'Butterfly Drops' harks back to the troubadour stylings of *Of Ruine Or Some Blazing Starre*, with nothing but Michael Cashmore's skeletal guitar to light the way before Stapleton sounds the last expirations of a huge iron lung and Tibet starts his slow narration. Some of the old vocal hysteria is gone, like he's now speaking from somewhere else, somewhere far away. 'You thought you were listening to the radio at night,' he whispers. The 17 minute 'Disintegrate Blur

36 page 03' dominating the album is a slow procession all aglow in artificial light, led by the percussive clank of water pipes deep in the hospital's bowels. Tibet's gorgeous, half sung refrain coils through the track in slow motion, as it unfurls a litany of everything that suffers and is lost. But Stapleton has the most fun with 'Mothering Sunday (Legion Legion)' where he runs an almost slapstick cut and spliced soundtrack full of shattering glass, ominous footsteps and the pomp of marching bands beneath Tibet's account of the fevers of the ward's various patients – 'all nothings drifting through'.

'Nichts' is a torrential wall of white noise which masks the deranged ranting of a blues preacher and slowly gives way to 'Die, Flip Or Go To India', a jolting change of perspective that highlights the eerie artificial silence of the ward, occasionally punctuated by the metallic ring of surgical instruments and the slurp of tubes. It ends in the melancholy beauty of the largely acoustic 'Walking Like Shadow', where Tibet laments the fact that in the end nothing, not even death's continuous rushing-toward, is enough to melt our hearts and wake the sleeping.

In October 2002 I asked Tibet what he took from the experience. 'The fact that we're all going to die,' he responded. 'The fact that we're all going to be judged. Before I went in there it was just a theoretical idea, people don't really think they're going to die. We are going to die. Anytime. We will be judged and we will be taken to that seat of judgement, and there are angelic forms surrounding us everywhere, and there are demonic forms surrounding us everywhere. That the world is a trans-dimensional battleground and that the final battleground is the divine against the satanic.' An odd thing happened while he was in hospital, he relates. 'Do you remember those little toy eggs that you could buy? Little yellow eggs that spin around faster and faster until finally they open like a flower to reveal a baby chicken. In hospital I actually started making a list of all the things I was going to do when I got out, ways to get away from the less important things in life, things that I didn't need, things that shouldn't matter. Then one day I was lying in hospital, I was looking up at the ceiling, having theoretically purged myself of all the

things I no longer needed, and in a similar way to the way I saw the Angel of Death, I saw one of those little yellow shells starting to slow down and close itself up again. I saw old habits and old structures closing in once more and manifesting themselves as an Imperium over me. I couldn't think what to do to stop them. Then – bang! I was closed again.'

*Afterword:*

*Will He Wake In Time To Catch The Sunset?*

Re-reading *England's Hidden Reverse* I'm struck in particular by a comment that John Balance made when describing the kind of exploratory, off the wall behaviour of the artists and musicians associated with 1983's Equinox Event in London. 'It was a very nihilistic little group of people,' he says. 'Yet we've all developed and changed and our creativity has been very long-lived when it could have gone the other way and everyone could just have committed suicide.'

Balance died after a drunken fall from the balcony of the stone staircase of the house he shared with Peter 'Sleazy' Christopherson in Weston-super-Mare on 13 November 2004. As Christopherson recounted afterwards:

On the early evening of November 13th 2004, Jhonn and I were at home. Jhonn had been in the oblivion of vodka for a couple of weeks although that day he had eaten some soup and had a bath and was not quite as insensible as he had been. I was watching TV (*The Adventures of Sherlock Holmes*) when I heard a noise in the hall. Jhonn was lying face down on the wooden floor breathing noisily. He was deeply unconscious. Apparently he had tipped over the banisters and fallen some 12ft to the floor below onto his head. I called the ambulance and they were at the house in 7 minutes. Jhonn was rushed to hospital,

but despite the best efforts of the doctors in A&E, he did not regain consciousness. His condition deteriorated over the next few hours, and at 9.20pm he was pronounced dead.

Balance's drinking had been out of control for some time. He would spend weeks alone, sopping drunk, locked up in his room. When I visited Balance and Sleazy at their home for a weekend of interviews in 2002 Balance had his arm in a sling after a drunken fall while cruising the seafront in the dark. Cosey Fanni Tutti believes that it was the move to Weston that accelerated his demise, half crazy with boredom and cut off from the energy of London that he needed but that he had come to despise. 'That was a depressing place to live,' she told me when I interviewed her and Chris Carter in January 2015. 'Weston is all retirees and bored young people. That's why it has such a bad drug problem. Balance should never have left London. He was bored out of his mind there. Sleazy could always occupy himself but Balance needed stimulation. I think the move to Weston was what killed him in the end.'

Cosey also suggested that Balance had begun playing to a false image of himself; one that the cult of Coil as cosmonauts of inner space had served to fix. 'It's also that self-loathing thing Balance had,' Cosey insisted. 'He knew that his behaviour was self-destructive but he kept on doing it. He used to ring me up when he was drunk and it wasn't euphoric phone calls. One of the saddest things was when Balance was on this hedonistic road to hell and he said to me, 'Look, but our fans expect it of me now.' I said to him, 'You simply cannot accept that. This is your life, you cannot hand it over. You cannot accept that people want to look at you and watch a train wreck to the point of crashing.' But it is hard, because it's all wrapped up in who you think you are and who you have become by way of what you do.'

At Weston Balance would spend afternoons in his pyjamas watching *Ready Steady Cook*. One morning I watched as he opened a parcel that contained a first edition copy of a rare book by the shamanic poet Vachel Lindsay. After a desultory flick through it he tossed it onto the floor where it slid behind a pair of curtains. I remember thinking it would probably never be retrieved.

When I last saw him, at the signing event for the first edition of this book in London, he looked almost unrecognisable, dressed in nothing but a brown monk's cowl, a huge, outgrown beard, his skin a sickly grey. And while it's tempting to say that in the end perhaps Balance was overwhelmed by the nihilism that he identified in the scene, that he wasn't able to channel it elsewhere, it feels too simplistically prophetic.

Both Balance and Sleazy, who passed away peacefully in his sleep six years later, on the 25 November 2010 in his adopted home of Bangkok, shared a lifelong commitment to a systematic investigation of the extremes, to going as far as they could, into altered states, into new ways of framing reality, and reporting back with their findings. That was Coil's true mission.

I recall a radio discussion shortly after the death from alcohol abuse of the footballer George Best in 2005. Tony Wilson of Factory Records was on the panel and while everyone insisted that his death was a tragedy, the result of the crippling illness of alcoholism, Wilson refused this simplistic reading in favour of celebrating the way he had lived. I can never remember exactly what he said but it sticks in my mind, or perhaps I misremember it, as being something like, he had his own way of going and he went, which in turn makes me think of the magickal idea of the God that goes, of the ankh as a pictogram of a sandal and of Balance's own going; up, further back, and faster. Still, I've yet to meet a self-described practicing magician who was able to secure even his own most basic happiness.

In many ways Balance's death – which took place just after the first edition of this book left off – marked the end of The Reverse or more properly its switch into forward gear as it hurtled towards some kind of backwards resolution.

David Tibet and Current 93, meanwhile, made a concerted attempt to step out of the underground and into the mainstream, with a broad series of collaborations involving country singers Rickie Lee Jones and Will Oldham through Ben Chasny of free folk group Six Organs Of Admittance, English avant-psych legend Simon Finn, saxophonist John Zorn and porn star Sasha Grey. If the collaborations weren't always successful, this period did produce some gems of its own: the beautiful

'Passenger Aleph In Name', on 2010's *Baalstorm, Sing Omega* hints at the hallucinatory patripassianist song of *All The Pretty Little Horses*, while his 'tribute' to John Balance, Myrninerest's 2012 album, *'Jhonn,' Uttered Babylon*, was bolstered by guitarist James Blackshaw's inspired steel string settings. But nothing matched the inviolable beauty and otherworldly appeal of the recordings he made with core collaborators Michael Cashmore and Steven Stapleton in the early-to-mid 90s.

Indeed, even Stapleton seemed to make a deliberate move out of the shadows, reinventing Nurse With Wound as the kind of live behemoth you always imagined the original Faust might have been while going through a creatively accelerated though qualitatively varied string of releases, from throwaway collaborations with Faust themselves, Andrew

Liles and Larsen to startling one-offs like the eerie series of 'Shipwreck Radio' broadcasts made by Stapleton and Colin Potter while in residence in Lofoten, Norway in 2004 or the inspired homage to kosmische krautrock that he made with Diana Rogerson under the name A Bad Diana, 2007's *The Lights Are On But No-One's Home*.

And in the shadow of Balance's death the reformation of Throbbing Gristle in 2003 – the one group you thought you could rely on to stay dead finally succumbing to the culture of nostalgia – seemed to mark the ultimate reorientation of The Reverse towards the future.

Coil's 'final' album, 2005's *The Ape Of Naples*, at first seemed like an ill-fitting memorial, a half-completed mish-mash of ideas that struggled to bear the weight of Balance's passing. It was only when it was united with its twin, *The New Backwards*, the final version of the uncompleted album that hangs over the bulk of Coil's back catalogue, that it finally made sense. Issued as a deluxe vinyl box set by the American Important label in 2008, it mixes timelines with such hallucinatory *élan* that it feels like a beginning as much as an ending. Indeed, Christopherson's memorial to his late partner, 'Going Up', may well be the most perfectly realised confluence of all of the various strands that made Coil's music so singular and magickal; its creative usurping of consensual reality; its obsessive queering; its otherworldly beauty; its sense of memorial for the future. Using a radically re-arranged version of the theme from notorious British comedy sitcom *Are You Being Served?* overlaid with a haunting out-of-focus impromptu version from Balance's final live performance it manages to be profoundly moving and serious without ever surrendering its sense of camp.

Ultimately, *England's Hidden Reverse* is a document of a group of extraordinary people through a moment in time that briefly pointed somewhere else. As a cultural moment it proved impossible to sustain. It will come again, one day, from out of the past, I'm sure. But for now, the dreamer is asleep.

David Keenan, Glasgow, 2016.

*Acknowledgements:* Strange Attractor Press would like to thank the following for their time, energy and contributions to this new edition of England's Hidden Reverse: Richard Bancroft, Ruth Bayer, Richard Bellia, Vicki Bennett, Alex Binnie, Chris Bohn, William Breeze, Ossian Brown, Elijah Burgher, Chris Carter, Geoff Cox, Michel Faber, Clive Graham, Alexander Hallag, John Hirschhorn-Smith, Paul Hurst, William Fowler, Christine Glover, David Keenan, Tony Herrington, Johan Kugelberg and Boo Hooray, Ian Johnstone, Andrew Lahman, Mark Lally, Claus Laufenburg, Thomas Ligotti, Andrew Liles, Drew McDowall, Daniel Mckiernon, Antal Nemeth, José Pacheco, Rosemary Pardoe, Ivan Pavlov, Robin Rimbaud, Gavin Semple, Steven Stapleton, Matthew Levi Stevens, Andrew Thomas, David Tibet, Thighpaulsandra, Stephen Thrower, Mark Titchner, Cosey Fanni Tutti, Mark Valentine, Jordi Valls, Petr Vastal, Adam Vavrick, Johnny Volcano, Lawrence Watson, Jill Westwood, Michael York, Keiko Yoshida. The Coil, Current 93 and Nurse With Wound Facebook groups have all also been most helpful.

*We would like to commemorate those who aren't here to see this new edition:* John Balance, Peter Christopherson, Ian Johnstone, John Murphy. *This book is dedicated to them.*

*Image Credits:* Images on the following pages were either taken by or contributed by: James Barraclough: 106. RM Bancroft: 246. Ruth Bayer: 63, 66, 204, 212, 213, 234, 237, 238, 249, 250/251, 280, 293, 349. Richard Bellia: 168. Vicki Bennett: 304, 409, 415. William Breeze: 372, 410. Ossian Brown: 22, 23, 24, 25, 30, 33, 62, 94, 97, 99, 114, 115, 116 145, 164, 182, 197, 227, 282, 290, 292, 301, 302, 314, 356, 366, 374, 377, 396, 399, 400, 402, 403, 406, 407, 410, 413, 416, 449. Danielle Dax: 110. Amanda Fisher: 372. Lesley Happe: 89. Clive Graham: 210. John Hirschhorn-Smith: 36, 37. Ian Johnstone: 220, 221, 224, 225, 378. Mark Lally: 16, 19, 426, 172, 173. Mark Pilkington: 430. Genesis P-Orridge: 61, 150, 185. Produktion (Paul Hurst, Christine Glover): 6, 48, 49. Robin Rimbaud: 160, 161, 162, 232, 287, 328. Rosemary Pardoe: 341. David Tibet: 41, 44, 53, 100, 128, 131, 178, 191, 195, 197, 203, 206, 209, 210, 214, 217, 242, 245, 246, 255, 278, 318, 327, 333, 334, 337, 338,, 355, 358, 363, 364, 380, 388, 392, 419, 421, 424, 1, 2, 3, 4, 5, 6, 7, 8, 9, 10, 11, 13, 14. Andrew Thomas: 259, 264, 265, 266, 267, 268, 269, 270. Steven Stapleton: 69, 70, 73, 74, 76, 79, 82, 83,89, 113, 120, 132, 133, 156, 157, 188, 198, 201, 256, 258, 260, 261, 263, 273, 361, 368, 368, 384, 385, 387. Petr Vastal: 343. Adam Vavrick: 357. Johnny Volcano: 411. Lawrence Watson: 167, 229, 308, 309, 311. Jill Westwood: 103, 126, 141, 146, 147. Michael York: 411. Keiko Yoshida: 21, 29, 136, 165, 192, 230.

# Index